Raise your hand if you want to fly in space! If so, you share a quest with millions of dreamers around the world who have patiently, and impatiently, anticipated Sunday afternoon drives down celestial freeways. Yet, since human space travel began, fewer than 560 professional astronauts, cosmonauts, taikonauts and a-half dozen millionaires have gazed down at Earth from inside a spaceship. Given so few orbiting travelers, what made so many ordinary people think they had the slightest chance to fulfill their dream? Because for the past 60 years, space visionaries, aerospace companies, government agencies, and the media have told us our ticket to ride was just a rocket away. All we had to do was "keep the dream alive."

See You in Orbit? Our Dream of Spaceflight *will guide you on historical, personal, irreverent, and often-humorous tour of the promises, expectations, principal personalities, and milestones regarding the goal individuals have to fly in space. At the end of the tour we'll assess whether we are getting closer to the day when we can greet fellow dreamers with the joyful salutation: See You in Orbit!*

The door to private and commercial human exploration of space is finally open! *Generations from now, we will look back at this time as the Second Golden Age of space exploration after the moon landings 50 years ago. Few have had both a ringside seat as well as been in the ring as Alan Ladwig. This book chronicles the important but difficult change from purely government-sponsored space exploration through public private partnerships and purely commercial and private endeavors.*

Richard Garriott, Private Astronaut Soyuz TMA 13

Ever dreamed of flying in space? Me too. Alan Ladwig chronicles our deep and persistent yearnings, from pie-in-the-sky fantasy to lunar footprints, a savvy insider's narrative of a timeless human desire. **This book is your tourist rocket to the cosmos as we await the real thing.**

Lynn Sherr, Journalist, author of *Sally Ride: America's First Woman in Space*, semi-finalist NASA Journalist-in-Space Competition

Ladwig tells **a rollicking good story about the dream of spaceflight from test pilot astronauts to wealthy adventure tourists.** *But See You in Orbit? is much more than a delightful narrative of what has already transpired. It also peers into the future to project what might be as entrepreneurial firms offer opportunities for humans to orbit far beyond the dreams of the pioneers.*

Dr. Roger Launius, author of *Reaching for the Moon: A Short History of the Space Race*

SEE YOU IN ORBIT?
Our Dream of Spaceflight

MARK —
HOPE YOU ENJOY THIS HISTORY
AND GLIMPSE OF THE FUTURE
OF SPACE TOURISM. HERE'S
HOPING WE HAVE ROCKET
BACK PACKS SOON!

Alan Ludwig

SEE YOU IN ORBIT?
Our Dream of Spaceflight

Alan Ladwig

Foreword by Robert K. Weiss

To Orbit Productions
Falls Church, VA

Copyright © 2019, Alan Ladwig and To Orbit Productions LLC
All rights reserved

Library of Congress Cataloging-in-Publication Data

Ladwig, Alan
 See You in Orbit? Our Dream of Spaceflight

 Includes references and index
 1. Space Tourism
 2. Space Travel—United States—History
 3. Astronautics –United States—History

Library of Congress Catalog Number: 2019914178
ISBN 978-1-7332657-0-6
ISBN 978-1-7332657-1-3 (ebook)

For Information about special discounts for bulk purchases or to schedule
the author for an event, contact:
Alan Ladwig
Email: ToOrbitProductions@gmail.com
Website: www.ToOrbitProductions.com

Credits
Book design: Linda and Jeffrey Swoger
Cover art design: Alan Ladwig
Cover photo: Copyright © J. Larry Golfer
Author photo: Bill Ingalls

Printed in the United States of America
First edition 2019

10 9 8 7 6 5 4 3 2 1

DEDICATIONS

To My Wife:
Debbie Ladwig

To My Mentors:
Hulda "Toots" Shales, Harvey Eisner, John Whiteside (Lt. Col. USAF Ret.), Barbara Marx Hubbard, George Keegan, Dr. Peter Glaser, Fred Koomanoff, Chuck Bloomquist, Dick Wisniewski, Dr. Glenn Wilson, James Abrahamson (Lt. Gen. USAF Ret.), Dr. Carolyn Huntoon, Ann Bradley, James M. Beggs, Tom Rogers, and Dr. Sally Ride

To the Teachers:
The 114 State Finalists of the Teacher in Space Program

To the Dreamers:
All the wonderful people who wrote to me at NASA to share their passion for the dream to fly in space

TABLE OF CONTENTS

FOREWORD

Alan Ladwig and I met in the early 1970s while we were students at Southern Illinois University in Carbondale. At the time, I was the co-host of *Kaleidoscope*, a variety and talk show broadcast on WSIU-TV, the regional PBS station. Alan appeared as a guest on the show, along with Barbara Marx Hubbard, an heir to the Marx Toy fortune, and Lt. Colonel John Whiteside (USAF, Ret.) of the Committee for the Future (CFF). They appeared on the show to explain their upcoming space symposium entitled "New Worlds Week," of which Alan was the Chair. The committee was a new citizens' advocacy group supporting a higher purpose for space exploration instead of the global geopolitical competition between Russia and the United States—a cold war demonstration of technical and military superiority.

I was intrigued by their plans to employ a unique format at the conference called SYNCON. An acronym for Synergistic Convergence, SYNCON was designed to bring together participants from diverse disciplines to create a positive future for humanity. The conference was to be staged in the Student Center ballroom within a 100-foot-diameter wheel created by design students. The wheel was divided into six sections to accommodate different disciplines. As the week progressed, walls dividing the sections were gradually removed to encourage a convergence of ideas and solutions.

Innovative aspects of SYNCON featured a pre-digital, zoom-like, inter-video system that allowed participants within different sections of the wheel to confer or view proceedings or reference material on demand. It also featured extensive videotaping of all the deliberation with the sections, and the production of an evening news

show incorporating conference proceedings with world events. The program was broadcast to participants at the end of each day. Because of my own interest in space and remote video technology, I agreed to become the designer and executive producer of the video system and programming for the conference. Thus began an almost five-decade-long friendship with Alan, cemented by our mutual attraction to space exploration and dedication to being space activists.

After we collaborated on the second SYNCON held in Los Angeles in August 1972, we became roommates with the charter to establish west coast operations for CFF. Our plans were interrupted when Alan was drafted into the Army where he spent the bulk of his time safeguarding his tan while stationed in Greece. While he was away, I pursued a livelihood in the video profession, and ultimately in the feature film and television industry. When he returned from the Army, Alan followed his passion for space activities. Over the next 45 years, he excelled in leadership positions with the space sector for nonprofit, commercial, and media organizations, but especially at NASA, where he served in key positions during multiple "tours" at the mostly venerated organization.

In 1996, I was complaining to Alan that all the conferences I attended regarding the future of travel, exploration, and settlements in space dealt with time frames that were 50, 100 years, and more into the future. I asked Alan if he knew individuals or companies that were doing something different and exciting. Most important, were they doing it in a fairly immediate time frame and might they have opportunities for me to participate and support. Alan told me he knew somebody that some folks thought was "nuts," but his gut told him that this person and I would get along. That person was Dr. Peter Diamandis, creator of the XPRIZE. Dr. Diamandis had created a competition as the central catalyst of a non-government way for people to get into space. All you had to do was be the first to design, build, and fly a spaceship capable of carrying three

people into space and launch the same spacecraft again within two weeks time. Do that without government funding and you could win the $10 million cash prize. Alan made the introductions that kick-started my involvement with XPRIZE. I joined their board as the vice chair and ultimately became president of the organization. Among other responsibilities, I created events to generate excitement for commercial space and space tourism. To learn more about the XPRIZE, you will have to read my book to be published later this century.

In this new role, Alan and I frequently collaborated on numerous space gatherings and initiatives. We even shared an obsession for collecting space toys and other examples of the intersection of space and popular culture, art, models, flown artifacts, and more. Ultimately, we donated our combined world-class collections to the St. Louis Science Center. This especially pleased our wives, who were then able to reclaim major portions of our homes that had become adjunct "space galleries" and return them to their original intended use—residences for our families. What a concept!

Over all these years, I've followed and admired Alan's dedication to directly engaging the public in space activities and events. His leadership of NASA's Space Flight Participant Program helped to change perceptions of who should be "allowed" to experience Earth and space from orbit. He has now completed this wonderful and impressive history of the dream many of us have to fly in space. Since he enjoyed a front row seat to many of the events and proposals to expand space flight opportunities, I can't think of anyone better suited to tell this still unfolding story.

In the February 1972 issue of *New Worlds* magazine, Colonel Whiteside wrote this about the chair of SYNCON:

Alan represents a new kind of leader. He works as an activator, facilitator, and initiator rather than a chairman . . . He knows the wiles of the establishment and bureaucracy: still he persists and

prevails. Alan is one of the several hundred of his peers working quietly but effectively to put the New Worlds option into the arena of public discussion . . . He has the chance to raise a banner of hope, which, unlike the brief uplift of John Glenn's orbital flight a decade ago, can truly fly for generations to come.

Almost five decades after these words were written, Alan is still working to "raise a banner of hope" and has completed this compelling history of our dream to fly in space. In pursuing your dream, whether it is going to space or some other grand goal, be like Alan: persist, prevail, and share your stories with the rest of us. This fantastic book is a narrative gateway to space that tells the story of our space aspirations and sets the stage for the near future. For most of us, for now, (though changing even as you read this) it is the next best thing to being there.

Ad Orbis,

Robert K. Weiss
Film and Television Producer,
Vice Chair of the XPRIZE Foundation

INTRODUCTION

We tell stories to try to come to terms with the world, to harmonize our lives with reality.
Bill Moyers, *The Power of Myth*

Ladwig is supposed to make sure it (Space Flight Participant Program) all runs smoothly . . . just like Ward Bond easing homesteaders across the prairie in Wagon Train.
Howard Rosenberg, *"NASA's Travel Agent"*

The Long and Winding Road

This book has been a crime of passion for over three decades. In the mid 1980s, I was manager of the National Aeronautics and Space Administration's (NASA) Space Flight Participant Program—the opportunity for non-astronauts to fly on space shuttle missions. A teacher was selected for the first participant flight, to be followed by a journalist. An artist may have been next.

Tragically, the program came to an early end when the Space Shuttle Challenger exploded during its launch ascent killing the crewmembers, including high school teacher Christa McAuliffe. Even after the accident, private citizens wrote to me asking for a ride on the shuttle. Despite the disaster, their dream to fly in space was not diminished. Their unwavering resolve inspired me to tell this story.

I started to outline the book in 1989 while serving in the Office of Exploration at NASA Headquarters, but it didn't seem practical to write on a part-time basis. Fortunately, my wife Debbie shares my passion for space (We met at NASA) and supported my decision to resign from the agency, cash in my meager pension, and commit to writing full time. In those days, the Internet and the ability to con-

duct research online were in their infancy. I spent hours in the NASA archives and the Library of Congress researching hard copies and microfiche film of relevant information.

The publishing juggernaut proved to be a much tougher nut to crack than I bargained for. With my share of rejections from literary agents and publishers, it didn't take long to see that giving up a job and salary was, shall we say, ill advised. You read stories about poor, struggling writers, but you never want to be one.

So back to work I went—as an editor and writer for a space magazine, then as a NASA contractor, and eventually back to the agency as a political appointee for the Clinton administration. An offer to publish did arrive from a university press, but considering I was again working fulltime, finding free time to devote to the book slipped away. The project was pushed to the back burner and remained there for another 25 years.

In 2014, I resigned from my third tour at NASA, this time as a political appointee for the Obama administration. I was more than ready to focus on the good life of retirement. Debbie followed a year later, and we spent the next four years traveling around the U.S. and other countries, creating works of art, playing on our lake, and tending to rescue pets, including a rabbit and our terrier-poodle mix from Puerto Rico, Zorro.

In the summer of 2018, the flames reignited due to the ubiquitous news stories about the promise of commercial space tourism. Your chance for a spaceflight was coming to a launch pad near you soon! Advocacy investors like Jeff Bezos, Robert Bigelow, Richard Branson, and Elon Musk became household names as they promised to deliver on the long-sought dream of spaceflight for "ordinary people." Not only did they entice us with promises of suborbital hops but also bold plans for space hotels, trips around the Moon, and settlements on Mars. With their applications of disruptive technologies to traditional operations, a space renaissance emerged.

Given all the excitement, I once again pulled out four-file drawers worth of research and note cards. There was also a need for new research to capture all the progress that had been made over the last three decades. After all this time, Debbie is still the number one supporter of my dream to tell this story. It would not have been possible without her.

Haven't We Met?

This story is intended to harmonize your dream to fly in space with reality. I know a little something about the quest.

Although the selection criteria for the first two space flight participant opportunities were designated for an educator or reporter, it didn't stop thousands of people from writing to NASA to plead for a chance to board the space shuttle. If that was you, chances are your letter ended up on my desk. I was the one who sent back that heartbreaking form letter that threw cold water on your dream. (And back then it was all done by letters sent through the U.S. Postal System. I have no doubt the number of inquiries would have been many times greater had email been in use.)

Thinking my response was insensitive and rude, you then wrote to the NASA Administrator to appeal your case. Although his signed reply on Office of the Administrator stationery was a little less bureaucratic, a little more personal, the answer was still no. I wrote that letter, too.

Not satisfied with this brush-off, you contacted your senator or congressman demanding they intercede on your behalf. This time around, the response was sympathetic, and your representative assured you, "This matter has been brought to NASA's attention." However, you still didn't get the hoped-for, positive reply. Your honorable legislator may have signed the letter, but replies to constituents seeking a ride on the shuttle were frequently drafted at NASA by you-know-who.

By then you were really steamed, so you took your plea to a higher authority. You wrote to President Ronald Reagan to complain about the knuckleheads at NASA and Congress who did not take your request seriously. You mentioned that you voted for him in the last election and told him he was doing a wonderful job. The fact that you had just undergone a triple by-pass heart operation, wanted to experience childbirth in space, or were over the age of 90 or not yet 10 shouldn't stand in the way. Such qualities made you the perfect subject for unique experiments on the next available mission.

A few of you might have received an auto-penned reply from the president. Those were the replies that usually found their way into the local news: "When NASA told her no, ten-year-old Maggie Lamwood took matters into her own hands and petitioned the president for a ride into space." But guess who drafted the response to your presidential plea? That's right—me! To make matters worse, most of you didn't even receive a letter on White House stationery. You received another boilerplate epistle on NASA letterhead with my signature saying: "Your letter to the White House concerning your request to fly on the space shuttle has been referred to my office for reply."

For the really desperate, this was the last straw. You were destined to get on the shuttle, and no civil servant boob was going to stand in your way. My favorite example was Jerry Stoces, a high school student from California who was especially convinced of his unique capabilities to fly. He wrote to no fewer than 20 local, state, and federal government officials asking them to intervene on his behalf. In the end, all of his missives ended up on my desk, which of course earned him a mighty fine collection of my negative replies. He obviously became more than a little distraught over my constant rejections. On the envelope of one of his last letters, Stoces pleaded, "Please do not give this letter to *Anyone* other than the Administrator of NASA to *Read and Answer*."

Several years later, he moved to South America, but was still committed to his dream. This time Stoces tried to get approval to represent Bolivia and fly under the category of payload specialist. Whether he sent his letters to NASA or to members of Congress, his pleas created a string of required Action Items for me to answer. With so many inquiries from the public, it was challenging to devote so much time to the dream of one person. Stoces was a most persistent chap, but wait until you find out what he's up to today.

You may not have believed it then, but I didn't enjoy sending a rejection letter to your offer to jump into the rumble seat of the next shuttle. I was quite sympathetic and shared your dream. Is it too late to say I'm sorry? Hopefully, this book will explain why I had to squash your aspirations and bring you up to date on how you might now actually turn your dream into reality.

Stars in Your Eyes

Who knows how long we've been trying to flap our way into orbit? Some scholars believe the quest to mingle with the stars was embedded into our DNA eons ago. We've rushed to queue up at the launch pad every time some space merchant promised a new scheme to get us off the planet. We have patiently, and impatiently, anticipated Sunday afternoon drives along celestial freeways. It's a dream shared by a diverse demographic of age, gender, race, religion, or country of origin.

You aging hippies are content with retirement and would settle for a simple excursion into orbit on any old space taxi that could be towed out of the hangar. "Once around the park—I'm kind of in a hurry," will provide a natural high.

Many of you Generation X or Millennial readers hope to make flying in space a career. You've been to Space Camp three times, can dissect a rocket engine, and have your sights on joining the astronaut corps, whether with NASA or a private spaceliner.

The more extreme space cadets are ready to fill out a permanent change of address card. You've had it with this planet, and your destination lies beyond Earth's boundaries—way beyond. You're ready to sign a mortgage for a bungalow on the Moon or maybe a condo on Mars. You're a card-carrying member of the club that's convinced Earthlings are destined to thrive as a multi-planet species. Bezos, Branson, and Musk are the holy trinity of your church, and their every utterance is your gospel.

We like to think what draws us towards the dream is up close and distinctive. Sorry, but we're not all that unique. The motivation has been the same for years. In the 1920s, Robert Goddard was besieged by hundreds of volunteers to ride on his theoretical rocket to the Moon. In the 1950s, thousands of dreamers from around the globe signed up for the Hayden Planetarium's Interplanetary Tour, even though it was nothing more than a publicity gimmick for a single space lecture. A Pan Am Space Clipper in the 1968 movie *2001: A Space Odyssey* spurred more than 90,000 astronaut-wannabes to book a reservation with the airline's First Moon Flights Club. During the early flights of the space shuttle, over 10,000 armchair astronauts begged NASA for a chance to fly, while 14,000 educators requested applications to become the Teacher in Space. Over the past eight years, more than 800 people have made deposits for a $250,000 suborbital flight.

If you remove the dates from the letters to Dr. Goddard, to the Hayden Planetarium, or to NASA and place them side-by-side, it would be difficult to tell when the request was written. The penmanship in the letters to Goddard was better, but beyond that, the motivations for space travel include many common themes.

We believe a trek into orbit will fulfill a yearning spiritual quest or add meaning to our otherwise meaningless lives. Achieving the challenge of star travel will extract a new level of excellence and unearth our true potential. We hear those who have been there and back are

blessed with an Overview Effect, where national borders give way to a renewed respect for the common heritage of humankind.

For rocket engineer Krafft Ehricke, a trip into space would fulfill our destiny as children of the universe. He believed, "As time goes on, we will perceive ever more clearly that we are children not only of Earth, but of the entire universe whose call has a magical appeal to those who can hear their voice challenging us to fly high."[1]

Artist and space philosopher Earl Hubbard also reflected on the children of the universe theme. He believed that with the space program "Earth-bound history has ended. Universal history has begun. Mankind has been born into the universe. The long-range goal for mankind should be to seek and settle new worlds for the race of man."[2]

Being smacked by the Overview Effect and answering the magical call from the universe is all well and good, but after 58 years of human space flight, shouldn't we all be there by now? If all had gone as planned, we should already have received our first ticket for driving while intoxicated under the influence of star shine. However, fewer than 600 people have achieved an orbital perspective. Given so few travelers, why do so many of us think we have the slightest chance to fulfill our space flight dream?

We believe this can happen because for decades, visionaries, government officials, space companies, and the media told us our ticket to ride was just a rocket away. All we had to do was keep the dream alive. Unfortunately, all the optimism and promises of the past were too often overhyped and unrealistic. Are your chances any better now?

While you're pacing around the passenger lounge waiting for your row to be called, enjoy this history of the promise, problems, and policies of how your dream to fly in space has evolved. The story is told through a historical chronology, based on official records,

press reports, speech excerpts, anecdotes, and letters. Where appropriate, it is autobiographical, with personal reflections and experiences from my involvement with the Space Flight Participant Program and space outreach activities.

Spoiler alert: the story is told through the vernacular of the times. Certain words or phrases may upset current sensibilities, but the language reflects the norms and usage of the period. The Baby Boomers in the audience, and those who follow space religiously, will recognize familiar and previously told history. However, the information is conveyed in parallel with what was promised at the same time about space flight for us *ordinary citizens*. Those of you born after 1984 will find it disturbing to learn that there was a time when space travel wasn't an option for everyone who wanted to go. For you, the notion of launching a woman, a minority, or a teacher may seem like ancient history, but for me, it seems like yesterday.

When I managed the Space Flight Participant Program, a reporter asked me to describe the overriding rationale of why people volunteered for a flight. As I told him then, and I believe is still true today, "The dominant theme of 80 percent of the letters NASA received: "It's always been my dream to fly in space."[3]

If you are among that 80 percent, this book is for you. At the end of the story, you can determine if you are any closer to your dream and if you will ever join the zero gravity elite and earn the right to say, "See You in Orbit!"

1 THE DREAMS OF YESTERDAY

I assure you that I am not a lunatic that I am quite sober and I know that when I go my life is certainly in great danger . . . If you are in need of a crew, I am ready to go.
> G. A. Koh, Letter to Dr. Robert Goddard

Rocket-travel advocates appear dangerously sane in this age, when the dream of one decade becomes reality in the next.
> Lady Drummond-Hay, "Gossip of the World"

Here is the moment for which I have waited so long. If you can reserve my passport, never mind the place. I am ready to start . . . At last my dream will be realized.
> Jean Paul Lorrain, Letter to Hayden Planetarium

Reaching for Extreme Altitudes

For centuries, the space faithful have believed our destiny lies beyond Earth's boundaries. In mythology, Icarus hurled himself towards the sun with wings of wax and feathers. In our daydreams, we try to imagine what it must be like to sail around the Earth at 17,500 miles per hour. In our reality, we have invented scheme upon scheme to escape from the gravity wardens of Earth.

In *Man Among the Stars,* Wolfgang Mueller asserted the "true" space dream began in 1865.[1] While America's Civil War ground to a close, five works of European space fiction managed to ignite the public's imagination. The plot of each story—written by Jules Verne, Achille Eyraud, Alexandre Dumas, and two anonymous authors—revolved around human space exploration in general and journeys to the Moon in particular. In Mueller's judgment, these stories

differed from earlier works of space literature because "each put great value on the technical and scientific elaboration of the means . . . their heroes reached their common goals."[2]

Three of the founding fathers of the space program were among those inspired by these works of fiction. Working independently in the early part of this century, this trio, including a Russian, an American, and a Hungarian of German descent, dedicated their careers to a shared obsession to send rockets and humans into space.

The first of these pioneers, Konstantin Tsiolkovsky, was a Russian physicist and science teacher. He firmly believed, "Humanity will not stay on Earth forever, but in pursuit of new frontiers will first penetrate timidly beyond the atmosphere and then will conquer for itself the rest of the planets around the sun."[3] Considering the state of technology at the time, there was nothing timid about Tsiolkovsky's prediction.

Recognized as the father of Russia's space program, he pioneered theoretical concepts for rocket vehicles as a means to conquer gravity. In 1903, the year Wilbur and Orville Wright first took flight at Kitty Hawk, Tsiolkovsky published "Investigation of Outer Space with Reactive Devices." This treatise described basic principles of space flight, rocket design, and potential propulsion systems. His subsequent articles included diagrams of people living and working on orbiting space stations, complete with recycled air and water systems, gardens, trees, tunnels, and spacecraft docking ports. He eventually conceptualized a multistage, 300-foot-long passenger rocket train, which he predicted would launch by 2017.

Those who grew up in the U.S. are more familiar with the dreams of Dr. Robert Goddard, the father of American rocketry. Whereas Tsiolkovsky dealt primarily in theory, Goddard was a hands-on builder of rockets. Working from his laboratory in Worcester, Massachusetts, he continually violated the local fire safety laws with

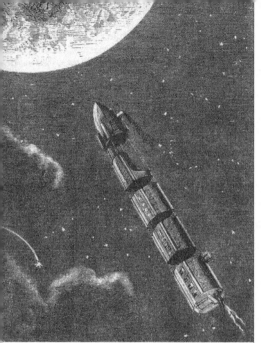

From *Earth to the Moon* by Jules Verne inspired the early space pioneers.
Photo: ESA

his liquid-fueled fantasies. From these fantasies came the first successful launch in 1926 of a liquid-propellant rocket. For health reasons, not to mention the encouragement of the local fire marshal, he packed up his rockets and headed to the wide-open spaces of White Sands, New Mexico. From this new base, he built larger rockets that reached higher and higher altitudes.

Goddard was primarily interested in rocketry as a tool for atmospheric investigations. However, in his 1919 monograph "A Method of Reaching Extreme Altitudes," he speculated on future applications of rocket technology. Towards the end of the article, he acknowledged that it might be feasible to someday send a spacecraft to the Moon. Amused by this speculation, the press referred to Dr. Goddard as the "Moon Man." *The New York Times* went so far as to say he lacked the "knowledge ladled out daily in high schools."[4] Fellow scientists thought he might have sniffed a little too much kerosene; clear-thinking people knew that a rocket couldn't function in the vacuum of space. As a result of these negative reactions, it is easy to understand why Goddard shunned publicity and conducted much of his future research off the grid.

While the press and his peers were skeptical of Dr. Goddard's theories, the general public was ready to sign up for the journey. He received more than a hundred letters from volunteers eager to fly on his yet-to-be-built Moon Rocket. Ernest proposals from men and

women, young and old, here and abroad, poured into his office and to his research sponsor, the Smithsonian Institution.

For example, Professor C. Baucia of the International Literary Musical Institute in Baltimore offered himself "to science willing to be a passenger at the time the projectile will be perfect."[5] A Hollywood publicity agent thought Goddard's "torpedo rocket" ought to carry a greeting from his client, actress Mary Pickford.[6] G. E. Maxwell of New Mexico said he would be glad to fly, provided "my name be withheld from the public and my expenses be paid from my home to the starting point."[7]

A *New York American* story on Goddard's unsolicited helpers reported that Ruth Phillips of Kansas City, Missouri had volunteered to accompany Captain Claude Collins to the Moon. Not wanting to be left behind, Vanora Guth of New York City volunteered to make the trip with Captain Charles Fitzgerald, who it seems had "offered to precede, go with, or follow Captain Collins."[8]

Some of the mail intended for Robert Goddard ended up in the hands of others who shared his last name. A letter from France found its way to the office of Charles Goddard in New York City. Author of such best sellers as *The Perils of Pauline* and *The Exploits of Elaine*, Charles Goddard forwarded the letter to Harold Goddard at Swarthmore College. In a postscript Charles asked:

> By the way, what has become of that rocket project? I am sure there are a great many people . . . who would be glad to contribute a dollar or two . . . as a sporting event, to see how far it would go. I suggest that you send as a passenger Senator Royal S. Copeland, who would love the publicity . . . The Sovereign State of New York would be quite willing to let you have him.[9]

From Swarthmore College, Harold redirected the letter to the appropriate Professor Goddard. In his forwarding correspondence, Harold noted Charles' suggestion to fly Senator Copeland and added,

"If you can spare the space in your rocket, you ship the entire Senate to the moon. At any rate squeeze in Henry Cabot Lodge."[10] Neither suggestion mentioned anything about a return trip for the gentlemen from Congress.

Speaking of politics, one volunteer recognized the potential post-flight recognition a trip into space could provide to someone seeking elected office. Signed "Pro Bono Publica" (for the good of the public), the writer recommended a seat "be reserved on your ship for Wm. J. Brogan. He is eminently qualified by training and natural qualities . . . Besides it will keep him before the public and might secure for him on his return, the nomination for Presidency."[11]

Goddard's volunteers saw space travel as a way to add meaning to their lives. For Dr. Franz von Hoefft, space travel was a way to do something worthwhile: "In our poor little country men have nothing more that makes their life worth living. The honor as first chauffeur of a rocket to the moon at least would give me something of the kind."[12] From Finland, Ake Tollet proclaimed he was willing to "risk (his) life for the implementation of your scheme" if Goddard could only find a use for him.[13]

The Portsmouth Star pointed out that Goddard's rocket wasn't even a new idea. In a front-page story titled "Rub-A-Dub-Dub, Three Men in a Rocket Will Try to Reach the Moon," the *Star* reminded readers, "It is (an idea) one hundred learned men have had for opening social, commercial and tennis relations with the folk in the moon."[14]

Alas, all those who volunteered to jump into the rumble seat of Goddard's space ship were disappointed. C. G. Abbott, the acting secretary of the Smithsonian, prepared a terse rejection form letter admonishing volunteers: "I think there is no possibility that any volunteers will be called for a trip to the moon either in your lifetime or in mine, but if there should be we will bear your offer in mind."[15] Sound familiar?

Goddard himself seemed more irritated than pleased with the public's enthusiasm. "I wish to say," he snapped, "I have asked for no volunteers. There is, at this moment, no rocket ship contemplated for the moon. If there were less volunteering and more solid support, I could get along much faster . . ."[16]

While Dr. Goddard was attempting to control the heat generated by overanxious volunteers, a third rocket pioneer was adding fuel to their dreams. In Germany, Dr. Hermann Oberth ignited the public's imagination with his visions for human space travel.

In 1903, the same year the Wright brothers first flew at Kitty Hawk, Konstantin Tsiolkovsky sketched out his plan for a space station.
Photo: NASA

Oberth's first book, *The Rocket into Interplanetary Space*, became an instant best seller. Self-published in 1923, the slim volume documented Oberth's views on the fundamentals of rocketry, propulsion systems, and vehicle design. The part where he predicted human passengers would one-day travel to space appealed remarkably to the dreamers in Germany. The book included a diagram of a space station to be used for weather observations, as well as an assembly port for spacecraft bound for celestial destinations. Again, the press and other scientists were skeptical, but the public believed in Oberth's vision and the shape of things to come.

Whereas Robert Goddard preferred to conduct his research out of the public eye, Hermann Oberth believed publicity was essential to promote the space cause. An early president of the German Society for Space Travel, he became a prolific writer and lecturer. Oberth's success in inspiring the public led to a brief career as a technical advisor for the first space fiction film. Movie director Fritz Lange hired Oberth to design and build a realistic rocket for *The Girl in the Moon*. In ad-

dition to duties as technical advisor, Oberth was asked to construct and launch a rocket as a publicity stunt for the movie's premiere. While this attention grabber did not materialize, the film's release in October 1929 proved to be an unqualified success and stimulated substantial public interest in space flight.

Even before Oberth published his book, the "jet-setters" of the day were already expressing their interest in visions for space flight. After the German Society of Space Travel brought the topic to the attention of Lady Drummond-Hay, she reported on the space dreams of the rich and famous in her "Gossip of the World" column for *The Mentor World-Traveler* magazine. The German rocketeers recommended that she "interest some newspaper group in rocket flights to the moon and probably Mars later."[17] In her October 1920 column, Lady Hay reported on the interest in space of one of her favorite celebrities, the Infante Don Alfonso. Cousin of the King of Spain and head of the Spanish Air Service, Alfonso was "captivated by the dream of space travel."[18] During a South American tour aboard the Grand Zeppelin, Lady Hay observed, "Alfonso and Colonel Emilio Herrera, incessantly discussed rocket transport and its possibilities as an every-day, feasible proposition."[19]

However, if you wanted to join one of these everyday flights, you needed cash—lots of cash. After her discussion with French rocket designer Robert Esnault-Pelterie, Lady Hay observed, "Before we discover the moon, we have to discover a millionaire willing to spend about 400,000 pounds ($7 million in today's dollar) on the expedition."[20]

Lady Hay also reported on the excitement about the prospects for lunar expeditions. In New York, Walter B. Bevan, a "wealthy rocket amateur," was engaged in a "friendly rivalry" to beat Herr Robert Krask's efforts. Meanwhile in Kent, Ohio, Jim Sorgi was secretly building his own rocket destined for either the Moon or Mars. In signing off on her column, Lady Hay noted 87 people had already

applied for permission to accompany Mr. Sorgi on his not-so-secret journey, and "twenty (were) women."[21]

Of the three key rocket pioneers, only Hermann Oberth lived to see the dream of human space travel become a reality. In July 1969, he was in the stands at Cape Canaveral for the launch of Apollo 11. The contributions to rocket research by this visionary troika spawned generations of technical activists committed to bold visions for humans in space and inspired early dreams of citizen spaceflight.

Uncle Sam Vants You

During World War II, there was little time to focus on thoughts of launching rockets into space, with or without passengers. The members of the German Rocket Society were drafted into the service of Hitler's dream of world domination. Instead of shooting for the Moon, the German engineers were ordered to launch their rockets towards London. The Aggregat-4 (A-4) / Vergeltungswaffe-2 or Revenge Weapon-2 (V-2) rocket, once intended for scientific investigations, was transformed into a frightening vengeful weapon.

In October 1942, the V-2 became the first rocket to surpass the speed of sound and cross the border into space. Upon completion of this milestone launch, Chief General Walter Dornberger turned to his young aide and asked, "Do you realize what we accomplished today?" The assistant, Dr. Wernher von Braun, replied, "Yes, today the spaceship was born."[22]

The V-2s were not used as a weapon of mass destruction until 1944 when the Germans started to launch the rockets at cities, including London, Antwerp, and Paris, to name a few. Over 3,000 rockets were launched, killing more than 9,000 civilians. Fortunately, the war ended before the rockets extracted their full

measure of vengeance on the U.S. Plans were underway to add a booster stage to a V-2 in an attempt to reach New York City.[23]

Unfortunately, von Braun's interest in the V-2 as a spaceship put him at odds with Gestapo Chief Heinrick Himmler. Convinced that von Braun's research interests were aimed more towards the mesosphere than the enemy across the Channel, Himmler charged him with treason. Only General Dornberger's last minute intervention saved young Wernher from a stint in the Gestapo's gulag.

As the Allies closed in on the Peenemunde rocket base toward the end of the war, the German missile men caucused to determine their future. According to Dornberger, "We despised the French, we were afraid of the Russians, and we didn't think the British could afford us. That left the Americans."[24] With von Braun as their spokesman, 118 of Peenemunde's best and brightest surrendered to the U.S. Army. Beginning in September 1945 and continuing for the next several years, over 1,600 researchers from the German Air Force and Navy were brought to America.

The code name for this recruitment effort was Operation Paperclip, so called because a metal paperclip was attached to the files of the Germans the U.S. Army wanted to bring to the states. In less than five years, German space engineers including von Braun, Dornberger, Konrad Dannenberg, Kurt Dubus, Krafft Ehricke, brothers Fritz and Heinz Haber, Eberhard Rees, and Ernst Stuhlinger emerged as leading advocates for the American space program. Free from servitude to Hitler's maniacal plans, the German rocketeers redirected their energies towards the vision of human space flight.

Prior to his arrival in America, Dr. von Braun had documented the technical development of the V-2 in a scientific article titled

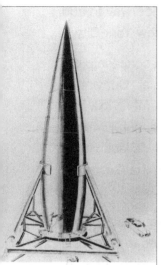

Douglas Aircraft "World-Circling Spaceship," 1946
Photo: NASA

"Survey of the Development of Liquid Rockets in Germany and Their Future Prospects."[25] In the article, he foresaw technological breakthroughs that would make it possible someday for crewmembers to glide beyond the atmosphere in rocket planes.

In 1946, advance planners at the Douglas Aircraft Company completed a study on the "Preliminary Design of an Experimental World-Circling Spaceship." Their review encompassed a "conservative and realistic engineering appraisal of the possibilities of building a spaceship which would circle the Earth as a satellite."[26] The study was primarily directed towards understanding requirements to launch a 500-pound scientific satellite into space. Nonetheless, the report admitted, "In the back of many of the minds of the men working on this study, there lingered the hope that our impartial engineering analysis would bring forth a vehicle not unsuited to human transportation."[27]

The Douglas report estimated an unmanned scientific satellite could be completed in five years at a cost of $150 million, and be launched from a Pacific island near the equator. As for a vehicle with humans on board, the study saw no insurmountable obstacles and offered reasonable "assurance that the hope of an inhabitated (sic) satellite is not futile."[28]

During this period, government-sponsored space research was conducted in secret by the military services. That changed in December 1948 when Secretary of Defense James Forrestal released his annual report and let the cat out of the bag to reveal America's engagement in a new program: "The earth satellite

vehicle program, which is being carried out independently by each branch of the military service, was assigned to the committee on guided missiles for coordination."[29]

No one knows why Forrestal chose to make the program public or why so little information about the satellite was provided. However, the reveal led to much speculation that America was developing a man-made orbiting platform from which to launch rockets at any point on earth. Due to a series of unrelated disagreements with President Harry S. Truman, Forrestal was forced to resign as secretary of defense just three months later.

Several years later in his book *Rockets Beyond the Earth*, Martin Caidin described the impact of Forrestal's revelation: "Projects to tax the credulity of the average American citizen flashed onto the newspapers when the secrecy veil covering certain military projects in this country was partially lifted . . . a fantastic new series of projects that actually contemplated the establishment of giant, manned space stations above the Earth!"[30]

Forrestal's announcement confirmed that the government was seriously conducting research in an area normally considered to be pure science fiction. Caidin observed the first public reaction to such a notion would normally be greeted with laughter or dismissed as a joke, "But when the Department of Defense issues such a statement, it's no longer funny."[31]

It may have been nothing to laugh at, but the technology of the day had quite a way to go before humans would ride in spaceships to inhabit orbiting space stations. Around this time, the highest distance a military rocket had traveled was 21,756 miles short of the proposed space station altitude. In February 1949, Project Bumper, an Army rocket mounted on top of a captured German V-2 rocket, soared to a record altitude of a measly 244 miles.

11

Rhesus Pieces

The animal kingdom has made tremendous contributions and sacrifices to our dream of space flight. Even though there were plenty of volunteers willing to be hurled into space on top of missiles, there was little knowledge of whether or not our flesh, bones, and brains could survive a flight. To answer this question, the Air Force initiated an intensive medical research program that included studies on how animals might be employed to help investigators understand the effects of space travel on humans.

Dr. Heinz Haber of the USAF School of Aviation Medicine suggested, "Long before man ventures into space, animals will be sent in small rocket ships for the study of radiation effects over extended periods of time."[32] He recounted how 150 years earlier, animals had been sent aloft in a balloon flight, "and it seems that more such honors are in store for the animal kingdom. Unfortunately, however, these dumb animals will be unable to communicate their experiences."[33] Given what was about to happen to these "dumb animals," it's not clear they would have agreed that the flights were all that great of an "honor."

The Aeromedical Field Laboratory at Holloman Air Force Base in New Mexico selected Rhesus monkeys as passengers for rocket test launches. Despite your dream of space flight, you would not have rushed to be a passenger on these missions. Even though engineers had gained confidence in their ability to shoot rockets into the atmosphere, they had yet to master successful techniques for reentry and landing.

For these tests, the monkeys and scientific instruments were wedged into the cramped quarters of a V-2 nose cone. Beginning in June 1948 and continuing until December 1949, a succession of monkeys—all named Albert—made the ultimate sacrifice for our dream of space travel. On the maiden monkey

mission, Albert I experienced breathing difficulties in the capsule and is thought to have died before launch. As it turned out, the reentry parachute failed anyway. One year later, Albert II survived a launch to an altitude of 83 miles, but during descent, the parachute system again failed, and he was killed on impact; Alberts III and IV suffered similar fates.

In 1951, the laboratory switched rockets from V-2s to the Navy's unguided Aerobee suborbital sounding rocket. On the first Aerobee flight in April, medical instrumentation recorded the respiration and heart rate of the Rhesus test subject, and "valuable data (was) acquired . . . which indicated that weightlessness had no apparent disturbing effect upon the animal."[34]

Weightlessness may not have been disturbing, but those landings were another story altogether. The parachute system again malfunctioned, and yet another monkey accepted the fate of a kamikaze pilot. On a launch six months later, the parachute finally deployed properly, and a crew of eleven mice and one monkey survived a landing from an altitude of 44 miles. Regrettably, it took the recovery team over an hour to locate where the capsule landed. The scorching desert temperatures took its toll, and before the capsule was recovered, the monkey and two of the mice had perished.

In May 1952, monkeys finally survived long enough to be honored at a post-landing reception. On the last Aerobee medical test flight, two mice and monkeys Pat and Mike survived a launch, reentry, landing, *and* recovery. Just as space travelers today enjoy post-flight fame, Pat and Mike became instant national heroes and the first primates to pierce and survive a trip to the upper atmosphere. Once the flight surgeons had completed the mandatory post-flight check-up, the monkeys became resident celebrities at the National Zoo in Washington, DC.

Doctors Heinz and Fritz Haber finally came up with a technique that lightened the load for the Rhesus test subjects. The brothers devised a new medical research method that enabled humans to experience brief periods of gravity-free flight. For this technique, human subjects rode in an aircraft as it performed aerodynamic parabolas. When the aircraft went over the top of the parabola, passengers experienced up to 30 seconds of relative weightlessness, or free fall. In technical terms this was referred to as "Keplerian Trajectories," but to those who occasionally experienced symptoms of motion sickness, the ordeal became affectionately known as a ride on the "Vomit Comet."

Magical Mystery Tour

Once the military space research program became common knowledge, rocket enthusiasts could not stop talking about their dream to send humans into orbit. Missionaries circled the globe preaching to anyone who would listen about the promise of space travel.

In March 1950, officials at the Hayden Planetarium in New York City recognized you didn't have to be a rocket scientist to have a yen to travel in space. To add a bit of whimsy to author Willy Ley's "Conquest of Space" lecture, an Interplanetary Tour Reservation Desk was set up in the museum's lobby. Lecture attendees were handed a Planetary Tour Reservation Form. "You are one of the first to request a reservation on a space-tour," the form stated. Applicants were instructed to place a check next to their preferred destination: the Moon, Mars, Jupiter, or Saturn. Before departure, reservists were advised to "consult the S-T safety manual for complete takeoff preparations including anti-blast protection and care of personal equipment."[35] The estimated departure date for a trip to the Moon on the spaceship Lunaria was 1975.

Following the evening lecture, numerous newspapers and magazines carried stories about the clever promotion, and the museum was soon inundated with requests for the form. Letters from across America and around the world arrived by the sackload. Museums in other cities, newspapers, and book publishers asked for permission to replicate the application form. The HO-TAM Company Ltd. travel agency in the Netherlands petitioned to reproduce the form and offered to become the "official Agents for the European Continent."[36] The Hayden gave its consent to all requests and agreed to accept all applications.

That summer, two space fiction movies premiered at the nation's theaters. Film producers of *Rocket Ship XM* and *Destination Moon* wasted no time in capitalizing on the planetarium's promotion. Reservation booths were set up in theater lobbies on Main Streets across the country. At the Liberty Theatre in Cumberland, Maryland, the entire Chamber of Commerce wanted in on the act. Merchants handed out the Interplanetary Tour Reservation forms and placed space education displays in the lobby. In a letter to the Hayden, theater manager Monroe Kaplan admitted, "Naturally we are not well versed in what comprises an educational display and would appreciate your advice."[37]

What had begun as a tongue-in-cheek promotional stunt grew beyond the planetarium's wildest imagination. This was no stunt to the 26,000 applicants who wrote to the museum over the next two years; they were dead serious. Initially, Frank Forrester, supervisor of Guest Relations, responded individually to requests but was eventually forced to develop a form letter. Along with the letter, the museum sent an information packet including a list of space societies around the world, a recommended reading list, and sources for pictures, slides, and reference materials.

The best part of the packet was the wallet-size reservation certificate for the "Hayden Planetarium Space Travel Tours, Inter-Planetary Route." One side of the certificate displayed the Hayden's logo featuring its Zeiss planetarium projector superimposed over a winged-rocket ship. The reverse side displayed a "Space Ship Time Schedule."

Traveling at a speed of 25,000 mph, it would take nine and one-half hours to reach the Moon, some 240,000 miles away. At the same speed, 1,333 days were required to reach the 790,000,000 miles to Saturn. The fine print on the card included the disclaimer: "The Planetarium cannot be responsible for delays en route caused by meteor showers." The future space tourists were told to present their card at the museum "when announcements of flights are made."[38]

Those who completed the form came from all walks of life and with a wide range of rationales for going. Although the museum accommodated inquiries from news reporters for names of individuals from specific cities, they refused requests for copies of the complete list. Both R. M. Barnes of Jersey City and Walter Moore of Chicago wanted to contact all those who had enrolled in order to establish local space organizations or a "Space League."[39]

Believing the spaceship Lunaria was on the pad and ready to launch, Elsie Sherwood enclosed a $1 bill with her reservation form. From her home in Westwood, Massachusetts, Miss Elsie wrote, "I am a female about 60 and therefore expendable. I have been around the world three times and will gladly go further."[40] Frank Forrester returned her dollar explaining, "According to estimates almost 4 billion of these dollars will be needed to start a research program leading to a space ship. This astronomical figure is one for the government to worry about, not mere humans like you and me!"[41]

Despite the travel expense, some applicants saw tremendous entrepreneurial potential in a trip to the Moon. Breese Industries of Santa Fe made a bid for a list of those who filled out the form to promote an unspecified "product of interest to space travel."[42]

Twelve-year-old Galeta Karr of Chicago also sought to establish an unspecified business on the surface of the Moon. On the opposite side of the Windy City, insurance agent Angus Chassells requested a charter for the first lunar insurance company.[43] Ed Meade from British Columbia thought the trip would benefit his job as a reporter for *The Vancouver Provence*. He wanted to be sure that his press credentials entitled him "to use the space ship's communications to file" stories during the trip.[44]

Sixteen-year-old Ruby Massengale from Hattisburg, Mississippi calculated she would be 32 in 1975 and in an excellent position to take the trip. She didn't want to go for "selfish reasons like money, fame, or adventure," but was interested in "progress for all mankind." Ruby captured the essence of what motivates many who hold the dream of space travel when she concluded, "It seems like this longing is actually part of me."[45]

Planetarium Chairman Dr. Robert Coles decided to store all the forms in the archives and promised to turn the letters over to "the proper authorities when the first real rocket ship is planned, from which they may choose passengers to go along."[46] A space history tome observed the applications "may be only the wistful dreams of a young boy . . . (but) tomorrow, when the dreams are history and the accomplishment is fact, they will provide an interesting and poignant part of man's attempt to conquer space."[47]

The Prophet from Peenemunde

While working under contract for the U.S. Army, Wernher von Braun became a tireless promoter of human space flight. Like his mentor Hermann Oberth, von Braun was an extrovert who

delighted in dazzling the public with his visions of space. Officially, he was not involved in the determination of Federal space policy. Unofficially, his charismatic personality and inspirational speeches and writings elevated him to the rank of spiritual leader of the growing national space religion . . . err, I mean movement.

In the fall of 1950, the world's foremost aeronautical experts and space visionaries gathered in Paris for the First International Conference on Astronautics. The delegates created a permanent organization for space societies that became the International Astronautical Federation (IAF). Ever since, this annual gathering of IAF members represents a fertile field of rhetoric, information exchange, inspiration, and hype for space travel dreams.

Following a 1951 speech at the Second IAF Congress in London, von Braun captured a great deal of public attention with his proposed "Mars Project."[48] This ambitious mission required a capability to launch a crew of 70 and 37,000 tons of fuel, materials, and supplies into orbit. The project called for the crew and cargo to be delivered to a 1,750-mile-high space station to assemble ten ships for a five-year, round-trip journey to Mars. In the year when hapless monkeys were routinely being shot into the upper atmosphere only to be plowed back into the dunes of White Sands, a plan to send convoys of men to Mars must have sounded exceedingly aspirational. Say now—maybe the Hayden Reservation Tour wasn't such a gimmick after all!

Speaking of the Hayden, the tremendous enthusiasm generated by the Interplanetary Tour promotion led to an annual lecture series at the museum. Dr. Coles believed, "It (was) important that the layman be fully apprised of the nature and extent of any project of such magnitude . . . (and) be given a true picture of where we stand today."[49]

The Hayden's Second Space Symposium convened on Columbus Day, 1952, "the connotation being both obvious and appropriate."[50] Despite their expressed interest in educating laymen, attendance to the second lecture was by invitation only and limited to representatives from professional societies, research groups, and members of the news media. The lay dreamers would have to read about the lectures in the extensive follow-up media coverage of the event.

Willy Ley was again on hand and introduced the symposium with a review of space achievements to date. Dr. Fred Whipple of Harvard spoke on "Astronomy from the Space Station," George Smith of Emerson Radio addressed "Radio Communication Across Space," and Fritz Haber discussed medical considerations for human flight. After an intermission, Milt Rosen of the Navy's Viking Research Project offered a "Down-to-Earth View of Space," which tried to temper von Braun's exuberant rhetoric on "Steps for the Realization of the Space Station."

Media coverage focused primarily on the Rosen-von Braun debate. On one side, stood the dynamic Wernher von Braun, promising that within 15 years, space ships as big as Navy cruisers could be in orbit 1,000 miles above, serving as assembly depots for planetary expeditions. Milt Rosen, on the other hand, was a low-key engineer pleading for the public to adopt a more cautious outlook. "Plans for space travel," cautioned Rosen, "are based on a meager store of scientific knowledge and a large amount of speculation."[51] Interplanetary Tour reservation cardholders were truly disappointed when Rosen cautioned that even unmanned launches left much to be desired. There was "one chance in a hundred a rocket will go where it was expected to go . . . not completely reassuring for a passenger."[52]

Among those in attendance at the symposium were Seth Mosely II and Cornelius Ryan from *Colliers* magazine. Despite Rosen's rebuke of the eager optimism of others, Mosely and Ryan were excited by their presentations and decided to spread the good word to the readers of their publication. Over the next five months, Willy Ley, the Haber brothers, Whipple, and von Braun met in the magazine's editorial offices to speculate on the future of human space travel. Artists Chesley Bonstell, Fred Freeman, and Rolf Klep were enlisted to illustrate the visions. This ongoing roundtable led to a seven-part series, which appeared in Colliers between 1952 and 1954. At the time of publication, no other general interest magazine had devoted such extensive coverage of text and images to the subject of space travel.[53]

In the lead editorial of the first installment, "What Are We Waiting For?" Cornelius Ryan laid the foundation for the series. The upcoming articles would review the principles of space flight, requirements to construct a 50-person space station, potential science research activities, medical and training considerations, the military value of space, and the feasibility of sending human crews to the Moon and Mars. Readers were reminded the series was not science fiction, but "an urgent warning that the U.S. must immediately embark on a long-range development program to secure for the West 'space superiority.' If we do not, somebody else will. That somebody else very probably would be the Soviet Union."[54]

Since the existence of the military's research program had been admitted back in 1948, Ryan wanted to know why so little progress had been made. He was concerned the Soviet Union would establish a space station and arm it with radar-controlled, atomic projectiles aimed at targets on Earth. Such "a ruthless foe . . . could actually subjugate the peoples of the world." On the

other hand, if the West were the first to establish a space station, "It would be the end of Iron Curtains wherever they might be."[55]

The editorial also called for a national commitment to space research on par with the Manhattan Project for the atomic bomb. Because the technical requirements were "cut-and-dried," Ryan believed a space development program would be less risky than the technical gamble that had been taken to build the atomic bomb. In his assessment, all we needed was the approval, about ten years of effort, and $4 billion. To soften the impact of the projected price tag, Ryan emphasized this was just a fraction of the $54 billion spent on rearmament since the beginning of the Korean War. To Ryan, $4 billion was a negligible expense for a project that "would guarantee the peace of the world."[56]

The first installment included an article titled "Can We Survive in Space?" in which Dr. Heinz Haber discounted the pessimists who maintained, "Crew members of a rocket ship wouldn't live to experience space."[57] Based on the promising results from centrifuge experiments and parabolic flights, he had reason to be optimistic. As far as who would be "qualified" to fly, Dr. Haber was convinced a traveler needed to be "physically sound and well informed on pertinent subjects," such as astronomy and theory of space travel. He predicted, "Most of the early spacemen are likely to be pilots who have flown in jet or rocket airplanes."[58]

The third Colliers installment further detailed the qualifications for space men. Qualified candidates needed to be between the ages of 28 and 35, have a college education, and be of medium weight and height, between 5'5" and 5'11" tall. Dr. Haber noted exceptionally tall or short people tend to have poor blood circulation, which would be a disadvantage in adjusting to weightlessness. Even if you possessed the necessary physical attributes, there was no guarantee you would complete the five-year

training course: "Of every 1,000 applicants who meet those standards, 940 are expected to wash-out during the stringent medical and psychiatric examinations which precede training . . . We'll find that 55 of the remaining 60 students can't cope with the physical, emotional and educational demands of rocket flight."[59]

Sorry ladies, but in Haber's opinion, you could forget your orbital dreams—at least for the trips to the Moon and Mars. In a brief sidebar titled "Reasons for Ban on Women," he explained, "Women, who may beat out men for certain crew jobs, won't go along on interplanetary journeys, where privacy will be lacking for long periods."[60] Women might, however, qualify for shorter flights. Unless you count the observation, "Men working under strain for long periods tend to become irritable and less efficient," no other reason was given for the ban on females.[61] Perhaps Dr. Haber assumed that no self-respecting woman would want to float around in a cabin full of irritable, inefficient men.

You Must Have Been A Beautiful Baby

Few engineers worked harder than Wernher von Braun to take advantage of the public's growing curiosity about this new frontier. Now serving as the chief of the Army's Guided Missile Development Division in Huntsville, Alabama, he even tried to lure children into his crusade. In 1953, taking a cue from baby-kissing politicians, he convinced the Base newspaper to sponsor a "Space Baby" contest. Local citizens were invited to submit photographs of their little future space cadets. From among the 60 entries, a picture of one-year-old Nancy Carpenter propped up next to a book by Isaac Asimov caught von Braun's eye. Space Baby Nancy received the first-place prize, a round-trip ticket to the Moon! Jerry Willard, the first runner-up, had to settle for a ticket to the asteroid Hermes, while the consolation (or should I say, constellation) prizes for the next eight runners-up were tickets to each of the planets.[62]

Nancy's ticket, signed by von Braun, proclaimed, "The bearer of this ticket is entitled to a round trip to the Moon via the first available rocket ship. Stop-over privileges at the baby satellite. Not negotiable outside the Milky Way." Surely, a ticket signed by Mr. Space himself would one day be valid.

There's Nothing Mickey Mouse About Fantasy Land

The lecture hall at the Hayden Planetarium seated approximately 800. The message from the symposiums spread to thousands more through the pages of the *Colliers* series and related media coverage. On a Wednesday evening in March 1955, Walt Disney delivered the vision of space into the living rooms of millions of families across the country.

You may have come home from school that day and plopped down to watch the *Mickey Mouse Club Show*. True Mouseke- teers will fondly remember Wednesday as "Anything Can Happen Day." Perhaps when Mickey flew in on his magic carpet dur- ing the opening number, you sang along: "Today is the day that is filled with surprises, nobody knows what's going to happen! Why, you might find yourself on an elephant on the Moon, or rid- ing in an auto underneath a blue lagoon."[63]

Later that night on Disney's other show, *Disneyland*, we actually did find ourselves on the Moon. As he did every week, Disney opened the show and introduced the first episode of a three-part "Man in Space" series. Sitting on the edge of his desk holding a model rocket, Disney explained, "One of man's oldest dreams has been the desire for space travel. Until recently this dream seemed impossible, but great new discoveries have brought us to the threshold of a new frontier."[64]

Through a combination of cartoons, animation, and lectures from experts, the series reviewed advances being made to take us into the new frontier. And who were the experts who pre-

Walt Disney and Wernher von Braun collaborated on a three-part "Man in Space" series broadcast on *Disneyland* TV show in 1955.
Photo: NASA

sented this view of Tomorrowland? None other than Wernher von Braun, Willy Ley, Heinz Haber, and another Peenemunde alumnus, Ernst Stuhlinger. Much like the *Colliers'* magazine articles, the "Man in Space" series covered basic space history, rocket theory, folklore, technical advances, space station assembly requirements, a simulated trip to the Moon, and plans for a journey to Mars. Other movies and television shows had dealt with space fantasies, but few had presented the possibilities of space in such a realistic manner or with such recognized authorities. After watching all three episodes, one couldn't wait to get on Disneyland's new ride that simulated a trip to the Moon. As Uncle Walt assured us in the second series segment, "Tomorrow the Moon," "Visitors may experience the thrills that space travelers can encounter when rocket trips to the Moon become a daily routine."[65]

While I was fascinated by all three episodes, my passion for space had yet to emerge. I was only seven at the time, and I was fixated on "The Adventures of Spin and Marty," one of the series shown during TV episodes of The Mickey Mouse Club. My dream was to ride horses at the Triple R Ranch and hopefully snag a date with that saucy Mouseketeer Annette Funicello. Yippee Yay, Yippee Yi, Yippee Yo!

Gentlemen, Start Your Engines

It wasn't only Mouseketeers who were inspired by what they saw in the Disney series. According to a report in the *Los Angeles Herald Tribune*, "Disney's immediate achievement, with the aid of the triumvirate of space authorities, is the suggestion that space travel no longer is a wild dream . . . About half of the voting population of the U.S.A. probably will have reached two impressive conclusions: 'It can be done!' and 'Let's get on with it.' U.S. space partisans are well aware of the potential of a nation of believers."[66]

Four months after the first "Man in Space" episode aired, the believers finally had something to cheer about—sort of. On July 29, 1955, President Dwight Eisenhower announced that America planned to launch an unmanned satellite for the International Geophysical Year (IGY) scheduled to begin in 1957.[67] The National Science Foundation financed the satellite program, with experiments selected by the National Academy of Sciences, and logistics and technical support provided by the Department of Defense.

Vanguard, a rocket under development at the Naval Research Laboratory, was selected over the Army's Jupiter launcher as the satellite carrier. Although the rocket was capable of launching a scrawny 20-pound satellite, we were supposed to take heart in the name "Vanguard," in anticipation of bigger and better things

to come. Shortly after the president's announcement, the Russians made it known that they, too, intended to launch a satellite for IGY—and incidentally comrades, theirs was going to be bigger and launched sooner than ours.

With the coming of the IGY, the focus of most rocket engineers turned from dreams of human convoys to the challenge to launch a simple satellite. Besides, many researchers remained convinced that human space flight faced formidable barriers. As historians recollected in *This New Ocean*, "In 1954, the year Major Arthur Murray climbed to about 17 miles in the X-1A, the idea of manned rocket flight to an altitude of 50 miles seemed exceedingly visionary."[68] Just two years later in an X-2 jet, Captain Ivan Kincheloe Jr. made it almost half way to space when he soared to a record altitude of 25 miles.

The same year Kincheloe completed his milestone, Nihon Uchu Ryoko Kyokai, a Japanese space travel group, began to accept reservations for extraterrestrial real estate much further away. Over 1,800 people purchased approximately 330,000 square meter parcels on Mars being offered by the travel association. According to *Daitoa Kagaku Kidan (Strange Tales of Greater East Asian Science)* by Hiroshi Aramata, the reservation confirmation slips listed the qualities required of anyone planning to become Martians. This included attributes such as "respect for science, love of fine arts, generosity, selflessness, and sense of fellowship."[69] The sponsors even brought the would-be landowners together at an annual event. I wonder if they still meet?

Two of the former German rocket engineer refugees believed rocket planes like the X-series, not missiles, offered the best hope for human space flight. Back in 1951, Walter Dornberger and Kraft Ehricke had proposed a manned vehicle as a long-distance alternative to guided missiles. This concept, known as

BOMI (BOmber MIssile), offered a two-stage, reusable trans-porter for the delivery of nuclear bombs. Dornberger felt a major advantage of this vehicle was the option to have crewmembers on board. While a guided missile couldn't be recalled, BOMI could make a last-minute U-turn in case the commander in chief had second thoughts. It was the unofficial civilian applications, however, that were the real motive behind BOMI. If it could carry soldiers, then with just a few modifications, it could also take passengers to space. According to the calculations of Dornberger and Ehricke, the U.S. could have a reliable, reusable, routine space transport by 1975.

Due to competing designs and budgetary issues, BOMI never made it off the drawing boards. Instead, the National Advisory Committee on Aeronautics (NACA) and the military initiated a cooperative research program for the X-series rocket planes. These rocket-powered jets propelled America into supersonic research that led to the X-15 program.

In February 1957, NACA and the military decided to take the next step and established a steering committee to study the feasibility of a hypersonic boost-glide research vehicle. Designated as the X-20 or Dyna-Soar (for dynamic soaring), the piloted vehicle would be sent into orbit on top of a booster rocket and return to Earth to land like a jet.

At about the same time at a Space Flight Symposium in San Diego, Air Force Major General Bernard Schriever predicted it would not be difficult to extend missile developments to surface-to-surface transportation or space travel of personnel. Head of the Ballistic Missile Program General Schriever believed in addition to the military importance of space, America's prestige as a world leader might dictate that we undertake human expeditions to the Moon and even interplanetary flight.[70]

For the moment, however, U.S. prestige was focused on the goal to launch Vanguard in time for the IGY. *Life* magazine revealed that due to technical issues, the development of the rocket was behind schedule.[71] This must have caused at least a few top officials to wonder if they had made a mistake the previous September when they had symbolically tied Wernher von Braun's hands to Earth. At that time, von Braun's Jupiter team successfully launched a four-stage rocket 3,300 miles down range to an altitude of 680 miles. It could have placed a payload into orbit, but under orders from the Pentagon, Jupiter's fourth stage was not fueled. Instead, it was loaded with sand and plunged into the ocean. One can only speculate on how things would have developed had the fourth stage carried fuel.

Several reasons have been offered for the restriction placed on the Jupiter team. Federal policy officials were concerned with the new legal issue of space sovereignty and were afraid the Soviets might protest the flight of a U.S. satellite over their air space. Some thought it better strategy to let the Soviets launch first. Second, it had only been 11 years since the end of World War II. Senior government officials were afraid using an Army missile developed by a squad of former Third Reich rocketeers might make some people nervous. Compared to today, it would be a little like placing former members of the Taliban in charge of artillery training at Ft. Bragg.

Evidently the Pentagon's Deputy Chief of Research, Lieutenant General James Gavin, thought von Braun might try to pull a fast one and substitute a live stage for the harmless sand castle in the Jupiter's fourth stage. Gavin told von Braun's boss, General John Medaris, "I'm holding you responsible to see there are no *accidents*."[72] The Pentagon brass need not have worried; the Jupiter rocketeers contained their aspirations and settled for

knowing what might have been. As Dr. von Braun quipped after the launch, "The old cucumber did it!"[73]

Thirteen months later, it seemed like the only "accident" that had occurred that day was not letting von Braun's "old cucumber" be tossed all the way to orbit. On October 4, 1957, the Soviet Union won the first heat of the Space Race with the launch of its "Fellow Traveler of Earth," better known as Sputnik. Pumped full of nitrogen and carrying batteries, radio transmitters, and science instruments, this satellite turned into 184 pounds of panic.

The fact that Sputnik was launched on the 40th anniversary of the Bolshevik Revolution was a real poke in the collective American eye. How could communism have beaten good old democracy? People went nuts. Politicians, journalists, and policy pundits trashed President Eisenhower and his conservative policies.

The president didn't really understand all the fuss over this "orbiting volleyball," and no, it did not cause him "one iota" of apprehension over our national security.[74] It didn't seem to bother the people over at NACA either. At their annual meeting a week later, the success of Sputnik wasn't even mentioned.[75] What the heck, as the secretary of defense observed; it was just "a nice scientific trick."[76]

How Much Is That Doggy in The Window?

You want tricks? How did you like the follow-up where the Russians strapped a canine into a second Sputnik and hurled half a ton of hardware and instruments into orbit?

According to Vasiliy Pavlovich Mishin, the Soviet's deputy chief designer of rockets, "Khrushchev had drawn great satisfaction from the political impact of the first Sputnik, so he promptly put in a rush order for a second."[77] A month later, a mixed-breed hound named Laika was launched in Sputnik 2, a feat which

29

drew praise from space engineers but protests from animal rights activists. You see, Sputnik 2 was a no-frills flight with only a week's worth of food, water, and oxygen. Laika may have been the first mammal to achieve orbit, but he also became the first to die there.

It turned out Walt Disney wasn't the only one who knew how to produce a film on the glorious promise of space. Four days after Laika ran away in orbit, a Russian space film, *Road into Interstellar Space*, premiered in Moscow. The movie featured cosmonauts engaged in construction and mining activities on the surface of the Moon. In the distance, Soviet space men could be seen erecting a cosmodome in orbit.

With not one, but two Sputniks overhead, the visions of Wernher von Braun were much in demand. In their November 18, 1957 issue, *Life* magazine featured him with a cover story titled "The Seer of Space." According to the article, we should have listened to von Braun when he had warned what the Russians were up to, instead of dismissing his remarks "as if made by a tiresome crackpot."[78]

The following week at the Waldorf-Astoria Hotel in New York City, von Braun outlined "The Next 100 Years" at a symposium sponsored by the Seagram Company. He reassured the audience the Soviets were not about to monopolize lunar settlements; our march into space would evolve along the lines of development in Antarctica. The lunar surface would most likely be subdivided by the United Nations and parceled out to the major powers.

By the year 2057, he believed the lunar horizon would include lavish excursion hotels complete with cozy honeymoon suites and gambling joints. The hotels would be "operated by several national space lines for the purpose of attracting more passenger

traffic, in addition to their main business of hauling commercial cargo."[79] No doubt, spacedreaming newlyweds paid little attention to the predicted date for von Braun's honeymoon suites and were ready to say, "I do! I do!"

Seconds Anyone?

Honeymoon suites and gambling joints, eh? Well, that was a long way off, and the U.S. still hadn't launched a single solitary satellite. On December 6, 1957, Americans anxiously watched the live television coverage of the long-awaited Vanguard rocket launch. The image of national space lines to the stars faded in an instant as the rocket exploded on the launch pad. Horrified viewers watched Vanguard collapse, looking "like a broken, old stove pipe with a dunce cap on top."[80]

That did it! The Army was finally given the go-ahead to unleash von Braun and his team. Eighty-four days later, on January 31, 1958, a Jupiter-C rocket (renamed Juno 1 for this civilian event) thrust the Explorer 1 science satellite into orbit. Launching a 31-pound satellite was not half as impressive as condemning Laika and 1,200 pounds of hardware to orbital eternity, but at least the U.S. was finally on the scoreboard.

Even though the Jupiter launch was an Army success, the military's inter-service rivalry over space research continued. The Air Force had proposed "Man-in-Space-Soonest," a five-year plan for development of reconnaissance, communications, and weather satellites; recoverable capsules, both "manned and unmanned;" an inhabited space station; and eventually a human base on the lunar surface.

The Navy wanted to sail the high seas of space with their "Manned Earth Reconnaissance" program and send sailors into orbit on a rocket with a return in a delta-winged glider.

The Army and von Braun proposed "Man Very High," a concept to launch a soldier in a sealed capsule to a 150-mile altitude and then splash down in the Atlantic. It was proposed as a collaborative effort for the three service branches, but when the Air Force declined to join the team, it was renamed "Project Adam" and presented solely as an Army initiative. Had there been a bit more collaboration and less competition, perhaps the military would have led the way for human space travel.

While the service branches squabbled, personnel and supporters of the National Advisory Committee for Aeronautics (NACA) became more vocal and proposed that space activities be placed in the hands of this civilian agency. The science and engineering research community was unimpressed with military objectives in space. When asked for his opinion of von Braun's Project Adam, NACA Director, Dr. Hugh Dryden, told a congressional committee that it had "about the same technical value as shooting a young lady from a cannon."[81] This may be one of the few times anyone gave thought to the value of women in the space program.

To establish priorities for federally sponsored space research, President Eisenhower established a Presidential Science Advisory Committee. Deliberations by this committee resulted in the publication of "Introduction to Space," the first policy statement on civilian space activities. The policy contained a rather general timetable to accomplish specific space goals under four broad headings: Early, Later, Still Later, and Much Later. Launching scientific satellites could be accomplished "Early," while a human mission to the Moon might occur "Much Later."[82]

Dr. Lee DuBridge, president of the California Institute of Technology and a member of the Advisory Committee cautioned, "Many fabulous and flamboyant" space schemes were being seriously discussed by the public and in high political and military circles.

"We are uncomfortably close," cautioned DuBridge, "to the situation where one of the great technical achievements in man's history (the launching of the first Earth satellites) instead of stimulating a vastly improved and valuable program of real research is being allowed to convert us into a nation of space cadets in which billions of dollars will be wasted on fanciful and fruitless, ill-conceived projects . . ."[83] If it were up to DuBridge, the fanciful and fruitless dreams of civilian space travel probably wouldn't occur until Much, Much, Later.

While the Department of Defense hoped to be appointed as the lead agency for the human exploration of space, President Eisenhower and Congress put an end to any such notion. They agreed that a new civilian agency would lead the nation into the space frontier. On October 1, 1958, the National Aeronautics and Space Administration (NASA) was born.

With the creation of NASA, NACA was abolished, and its three research laboratories were transferred to the new agency. These included the Langley Memorial Aeronautical Laboratory in Hampton, Virginia (renamed the Langley Research Center), the Ames Aeronautical Laboratory at Moffett Field (renamed the Ames Research Center), California, and the Lewis Flight Propulsion Laboratory in Cleveland, Ohio (renamed the Lewis Research Center). NASA established the Beltsville Space Center in Beltsville, Maryland (renamed the Goddard Space Flight Center) and eventually took control of the Jet Propulsion Laboratory in Pasadena, California operated by the California Institute of Technology. Research efforts of the Naval Research Laboratory, the Air Force Missile Systems Division, and the Army Ballistic Missile Group (Wernher von Braun's team) were also transferred to NASA. By default, NASA became the new curator of the dream.

With a civilian agency tasked to lead us into space, hope sprang eternal, but we were advised not to run out for a spacesuit fitting just yet. The initial treks into the great unknown would not be pleasure trips. As Wolfgang Mueller cautioned in *Man Among the Stars*, the first steps "will be daring, exhausting undertakings full of hardships which will make unprecedented demands on the physical and psychic endurance of the participants. The crews that eventually start on the great adventures will not be adventurers."[84]

So where would the people who were daring, capable of withstanding unprecedented physical and psychic demands come from?

2 CALLING ALL ASTRONAUTS

*Not counting a dozen possible exceptions, nobody who is now
18 years or older will get into space as a pilot or a crewmember. He
(or she) may make it as a passenger after waiting two or three decades
. . . if he can afford the price of the ticket. But not as a crewmember.*
　　　　　Willy Ley, *Satellites, Rockets, and Outer Space*

Are you one of the spacemen Mr. Carpenter? Well, you're a nut.
　　　　　Life magazine

*To be the first man to fly to outer space, to enter into single combat
with nature, can you dream of anything greater?*
　　　　　Yuri Gagarin, "Soviet Traveler Returns From Out
　　　　　of This World"

Reaching for Extreme Altitudes

With the creation in 1958 of the National Aeronautics and Space
Administration (NASA), it looked as though the Federal Government
was serious about the business of astronautics and human space
flight. Could, or would, the new agency help us achieve our dream
of spaceflight?

The Space Race was in the early stage, but surely the first human in
space would be a red-blooded American. One of NASA's first tasks
was to select the individuals willing to sit on top of a guided missile
and blast into the domain once thought of as science fiction.

What were we going to call these guys? And back then, it was all
about guys. For years, "Space Man" filled the bill, but that sounded
too much like something on the marquee at the local movie theater.

"Crewmember" was a little on the bland side. "Space Cadet" conjured up the image of a youthful refugee from the Tom novels—Swift and Corbett.

As with many of its programs, NASA looked to the language of the ancients for an appropriate name. These courageous pioneers would henceforth be known as "astronauts," from astro (star) and nauts (sailor)—the star sailors. Much like Jason and the Argonauts who searched the high seas in the good ship Argo for golden fleece, the astronauts would sail the ocean of space in search of . . . who knows what . . . certainly not goat hair. Similarly, the Soviet Union referred to their space pilots as "cosmonauts"—sailors of the universe.

The "astronaut" moniker had been used in earlier works of literature. In 1648, French author Cyrano de Bergerac referred to "astronauts" in his novel *Voyage to the Moon*. Almost 300 years later, the name popped up in a "Buck Rogers" cartoon strip. In a 1936 episode, Captain Rogers is shown listening to a message coming through his helmet: "Patrol 891—Astronaut Flint speaking."[1]

The term wasn't always reserved for those lucky enough to actually make the trip into space. Early 1950s dictionaries included "technicians, engineers, support crew, and advocates of astronautics" in their definition for astronaut. "A traveler in extraterrestrial space" wasn't mentioned until the second explanation in many dictionaries. In describing aeronautical engineers in *Man Among the Stars*, Wolfgang Mueller observed, "In background, profession and way of life they differ widely; but they all belong to an unprecedented world-wide fraternity which recognize no boundaries; they are the pioneers of space travel—they are the astronauts, the travelers whose destination is the stars."[2] *The Real Book of Space Travel* described astronauts as "those who are working to reach space."[3] In a 1958 issue of *Life* magazine, an article on human space flight, referred to "astronaut Krafft Ehricke, space engineer for Convair . . ."[4]

Once NASA appropriated the term for its space rangers, those who performed their duties on the ground were quickly expelled from the astronaut clan. It soon became a totally exclusive club. It would be a long time before any of us would be allowed to join.

How would club membership be determined? Even though America's track record for shooting monkeys and instruments beyond the mesosphere left much to be desired, thousands of human volunteers were ready to go through Hell Week for the astronaut fraternity.

Major David Simons, chief of Space Biology at the Air Force Aeromedical Laboratory, was convinced his shoulders were broad enough to carry the astronaut mantle. In addition to being a leading researcher in the field of space medicine, he often served as a test subject for his own experiments. In August 1957, two months before the first Sputnik launch, he ascended to a record altitude of 102,000 feet in the Man High II balloon flight. A month after Sputnik 2, Simons' photo appeared in newspapers across the country along with his offer to volunteer to go the additional miles into orbit to become an astronaut.

Displaying an eagerness to volunteer wasn't necessarily seen as an attribute. Medical researchers believed, "Any man who would blindly volunteer to be fired into space would also show evidence of serious mental instability." It would be better to "pre-select a rather small group from which volunteers would be sought after having had the program carefully explained to them."[5]

Since the feasibility of human space flight had been under review for almost 20 years, a foundation existed to determine astronaut qualifications. Based on the research, it seemed obvious that the individuals would have to be in superb physical condition. A space traveler should also be devoid of emotional flaws and provide evidence of courage and daring. Those with a strong background in engineering or science would also have a leg up on the competition. Finally, a star sailor should be resourceful, respond well to pressure,

and have nerves of steel. Like an Air Force general announced at the time, "What we're looking for is a group of ordinary supermen."[6] Either that, or extremely virile Boy Scouts.

The assignment to identify men with nerves of steel fell to Robert Gilruth and his Space Task Group at NASA's Langley Research Center in Hampton, Virginia. At first, the Task Group flirted with the idea of throwing the application process open to volunteers from sea to shining sea. In fall 1958, they prepared a Civil Service announcement for the position of "Research Astronaut-Candidate."

According to the notice, potential applicants would have to demonstrate a willingness to accept hazards, tolerate severe environmental conditions, and react well under stress. Test pilots, submariners, arctic explorers, and veteran combat pilots were examples of professions thought to possess the necessary qualities. If you had experience as a parachute jumper, mountain climber, or scuba diver, you may also be qualified, "depending upon heights or depths obtained . . . and emergency episodes encountered."[7]

Sensing a barrage of applications from eager, but unqualified dreamers, President Dwight D. Eisenhower stepped in and over-ruled NASA's plan. Although Ike intentionally established NASA as a civilian agency, he decided astronauts would be selected from the ranks of our military test pilots. Gilruth later commented on the wisdom of the president's intercession: "It was one of the best decisions he ever made. It ruled out the matadors, mountain climbers, scuba divers, and race car drivers and gave us a stable of guys who had already been screened for security."[8]

Task Force member Dr. Robert Voas believed the achievement of human space flight at the earliest possible time was NASA's top priority. Therefore, while "others could undoubtedly have been trained . . . (the test pilots) had a tremendous head start in the most important factor of all—technical skill."[9]

In the previously mentioned *Man Among the Stars*, Wolfgang Mueller agreed with the assessment to select from military pilots: "They (astronauts) will represent the realization of a human type which is already being bred in military installations and in industry, the fore-runners of the generation which will conquer space."[10]

With the directive from President Eisenhower, NASA went forward with a process to select the "ordinary supermen" from the military. Selection criteria called for a candidate under the age of 40 years, no taller than 5'11" and in excellent physical condition. Aspirants would also be required to have a bachelor's degree in engineering (or the equivalent), have logged 1,500 hours flying jets, and be a graduate of the military test pilot school.

NASA's first Administrator, Dr. T. Keith Glennan, publicly announced the call for astronauts on December 17, 1958, the 55th anniversary of the Wright brothers' first flight at Kitty Hawk. The selected space pilots were to be assigned to NASA's new program to place a man in orbit—Project Mercury.

According to Operations Chief Charles Mathews, the name Mercury was chosen during a meeting of the Space Task Group.[11] In ancient Rome, Mercury may have been content in serving as the *messenger* of the gods, but in America, Mercury astronauts soon *became* the gods. Men who were destined to play the "symbolic role as the single combat warriors of the Cold War" could hardly be viewed as mere messengers.[12] The fact that Mercury was also known as the omnipotent chief of physicians and thieves was seldom, if ever, mentioned.

A selection committee, chaired by Gilruth's deputy Charles Donlan, screened 508 military service records and zeroed in on 110 pilots who met the minimum qualifications. From this group, the list was narrowed to 32 candidates who, after having the program carefully explained to them, volunteered to go through an elaborate battery of medical and psychological tests, with 18 achieving a passing grade.

The tests were conducted at the Lovelace Clinic in New Mexico and at the Wright Air Development Center in Ohio. On April 9, 1959, NASA Administrator Glennan presented the seven selected astronauts to the public. Soon we knew test pilots Scott Carpenter, Gordon Cooper, John Glenn, Gus Grissom, Walter Schirra, Alan Shepard, and Deke Slayton as well as we knew the boys next door. The magnificent seven were described as "premium individuals picked for an unconventional task . . . the best of a very good lot, a bright, balanced, splendidly conditioned first team, willing—eager, in fact—to undertake an assignment most men would find unthinkable."[13]

The Original Seven Mercury astronauts with Wernher von Braun. From left to right: Gus Grissom, Wally Schirra, Alan Shepard, John Glenn, Scott Carpenter, Gordon Cooper, Deke Slayton, Werhner von Braun.
Photo: NASA

Judging from the letters starting to arrive at NASA, undertaking the astronaut's assignment wasn't all that unthinkable to a lot of men—and women. Even though Mercury qualifications had ruled out all but military test pilots, other dreamers still clamored for their chance to participate.

In his cover story "What's It's Like to Fly in Space," *Life's* science editor, Warren Young, catalogued the reasons so many people aspired to fly in space:

> Some of them see the trip as a form of escape, either a psychotic escape from humanity or a simple, old-fashion escape from woman trouble. Some are thrill seekers who think a ride into space would merely be an exceptionally cool hot-rod drag. Some are ridden by guilt complexes, either justified or imagined, and think volunteering will bring atonement.[14]

As you will notice, the rationales sited by Young are similar to those expressed by the volunteers who wrote to Robert Goddard.

Young's article was based on his experiences as a "journalist observer," which gave him a unique, behind-the-scenes opportunity to get "jerked, jolted, roasted, frozen, and spun" in the same medical tests that had been designed for the Mercury astronauts. Two decades later, journalists would cite the "observer" merit badge as proof they deserved to be the first public scouts in orbit. For the time being, the journalists and the public volunteers would have to settle for vicariously experiencing space adventures through the exploits of America's new heroes—the Original Seven.

Quit Monkeying Around

Though the assignment was not without its share of risks, being a Mercury astronaut was perceived to be the greatest job in the galaxy. There was still considerable debate in the medical community as to whether or not a human could even function in space. Would an astronaut be able to survive the excessive forces of gravity during

launch ascent without blacking out? Would cosmic radiation cause cancer or sterility? What effects would sustained periods of weightlessness have on an individual's ability to perform specific tasks? Most doctors felt it was too dangerous to send a person into space without a better understanding of so many unknowns.

Although the responsibility for the human space program had been assigned to NASA, the military still had a series of animal experiments in the pipeline. In December 1958, a South American squirrel monkey was jammed into a cylinder and sent for a 13-minute, 290-mile-high flight on top of a Jupiter rocket. The monkey's name was Old Reliable; unfortunately, the capsule wasn't. Old Reliable survived the flight, but upon landing in the ocean, the capsule's nose cone cracked, quickly filled with water, and sank. The curse of the monkeynauts continued.

NASA launched a monkey mission the following May. This time, there were two female passengers: Able, a South American squirrel monkey, and Baker, of the Rhesus persuasion. Their rocket zoomed on a nine-minute, sub-orbital flight to an altitude of 360 miles. Believe it or not, *they survived the landing*! The media attention heaped on Able and Baker almost surpassed the adulation bestowed on the Mercury astronauts when they were introduced the previous month. When these two heroines were brought to NASA Headquarters for a post-flight press conference, the journalists acted like . . . well, like a bunch of journalists.

Scribes and cameramen shoved and clawed for position in a packed room that thanks to television lights was a toasty 100 degrees. "Here Baker! Here Able!" the reporters shouted. For the most part, the monkeys ignored the commotion and quietly munched on peanuts.[15] Noting the stifling heat and the journalistic frenzy, Dr. Glennan cracked, "I'm not sure that the monkeys' ordeal in flight is comparable to the ordeal that they have just been through and that you are sitting through."[16]

Miss Able's fame was extremely short-lived. Although both monkeys became cover girls for *Life*, she expired on the operating table the day after the press conference. She had survived the effects of zero gravity, the reentry and landing, and the assault by the press, but when doctors attempted to remove an electrode from her noggin, Able stopped breathing. Not even mouth-to-mouth resuscitation could save her. Yet another space monkey gave its life in the name of your dream. Astronauts beware: Miss Able was later stuffed and put on display at the National Air and Space Museum.

Squirrel monkeys Able and Baker survived a trip into space in May 1959. Here, Miss Able poses with a model of a Jupiter missile prior to her flight. *Photo: NASA*

Although a NASA-sponsored monkey flight in December 1959 also proved successful, many medical experts still felt it was too risky to commit to human flights. Doctors at the Holloman research facility decided to move up the evolutionary chain and fly a chimpanzee in a Mercury capsule. Since the DNA in chimpanzees and humans is so similar, researchers believed the furry primates would serve

as efficient conscripts for space flight training. With chimps con-fiscated from the jungles of Cameroon, Holloman established the "Restraint Conditioning of Large Biological Specimens" program. With the acronym RCLBS, it was clear these doctors knew nothing about marketing.

Whereas monkeys had been passive passengers, the chimpanzees were trained to be active mission participants. At "Chimp College," the students were taught on simulators similar to those used by their astronaut cousins. The chimps learned how to perform a va-riety of tasks by pushing a series of buttons and levers. Correct responses brought food pellets, while wrong answers delivered an electrical jolt to the bottom of their feet. The learning curve to avoid those nasty shocks was swift. An Air Force press release describing a typical day in class somberly noted "destiny, like an invisible sign, hovers over their troglodyte brows."[17]

With chimps in training, it didn't take long for the jokes to begin about qualifications to be an astronaut. I mean, if a chimp could do it—well, you can imagine. Between the jabs and the snide com-ments from non-astronaut test pilots and researchers who believed robotic missions were preferable to begin with, the Mercury boys became a little testy.

In a speech before the Society of Experimental Test Pilots, astro-naut Deke Slayton went on the offensive:

> First I would like to establish the requirement for the pilot . . . The objections range from the engineer, who semi-seriously notes that all problems . . . would be simplified if we didn't have to worry about the bloody astronaut, to the military man who won-ders whether a college-trained chimpanzee or the village idiot might do as well in space as an experienced pilot . . . I hate to hear anyone contend that non-pilots can perform the space mis-sion effectively.[18]

That silenced the critics—for a while.

Excursion Fares to the Planets

One evening in August 1960, my parents hustled my brother Glen and me away from the TV set and into the backyard. They told us to scan the sky for a glimpse of a satellite that was scheduled to pass overhead. It was ECHO-1, a one hundred-foot round Mylar balloon—America's first passive communication satellite. When we caught the first glimmer, it didn't look much different from a high-flying jet. For a moment though, just for a moment, we imagined ourselves behind the controls of a spaceship darting across the stars.

As ECHO-1 twinkled overhead, a dreamer's imagination was re-inforced by promises made at the 11th International Astronautical Federation (IAF) Congress underway in Stockholm. Up to this point, no living creature had been successfully launched into and retrieved from an orbital flight. America's chimps had not yet flown, and we all remember what the Russians did in 1957 to man's best friend. This made one of the 1960 IAF sessions even more interesting when a trio of engineers from the Douglas Aircraft Company told delegates space travel could become quite inexpensive.

In a presentation titled "Direct Operating Cost Analysis of a Class of Nuclear Spaceships," Max Hunter and his fellow Douglas engineers offered an economical alternative to the standard chemical rockets. They concluded, "Nuclear vehicles have been found to present near-term capability . . . for the exploration and possible exploitation of the moon and nearby planets based on the achievability of cargo carrying direct costs on the order of one dollar per pound."[19]

Did they just say $1.00 a pound? In 1960, the price to send a pound of anything into orbit with chemical rockets was well over $20,000.

Well, your luggage might go for $1.00 per pound, but it would cost more for you to climb aboard. "Personnel transport," the audience was told, "may be achieved on similar missions at costs from $500

to $5,000 per pound for round-trip lunar and one-way Martian missions respectively." For those in the waiting lounge who wanted to vacation beyond the sands of Mars, "Personnel transport over the range of terminal planets" (from Jupiter to Pluto), "may be on the order of $2,000 to $50,000 per passenger."[20]

Unfortunately, propulsion technology at this time was based on expendable, chemical rockets. Imagine if the government had invested heavily in Hunter's idea for an aggressive nuclear research program with reusable spaceships. Mercury astronauts wouldn't have been the only ones checking into Cocoa Beach motels. Hunter believed his program would net "space transport capabilities throughout most of the solar system with costs roughly comparable to those currently required for air transport on the surface of this planet."[21]

The Douglas engineers stressed their direct-cost analysis should not be confused with passenger ticket price. Calculations for passenger flights required the addition of indirect costs—considerations like fleet maintenance, management, and business operations. Even so, they were confident, "There is no valid reason to assume that the indirect costs will be a much different proportion of the total operating costs than is the case for current aircraft transport systems."[22]

Time magazine introduced a story on Hunter's talk with a nursery rhyme: "Sing-song, merry-go-round, here we go off to the moon-oh." The article didn't specify when, but left the impression that it wouldn't be long before space travelers would be able to suit up and fly right. "Costs of a round-trip ticket to the moon," the article concluded, "would be $900, about $40 less than the current first-class jet fare from New York to Paris and back."[23]

A few months after the IAF meeting in Stockholm, Wernher von Braun indicated the Douglas boys weren't so far off the mark. By this time, von Braun had been appointed director of NASA's Marshall Space Flight Center in Huntsville, Alabama. In an article for *Space*

World magazine titled "What I Believe," von Braun predicted, "It is entirely conceivable, within our lifetimes that rocket ships will be transporting people to vacations in space, and that some of the famous European spas will be competing with new spas on Venus." [24]

Vacations in space may have seemed wildly optimistic, but von Braun and his merry band of engineers had faith that advances in propulsion techniques would bring down launch costs and expand passenger opportunities. Until then, the famous European spas need not worry about extraterrestrial competition.

Around this same time, the Hayden Planetarium's Interplanetary Tour publicity gimmick was no longer considered all that interesting or poignant. Knee-deep in applications and tired of the mailing expense (three cents a stamp for domestic first-class mail and more for overseas), the Hayden quietly killed off the promotion. By 1958, responses from the new supervisor of Guest Relations, James Pickering, were not as cheery as those of his predecessor. In one letter, Pickering threw Frank Forrester under the bus by saying the whole thing had been an "elaborate promotional stunt under the previous administration."[25] He groused, "The idea exploded and became a nuisance. We have not had anything to do with it now for some years, but the (application) persists in many forms. We have no wish to become involved in any such adventure again."[26] In his 1961 response to a reporter doing a follow-up story on the promotion, Pickering begged, "We shall be grateful to you if you will avoid all mention of it."[27]

Pickering may have wanted to avoid all mention of the tours, but there were still those 26,000 space maniacs and their reservation cards. In 1964, Donald Tepper of Edmonton, Alberta wrote to the Hayden to inquire about the flight schedule. "Fourteen years have passed, eleven remain. The schedule may not be far from correct. My mother, brother, and I signed up for Saturn . . . I am curious . . . Are our seats still reserved?"[28] In his response, Pickering told Mr.

Tepper to forget it. He also complained the large number of reservations that had come in over the years "made it difficult for us to perform our regular, and perhaps more necessary functions . . ." "Besides," concluded Pickering, "we have disposed of the names which were fictitious to an astonishing percentage and have completely discarded the idea."[29]

Fictitious names? Try telling that to Mr. Daly's entire 8th grade class from the Central School in Whitehall, New York!

Who's on First?

He wasn't destined for a Venusian massage, but a troglodyte named Ham beat out classmates Minnie, Tiger, Elvis, and Enos to become the first chimpanzee to be launched into space. In addition to providing insights on life science issues, the mission was a test of the Mercury capsule and its systems. Prior to his flight, Ham (short for Holloman Aerospace Medicine, alias Change, alias number 65) received fan mail from fellow chimps. The handlers of celebrity television chimp Zippy sent Ham a telegram that said, "Good luck on your trip . . . I wish I could join you . . . Happy landings."[30] Another telegram, signed simply "A Chimpanzee" implored NASA to "Send astronauts first!"[31]

Ham earned his astronaut badge on January 31, 1961, when a Redstone rocket blasted him to an altitude of 157 miles for a sub-orbital hop. It was a good thing this was just a warm-up for humans. The bell-shaped capsule sailed faster, higher, and farther than planned. The flight and the period of weightlessness lasted two minutes longer than expected. The forces of gravity on reentry were three times greater than predicted. The capsule overshot the designated landing site. There would have been hell to pay had all these *anomalies* occurred on a flight of one of the Envoys of Mankind.

Most news stories on the mission described Ham as grinning when his capsule was retrieved and the hatch was opened. What did they

On January 31, 1961, a chimpanzee named Ham paved the way for the Mercury astronauts.
Photo: NASA

know? Jane Goodall, who is quite conversant in chimpanzee, once assured me his reaction was actually a sign of blatant hostility. When the NASA public affairs staff tried to cram Ham into a duplicate capsule for a post-flight photo op, he went bananas. Having received two shocks to his feet during the mission, he was in no hurry to re-enact the experience for a bunch of journalists. If his flight was an example of what the dream of space flight was all about, by all means, don't send another chimp; launch an astronaut.

After Ham's mission, there were still a few nervous Nellies reluctant to give a thumbs-up for an astronaut flight. Maybe there should be one more chimp flight, just to be sure. Congressman James Fulton (R. PA), a member of NASA's budget committee, thought this was ridiculous. Said the gentleman from Pennsylvania, "I think we are getting to the point where if they are afraid, let more of us go who aren't afraid of the risk. If a flight was good enough for Ham and a chimpanzee can do it, why couldn't a man do it? I'm always laughed at, but I'd go in a minute."[32] He was right about one thing: he had made this offer to fly so frequently, he was always laughed at.

Earlier that year, astronauts John Glenn, Gus Grissom, and Alan Shepard had been named to the A-Team from which the first Mercury commander would be selected. Since one of them would follow in Ham's footprints, they had watched his flight with more than a little interest. Congressman Fulton and others may have been under the illusion that there was nothing to it, but Major Glenn put that to rest

real quick: "You just don't walk up and say, 'Shoot me out of the cannon, I'm ready for space.' Sitting on your laurels is for the birds. I've had the training to be a space pilot."[33] It was space pilot Alan Shepard, however, who won the coveted assignment to be the first astronaut to be shot out of the cannon.

The U.S.S.R. was also training space pilots. Like the dreamers in America, the Soviets had more than their share of volunteers. As author Y. I. Zaitsey reported in his history of the Russian space program: "Thousands of patriotic Soviet citizens of all ages and professions expressed their desire to take part in space flight. However, before the choice of candidates could be made, it was necessary to ensure that they possessed the required physical, moral, and professional qualities."[34] Just like NASA, the Soviets had determined these "professional qualities" could best be found among the ranks of military test pilots.

While U.S. officials debated whether or not it was safe to commit to a human flight, the Russians strapped a cosmonaut on top of their Proton rocket. Even though they had not launched anything as sophisticated as a lever-pulling chimpanzee, the Soviets had sent several animals into orbit. In August 1960, canines Strelika and Belka, 42 mice, two rats, and a jar of flies were retrieved from an orbital mission aboard Sputnik 2. Four months later, two more hounds, Pchelka and Mushka, "endured their orbiting period satisfactorily." Unfortunately, during landing—the bane of the America's Rhesus test subjects—the capsule went off course, and they transpired in the heat of reentry.[35]

On April 12, 1961, cosmonaut Yuri Gagarin was launched into orbit inside a Vostok capsule, becoming the first human to sail the ocean of space. Gagarin confirmed that the experience was as transcendental as we had imagined: "The feelings that filled me I can express with one word: joy."[36]

The dream, at last, was fulfilled! That visionary Russian rascal Konstantin Tsiolkovsky must have been dancing among the stars.

Scribes from *Life* magazine were dispatched around the world to canvas reactions to Gagarin's achievement. Hazumi Maeda of Japan exulted, "I knew Russia would do it first. Socialist science is superior to that of western nations." German secretary Elizabeth Gulewycz worried that "Soviet boasts of ultimate superiority may not be groundless after all." African student C. Bamba noted, "Americans talk a lot. Russians kept silent until success came. The results speak for themselves." Looking beyond the political ramifications of Gagarin's feat, Lashkar Singh, a cab driver from India, predicted people from his country would also fly in space. "We are not a lesser nation than Russia," declared Singh. "We will do it (too)."[37]

In the same article, correspondent Hugh Sidey captured the frustration American space engineers felt: "All we do is make studies and studies, but nobody makes decisions," griped an anonymous rocketeer. According to Sidey, President John F. Kennedy was ready to change the status quo and make a decision. Concerned that America's national security and status as a technological leader were in jeopardy, Kennedy was ready to "define U.S. space aims and work hard to achieve them."[38]

Maybe the administration should have worried less about status and paid more attention to the advice of Zen philosopher Alan Watts. In another article in the same issue of *Life*, Watts advised, "The point I make about status is this, play it cool, don't get taken in." From the serenity of his home in Mill Valley, the ex-Anglican priest calmly observed, "Life is not one-upmanship."[39]

The Kennedy Administration and the majority of the public were not Zen followers and didn't like the idea of being one-upped by the godless Commies. They wanted America to jump ahead of the Russians. As far as the president was concerned, "There is nothing more important."[40]

Though there were moments of hesitation, a month later America finally succeeded in putting a man into space. Oval Office advisors lacked confidence in the abilities of the young space agency and encouraged Kennedy to postpone the first manned Mercury launch. The administration was still smarting from the failed attempt to invade Cuba during the "Bay of Pigs Fiasco" and didn't figure they could handle another public screwup.

Dr. Edward Welsh, the president's point man on space, managed to ease their concerns. Welsh assured Kennedy there was no need to "postpone a success," and explained that the risks were "no greater than a plane trip from here to Los Angeles in a rainstorm."[41] Really? When's the last time you traveled to Hollywood in an out-of-control jet that sent you flying ass over teakettle and the pilot calmly told you to stay in your seat?

Based on Welsh's guarantee, Kennedy gave NASA the approval to start the countdown clock. Sitting on the pad, Alan Shepard grew impatient as technicians tinkered a little too long with last-minute pre-launch glitches. Crammed inside the 9x6-foot Freedom 7 capsule, Shepard barked, "I'm cooler than you. Why don't you just fix your little problems and light this candle?"[42]

Before climbing aboard his space capsule, Yuri Gagarin stopped to take a leak on the launch tower, a tradition followed by cosmonauts to this day. Alan Shepard didn't tinkle on his launch pad, but being cooped up so long waiting for lift off, he was forced to pee in his spacesuit. The guys in Mission Control were afraid the urine would short-circuit Shepard's space suit. As far as we know, this tradition has not endured.

The candle was finally lit, and 78,000 pounds of thrust shot Commander Shepard into a sub-orbital arc. Suddenly, everything was "A-OK." He may not have circled the globe, but at least Shepard was in control of his spaceship, not a mere passenger like Major Gagarin was on his flight. Louise Shepard put her husband's 15-minute date

with destiny into perspective when she told a reporter, "This is just a baby step, I guess, for what we will see."[43]

President Kennedy saw it as a big step and, with Shepard's Freedom 7's brief excursion on the scoreboard, committed the nation to an ambitious program to "send a man to the moon and return him safely by the end of the decade."[44] Forty-two years after Goddard was ridiculed for so much as speculating that a journey to the Moon was feasible, the Apollo program became the all-consuming focus of the U.S. space program.

In Our Space-Cycle Built for Two

To achieve Kennedy's challenge, a boatload of new technologies and capabilities was required. To accomplish this, Project Gemini, which could carry two astronauts, was designed as a warm-up for Apollo. To help meet the flight demands of Gemini, a second class of astronauts was selected in 1962. The age requirement for this group was lowered from 40 to 35, and in addition to engineers, men with degrees in the physical and biological sciences were eligible. The most significant change from the Mercury astronaut criteria allowed test pilots from outside the military. This meant civilians, like X-15 pilot Neil Armstrong, could apply for membership to the astronaut fraternity.

Up to this point, the X-15 pilots had not received the same national acclaim heaped on their astronaut-brethren. Even though their rocket flights took them beyond the Earth/space border, the X-15 pilots were not as famous as the Mercury astronauts. However, in August 1962, an X-15 pilot did finally hit the national spotlight—big time. Air Force Major Robert White landed on the cover of *Life*, topped off with the cherished trip to meet Jack and Jackie Kennedy at the White House.

White was the first X-15 jockey to take his jet-black rocket plane through its paces, 50 miles above the California desert. This ac-

complishment earned him the exclusive badge of badges—the astronaut badge. From the threshold of space, White gazed out at the panoramic view and rejoiced, "There are things out there! There ab-so-lute-ly is!" The caption with his photo on the cover of *Life* proclaimed, "Boy, what a ride!"[45]

For a brief moment, it looked like more chimpanzees might get a chance to earn their astronaut wings. Someone suggested an astronaut *and* a chimp team-up for a Gemini flight. There had been tremendous public interest in the exploits of Ham and Enos (the second chimp to fly), who preceded John Glenn's orbital milestone in 1962. Think of the possibilities of sending the likes of Gordon Cooper or Deke Slayton on a mission with a chimpanzee named Elvis. Talk about something that would make an astronaut feel all shook up! By this time, astronauts had logged six Mercury missions into their flight books and were just beginning to live down the guffaws that a chimpanzee had flown in the capsule first. Now these American idols were expected to train for a mission with the most recent graduates of Chimp U? No way! That was for Tarzan, not Superman.

The proposal for this unwanted blind date was shelved, but not before it reached the attention of Capitol Hill. At the 1963 NASA budget hearings, Senator Howard Cannon (D. NV) asked Administrator James E. Webb about the rumored flight pairing. "We sent man up to find if he could do missions in space better than a machine," surmised Cannon. "Is the purpose of this new team of a man and a monkey to find out if the monkey can do a mission in space better than man, or what is the purpose?"[46]

A somewhat baffled Webb came up with unconvincing medical purposes. A chimp could be "more completely" instrumented than a man—as in, "You want to stick that probe where?" Struggling for a better explanation, Webb suggested, "The presence of the man is to observe, in very close detail, the precise conditions that the

animal is being subjected to, and where the readings of the instruments are giving us the results, again, uses the man for a purpose superior to that instruments could perform . . . so we have a very great advantage in this combination of two men, or one man and a chimpanzee."[47]

Say what? In other words, the astronaut would be there to *observe* cousin Minnie during the flight and make sure she didn't yank out her probes.

Those attending the hearing had to be thinking, "Let me get this straight: While an astronaut's presence might offer superior performance to what instruments could do, if push came to shove, the gadgets could do a decent job like they did for the flights of Ham and Enos? So tell me again, why is the astronaut going along?" Funny, but after Webb's encounter with Senator Cannon, you didn't hear anything more about pairing chimps with the Messengers of God.

What you *did* start to hear about were the opinions astronauts had about who might be qualified to join them in space. Speaking on "Aerospace and Its Impact on Youth," Gus Grissom told a conference of educators not everyone was cut out for his line of work: "We are astronauts because we have the inherent ability to control high-speed aircraft, to operate and understand complicated equipment and to make detailed scientific observations. But not everyone is suited for this type of work, in the same way that everyone cannot attain the skills of a surgeon. It all develops from an inborn talent."[48]

Grissom told the teachers "to take a reasonable attitude" towards their educational duties. While it was certainly necessary that everyone understand the basic principles of space science and technology, "The job of schools and teachers is to educate only a small portion of the population as engineers and scientists. Only the best suited and naturally adept in science should be encouraged to follow a career in these fields."[49]

For Grissom, "It seems that the role of education now is to begin preparing, (and) building a system where science is a course begun early and stressed as the more basic subjects of English and history." With such a foundation in place, we could then produce "undreamed of scientific triumphs" and "our education system will match the discoveries being made in space." He did admit that he "was no expert in education."[50] It's doubtful any of the teachers raised their hands to disagree.

Meanwhile, the Defense Department had not given up on the idea of having their own manned space program separate from NASA. In an article in the in-house magazine *General Electric Forum*, Secretary of the Air Force Eugene Zuckert explained there were special military missions requiring a space perspective that NASA could not provide. To accomplish such missions, Zuckert promised, "The Air Force will make orbital flights much sooner than previously planned."[51]

With his prediction, Zuckert raised the Air Force flag, but neither Congress nor the president saluted.

3 ASTROCHICKS

It is inconceivable to me that the world of outer space should be restricted to men only, like some sort of stag club.
Jane Hart, "Qualifications for Astronauts"

The fact that women are not in this field is a fact of our social order. It may be undesirable. It obviously is, but we are looking to people with certain qualifications.
John Glenn, "Qualifications for Astronauts"

All this talk of putting a woman in space makes me sick at the stomach.
Unidentified NASA spokesman, *Life* magazine

Sky Queens

So far, we have followed the exploits of the daring young men selected for NASA's initial human space flights, with little attention to women, daring or otherwise, who would have liked to join the astronaut corps. Only Ralph Kramden, the character portrayed by comedian Jackie Gleason in the 1950s television sitcom *The Honeymooners*, seemed interested in sending a female to orbit: "One of these days Alice—Pow! Straight to the Moon."

The struggle of women to gain a seat in space followed a plot similar to their efforts to gain acceptance as airplane pilots. Just like adventure-seeking males, females had their heads in the clouds since air flight began. In 1910, the Aero Club of France issued the first pilot's license to Baroness Raymonde de Larouche, and a growing international sorority of "Tomboys of the Air" soon joined her.[1] The thought of pilots wearing corsets gave male flyers the willies. What if a woman was hurt or killed in an accident? Why, it could set aviation back to Kitty Hawk!

Despite being tagged with the nickname "Powder Puffers," female pilots achieved aviation feats of distinction. We are most familiar with the exploits of Amelia Earhart, but it was fellow aviatrix Jacqueline Cochran who played a pivotal role in the space aspirations of women. For over thirty years, she crisscrossed the globe in a gaggle of planes, racking up countless international aviation records. During World War II, Cochran helped establish and lead the highly successful Women's Airforce Service Pilots (WASP). As if a trophy case full of aviation loving cups wasn't enough, she also went on to become an extremely successful, wealthy cosmetics entrepreneur.

In 1943, as Cochran was orchestrating her all-girl WASP patrol above military air fields, 12-year-old Geraldyn "Jerrie" Cobb was learning how to fly. Once she climbed behind the stick of her father's two-seat Waco bi-plane, the ponytailed pilot knew exactly where her destiny would lead. By the time she was 17 and could legally apply for a pilot's license, she had already logged 200 hours in the air. She passed the normal two-hour flight test in 45 minutes, and in March 1948, drove home with her "ticket to the sky."[2]

By 1953, Cobb was working as a flight instructor in her home state of Oklahoma. That same year, Jackie Cochran became the first woman to slam a jet through the sound barrier. A little more than a decade later, these two pilots would find themselves working in an uneasy alliance to promote the dream of women to fly in space.

Anything You Can Do

In 1957, Lester Del Ray predicted that a woman's place might, indeed, extend into space. Writing in *Space Flight: The Coming Exploration of the Universe*, Del Ray predicted:

> Girls will also want to go out into the space service. They will probably do at least as well as men; for long and difficult trips, women may be preferred, since it has been proved that they are

58

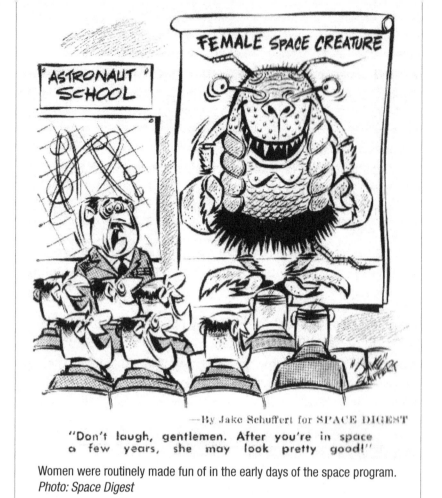

—By Jake Schuffert for SPACE DIGEST

"Don't laugh, gentlemen. After you're in space a few years, she may look pretty good!"

Women were routinely made fun of in the early days of the space program.
Photo: Space Digest

able to stand monotony better than men. Some girls may become pilots. The word spaceman must be used to mean either boys or girls, with no difference in the type of job they will do.[3]

The delegates of the 1958 Commonwealth Space Symposium in London didn't feel the same as Del Ray. At the symposium, Dr. T.C. Helvey "had male delegates rolling in the aisles with laughter . . . when he proposed that two men and a woman (preferably not a shapely blonde) be sent as an ideal team to the Moon!" When the rollicking conferees got a grip on themselves, Dr. Helvey explained his opinion was based on "a combination of logic and human psychology." Experts in human factors believed sending three men in a can

to the Moon spelled trouble. They feared that the effects of isolation might unleash pent-up hostilities and endanger the mission. Helvey was convinced that if a woman went along for the cruise, "hostility would be cooled and tensions eased, out of respect to her."[4]

As delegates chuckled in London, that "shapely blond" Jerrie Cobb was flying as a test pilot for Aero Commander, Inc. of Oklahoma. By then, she had numerous international speed records and had logged more than 7,000 flight hours in over 60 kinds of aircraft, including a jet fighter. Among her many honors was the cherished "Golden Wings" presented by the Federation Aeronautique International.

One morning in September 1959 while staying at Miami's Fontainebleau Hotel, Cobb met two men who were about to rocket her aspirations to new heights. In town for the annual meeting of the Air Force Association, Cobb was introduced to Dr. W. Randolph Lovelace II and Brigadier General Donald Flickinger. The doctor and the general were experts in the field of space medicine and had been in charge of the medical evaluations of the astronauts for Project Mercury. During the conversation, the medical duo mentioned they had just returned from a space science meeting in Moscow, where they developed the distinct impression the Russians were planning to put a woman in space. When she heard this, the 28-year-old Cobb later recalled she "felt a cool flitter of excitement run up the back of my neck."[5]

Dr. Lovelace described the grueling physical exam that had been devised to sort out the men from the boys among the Mercury volunteers. "Only the 'superb' specimens get through," he told Cobb. But tests by the British Medical Council and other sources found "Women are better than men at withstanding pain, heat, cold, loneliness, and monotony." Therefore, Lovelace and Flickinger were curious to know if those findings could be applied to the conditions in space. They wanted to establish "whether there is a group of highly

experienced women pilots who can endure" the same tough physical tests given to the Mercury candidates.[6]

Since her logbook of 7,000 hours exceeded the flight time of any of the Mercury astronauts (though not in jets), Dr. Lovelace asked Cobb if she would be "willing to be a test subject for the first research on women as astronauts." With tears in her eyes (and wasn't that just like a woman), she leaped at the opportunity. She later expressed how fortunate it had been she "was in just the right place at just the right time."[7]

Let's make one thing perfectly clear: these were *not* NASA-sponsored tests. While both Lovelace and Randolph were aerospace medicine consultants for NASA, the tests were to be conducted at the private Lovelace Clinic in Albuquerque, New Mexico and at the Navy's stress test facilities in Pensacola, Florida. NASA was not even asked if it was interested in the test results.

Cobb was told to report to the Lovelace Clinic the following February. To get in shape, she began a daily exercise regimen that included pedaling 20 miles on an exercise bike and running five miles. This was at a time before we became a nation of marathon fanatics, and when *Life* magazine had made a big deal out of John Glenn's two-mile-a-day jogs. When Cobb pulled up to the clinic, another space class was in session down the road at Chimp College where Ham and his troglodyte classmates were learning to fly a Mercury simulator. If the government was willing to spend money to train a pack of chimpanzees to fly, surely a program for women was a reasonable consideration.

For the rest of the month, Cobb was put through the same Phase 1 drills Alan Sheppard and the guys had come to know and hate. For eight hours a day, the doctors gazed into her eyes, injected ice water into her ears, eavesdropped on her bodily sounds, and wired her neurons. Technicians drained her blood, strapped her to a spin-

table, and stuck probes into all manner of unmentionable places on her 5' 7" frame. Psychologists administered personality tests and asked her if she wished she were dead. Finally, after her "lean body mass" proved to be satisfactory, the sadistic medicine men informed her she "passed the Mercury astronaut tests."[8]

Well, that wasn't exactly true. What she had done was pass *part* of the *physical examination* that had been given to the male test pilots. Already seeing herself behind the wheel of a Mercury capsule, she heard it her way.

Don't get me wrong, when compared to the 31 male candidates that had gone through the examination, her results were just as "superb." A technician noted, "Miss Cobb required less oxygen per minute than the average male astronaut—this means less oxygen by weight will be needed for the women crew members."[9] As we have learned, less weight meant less cost. But NASA had never asked for the test!

Jerrie Cobb gazes skyward with her dream to be the first female astronaut. *Photo: NASA*

Whereas the coming of the Mercury astronauts had been preceded with great fanfare in the press, Cobb's coming was on the QT. This business about letting woman in the astronaut clubhouse was extremely controversial, and Lovelace and Flickinger didn't want to upset the apple cart—at least not just yet. Dr. Lovelace decided the upcoming IAF Congress in Stockholm would be an appropriate place to present the test results. This was the same IAF meeting mentioned earlier where Max Hunter unveiled plans for a $1-per-pound reusable nuclear-powered space ship.

In the meantime, few knew about Cobb's test. The world would have to wait another six months to be introduced to "the very highly motivated, intelligent, and stable" Miss Cobb. The clinic's doctors had been impressed with her "exceptional ability to remain passive and relaxed when action is unavailable or unwise."[10] Right then, Lovelace thought it was unwise to let too many people know what he was up to.

Before Lovelace made it to Stockholm, *Life* magazine science editor Al Rosenfeld stumbled onto Cobb's clinic tests. In exchange for an exclusive on the story, *Life* agreed to hold off on the story until after the IAF Congress. As part of the arrangement, the magazine sponsored a press conference on August 19, 1960. It was time for Jerrie Cobb to meet the press.

The newsmen asked her the kinds of questions you would expect them to pose to a serious would-be space pilot:

Question:	Are you afraid of anything?
Cobb:	Yes, of course—grasshoppers.
Question:	Why do you want to beat a man into space?
Cobb:	I don't . . . Women can do a useful job . . . We aren't in a contest.
Question:	You wouldn't mind being on a co-ed space flight?
Cobb:	On the contrary, I think it would be delightful.

That last one broke a few pencil leads and caused a round of laughter. She quickly let them know her respect for the cosmos was no joke. When asked how she personally felt about space, Cobb replied it was "God's unspoiled world which humans should not trespass upon without a feeling of reverence."[11]

The subsequent press coverage duly reported Cobb's answers, along with excerpts from Dr. Lovelace's Stockholm speech. As the good doctor had told the conference delegates, "It now appears that women are not only capable of withstanding the stresses of spaceflight, but in some areas are more suitable than men."[12]

We also became familiar with Cobb's vital statistics: 36-27-34. In those days, we knew the vital statistics of a *lot* of women. *Time* magazine proclaimed (wrongly) that she had become "the first U.S. lady astronaut . . . If all goes well, perhaps in late 1962 (she) will don a formless pressure suit, tuck her ponytail into a helmet and hop atop a rocket for the long, lonely trip into space."[13]

Not bloody likely.

Not since Miss Able and Miss Baker hit the cover of *Life* had a female space cadet made such a hit with the media and the public. Mail by the bagful poured into her Oklahoma office. From around the world came notes of support and requests for interviews and speeches. She didn't exactly replace Davy Crockett as the new hero for kids, but she didn't do badly. One woman sent her a new song about the "Legend of Jerrie." Madison Avenue couldn't wait to get a hold of her (if only they could do something about that ponytail) and slap her figure on billboards and magazine ads. The fan mail was answered; the offers to pose with a cigarette dangling from her lips were not. Miss Cobb was not in this for "some kind of novelty or publicity." She was "deadly serious."[14]

The Mercury astronauts must have been dumbfounded. My God folks, all she did was pass a physical exam, and only one-third of the exam at that!

Time ran the account of "astronautrix" Cobb next to the story on Max Hunter's "Ticket to the Moon," where we learned, "a scant $500 should one day cover basic costs of one passenger's round-trip transportation to the moon."[15] There it was in black and white: enough cannon fodder for a battalion of dreams. Pack your bags, honey; we're all going to space!

In between speeches to Rotarians, the League of Women Voters, and endless interviews, Cobb squeezed in the next two phases of the physical exam. She had already made a side trip to the NASA's Lewis Research Center (now the Glenn Research Center) in Cleveland to be mauled by the MASTIF (Multi-Axis Spin Test Inertia Facility). This hulking monster of a machine tested one's ability to properly control the pitch, roll, and yaw of a spacecraft while being tumbled, twisted, and turned every which way. Cobb soon tamed the wily beast with her "exceptionally quick" responses. When they asked her if she had enough, she told them to put another quarter in the record machine.

The second phase of the test was conducted in the fall at the Veterans Administration hospital in Oklahoma. There they re-probed her pulses, asked her to decode ink splotches, and charted her brain waves. Psychologists had a field day when they locked her in a dark room and dropped her in a water tank for almost ten hours during the profound sensory isolation experiment. Not even the astronauts had been tested so profoundly. She "excelled in loneliness," and passed the rest of the tests with flying colors. In the opinion of one doctor, "She had very much to recommend for selection as an astronaut candidate."[16]

Unfortunately, no one had yet asked NASA if they cared.

Cobb was equally as impressive during Phase 3 of the tests at the Pensacola Naval Air Station in May 1961. She endured more EEGs, more X-rays, more probes. By then, she must have thought her dissection was next on the menu.

On the obstacle course, she was able to scale six-foot walls in a single bound. Before climbing into a Douglas Skyraider, they jammed needles into her skull and zoomed through eyeball-popping dives to test G-load stress. Navy policy prohibited women from riding in jets, so the Pensacola officials had to contact the Pentagon to report that it "wished to ascertain the difference between men and women astronauts." The Pentagon wired a humorous reply: "If you don't know the difference already, we refuse to put money into the project."[17] Nonetheless, Cobb was cleared for takeoff.

They tried to drown her in the Dilbert Dunker to see if she could make her way to the surface from an upside-down capsule. In a ride too sickening for amusement parks, she was strapped on a table, spun around a room at what must have felt like the speed of light, and was then expected to throw darts at a target five feet away. Wrapped in an ill-fitting pressure suit, she climbed into a chamber on a simulated sentimental journey to an altitude of 60,000 feet to see how she performed in "reduced suit mobility."

Again, yes, once again, she flew through these super-human tasks as well as or better than the Mercury men. The Navy had let her into machines no dame had ever seen before. Based on this overwhelming evidence for the plaintiff, surely, NASA would now invite women to ride on their rockets. But NASA had never asked for the tests!

Earlier that month, Mercury astronaut Alan Shepard blasted into a sub-orbital arc in the Freedom 7 capsule, but there was little chance that such friendship would extend to the divine Miss Cobb. The super girl from Oklahoma had better have enjoyed her simulated 60,000-foot-high journey in the altitude chamber; it was as high as she would ever get towards the boundary of space.

The Baker's Dozen

Dr. Lovelace was certain there was "no question but that women will eventually participate in space flight; therefore, we must have

data on them comparable to what we have obtained on men." It was obvious that one test did not a scientific certainty make, so he intended to "ultimately examine 12 or more women pilots."[18] Ultimately, he did just that.

Jerrie Cobb and Jackie Cochran provided names for the additional "astronaut" test subjects. In her autobiography and in congressional testimony, Cochran took credit for giving Dr. Lovelace a list of candidates who were members of the Ninety-Niners, the sorority of female pilots. According to Cochran's account, the only reason Jerrie Cobb had been picked for the initial tests was that she was the only one who could afford to pay her own expenses. This was a cheap shot and not true. By then, Cochran enjoyed considerable wealth from her cosmetic business and told Lovelace she would pay the "travel and maintenance expenses" for additional female test subjects. "It was not the results of the tests on the first candidate that gained approval for research on the others. A group was considered important from the start," Cochran insisted.[19]

Cobb tells a different story. In her autobiography, *Woman into Space*, she related the story of how she met Lovelace by accident at the Fontainebleau Hotel and recalled seven of the twelve women who were eventually tested at the clinic were identified from two lists she produced. Regardless of where the lists originated, the selection criteria for the female candidates was much the same as for the Mercury men: under the age of 40 (which, much to her disdain, ruled out the 50 year-old Cochran), logged 1,500 hours (though, of course, not in jets), and had at least two commercial pilot ratings.

Medical researchers from Middlesex College recently had reported their belief that "small, chubby girls" would do very well in space. Evidently, short women with robust figures were "best adapted to convert food into energy," and compared to bulking men, ate comparatively little.[20] That may be so, but not many Ninety-Niners weighed in with measurements for a husky-sized jump suit.

From 20 candidates, 12 were selected to follow the trail Cobb had blazed a year earlier. With their heads filled with dreams of flying an arc in space, the candidates marched two-by-two, including one set of twins, through the Phase 1 tests. Propelled by their elusive dream, the women took a giant leap of faith to get to Albuquerque.

Even though there was no guarantee of where all this might lead, a few candidates quit their day jobs. Rather than spend their vacation on a warm beach somewhere, the women opted for the cold cubicles of the clinic. If they ever actually made it into space, another more-lasting sacrifice might be required. Some medical experts feared the effects of radiation might make female astronauts risk sterility.

Although they were never brought together at the same time, Cobb christened the merry band as the FLATS: Fellow Lady Astronaut Trainees. While the rest of the FLATS were letting the boys in white coats sneak a peek into their bowels and brains, Cobb managed to become a NASA consultant.

After her successful foray through the tests in Pensacola, Cobb was invited to Tulsa for the First National Conference on Peaceful Uses of Space. Dr. Lovelace was scheduled to give a speech on "The Future Problems of Man in Space," and wanted Cobb on hand for Show and Tell. Enthusiasm for the space program at the conference was contagious. The day before, President Kennedy had played rough with the Soviets and slapped them with his lunar gauntlet. This made a major hit with the 1,000 wild Midwesterners who were tired of being humiliated by a bunch of Commie Pinkos. Had it been up to Cobb, JFK would have thrown down the other glove to see who could launch the first woman in space, namely her.

While the attendees were finishing their dessert at the conference banquet, NASA Administrator James Webb stood up and announced he was appointing Miss Jerrie Cobb as a consultant to NASA. Cobb

almost fell out of her chair. She later confessed, "I couldn't believe it! I was actually to have a say in America's move into space! It was too good to be true."[21]

It wasn't long before her "too good to be true" observation proved to be correct. Cobb was going to have as much to say about America's move into space as the rest of the conference attendees who received party favors certifying them to be "A-OK Astronaut(s) of Oklahoma." Even though NASA had never asked for the tests that Randy Lovelace had initiated, the agency was being pressured to take a stand on the issue of women in space. NASA felt Kennedy's declaration was going to give them challenge enough without being distracted with the task of initiating an entirely new program for astronauts of the female persuasion. By lassoing Cobb as a consultant, Webb figured he might be able to bring her under control.

Hotel Lovelace or Heartbreak Hotel?

An article in *Space World* magazine suggested one of the biggest obstacles to a program for "astronettes" was the "cultural bias of American Men exposing their women to the hazards of space flight." Women in the U.S.S.R., on the other hand, suffered from no such handicap. Under the Soviet system, ladies and gentlemen competed for jobs requiring physical strength, and it would not be unusual to find a woman in Moscow engaged in "such heavy jobs as street sweeping."[22]

Cultural bias aside, Cobb was on top of the universe. Stories about her astronaut tests popped up everywhere. The head of NASA had just appointed her as a consultant, and the public was cheering her onward and upward. Cobb was convinced "an astronaut training program for women had to follow as day follows night. It was the natural order of things."[23] She tore into her consultant assignment with all the gusto of an Oklahoma tornado.

After a private meeting with Webb and two other top NASA officials in June 1961, Cobb submitted a six-page plan for a program to put the first woman in space. She recommended that NASA begin to train qualified women on Mercury systems, assign a woman to a Redstone ballistic shot as soon as feasible, and begin to gather medical data on a larger group of women. This latter suggestion would soon be accomplished, as the other FLATS were about to undertake Phase 3 testing at Pensacola. She even offered to give speeches, interviews, and organize educational workshops to inform the public about the importance of space exploration. You didn't see Mercury astronauts offering to do that!

Due to scheduling difficulties, the Phase 3 test for the FLATS was pushed from July to September. This would be the first time all FLATS would be brought together under one hanger, so they agreed to celebrate on September 19. The inaugural ritual never took place. The night before they were to report to the gates of Pensacola, Dr. Lovelace broke their ever-lovin' hearts when he reported that the Navy had canceled the tests. He couldn't even tell them why.

Cobb exceeded the boiling point when she received a letter from Webb dated September 20 that stated, "I know we have been slow in working out arrangements for utilizing your services."[24] KABOOM! The Oklahoma Tornado transformed into the Hurricane from Hell. Cobb vowed to leave no department head unturned until she found out why the Pensacola tests were canceled and why Webb was so slow to utilize her services. A straight answer, however, was not forthcoming; she was put through a bureaucratic tango. She was bounced from office-to-office . . . from the Navy . . . to NASA . . . to Congress . . . to the White House. No man seemed to be willing to step out of the saloon and face Cobb at high noon.

The Navy told her the tests were canceled because NASA hadn't sent them the paperwork stating a "requirement" for the tests; go ask NASA. NASA responded they had nothing to do with the tests.

Since they didn't have a requirement, they couldn't be expected to provide the paperwork; go ask the Navy. Everywhere Cobb went, she was told it wasn't anything personal; establishing the requirement was a matter of "policy," and since there was no written policy concerning women in space, there wasn't anything that they could do. But good luck, sweetie; we personally believe what you're doing is great, and thanks for your interest in the space program.

What's A Nice Girl Like You Doing in A Place Like This?

Cobb kept up the pressure on NASA. Her frequent public speeches and assault on the bureaucracy were causing NASA unwanted publicity. This was becoming a public relations problem, so Jim Webb turned the matter over to Hiden Cox, the assistant administrator for Public Affairs.

In March 1962, Cox wrote to Cobb, "Despite the interest in your proposal from audiences who hear you we cannot undertake a program to train women as astronauts. We have not yet decided how many additional astronauts we need . . . "[25] The announcement for the second group of male astronauts was underway and would be released on April 18, so it is unlikely NASA hadn't decided on "how many additional astronauts" would be required. Cobb ignored Cox and wrote directly to Webb to express her disappointment that the matter had been turned over to public affairs. In her opinion, "Scientific values are reasons for these programs with public interest being secondary."[26]

The stage was now set for a clash of the Amazon Women from the air. Cobb assumed she could rely on a big gun like Miss Aviator of the Year, Jacqueline Cochran, for support. Certainly, Cochran would be sympathetic to the shabby treatment her sister aviators were receiving from those cold-hearted men.

Cobb was in for a big surprise. Instead of offering to lead a squadron in an assault on Washington, Cochran wrote a four-page letter to

Cobb and administered the blow the men at NASA were too polite (or too scared) to deliver: back off, you're driving everybody crazy.[27]

Whereas the arrival of Cobb in a Washington power room sent grown men running, Cochran was greeted as royalty. She was the sky queen, a flying legend, and a success in business to boot. She was on a first-name basis with Vice President Lyndon Johnson and belted back bourbons with any congressman worth knowing. When she broke the sound barrier, no less of a pilot than Chuck Yeager had been her chase-plane escort. Except for an accident of anatomy, she was one of the good old boys. In fact, when she walked off with the Bendix Trophy back in 1938, there was a rumor that she was a good old boy!

Cochran thought Cobb was giving women aviators a bad name. Instead of urging her to victory, Cochran told her to chill; women would travel in space, just not then. She advised, "Their time will come and pushing too hard just now could possibly retard than speed that date." Besides, Cobb wasn't the only one who had the dream: "I myself, would like to make the first flight . . . but after nearly thirty years of flying I decided that I could serve the others best by not becoming a competitor . . ." Cochran felt since she had a "detached attitude," she could "more objectively consider" the overall issue.[28]

This objectivity meant knowing how to avoid the resentment of men. Since there was no shortage of qualified males to be astronauts, there was no urgent need to identify women. If there was "no present national need for women," why risk irritating the men? Cochran had first demonstrated this principle during World War II with the WASP. When "pilots were returning from abroad . . . and available for air-duty," she recommended, "that the WASP be deactivated. Otherwise the WASP might have become the subject of resentment by the male pilots."[29]

Additionally, Cochran didn't believe the baker's dozen sampling conducted by Lovelace would prove much. A larger baseline program was needed, and it shouldn't be done in a rush. A crash program for women "might be regarded . . . in the nature of unnecessary drama." Finally, Cochran advised, Cobb should "accept this delay and not get into the hair of the public authorities . . . Then you can be particularly helpful . . . to create a group image."[30]

To keep her good old boy allies informed, Cochran sent a blind copy of her letter to Cobb to Secretary of the Army Elvis Stahr Jr. He, in turn, sent a copy to Webb and included a written note: "This is such a well-reasoned letter."[31] Stahr also believed that Webb and Cochran would hit it off and offered to set up a meeting.

As it turned out, Cochran and Webb had already met at a conference in Seattle. Earlier that year, Cochran had sent a letter to the administrator: "I agree with your decision not to include women at this time. Coming from the woman who at least comes closest to the qualifying experience . . . and one who would like to go, I think you might appreciate my views." She advised that NASA start a medical program and establish criteria norms based on experiments with a fairly large number of women over a long period. "A so-called crash program" to launch a female before the Russians did not "make sense . . . from a standpoint of overall national interests."[32]

Webb seemed to have missed Cochran's intent and responded that yes, "There have been many pressures to put woman in space first . . . however, the flight program has, from the beginning been for scientific and technological advance . . . Therefore, we use astronauts with experience in high-performance jet craft . . . if there are women with this experience, we will certainly consider them."[33]

Cochran quickly wrote back to make clear that she was on Webb's side. He should not think that she was "one of the people pressing to get women . . . as astronauts at this time." Cochran assured

Webb that the kind of crash program Jerrie Cobb and her ilk were pushing was not in the best long-range interests of women.

Tooting her own horn, Cochran added, "All this is being said by one who has great and understandable ambition to go into space and to be the first woman to do so . . . with more than 13,000 hours of flying time as command pilot and much high-speed precision flying . . . several hundred in jets . . . I may be the only one meeting the qualifications."

She concluded the letter to Webb by disclosing: "I have a general plan in mind that might solve your problem.[34] Webb seemed to agree with Secretary Stahr's assessment that Cochran's letter was "well-reasoned." He was convinced that here was a woman he could deal with, and she, too, became a NASA "consultant." The best way to silence critics or potential critics is to bring them into the tent.

Fools on the Hill

One of the members of the FLATS brigade was Jane Hart, who, in addition to being an outstanding pilot, happened to be married to Senator Philip Hart (D. MI). As the wife of a senator, she knew a thing or two about politics and how to win support for a cause. While Cobb took their case to the people, Hart hit the smoke-filled rooms of Congress.

Cobb admitted that their "strategy was to surround NASA—to force a decision one way or the other."[35] This strategy led to a meeting with Vice President Johnson, Senator Robert Kerr of Oklahoma, and Congressman George Miller, chairman of the House Committee on Science and Astronautics. It was agreed that Miller's Committee would create a special subcommittee and convene a round of hearings on "Qualifications for Astronauts."

Three days' worth of hearings were scheduled to begin on July 17, 1962. Representative Victor Anfuso (D. NY), chairman of the sub-

committee, opened the session by telling the standing-room-only crowd:

> We meet this morning to consider the very important problem of determining what are the basic qualifications required for the selection and training of astronauts . . . We are particularly concerned that the talents required should not be prejudged by the fact that these talents happen to be possessed by men or women . . . All human resources should be utilized . . . This committee is noncommittal, of course, but we will make sure that all the facts will be heard. [36]

Based on the history of congressional hearings, it was doubtful that the committee was "noncommittal."

Cobb and Hart were first on the agenda. In her opening statement, Cobb told the honorable members that her purpose was single and simple: "We hope that you will help implement the inclusion of qualified women in the U.S. manned space program." They weren't there to join the "battle of the sexes . . . only a place in our Nation's space future without discrimination." She pointed out since women had traveled on the Mayflower and on wagon trains, it was appropriate they should have an opportunity in the pioneering of space.

Congressman Anfuso thanked her for an excellent statement: "I think we can safely say at this time that the whole purpose of space exploration is to some day colonize these other planets and I don't see how we can do that without women." That gave the boys in the room something to snicker about.

In her opening salvo, Jane Hart let them know she wasn't there to be patronized: "It is inconceivable to me that the world of outer space should be restricted to men only, like some sort of stag club." She believed women should be admitted because they had a contribution to make. Then she let them know how she felt about their little snickers: "Now, no woman can discuss a subject like this without being aware that talk is going to inspire a lot of condescending little

smiles and humorous winks. But happily . . . there have always been men . . . like on this Committee, who have helped women succeed in roles that they were previously thought incapable of handling."

After Cobb presented slides depicting scenes of the FLATS going through the medical tests, the congressmen started getting rough. Anfuso bore down on the fact the women weren't engineers or jet test pilots, and not all the FLATS were college graduates.

Cobb parried and noted some of the FLATS worked as test pilots, though not in jets. Since women weren't allowed to fly jets in the military, they couldn't get the experience to qualify for test pilot school. She tried to steer the discussion towards the fact the FLATS averaged 4,500 flying hours each—more than the Mercury astronauts.

Joseph Karth (D. MN) brought her back to the subject of test pilots. Don't you think it is essential to be a test pilot to qualify as an astronaut? Isn't there a significant difference between flying commercial or private planes and being a jet test pilot?

Cobb, who by now had over 8,000 hours in the air, felt "equivalent experience" ought to count for something. Female pilots would not have racked up flying hours in the thousands if they hadn't had to cope with "emergencies calling for microsecond reactions." She offered further evidence from simulation test results at the Martin Company that showed women volunteers had the edge when it came to learning the control systems.

The hearing chairman jumped back in with more questions and wanted to know if the witnesses believed "the United States should be the first nation to launch a woman astronaut?" When Hart said yes, Mr. Anfuso brought up the old standby: What if someone was hurt or killed in an accident? Think of the "potential worldwide repercussions to our prestige." He wanted to know if this goal was worth the "risk and expense."

The women then presented their version of the Pensacola fiasco. Hart said it was a mystery to her why the tests were canceled. Cobb described the bureaucratic shuffle she had been put through in her attempt to get a straight answer out of NASA and the Navy. Mr. Anfuso didn't appreciate Cobb's tone of voice and quipped, "I know that you don't (mean to) criticize any branch of the Government. You just want answers."

Ken Hechler (D. W VA) didn't mind Cobb's tone and commended her and the others for their "initiative and courage. I think all you are asking is to keep step in the march of history."

James Fulton, a colorful Republican from Pennsylvania was on the side of these angels, but you'll recall he was also the Congressman who had offered to follow Ham into space when NASA hesitated in scheduling Alan Shepard's launch. He had the last word for the day and concluded since women paid taxes, they had as much right to "use the equipment" as men. "Secondly, when the scientists first started putting living animals in space it is rather remarkable that both the dogs and the monkeys were all without exception female." (Those strapping chimps, Ham and Enos, would have taken exception to that statement.) "Both Russians and Americans put female animals in space and suddenly stopped, when they found they were successful. I think that is very remarkable."

I'm sure Congressman Fulton felt he was being helpful to the cause, but it's doubtful the sex of the animals had much bearing on the test results.

Is That a Rocket in Your Pocket, Or Are You Just Glad to See Me?

There's a portrait of Jackie Cochran with a look of confidence and swagger that reminds me of Mae West. She had a commanding presence and was a personal friend of the male power elite of the aviation industry and politics. She held more national and interna-

tional speed, distance, and altitude records than any other living flyer, male or female. But at the afternoon hearing session, Cochran threw a monkey wrench into the space dreams that Cobb and Hart had expressed in the morning session.

Cochran proceeded to reel off a list of impressive personal accomplishments worthy of a military salute. As far as her views on women in space, she didn't believe there had been deliberate discrimination to date; why, she certainly had never been discriminated against. Second, she wanted to give male test pilots a lot of credit. The last time she checked, "Not one person in 100 would pass the requirements to become a test pilot."[37] Let's give these men the credit they deserve. The question of not including women as astronauts was not a matter of gender, but whether or not it would slow down the rest of the program. That decision was best made by

Jacqueline Cochran threw her fellow women pilots a curve ball by testifying NASA didn't need women astronauts.
Photo: The Smithsonian Institution

NASA, and should be left to the agency. Since they had determined there were enough qualified males, there was no need to start selecting females.

Cochran had no doubts women would one day perform and perform well in space, but testing a handful of female aviators wasn't going to provide the necessary "proof." It would be far better to test "a large group of women of various ages and experience a series of checks and tests on the ground, short of any astronaut trainee program . . . They need not be limited to pilots." During the war, Cochran had taken women with only 35 hours of flight experience and turned them into topnotch ferry pilots, so she didn't consider knowing how to fly ahead of time to be a necessary requirement for female astronauts. In her judgment, her proposed broad-based research program would produce a dozen or more qualified women who could then start astronaut training.

When it came time for questions, Chairman Anfuso referred to Cochran's comment that it had been natural that male astronauts had been selected from the test pilot gene pool. These men already proved they were experienced and could meet emergencies in space. "Does any woman," the congressman wondered, "meet those specifications . . .?"

Cochran didn't see how anyone could make such a claim. She then tried to tie Anfuso's question to her experience with WASP pilots: "The sad part of the (WASP) program was that our attrition rate was very high, due to marriage . . . somewhere in the neighborhood of 40%." Her WASP pilots "flew every type of aircraft this nation had, just as successfully" as men. But Cochran was quick to note this was because "we were well at the bottom of the barrel of manpower for (male) trainees when we started the women's program."

Despite the exemplary record compiled by the WASP, Cochran didn't see the need to rush for a female astronaut program at that

time. It would slow down the regular program and "waste a great deal of money when you take a large group of women in, because you lose them through marriage. That is why women are not on airplanes (as commercial pilots)." You spend all that money training them, and then they run off, get married, and get pregnant. Isn't that just like a woman!

Anfuso pressed her on the issue of whether women should be trained as test pilots. Since it cost $144,000 to check out a pilot in a B-47, she didn't think NASA could afford to train a woman; the agency wasn't economically sound enough for that. Cochran did, however, think it made sense to train a woman as "a crew member."

The great defender of women, Mr. Fulton, then stepped up to the mound: "Would you have the Air Force open up the Academy to these women for courses . . . so they can advance their careers in astronautics?"

Cochran's response was inexplicable. "I don't think you should open the Academy to women," she replied. "Maybe never . . . Don't clutter up the Air Force Academy with women unless we know we want them."

Fulton looked forward to the three seats proposed for the Apollo capsule. If not pilots, couldn't women make talented assistants? Cochran conceded having a woman as a medical technician or as an assistant pilot would be okay. In a half-hearted nod to the aspiration of women, Cochran told Fulton, "Don't misunderstand, I am not against women being in the program." Unimpressed, Fulton responded, "I don't think your testimony indicates that."

That was almost the last word—until Mr. Anfuso pointed out, "Mr. Fulton is a bachelor and he thinks women are out of this world. He would like to get them all out of this world." The hearings ended on a note of laughter.

How to Handle a Woman

Ten months after the FLATS were waived off from their training at Pensacola, NASA finally had to publicly explain what, if any, role it played in the cancellation of the tests. Director of Spacecraft and Flight Missions Dr. George Low represented NASA at the second day of the hearings. Mercury astronauts John Glenn (39-32-36) and Scott Carpenter (38-31-35) joined him. Glenn had become a national hero the previous February when he became the first American to orbit the Earth. Three months later, Carpenter spent five hours racing around the globe on his Aurora 7 mission.

Mr. Anfuso welcomed the NASA delegates and repeated the objectives of the hearings. He also speculated, "The development of new types of space craft . . . will perhaps not require such stringent qualifications on the part of crew members. It is not too early to begin to determine these facts."[38] And if the qualifications weren't too stringent, maybe one of these dames could fly.

Dr. Low led off by describing the new criteria for the selection of the second astronaut class for the Gemini and Apollo programs. Changes from the Mercury qualifications included lowering the age from 40 to 35, and increasing height from 5'11" to 6'. More important, in addition to engineers, those with degrees in the physical or biological sciences could apply. Also, test pilots from the civilian sector were now eligible. Dr. Low stressed the qualifications were not static and would no doubt be modified as experience in space flight increased.

Low noted applications had been received from 53 military officers and 200 civilians. Six applications came from women, but they did not meet the minimum qualifications. He mentioned *nothing* whatsoever about the very "problem" that had led to the hearings in the first place.

"Does an astronaut have to be a test pilot," Anfuso asked? Before answering, Colonel Glenn wanted it understood, "I am not 'anti' any

particular group. I am just pro space. Anything I say is toward the purpose of getting the best qualified people, of whatever sex, color, creed, or anything else they might happen to be."

Mr. Anfuso brought up the "catch twenty-two" situation women faced: the qualifications didn't discriminate against women, but they had to be jet test pilots. Women weren't allowed to be test pilots; therefore, they couldn't qualify. Would NASA oppose a parallel program to train women as test pilots so they could qualify?

Dr. Low said he "wasn't opposed to anything like that, in the future." However, NASA had plenty of qualified men at the moment. Additionally, "We don't foresee in the near future . . . the need, at any given time, for more than perhaps 40 to 50 space pilots." Therefore, since there was no need to cast a wider net, NASA had no plans to start a "training program for space pilots, be they men or women." The fact the Russians may or may not be training a woman didn't alter his view. The limited training facilities were already overloaded.

This last comment gave everybody an easy out. Mr. Anfuso felt it was the "best point you have made . . ." It was Anfuso's opinion that the Dr. Low was "not objecting to women, but at the present time, to let them use the things that you are using now for the astronauts, would be interfering with that program (to place a man on the Moon before the Russians)." In a concession of sorts, the congressman concluded, "In the future, when things were more relaxed, we could consider women. Why, we might even consider people from other countries."

The case for women was sinking fast.

Scott Carpenter wondered if maybe we should reevaluate the entire program and its goals. He questioned, "Is it to put an American on the Moon in the best and in the safest manner, or is it to put a woman on the Moon . . . or should we limit it to just putting a man on the Moon?" If it was to put an American man on the Moon, "We

must take the best American available, and we can get this type of man from the group that we have selected here—test pilots."

When it came to the question about airplane hours being equated to jet hours, Colonel Glenn was adamant. He didn't care how many thousands of hours a person had from flying "around in light planes or transports" because they are different types of operations. He was surprised we weren't taking a different tack: "Instead of trying to reduce our qualifications to a lower level . . . perhaps we should be upping the qualifications and saying we have to have test pilots with doctorate degrees and with even more experience than we have had so far."

Having had enough of this mauling of his maidens, Representative Fulton rose to their defense: "I disagree with your approach, because space is not an experiment or adventure. It is a new area where everyone will operate . . . women are paying taxes here, they shouldn't be kept out of space." On the basis of the requirements he had just heard, Colonel Glenn would have been eliminated because he didn't have the sacred engineering degree at the time of his selection. Since allowances had been made for "engineering equivalency" in Glenn's case, a similar case could be made for women concerning the jet pilot criteria. Since the military managed the test pilot schools, and since women were not allowed to attend, how could they ever become test pilots?

Fulton continued to slash away. Shouldn't we have a national goal to put a woman in space? Dr. Low hazarded a guess, "You gentlemen of the Committee are much better qualified than any of us to advise on what the national goal should be . . . I don't believe I am wise enough to state our national goals."

Fulton then opened up old wounds by bringing up chimpanzees: "You must remember that Ham made a successful trip, too. I think a woman could do better than Ham."

Glenn shot back, "That is not a fair comparison, sir, with all due respect. The missions these people are being selected for, Ham is not qualified either . . . If we can find any women that demonstrate that they have better qualifications for going . . . than we have . . . we would welcome them with open arms." When that last comment caused a great deal of snickering, the good-natured Glenn cracked, "For the purposes of my going home this afternoon, I think that should be stricken from the record."

The exchange continued, with Low defending the status quo qualifications and claiming NASA didn't discriminate against women. Maybe in the future, the criteria would change and women would be eligible.

Colonel Glenn became "Ace" for the day when he shot down the whole perception that the media had built up about the Lovelace tests: "The tests mainly are run to see if there is anything wrong with a person physically. It isn't that it qualifies anybody for anything. It just shows that they are a good healthy person." In hailing the name of the Washington Redskins, he proclaimed just because the mother of one of the players could probably pass the physical didn't mean she would be put in a game.

Congressman Fulton threw one last Hail Mary pass in an attempt to win the day. He disagreed with an approach where we should complete the Moon program first before we gave women a chance: "It is telling these women that we are going to wait 10 years." He didn't want to hear excuses about training facilities being "hard pressed." "You have adequate facilities. You are being given $2 billion more this year, and it is not all programmed . . . You could very well make a small start for these women." Let's face it, Fulton stated matter-o-factly, "The very setup of our military training structure now effectively eliminates every woman because the test pilot schools are all military and the women can't get in them."

Would NASA oppose a proposal from the committee to establish a small training program for women to let them qualify for tasks related to science and astronomy? Colonel Glenn replied, "I wouldn't oppose it. I see no requirement for it."

Mr. Anfuso ended the hearing by praising Colonel Glenn and Commander Carpenter: "When I see women here bring their children just to look at them, you can see what our youth is looking forward to. This is the kind of leadership that they want and they look up to—as great men as you are."

The hearings were over. The committee absolved NASA of fault in the cancellation of the physical tests for the women. The military made the decision all by themselves. No delay to the Apollo goal would be tolerated. Despite the heroics on their behalf by the acerbic Mr. Fulton, women would have to wait; business would proceed as usual.

She's Just a Girl Who Can't Hear No

After the hearings, Cobb and Hart were stunned. The promised third day of hearings never took place. Cobb submitted a supplemental statement and attempted to refute points raised by Low and the astronauts.[39]

Cochran also submitted a supplemental statement designed to further discredit Cobb.[40] She defended NASA's position and had the word of Dr. Lovelace himself: no woman had passed the Mercury Astronaut test; all Cobb had done was pass a preliminary medical exam. In her opinion, the whole matter has been given too much publicity, and it was too early to be giving all this coverage to the simple fact that a few girls had passed a medical exam: "Because the whole thing had been of research nature without any support or authorization by NASA, publicity could have been harmful to further work. That is why Dr. Lovelace had asked the 20 candidates to take a pledge not to engage in any publicity."

Jerrie Cobb didn't give up easily. In October, while back at her job as vice president of marketing for Aero Commander, she dropped a note to Mr. Webb: "I hope you don't mind if I keep trying, 'cause this means more than life itself. All I can do is keep working, trying and praying."[41] She also attached a couple of cartoons that referred to lady astronauts. A week later, she wrote Webb again, this time asking for a chance to pilot the X-15 rocket; if it's jet jockeys they wanted, then let her on the meanest horse in the corral.[42] They didn't let her saddle up.

A month later, Dr. Wernher von Braun addressed the subject of women in a speech he gave at Mississippi State College. He was lucky Cobb wasn't in the audience. When asked if women would get to fly, von Braun told the students, "The astronauts want them to go. They have 112 pounds reserved in the capsule for recreational equipment."[43] Oh, that Wernher.

Slightly less than a year after American women had their wings clipped at the Astronaut Qualification hearings, the predictions about the Soviets' plan to fly a female cosmonaut came true. On June 16, 1963, Valentina Tereshkova radioed to mission control: "I am feeling fine in the weightless state."[44] She sailed around the Earth 48 times in Vostok 6 and became the First Lady of Space. Her mission objectives even involved the first space rendezvous, as Lt. Col. Valery Fyodorovich Bykovsky brought his Vostok 5 within 3.1 miles (5 kilometers) of her capsule. The Russians announced Tereshkova's flight was part of an ongoing study on the effect of spaceflight on human organisms, including a comparative analysis of the impact of these factors on men and women.

Lt. Col. Tereshkova was not a test pilot and had a minimal technical background. The only remote relationship she had with the air was from her experience skydiving. Speaking before the National Rocket Club, NASA's Director of Biotechnology, Dr. Eugene Konecci, commented, "It is significant that she is not a pilot. This points to

the importance the Soviets attach to gathering biomedical informa-
tion on the effects of space flight and may be a preparation for flying
scientists who are not trained pilots." He added, "The Soviets have
always said they are going to colonize space . . . Women will play
an important role when space flight evolves from exploration to ex-
ploitation of heavenly bodies. What better way to get non-trained
scientists to go up than to show it can be done by a woman?"[45] Talk
about a backhanded compliment.

In a *Life* magazine commentary, author Clare Boothe Luce took the
American male ego to task for not encouraging women in space.
Despite guffaws from U.S. space experts, Luce insisted the Rus-
sians did not fly Tereshkova as a publicity stunt or to turn her into
some kind of human guinea pig: "The right answer is that Soviet
Russia put a woman into space because communism preaches
and, since the revolution of 1917, has tried to practice the inherent
equality of men and women."[46]

Ms. Luce reminded the experts, "The astronaut of today is the
world's most prestigious idol . . . (who) holds prestige and honor of
his country. But the astronaut is something else: he is the symbol
of the way of life in this country." With the flight of Vostok 6, the
Russians had demonstrated that woman can "actively share (not
passively bask, like American women) in the glory of conquering
space."[47]

An article on the next page displayed photos of the 13 refugees
from the Hotel Lovelace. The women were "exhilarated by Valen-
tina's feat, but depressed that it wasn't an American." Tereshkova's
"cosmonautical nickname" was Seagull; at least one bird had her
chance to fly. Luce described Jerrie Cobb as the "most un-consulted
consultant" in Washington.[48]

With the editorial from Luce, Cobb must have thought, "Now, maybe
we'll get some action." Recalling their ill-fated attempt the previous

year, Jane Hart told Luce, I'm tempted to go out to the barn and tell the whole story to my horse and listen to her laugh."[49]

In a July 1963 press conference, astronaut Gordon Cooper was quite adamant when asked for his opinion of women in space: "No women, absolutely zero women have qualified to take part."[50] This seemed like an unwarranted conclusion given Tereshkova's flight the month before out-orbited Cooper's Faith 7 Mercury mission the previous May by 18 laps.

Informed of his comments by the *Houston Post*, Cobb replied simply, "That's the same old NASA line . . . I don't have any more hope, I have the same hope, which is all the hope there is . . . I am not going to give up."[51]

With a patronizing sidebar, the *Post* article also felt compelled to point out that Cobb possessed "measurements that would make her a much more attractive 'astronette' than the chunky Russian woman."[52]

Having been downgraded from a hurricane to a tropical rainstorm, Cobb's impact was finally reduced to a drizzle. In a February 1964 letter to Chairman of the Senate Committee on Aeronautical and Space Sciences Clinton Anderson, she asked once more for permission to fly on the X-15. Senator Anderson asked NASA's Deputy Administrator Dr. Hugh Dryden for an opinion on the request.

Dryden informed the senator the answer was the same then as it was in 1962. It was not possible due to the limited number of flights and the substantial cost of each mission: "Participants have therefore been restricted to engineering test pilots with extensive experience in jet aircraft who have undergone months of special training . . . the maintenance of these standards is essential to the safe and effective operation of the X-15.[53]

Not long thereafter, Jerrie Cobb took her 10,000 hours of flying experience and retreated to the jungles of South America to fly medical relief missions.

In September 1963, President Kennedy proposed a joint U.S.-U.S.S.R. mission to the Moon.[54] When asked to comment on the initiative, Soviet Premier Nikita Khrushchev replied, "What could be better than to send a Russian and an American to the Moon together, or better yet, a Russian man and an American woman."[55]

At least somebody wanted to see an American woman in orbit.

I've Got You Babe

Less than four months after her milestone flight, Valentina "Seagull" Tereshkova toured Cuba and told reporters her next stop would be the Moon. She claimed to be a member of a lunar flight crew to be led by Yuri Gagarin. Tereshkova also claimed when she got back to Star City, she would propose a Cuban woman be included on the team.[56]

A month later, on November 3, 1963, Ms. Tereshkova teamed up with cosmonaut Andrian Nikolayev in a civil wedding ceremony. They became the first couple that had both flown in space to marry. A crowd of 1,000 space groupies hung around the gates of the state wedding palace. Premier Nikita Khrushchev served as toastmaster at the reception for the cosmic couple. In the late 1950s, there had been fears radiation would adversely affect the sex lives of space travelers and women might become sterile. Who knows what the breeding of Valentina and Andrian might produce? Not to worry. The following June, they did not beget some mutant creature from outer space; the first child born of cosmonaut parentage was a healthy, bouncing girl.

You know what Jackie Cochran had to say about women who got married and pregnant? There goes all that expensive training. However, this time, the woman didn't make the choice. Valentina actually did want to fly again, but the boys in the furry hats didn't want her anywhere near the launch pad. At a meeting of the American Institute of Aeronautics and Astronautics, Dr. Bernard Wagner reported

the "Soviets decided not to send any more women cosmonauts into space." Wagner suggested the space medical officials were dissatisfied with her performance on Vostok VI. She had been too excited during the mission as evidenced by wide variations in her pulse rate. She also did not recover from the post-flight effects as quickly as men.[57]

She was too excited? Again, wasn't that just like a woman?

Throughout 1964, astronauts prepared for the Gemini flights that were to begin in 1965. Since they weren't flying, they had a little extra time to hit the speaking circuit and preach "the same old NASA line," which included playing down the idea of female astronauts. Neil Armstrong told the Dallas Morning News, "Physiologically, women could make excellent astronauts. However, they lack the experience in flying high speed planes and handling complicated equipment . . . It would be very difficult to gain such experience."[58]

Speaking at Cedar Crest College in 1966 a month before the launch of Gemini 12, NASA's Associate Administrator for Manned Space Flight, George Mueller, gave precious little hope to the females in the audience. Although there were no women astronauts, "There had never been any discrimination with regard to sex or on any other basis." Dr. Mueller explained the problem: "We have not yet been able to find an applicant sufficiently qualified in both scientific and engineering background, who also possesses the required test pilot experience."[59]

We know, we know. Besides, what if one of them were hurt or killed in an accident? Why, it could send aeronautics back to Peenemunde.

It would take another 17 years before women were finally accepted into the astronaut corps, and 21 years before a woman broke the astronaut glass ceiling to fly in space.

4 DESTINATION MOON

Earth-to-orbit trips as convenient and cheap as a trip to Europe, and a flight to the moon that will be no more expensive than a trip around the world today, are worthy space goals beyond Apollo.
> Dr. Wernher von Braun, *A Look Into the Next 50 Years*

Dreams of eventual space travel are pure fantasy.
> Dr. Jesse Greenstein, *Scientific Progress and Human Values*

Who's the airline with a waiting list to the Moon?
> Pan American Airways Slogan

Integrating the Launch Counter

Around the same time women were being told to stay in the kitchen, African Americans were experiencing similar pushback to join the space race. Let's remember what was occurring with civil rights in the early 1960s.

While the white Mercury 7 astronauts were experiencing the freedom of zero gravity during parabolic flights in Houston, black and white Americans were engaged in Freedom Rides for civil rights in Mississippi and Alabama. In May 1961 when Alan Shepard went on his suborbital mission in his Freedom 7 Mercury mission, Freedom buses were routinely bombed, and transportation terminals had Whites Only waiting rooms, bathrooms, and drinking fountains.

Remember the October 1962 issue of *Life* magazine where Claire Boothe Luce had taken NASA to task for not having women in the astronaut corps? The same issue included a feature story on the confrontation at the University of Mississippi during which James

Meredith had to be escorted by Federal Marshals to register for classes. The civil rights movement was in full swing.

In August 1963, while NASA was conducting launch tests of the Little Joe rocket at the White Sands Test Range in New Mexico, 200,000 Americans came together in front of the Lincoln Memorial on the Mall in Washington, DC for a civil rights rally. It was here Dr. Martin Luther King Jr. delivered his "I Have a Dream" speech. In the meantime, the dream for African Americans to join the astronaut corps was going nowhere.

Just two years prior to Dr. King's speech, former CBS newscaster Edward R. Murrow wrote to NASA Administrator James Webb with a progressive suggestion. Now serving as the director of the U.S. Information Agency (USIA), Murrow asked Webb, "Why don't you put the first non-white in space?" He thought NASA "should enroll and train a qualified Negro and then fly him in whatever vehicle is available." Wearing his USIA hat, Murrow saw the positive contribution this could make in retelling "our whole space effort to the whole non-white world, which is most of it."[1]

In his response, Webb said that given the nature of the task at hand and the long lead-time for training, he didn't see how NASA could implement Murrow's suggestion, but he'd keep it in mind.[2]

President Kennedy was also encouraged to send African Americans into orbit. Whitney Young, the executive director of the National Urban League recommended that a black pilot be allowed to join the astronaut corps and endorsed Captain Edward Dwight. An Air Force pilot, Dwight had 2,000 hours of jet flight time to his credit and a degree in aeronautical engineering.

According to Captain Dwight, he received a letter from Kennedy in 1961 inviting him to become an astronaut candidate. In the 1990 PBS documentary *Black Stars in Orbit: NASA's African American Astronauts*, Dwight stated that the "Scuttlebutt was that Kennedy

wanted a black on the first Moon mission."[3] At the time, Dwight felt, "I'd get a chance to be on the cover of *Ebony* magazine."[4] This would have been comparable to the adulation *Life* magazine was bestowing on the white Mercury astronauts.

In August 1962, Captain Dwight was among 14 officers named to the Air Force Test Pilot School at Edwards Air Force Base in California. Sound barrier breaker Colonel Chuck Yeager was the base commandant. Graduates of the seven-month course became eligible for further training to become astronauts, managers, or consultants. Dwight told a reporter for *The Sunday Star*, "I knew that being a test pilot was a step toward space training, now I'm getting the next step."[5] Asked if he hoped to go into space, Dwight dropped his military manner and said, "Yes-sir-eee, by all means."[6]

Not everyone at the school was as enthusiastic about an African American getting such an opportunity. Dwight's time at the flight school was not pleasant, as he was frequently harassed, given the silent treatment, or personally insulted. Colonel Yeager was especially unreceptive to Captain Dwight's presence and didn't feel he was as qualified as the other candidates. In a direct confrontation with Dwight, a senior officer demanded:

> Who got you into this school? Was it the NAACP (National Association for the Advancement of Colored People) or some kind of Black Muslim out here to make trouble? Why in the Hell would a colored guy want to go into space anyway? As far as I'm concerned there'll never be one to do it. And if it was left to me, you guys wouldn't even get a chance to wear an Air Force uniform![7]

This kind of institutional and personal racism remains as gut wrenching now as it was then.

In October 1963, a month before President John F. Kennedy was assassinated, Dwight graduated from the school. However, with Kennedy's death, the captain lost his primary sponsor. When the

Edward Dwight had hoped to be the first African American astronaut.
Photo: U.S. Air Force

test pilot school board met to select candidates to proceed on to Phase II training, Dwight's name was not on the list. Disappointed and rejected, he publicly complained about the treatment he had received at the flight school. New President Lyndon B. Johnson did not appreciate Dwight's public criticism. There is some question as to precisely what happened to Dwight's pursuit of his dream, but he was suddenly transferred to an assignment as a liaison with the German test pilot school.

In fall 1965 while on a goodwill tour in Nigeria, astronaut Gordon Cooper was reported to have said, "When we find a woman or Negro with the right qualifications, they'll be selected. Presently, no Negroes or woman have been found to be anywhere near qualified."[8]

Dwight immediately wrote to President Johnson to counter Cooper's assessment. "I take strong issue to Colonel Cooper's implications that the American Negro is so backward and unqualified that he is incapable of performing space functions," argued Dwight. "The facts are that I am fully qualified in all respects to perform space flights."[9]

Dwight's protests were ignored, and by 1966, he was finally tired of all the opposition to his dream. He resigned from the Air Force and retired to Colorado, where he became a successful realtor and renowned sculptor.

While President Johnson had not been a fan of the outspoken Captain Dwight, he did want to see a black man in the astronaut corps and encouraged the Air Force to try again. The opportunity came

through a call for astronauts for the Air Forces Manned Orbiting Laboratory (MOL), a program designed to send two service men to a space station by 1970. In July 1967, Air Force Major Robert Lawrence was selected as a MOL astronaut. He had a PhD and over 2,500 hours of flight time in jets.

Asked in a press conference if his race was a factor, Major Lawrence replied his race was incidental and his choice was "probably a culmination of the great deal of training and help a lot of people put into preparing me for this. I feel it is an expression of success that they should enjoy rather than I." He also felt his selection was not a tremendous step forward, "just another thing we look forward to in civil rights, part of a normal progression."[10]

Tragically, in December 1967, Major Lawrence perished in an F-104 Starfighter flight while in the backseat as the instructor pilot for a trainee. He was instantly killed when the jet crashed. He became the ninth astronaut to die on the ground. With Major Lawrence's death, it would take another 11 years before an African American would see the inside of a spaceship.

The MOL program was cancelled in 1969, but a few of the military astronauts were able to transfer over and become NASA Astronauts.

The Bright Stuff

The first guys to break the test pilot's glass ceiling in the astronaut office were scientists.

Scientific investigations have historically been an important component of government-sponsored exploration activities. In the 1803 charter that President Thomas Jefferson presented to Lewis and Clark, he instructed them to record scientific information on celestial observations, the soil, mineral production, volcanic activity, and climate.

For the 1939 to 1941 United States Antarctic Service Expedition, President Franklin Roosevelt included objectives to conduct science

observations related to seismology, cosmic rays, biology, tide forces, magnetics, and physiology, as well as the establishment of two bases.

The advancement of science was listed as a major purpose of the U.S. space program when NASA was conceived. It seemed natural to assume that scientists would personally participate in missions of exploration. The previously mentioned International Geophysical Year was all about conducting science in space. As long as test pilots had the monopoly on astronaut slots, it was unlikely that working scientists would get a chance to explore in space.

Despite this history of science objectives for exploration, professional scientists were concerned over how little interest or respect Mercury astronauts had shown in conducting experiments on their missions. The astronauts felt such activities were the cause of problems associated with Scott Carpenter's Aurora 7 flight. In their view, too many experiments were crammed into the mission, taking time from Carpenter's piloting duties.

Science writer Earl Ubell was an early proponent of actually adding a professional scientist to missions. In an article for the *Los Angeles Times*, Ubell pointed out, "In the future, men traveling to the Moon and Mars will be invaluable adjuncts to instrumentation. A single hard rock geologist on the Moon, such as Nobel Prize winner Dr. Harold Urey, would be the most powerful instrument you could send there."[11]

In summer 1962, the National Academy of Sciences (NAS) convened a group of 100-plus scientists for a summer study at the State University of Iowa. Their task was to review the role professional scientists could contribute to human space missions. Their *Review of Space Research* offered an endorsement of human space flight, which was important because up to that point, the science community wasn't thrilled to see the large budget for the Apollo Program compared to a lower-level of funding for science research. As part of that endorsement, however, the report included the ob-

servation that a trained scientist would bring the ability and motivation to gather important information on missions and respond to unexpected situations or unanticipated phenomena. They believed an alert and knowledgeable scientist on the crew could make the difference between success and failure of experiments being conducted on a mission.[12]

The NAS Report recommended the establishment of four categories of scientists and their role in space missions:

- Ground Scientist—Develops experiments and "directs a *remote assistant*" (astronaut)
- Astronaut Observer—Conducts experiments until a Scientist Passenger can be trained and will assist the Ground Scientist
- Science Passenger—An established scientist who will perform experiments of his own or of others
- Scientist Astronaut—Combined qualifications of an experienced scientist and of an astronaut[13]

The report also put a high priority on establishing an Institute for Advanced Space Study. This entity would support and train scientists to maintain and develop the qualifications necessary to become effective science-astronauts. To accomplish this objective, they recommended the establishment of fellowships, summer programs, and similar mechanisms at all levels of professional development, including college students.

A further recommendation, with little chance of being implemented, called for Apollo missions to include one crewmember selected for their scientific ability. If that suggestion was dead on arrival, imagine the additional request to allow a science-astronaut on the crew of the first lunar landing.

The community of astronomers and geologists believed that a scientist could learn to become an astronaut just as easily as an astronaut could learn to conduct scientific observations. Nonetheless,

the report did recommend that current astronauts be given scientific training appropriate to their collaboration with ground scientists for future missions. Meanwhile, there was no consensus on which scientific discipline should be represented on an Apollo mission.

Speaking in Paris on "Environmental Problems of Man in Space," Dr. W. Randolph Lovelace II (the doctor who filled Jerrie Cobb's head with dreams of becoming an astronaut) endorsed the NAS Study and proclaimed scientists should be able to volunteer for space flight teams. Since it takes four to seven years to earn a PhD in science, Lovelace felt it was too much to expect test pilots to undergo the degree of science training required to perform complex experiments. He also believed the two-man Gemini missions would benefit from having a scientist fly next to a pilot astronaut.[14]

Dr. Homer Newell, NASA's director of Space Science felt scientists should be included in the next group of astronauts: "I have complete and utter conviction that we should take a scientist and make him a flyer rather than the other way around."[15]

NASA Administrator James Webb took a balanced approach to the debate to recruit scientists for flight. In response to the National Academy's Summer Study recommendations, Webb said engineers feel mission success requires test pilot engineers, but scientists want to be included as early as possible: "We will take this into consideration in determining the stage of development in manned space flight at which a science-astronaut will directly participate."[16]

Growing restless with the resistance, the National Academy of Sciences continued to apply political pressure to include scientists in the astronaut corps. To calm the critics, NASA promised to have conversations with the science community to find the earliest practical way to include a scientist on an Apollo mission.[17]

Yet another NAS group weighed in on the issue when its Space Studies Board released their report on "Space Research: Directions

for the Future." The report seconded that earlier Summer Study Report and recommended, "Opportunities be created as early as possible for highly experienced observational scientists to be taken to the Moon, essentially as passengers, in addition to the scientifically trained astronaut."[18]

Discussions between NASA and NAS continued over the next several months, when qualifications and a selection process were developed. In October 1964, NASA officially announced the decision to allow scientists to apply for the Group 4 astronaut selection. This would be the first time that selection criteria would emphasize academic achievement over flight experience. Eligibility was based on research and academic experience with a PhD in science or engineering, or a medical degree.

This breakthrough opportunity drew applications from 909 scientists, including four women. The NAS conducted the preliminary screening and determined 424 candidates met the "minimum qualifications." Of these, only 16 were "highly recommended."

African Americans did no better with the science-astronaut opportunity than they did becoming pilot astronauts. In a *Christian Science Monitor* article, reporter Neal Stanford noted there were no blacks in the first class of science-astronauts. According to Stanford, "NASA, in fact, would like to have a Negro astronaut, but he must come in as either a jet pilot or qualified scientist, and not be slipped in for social or political reasons."[19]

On June 29, 1965, NASA announced the selection of the first six science-astronauts: Dr. Owen K. Garriott, Dr. G. Edwin Gibson, Dr. Duane E. Graveline, Dr. Joseph P. Kerwin, Dr. F. Curtis Michael, and Dr. Harrison H. Schmitt.

The first three groups of astronauts must have just loved this addition to their ranks. Writing years later in *Rolling Stone*, Thomas Wolfe recorded the feelings of the pilot astronauts: "Confronted

The first science-astronauts were announced in 1965. Left to right: Owen K. Garriott, Harrison H. Schmitt, and Edward Gibson, Back row: Frank C. Michael, Duane E. Graveline, and Joseph P. Kerwin.
Photo: NASA

with the fact that there was going to be a new breed called science astronauts. What is this? These guys aren't even Cessna weekenders, the majority of them. The Right Stuff? No Stuff, Baby! It was suddenly like integrating the masonic lodge with black women."[20] Clearly, jet jockeys still felt they were the only ones qualified to escape gravity.

Not all of the earlier astronauts despised the decision to bring in scientists. In his book *Return to Earth*, Dr. Buzz Aldrin admitted the addition of a welcome change in a corps consisting mostly of pilots."[21]

Space Planes and Rocket Ships?

Meanwhile, back on the drawing table, various concepts were under review as the best means to send humans into space. In 1962, NASA and the Air Force established a hypersonic research program for an "Aerospace Plane" with a goal to significantly reduce launch costs. The program's charter was to design a space vehicle that would provide Earth-to-orbit-and-return capability, with a jet craft capable of making a 5,000-mile, unrefueled flight.[22]

At the Douglas Aircraft Company, engineer Phil Bono proposed an alternative idea to lower launch costs. In 1963, he advanced ROMBUS —Reusable Orbital Module-Booster and Utility Shuttle. A single-stage-to-orbit spacecraft, ROMBUS was designed to lift hundreds of tons of cargo and personnel and featured a vertical launch and landing capability. Such a vehicle, Bono predicted, would reduce launch costs for cargo to a bargain rate of $69 per pound.[23]

ROMBUS research led to ICARUS, named not in honor of the legendary figure who flew too close to the sun, but as an acronym for the Inter-Continental Aerospacecraft Range Unlimited System. Precisely because the wings made with feathers and wax led to the death of the mythical Icarus, someone more adept at marketing recommended a name change. Thus, ICARUS became Ithacus, which had nothing to do with either mythology or acronyms.

Ithacus captured the interest of Marine Commandant General Wallace Greene Jr., who had been looking for new methods to deploy his troops overseas. Sending the command "Move Out!" to new heights, the blunt-nose ballistic Ithacus was designed to deposit 1,200 battle-ready Marines anywhere in the world within 45 minutes. A strike force of jarheads could rocket the 5,600 miles from the Cape Canaveral Air Force Station in Florida to the dunes of Northern Africa in 33 minutes. This "Instant Infantry" was a strategic improvement over the normal ten-hour travel time. The Douglas employee newsletter insisted Ithacus was "not a way-out idea"

and could be available "without major scientific breakthroughs" by 1980.[24] The fact that astro-marines would not need to receive special flight training was an especially attractive feature.

Bono believed that technology from Ithacus could also be utilized for a passenger vehicle "which might eventually qualify as conveyances for Sunday sightseers on Space Age trips to Earth orbiting space stations."[25] One such concept proposed in 1964 was the bell-shaped Pegasus spacecraft. This Ithacus progeny was designed to accommodate 260 passengers and their baggage and fly 20 times faster than commercial aircraft of the day. Passengers would enjoy the view from one of four decks, and travel from Los Angeles to Honolulu in 18 minutes, or to Singapore in 39 minutes.[26] Unfortunately, all this talk of space planes and reusable passenger rockets was primarily confined to paper studies and articles in the aerospace trade press. Although Bono's design of a Recoverable Single-Stage Spacecraft Booster did result in a 1967 patent for NASA, the vehicle was never built.[27] All available funding for rocket development was devoted to the Saturn V.

Congressman Olin "Tiger" Teague (D. TX) quickly grasped the impact that reusable launch vehicles could have on launch costs. In a 1966 report on "Future National Space Objectives," Teague recommended the U.S. undertake "immediate planning for a new generation of spacecraft capable of recovery at low cost and which are ground recoverable (as) a requisite to attaining lower total mission cost."[28] Unfortunately, financing schemes to launch a cosmic cavalry or space tourists wouldn't occur until the 1980s and was of little interest to politicians in the 1960s.

How About a Photojournalist Riding Shotgun?

In March 1965, the launch of Gemini 3 became the first American space mission to fly two astronauts in the same capsule. Veteran astronaut Virgil Grissom and space rookie John Young orbited the Earth three times. Since Russian cosmonaut Alexsei Leonov had

recently stepped out of a Voskhod 2 capsule and into the record books with the first spacewalk, the ability for Gemini 3 astronauts to manually control the reentry of their spacecraft provided a much-needed boost to America's space confidence.

Leonov's brief star waltz clearly demonstrated that the U.S. had some catching up to do in the race to the Moon. Since this was obviously going to be a long contest, American space officials wondered whether taxpayers had the endurance to see the program through to the finish line. There were already those in Congress who questioned the sanctity of Kennedy's lunar landing time schedule. Critics of the Apollo program felt that the ten-year challenge had been made somewhat impulsively. What was the rush?

Concern over the growing doubts prompted aerospace companies to look for ways to stimulate and maintain public and congressional interest. The Martin Company, builder of Gemini's Titan rocket booster, submitted an unsolicited proposal to NASA Headquarters filled with ideas to enhance public support and to demonstrate the benefits of space exploration.

One suggestion carried the banner, *The National Geographic Society Space Expedition*. "If one or more Gemini spacecraft is available after the current objectives of the program have been completed," the proposal surmised, "one of these spacecraft could be used to unusual advantage by sending into brief flight, perhaps three orbits, an astronaut and a carefully selected writer/photographer . . . It would strengthen public relations between that program and the people whose taxes make it possible."[29]

The society's extensive involvement in exploration activities, such as expeditions to the North Pole, Antarctica, and Mt. Everest were offered as qualifying experiences. Given their worldwide prestige, tradition of support for exploration and science, and history of co-operation with the government, a Geographic journalist would make the perfect travel companion. Criticizing the shutterbug aptitude of

103

test pilot astronauts, the proposal dared to suggest, "No person untrained in photographic arts could hope to secure the kind of coverage a *National Geographic* specialist would make—indeed, pictures taken heretofore in space have been notably lacking in quality."[30] If engineers could have just put a joystick on that Nikon, I'm sure the astronauts would have taken much better photos.

The pictures in *National Geographic* magazine were famous the world over. They gave us an up-close look of exotic and rarely seen exotic destinations, international cultures, and majestic animals. Imagine the delights a *National Geographic* photojournalist might reveal during a trip around the Earth.

Mind you, up to this point, NASA had only conducted eight missions with astronauts on board. Despite this limited experience, the Martin Company believed a journalist on a flight "would demonstrate to the world that U.S. space flight technology and equipment had become so good that passenger flights are now practical for persons with no special physical or technical training."[31]

The proposal was even so bold as to take a shot at the astronauts for being, well, for being astronauts:

> Public interest and identification would be stimulated to a much greater degree than from previous flights because the passenger would be more like the public—not a highly trained astronaut. People would feel that they were 'getting the straight, unvarnished story' (and) could be made to feel that they are getting more direct personal benefit for their money.[32]

Evidently, the exclusive personal stories in *Life* magazine "as told by" the astronauts were considered to be somewhat varnished.

NASA had received worldwide applause for conducting its space activities in full public view. Therefore, it is curious the Martin proposal suggested the journalist's flight should "be a well-kept secret and announced by the President only a day or two in advance to

take advantage of the greatest amount of publicity."[33] It would have been challenging to conduct a stealthy training program, and it is unclear how keeping the mission secret would have resulted in the most significant amount of publicity.

Given their reaction to flying in tandem with a chimp, you can imagine how NASA officials and the astronauts reacted to the suggestion to put a journalist in the shotgun seat of a Gemini capsule. According to an engineer from the Office of Manned Space Flight, the idea did receive further review, but nothing came of it.[34] The "Citizen in Space" flag was ceremoniously raised, but no one saluted.

Throughout 1964, as NASA caught its breath between Mercury and the preparations for Gemini, no American astronaut ventured into space. This lull in the action didn't stop journalist Gerhard Pistor from popping into a Venice travel agency where he asked to be booked on the next flight to the Moon. The agent accepted a deposit of $20.00 and forwarded Pistor's request to Pan American Airways (Pan Am) and to Russia's national airline, Aeroflot. As a reporter, Pistor knew a good story when he saw one. "I'm naturally interested in space flight," he explained, "and going to the moon as a newsman is a good story—if I was first."[35]

Pistor wasn't the only one who knew a good story when he saw one; Pan Am eagerly embraced his request. They told him to expect to depart on a lunar flight in the year 2000. As the story spread, additional would-be space travelers contacted the airline to book reservations. Applicants were enrolled in the airline's new "First Moon Flights Club," complete with membership cards documenting the individual's rank in the queue.

Aeroflot, on the other hand, thought Pistor must be joking and sent a flip response to the travel agency saying, in effect, "Sorry comrade, but our first flight is already sold out. Maybe you could try for our second flight." [36] They further recommended that Pistor book a room at the Hotel Crater.

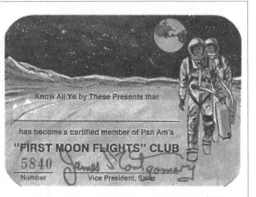

Pan Am makes the going great

★ First in Latin America
 ★ First on the Atlantic
 ★ First on the Pacific
 ★ First 'Round the World

Established in 1968, Pan American Airways' First Moon Flights Club eventually enrolled over 90,000 dreamers. Years later, dozens of the participants submitted their membership cards for a ride on the space shuttle.
Photo: Pan American Airways

When you think about it, Pistor had the right idea to book his reservation through a travel agent. He assumed it would most likely be commercial airlines, not some government agency that would provide the transportation service to make his dream come true.

Morris Furgash, president of the U.S. Freight Company, affirmed this assumption in a 1965 speech at the National Defense Transportation Association conference in Frankfurt, Germany. With the theme, "Transportation in the Year 2000," Furgash told his audience, "Transportation is the servant of the people—the genie which makes their dreams come true, the magic carpet of their future— the mobility of their dreams, their aspirations, and their resources." [37] And all this for a deposit of just $20.00!

Twenty-Twenty Hindsight—Reusable Rockets

In fall 1965, the Peenemunde alumni league was actively promoting their vision for space. Dr. von Braun was back in the news with another preview of coming attractions. In an interview with the *Chicago Tribune*, he predicted, "Space projects of the future will naturally be based on the extension of today's technology," such as the Saturn 1B and Saturn V chemical rockets.[38]

Chemical rockets, however, would not provide cheap seats to the stars. "As long as expendable launch vehicles are used to honor

round-trip tickets for passenger transport," von Braun believed, "customers in the ticket line face a $5 million fare for Earth-to-orbit flights and a $50 to $100 million figure for a lunar trip in the early to mid-1970s." Even at these prices, he cautioned we shouldn't "expect to open the first commercial space line to Earth orbit until 1985 or later."[39]

As other engineers like Phil Bono had predicted, it would take reusable vehicles to turn the business of space travel into a successful economic endeavor. Von Braun saw the answer in the development of a high performance, two-stage rocket plane called the Reusable Orbital Transport (ROT): "Passenger conveniences must be improved so that scientists, engineers, technicians, military personnel —even politicians and journalists—can make the trip."[40] What self-respecting politician would sign up for a junket on a contraption with the acronym ROT? What if something went wrong on the mission? Think of the headlines: "U.S. Senator Left ROTting in Space!"

Chemical engines would power ROT's first stage, a rocket plane, to orbit, at which point a nuclear-powered spaceship would kick in and ferry the passengers the rest of the way to the lunar surface. The nuclear system would reduce a lunar round-trip passenger ticket to $3 million. If rocket propellants were manufactured from lunar resources, the ticket price would drop to less than $1 million. Von Braun believed that after the Apollo program ended, a reusable transportation system should be developed. Such rockets would then enable "the invasion of the main body of man's true assault on space. Pilots and passengers, scientists trained as observers and experimenters, will follow in wave after wave to explore space in a big way."[41] Now you're talking!

At this time, Dr. Krafft Ehricke was developing space visions for the General Dynamics Corporation. Shortly after the von Braun interview in the *Chicago Tribune*, Ehricke delivered a speech up the road at Evanston College. He predicted several possibilities for the 1980s and '90s, including a human-tended space station to handle

the world's communication needs and orbiting information centers to supply doctors with information on any subject, regardless of how distant they were from the source of material on Earth. Ehricke also saw the healthcare field moving into space with "orbiting hospitals or lunar hospitals to relieve persons suffering from certain ailments by providing gravityless or low gravity conditions."[42] This notion wasn't all that unusual. For years, a number of aerospace medical researchers had been studying the feasibility of such health applications.

That autumn, Dr. Walter Dornberger also peered into his crystal ball. You will recall it was Dornberger, who with Ehricke, had proposed the BOMI (a piloted space bomber) project in the early '50s. Throughout his career Dr. Dornberger continued to promote the benefits of reusable spacecraft. On the eve of his retirement as vice president of Bell Aerospace, the former head of German rocket development insisted, "The more problems we experience in launching of the big, one-way boosters, the more the economy of space exploration will be investigated."[43] He believed America's space effort had erred in relying solely on the Saturn V rocket and our strategy was seriously flawed if we really wanted to see wide-scale development and activity in space.

"We must," admonished Dornberger, "use a completely different approach. We must get away from this launching from pads, which costs millions and billions of dollars, to the more conventional way of taking off from a runway." In what proved to be a painfully accurate prophecy, he concluded, "After we have gone to the Moon we will start over again. Project Apollo cannot be turned back, but the next time we must create an environment in space that can be used by men, not only for research but for commercial and military purposes."[44]

In his judgment, this environment would be created with the construction of a space station, resupplied by a space shuttle. Dornberger

argued, "If we had invested only a small part of the energies and funds expended on ballistic booster development into the space plane as a space transporter, we would not be heading down one of the most expensive dead-end roads . . . and would be much better prepared for the future."[45] But then, General Dornberger had been on the losing side of the World War II. What did he know?

True Grit

Surprisingly, while visionaries were predicting physical therapy flights to the Moon, the novelty of NASA's Gemini flights began to wear thin with the public. After a sparsely attended parade in Washington, DC for Gemini 5 astronauts Pete Conrad and Gordon Cooper, the *Washington Evening Star* observed, "We think it is an encouraging trend. Just possibly the lack of hoopla and gapers suggests that America has accepted the space program as serious business instead of a circus of stunt men."[46] Or maybe it was just a crummy day to go to a parade.

While the novelty may have diminished, the risks of space flight certainly hadn't. Each mission pushed systems and capabilities to new limits. Thankfully, the Gemini program did not experience repeats of rockets exploding into fireballs on the launch pad as had occurred in the pre-Mercury days. Still, the astronauts were given plenty of opportunities to demonstrate their skill and courage, proving human spaceflight was a risky business.

Some of the white-knuckle events are better known than others. On the second Mercury flight, Gus Grissom struggled with his ship in the famous blown-hatch incident that sunk his capsule. Mission controllers had held their breath when John Glenn reentered the atmosphere with a heart-pounding heat shield predicament during the first orbital flight. Due to a computer malfunction, James McDivitt and Edward White had to rely on instructions from Mission Control to safely guide the reentry of Gemini 4.

During an extremely dicey situation on Gemini 6, Wally Schirra and Tom Stafford kept their cool when their Titan booster shut down 1.2 seconds after ignition. Instead of hitting the escape button, they spent 90 minutes on top of the fully fueled missile and calmly went through their closeout checklist. Stafford believed had they elected to eject, he and Schirra would have become the first astronaut fatalities.[47] The activation of the escape system would have probably ignited the 100% oxygen environment in the capsule and consumed the astronauts in a fireball. Because of their decision to stay put, the ground crew was able to correct the problem, and a few days later, Gemini 6 was able to complete an orbital rendezvous with the Gemini 7 astronauts who had been standing by in orbit.

Neil Armstrong and David Scott had their chance to demonstrate true grit on Gemini 8. After successfully demonstrating the ability to dock with another space vehicle, the combined spacecraft began to spin and tumble uncontrollably. Unable to stabilize the Gemini capsule, Armstrong fired Gemini's thrusters to decouple the two spacecraft. Once separated, the Gemini capsule continued to tumble, but the crew showed no signs of panic. In a casual manner, Armstrong informed Mission Control, "Well, we consider the problem serious. We are toppling end-over-end . . . We cannot turn anything off."[48] After eight minutes, he was able to tame the beast. Though the mission had to be curtailed, Bronco Neil's pilot skills averted an in-orbit disaster.

As a result of these kinds of super-human reactions, the astronaut corps was now seen as the last bastion of hope for a new and improved Earthling. Impressed with the heroics of the Gemini 8 episode, *The Washington Post* editorial gushed:

> On the crowded globe beneath the soaring astronauts, men were still fighting each other, cursing each other, starving each other and maltreating each other . . . But hope soars aloft with the astronauts. The creatures who can do this, the beings who can

defy gravity, disregard distance, conquer space, circumnavigate the planet and mingle with the stars, may yet make the larger conquests of mind and spirit that are necessary if human beings are to live together in peace.[49]

Well, they left out the part about being able to "leap tall buildings in a single bound," but you get the picture.

The heroics and skills of the astronauts had saved numerous missions from catastrophe, but those in the business knew an accident in space was well within the realm of statistical probability. Industry experts believed that Soviet cosmonauts had died in unannounced space-related accidents and American astronauts had perished in related accidents during training on the ground. The 1966 edition of *Old Moore's Almanac* predicted that America's first space disaster would occur in 1967.[50] It is doubtful that anyone paid much attention to old Mr. Moore.

Way, Way Out

In March 1966, while astronauts Armstrong and Scott performed their impression of a pair of socks tumbling in the dryer, space advocates gathered in Washington, DC for the 4th Goddard Memorial Symposium. To this day, the conference and an accompanying black-tie dinner (known as the Space Prom), serves as the High Holy Day for those who practice the religion of space. With the theme, "Space Age in the Fiscal Year 2001," the 1966 symposium featured high hopes for space farers of the future.

In one of the symposium sessions, Wesley Kuhrt of United Aircraft Laboratories predicted interplanetary tours taking off early in the 21st century. According to Kuhrt, "A six-day round trip to the Moon via a 35-passenger, nuclear-powered 'clipper ship' would cost each adventurer $10,000. For an 18-month trip to Venus, the passenger would pay $35,000. But for $70,000 a passenger could ride the Mars Express to and from the red planet in 11 months."[51] Little wonders that civilians believed they might soon get a chance to obtain orbit.

Down the hall in another session, Detroit neurologist Dr. Lorne Proctor embraced the frequent comparisons between astronauts and Superman. By the year 2001, Dr. Proctor believed we could choose from astronauts "made to order." He foresaw "the coming of teams of superhuman astronauts, bred over several generations as a result of present studies in genetics and molecular biology." [52] Talk about space spinoffs. Imagine how some mad scientist could apply that little bit of genetic engineering.

Later that year, 20th Century Fox released *Way, Way Out*, a Jerry Lewis/Connie Stevens film about men and women on the Moon. "It all began in 1989," blared an advertisement, "when America and Russia sent men and women to live on the Moon!"[53]

On the same day the ad ran, Dr. Jesse Greenstein told a group of scientists the dream people have to live elsewhere in space was also way, way out. Speaking at a conference on "Science, Progress and Human Values," the professor diminished "the dreams of eventual space travel" as pure fantasy. According to Greenstein, "We cannot physically travel to explore stars in hope of finding habitable worlds. The stars that might support life are too far away."[54]

The race to the Moon was in danger of being overshadowed by the war in Vietnam. The turmoil of war, however, did not stop NASA. With the completion of the Gemini missions in November 1966, astronauts had demonstrated the ability to conduct space walks, rendezvous and dock with other vehicles, land at precise locations, and work for extended periods with no ill effects in micro-gravity. As attention turned to the first flight of the Apollo program, aerospace officials began to appreciate the degree of commitment a truly long-range space program would require.

Writing in *Astronautics And Aeronautics* magazine, Solomon Golomb addressed the subject from a historical perspective: "The Manhattan Project established that we could run a program for three years and two billion dollars . . . Apollo escalated the level to ten years

and $30 billion. The next major goal will be the establishment of permanent colonies on other planets. This may mean a commitment of 50 to 90 years and a price tag measured in Terrabucks.[55] Exactly how many zeroes do you suppose are in a Terrabuck?

Terrabucks—Schmerabucks! Frequent human space flight and NASA critic William Hines felt it was high time to reevaluate the objectives of the entire national space program. Writing in the *Washington Evening Star*, Hines cautioned:

> The apparent inactivity in the Soviet manned space program might reflect growing dismay over the tremendously high cost of astronautics where men are involved. The Russians may feel they have better things to do with their money, just as the U. S. would have if the Kennedy 'Moon message' had not been hung like an albatross around the national neck as a commitment involving American prestige before the world.[56]

President Kennedy's concerns about the escalating costs of the Moon challenge were not discussed until much later.

Accepting Disaster—Long Live the Dream!

On the morning of January 27, 1967, the "high cost of astronautics" took on new meaning. Veteran astronauts Gus Grissom and Ed White, along with rookie Roger Chaffee, perished in a flash-fire during a dress rehearsal for the first Apollo mission. The tragedy provided a jolting reminder that human space exploration was still a treacherous endeavor.

The fact that the accident occurred during a ground test seemed to be most surprising. The *Washington Star* noted, "There is bitter irony in the fact that the first disaster in our space program came during a simulated launch."[57] Administrator James Webb also was taken aback by the deaths during a ground test. Speaking to the press, Webb admitted, "We've always known that something like this would happen sooner or later, but it's not going to be permitted to stop the program . . . Although everyone realized that some day

space pilots would die, who would have thought the first tragedy would be on the ground?"[58]

In his own book, Gus Grissom confirmed this assessment of the "nature of test pilots to accept disaster," when he offered what became an eerie epitaph: "If we die, we want people to accept it." Grissom advised, "We are in a risky business and we hope that if anything happens to us, it will not delay the program. The conquest of space is worth the risk of life."[59]

The Apollo 1 fire caused heartbreaking soul searching among NASA's civil servants and contractors alike. Protocols were reviewed and modified, and safety became an all-consuming concern. While all of this caused delays to the Apollo program, the conquest of space continued. Fewer than ten days after the accident, NASA launched the unmanned Lunar Orbiter 3 mission to the Moon. Over the next ten months, 22 space science satellites were dispatched to orbit on a mix of Scout, Delta, and Centaur rockets. In November 1967, an unmanned Apollo Command/Service Module was launched on the first Saturn V rocket test. With continued due diligence, space officials believed it was still possible to achieve the hallowed goal to land on the Moon by the end of the decade.

Though tragic, the accident did little to diminish the optimism of space dreamers. A promotion sponsored by the Variety Travel Service in Brooklyn caught the attention of the *World Tribune Journal*. A sign in the agency's window proclaimed: "Reservations to the Moon Being Accepted Here NOW!" Sixty people left their $10.00 deposit with the agency.

Variety's President, George Hattem, said this trip wasn't like those expensive private charter flights to the Moon we had been reading about. He figured the estimated $25,000 to $50,000 ticket price for those flights was too expensive for the people in his neighborhood. His sights were set on sending one or two passengers in a seat next to the Apollo astronauts as "a kind of Civilian Review Board." After

an investigation by the Better Business Bureau, Hattem's customers were advised "to hold on to their $10 deposits . . . and keep the money in their own bank accounts where it will collect interest."[60]

Just four months after the Apollo 1 fire, Krafft Ehricke reminded his fellow members of the American Astronautical Society of the lure space had for the non-technical disciplines. In his speech on "Space Tourism," Ehricke referred to the broad public appeal of space. "The primary attractions which lie in the nature of space and in the lure of other worlds do not only affect engineers, scientists, and astronauts," observed Ehricke. "The space program had a deeper purpose than to watch astronauts in orbit."[61] For him, the deeper purpose would be realized when a broad swath of humanity was living and working in space.

Following Ehricke's presentation, lodging magnate Barron Hilton vowed when these children of the universe embarked on their vacations, they could count on staying in one of his hotels: "I firmly believe that we are going to have Hiltons in outer space, perhaps soon enough for me to officiate at the formal opening . . . There will be travelers in outer space; and where there are travelers, there must be Hiltons!" He envisioned a resort complex with one hundred guest rooms, nuclear powered kitchens and freeze-dried dining, wall-to-wall televisions, ceiling-high windows overlooking Earth, and of, course, a cocktail lounge. As Hilton reminded conference delegates, "If you think we're not going to have a cocktail lounge, you don't know Hilton—or travelers. Enter the Galaxy Lounge. Enjoy a martini and see the stars."[62]

Hilton was even willing to embroider another name on the guest towels. He foresaw the merits of striking a cooperative deal with an aerospace company to build and operate a space resort. Since the Douglas Aircraft Company had expressed an interest in the idea of a space station, why not "franchise the Hilton name and know-how to set up a chain of Hilton-Douglas orbiter hotels."[63]

Dr. Eugene Konecci thought orbiting hotels would be great for people in need of certain medical procedures. NASA's former Director of Biotechnology, Dr. Konecci, predicted heart patients and burn-victims would benefit from treatment in the gravity-free, germ-free wards of space hospitals. He also envisioned a day when "executives and other people (would) leave their terrestrial jobs for their annual physical and rest in space."[64]

NASA's head of human space flight, George Mueller, also thought a trip into space would do the body good. Speaking at a meeting of the British Interplanetary Society, Mueller felt, "Lack of gravity lightens the load on the heart and certain other organs, so an orbiting resort might also be a health spa. The $1,500 round-trip ticket might not be too costly for these benefits."[65]

Let's hope national health insurance will cover all these types of procedures and allow for preexisting conditions.

Welcome! Now Get Lost

A second opportunity for scientists to apply to the astronaut corps took place in August 1967 with the Group 6 solicitation. As reported in the Christian Science Monitor, "Scientists compete more intently for the few science-astronaut jobs open than do the jet pilots in the military services for the pilots' jobs. The glamour has not entirely gone out of space flying. What has happened is that its perils have become more apparent, its scientific opportunities more exciting, and its financial rewards less considerable."[66]

Chief Astronaut Deke Slayton was instructed to hire up to 30 new scientist-astronauts. However, because there was already a surplus of space men, he didn't intend to let any of them fly. For the Group 6 selection, NASA found that only 11 of the 923 applicants were qualified and hired all of them, including three physicians, three astronomers, two physicists, two engineers, and one chemist. When the scientists reported for training in Houston, Slayton told them they

were hired only because the government forced NASA to do so.

He further welcomed them with the warning: "We don't have a job for you, not any of you." Even before they had a chance to try on a flight suit, Slayton offered to accept their resignations and promised they would only be given ground assignments if they did not quit. Slayton warned them not to fool themselves into thinking they would ever fly in space. The shocked scientists named themselves the "XS-11" or "Excess Eleven." [67] At least they had a sense of humor.

Space Odysseys

In spring 1968, space enthusiasts were all abuzz over the movie *2001: A Space Odyssey*. Based on a novel by science fiction guru Arthur C. Clarke, the film depicted a time when orbiting hotels and space clipper ships were the norm. At a press conference prior to the film's release, Clarke predicted, just as with aviation, space travel costs would decrease as the technology improved. The development of a reusable spacecraft, the capability to refuel in orbit, and advancements in nuclear propulsion would make routine journeys to the Moon "comparable in cost to that of global jet transport today."[68]

The movie was an instant success and delivered yet another blast of inspiration for all space traveler hopefuls. Film critics praised the dazzling special effects and the cosmic meaning of the Monolith. Space daydreamers could not help but focus on the routineness of it all: a space plane sporting the Pan Am logo, a double-decked space station with a Hilton hotel, and two-way picture phones to reach out and touch someone on Earth. The haunting mutiny of the all-knowing computer HAL didn't faze the dreamers.

Before everyone got carried away with the thought of 100 astronauts working in a space station or with the notion of stealing souvenir ashtrays from Hilton's Galaxy Lounge, there was the matter of landing men on the Moon. Twenty-one months after the Apollo 1 fire, the launch of Apollo 7, featuring a test of the Command Module,

put the country back on track towards the landing goal. It was the launch of Apollo 8 two months later, however, that really captured the public's attention.

From a vantage point 200,000 miles away in lunar orbit, the Apollo 8 crew sent back stunning images of Earth. The sight moved astronaut Frank Borman to describe the planet as a "grand oasis in the great vastness of space."[69] Pretty poetic—for a test pilot.

The International Flat Earth Society was unimpressed with the Apollo-eye view of Earth. According to Society Secretary Samuel Shenton, the photos may have shown a circular planet, but that didn't prove it was a globe.[70]

For President Lyndon B. Johnson, Apollo 8 provided a special sense of satisfaction. In his last month in office, the president recounted the expectations and dreams that he and others had when NASA was created back in 1958. In a congratulatory phone call, a sincere LBJ told the Apollo 8 crew, "You have made us to feel akin to those Europeans nearly five centuries ago who heard the stories of the New World for the first time."[71]

Like those Europeans, a growing number of would-be space travelers were anxious to go and see the current New World for the first time. According to an article in *This Week* magazine, over 2,000 hopefuls had written to Pan Am and TWA seeking rides to the Moon. According to Pan Am, the ticket price had yet to be determined, but "It will undoubtedly be an expensive trip. When we finally start to ask the passengers for money, a lot of them will probably drop off the list."[72]

A lot of them may also have dropped off the list had they been aware of the in-flight experience of Apollo 8 Commander Frank Borman. About 28 hours into the mission, flight surgeon Charles Berry and Commander Borman had this little exchange: "Frank, this is Chuck. The story we got from the tape and from Jim (Lovell) a while ago

was at some point ten to eleven hours ago, you had a loose BM, you vomited twice, you had a headache, you've had some chills, and they thought you had a fever. Is that an affirm?"[73] Other than that, Commander, how about that view?

The Greater Cocoa Chamber of Commerce also jumped on the Moon flight reservations gimmick. Located in the backyard of NASA's departure pads, the Cocoa Beach business community wanted to reward all those cash-carrying tourists who had been coming to town. The Chamber distributed certificates to tourists that read, "This is to certify that we have made reservations for (name) on the first outer space satellite to be launched from this area soon."

On a variation of the theme, a Cocoa radio station initiated a contest that asked people to state in 25 words or less the first words the astronauts would speak upon landing on the Moon. Those contestants who came closest would be issued tickets for a Moon flight of their own. Elizabeth Zarder, a teenager from Port St. Lucie, was one of the winners who received a claim ticket issued by Trans World Airline (TWA) for a seat on its "Moon Charter Series, departures: to be announced."[74] Too bad TWA went out of business.

Earth-bound entrepreneurs were also anxious to go to the Moon and set up shop. Convinced lunar colonization was just around the corner, a London businessman delivered a proposal to the American and Russian embassies. Tom Barker, a bingo hall operator, requested permission to open the first amusement hall on the Moon. It's not known what the Soviets told Mr. Barker, but the Americans told him they had no plans for lunar settlements. He was informed there were many factors that would inhibit large-scale lunar development, not to mention bingo parlors.[75]

Another of Her Majesty's subjects had a similar idea for a space entertainment enterprise. Shawbury Innkeeper Jack Warner asked

the U.S. government to grant him a license for the first pub on the Moon. Patrons, he promised, could look forward to tipping a pint and playing darts in his Lunatic Tavern.[76] It looked like Barron Hilton's Galaxy Lounge was already getting a competitor.

Moondance

Even before the first Apollo lunar landing, NASA was already looking to the future. There were robust plans on the drawing board for human-tended space stations and space ships to shuttle astronauts to and from orbit.

To excite the space faithful, *Aviation Week & Space Technology* confirmed that NASA was zeroing in on a new space station design as the next national challenge: "All previous concepts have been retired from active competition in favor of . . . a 100-man Earth-orbiting station with a multiplicity of capabilities and the launch of the first module with as many as 12 men by 1975. Top NASA officials were reported to have rejected earlier space station plans as too conservative."[77]

On June 24, 1969, just 23-days before the much-anticipated lunar launch, Wernher von Braun visited the 3,000 year-old temple of Apollo at Delphi, Greece. After consulting the Oracle, von Braun declared, "I am convinced that we will succeed because no other space operation was ever so well prepared in advance." Although he was probably hoping for a sign from the ancients that everything was proceeding according to a universal grand plan, he admitted that the "Oracle was ambiguous, as usual."[78]

The Oracle may have been ambiguous, but on July 20, 1969, fifty years after Robert Goddard theorized about the possibility of flights to the Moon, two Americans placed their footprints on its surface. The world rejoiced when Neil Armstrong and Buzz Aldrin dipped their toes into the Sea of Tranquility. President Kennedy's challenge had been achieved.

When Armstrong took his first step onto the lunar surface at 9:56 PM CST, I heard the news on a car radio in the parking lot of Aurora East High School in Illinois. Sitting with me was Miss SIU Montie Whitten and her chaperone. I had been in charge of publicity for the Miss SIU contest and had driven us up from Carbondale to Aurora for the Miss Illinois pageant. We pulled into the lot about ten minutes before Armstrong began his historic ascent, so we stayed in the car transfixed while waiting to hear the first words to be uttered from the Moon. Little did I know at that time that just five months later I would be recruited for a career dedicated to space exploration. When Armstrong finally spoke, goose bumps were bouncing around the inside of the car.

At the time of the landing, Richard Nixon had been president for only seven months. He could hardly be called a card-carrying member of the space society, but to the chagrin of Democrats, he basked in the national outpouring of emotion and international goodwill generated by Apollo's success. In congratulating the astronauts upon their return, Nixon proclaimed, "This is the *greatest week in the history of the world since creation!*"[79]

With a slightly different slant on the beginning of things, at a pre-launch press conference, Wernher von Braun declared the event to be "equal in importance to that moment in evolution when aquatic life came crawling up on the land."[80] To writer Norman Mailer, the landing showed, "A bureaucracy had embarked on a surrealistic adventure."[81]

For space advocates, it didn't matter if the Moon landing was equated with the creation or with evolution, but they reveled in the "surrealistic adventure." In a post-Apollo 11 speech at the National Press Club, NASA Administrator Thomas Paine proclaimed, "The great contribution of our generation of astronauts is blazing of trails for all future generations of men who want to . . . conquer new worlds . . . and extend itself through the solar system."[82]

121

Arthur C. Clarke again expressed his belief that the technology and experience from Apollo would lead to lower excursion fares for passengers. In a special edition of *Look* magazine, Clarke said the reason the current cost of space travel was in the millions was "the measure of our present ignorance and the primitive state of space technology . . . The time will come when the cost of a lunar journey may be comparable to that of round-the-world jet flights today."[83] It would be just our luck if we had to book a flight a month in advance, depart on a Tuesday, some restrictions would apply, we'd be stuck with a middle seat, and our luggage would be lost as we headed for Mars.

Clarke's prediction of bargain fares was welcome news to members of Pan Am's Moon Flights Club. The success of Apollo 11 had created a brisk business for Pan Am ticket agents. By now, the airline had adopted the slogan, "Who's the airline with a waiting list to the Moon?" The Flights Club's membership had grown to 30,000. "The starting date of service," the travelers were notified, "is not yet known." In a caveat that was certain to add years to the wait, Pan Am cautioned, "Equipment and route will, probably, be subject to government approvals."[84]

Trans World Airlines' waiting list contained a mere 6,200 names, but they did get a jump on the competition by filing with the Civil Aeronautics Board for Earth-Moon-Earth flight routes. During the final four days of the Apollo 11 mission, another 1,200 applications were dumped on the desks at TWA.[85]

As a sidebar to an Apollo 11 story, the *New York News* reached out to the Hayden Planetarium to track down a few of those dreamers who had filled out applications for the Interplanetary Tours stunt back in 1950. "No can do," reporter Linda Scarbrough was told; it seems the museum had lost track of the forms. According to box office manager Joseph Connors, "The last anyone remembers about the reservations is that they were put in a metal box and

stored in the basement."[86] During a renovation project, the box was misplaced. No wonder NASA had never contacted Elsie Sherwood or Angus Chassells to fly on an Apollo mission!

Let's See ... What on Earth Might a Geologist Do on the Moon?

While they may have finally joined the astronaut corps, the demands from the science-astronauts to be included on future Apollo missions were completely ignored. The recommendation from the National Academy of Sciences to include a geologist on the first Apollo landing had been given zero consideration.

In late summer of 1969, the confetti and streamers celebrating the Apollo 11 triumph had barely been swept up when *The New York Times* reported on a controversy over the future of science-astronauts. Who should be sent on future missions? Who should control the astronaut's schedule? Should the U.S. now proceed with an unmanned program or a crash program to put astronauts on Mars? The paper reported, "The fact that it is the scientists who have been resigning while the test pilots receive public acclaim makes it evident where the balance of power lies. But the issue is far from settled . . . It would not be surprising . . . if NASA sought to ease scientists' irritation by satisfying so many of their demands."[87]

In an August 1969 article, *The Washington Post* reported that except for Harrison Schmitt, every science-astronaut had been removed from the lunar landing training list. NASA officials denied this and said the other scientists had been assigned to train for the proposed long-duration, Earth-orbiting Apollo Application missions.[88]

Another article in *The Washington Post* further focused on the limited abilities a non-geologist would be able to add to science discoveries on the Moon. In their view:

> The Apollo 12 crew had successfully executed everything they had to do. But it was apparent that they were frustrated in their science objectives, even though they had many hours training in

geology. For the most part the ground looked the same to them. Most of the rocks looked the same. That is the classic lament of an inexperienced geologist when he goes into unfamiliar terrain for the first time.[89]

Meanwhile, *Science* magazine reported NASA's neglect of science research goals in favor of engineering had caused dissatisfaction in the science community. They noted scientist-astronauts complained they were not encouraged to keep up to date on their science research, causing three to resign.[90]

The prospects for science-astronaut flight got even grimmer when Congress put an end to blank checks for the Apollo Program and decided to cancel three Apollo missions: 18, 19, and 20. This caused dissatisfaction among all the astronauts, and five resigned following the Apollo 11 mission. Deke Slayton did not discourage the resignations: "The fact is, we don't need them."[91]

It wasn't until Apollo 17, the last lunar flight, that scientist Harrison Schmitt was finally named to a mission. His assignment was not without controversy, as Schmitt bumped former X-15 pilot Joe Engle from the crew. A *Washington Star* editorial observed:

> The argument for the scientist-astronaut has come . . . It always made sense . . . any congratulations to NASA for finally putting a geologist on board might be accompanied by a raised eyebrow over the obvious tokenism . . . Why they waited so long to put a scientist into the richest geological treasure house has yet to be discovered.[92]

On December 14, 1972, Schmitt and mission Commander Gene Cernan were the last astronauts to walk on the Moon.

The previously mentioned Apollo Applications Project evolved into the Skylab Program, America's first orbiting space station. During 1973, three crews visited Skylab, with one scientist on each mission. All three had been selected in the first science-astronaut selection process in 1965. They had waited eight years to fly.

We're Going to New Worlds

During a post-flight appearance at Marquette University, student protestors greeted the Apollo 11 crew with a barrage of tomatoes.[93] The students believed the space program was a waste of money and wanted the astronauts to know the funds could be better applied to more important social and urban problems.

In New York City, a new citizens space advocacy group disagreed with the Marquette students. Inspired and full of optimism following the success of the first Moon landing, the Committee for the Future (CFF) believed pressing social and urban problems and the goals of the space program did not have to be mutually exclusive. With its philosophical roots anchored to the writings of New York artist Earl Hubbard and his wife, Barbara Marx Hubbard, CFF felt the drama of space exploration was just the tonic for a new, improved planet Earth.

In his 1969 book, *The Search is On*, Earl Hubbard reasoned, "We must conceive of making Earth *both* a beautiful place to live *and* a point of departure . . . The frontier of urban evolution is the frontier of Mankind in the universe. We must relate urban renewal to the transcendence of Mankind or it will not work . . ."[94]

Arguing for an expanded program of space exploration, Hubbard believed, "Man's task is to remove this species from a provincial, gravity-bound point of origin into the vast arena of abundant life that the universe represents. Of course, the species will be transformed. This is to be expected and hoped for. This is what we are seeking." [95]

With these beliefs as a base, the Hubbards sought out like-minded citizens. They found a soul mate in a soon-to-be-retired Air Force Colonel John Whiteside, who, along with Barbara Hubbard, became the organizing directors of CFF. Colonel Whiteside, who had coordinated media coverage for the Mercury flights at Cape Canaveral, believed the public's natural enthusiasm for the nation's space activities could be tapped as a political force.

The daughter of toy magnate Louis Marx, Ms. Hubbard provided contacts and seed money for CFF's activities. She blossomed into an eloquent speaker who captivated audiences (this author among them) with her dream of a better world to be realized through the challenge of space exploration.

Colonel Whiteside was the father of college friends of mine at Southern Illinois University. I met him during Christmas break 1969 when I went to visit his daughter Linda and son John on my first trip to New York City. When he picked me up at the airport, the Colonel chirped: "Hi, we're going to New Worlds." That introduction changed my life. I was immediately drafted to become a student leader for the work of the committee.

The overarching goals of the CFF were similar to those espoused in Krafft Ehricke's "Extraterrestrial Imperative."[96] In the Imperative's tenets, Dr. Ehricke shared his view that space exploration was not some discretionary jobs program for a handful of aerospace engineers, astrophysicists, or lunar seismologists. He believed humanity needed to expand and transcend the limits of the planet. The resources of space could be used to create an Earth-Space system to secure a long and positive future for humanity.

The committee picked up on this theme and shared Dr. Ehricke's belief that we all had a stake in humanity's inevitable evolution into the universe. Sending a few astronauts to the Moon was indeed just a small step. CFF believed the real purpose of the space program was to send civilization outward and up the evolutionary spiral where an expanded consciousness would create New Worlds in Space and New Worlds on Earth.

5 OUR SHIP IS IN

Although the concept of such a space transportation capability is not new, advances in rocket technology . . . now permit the initiation of an experimental effort for a Space Transportation System . . . a chemically fueled reusable space tug or vehicle for moving men and equipment to different earth orbits.

> The Post-Apollo Space Program: Directions
> for the Future

I have decided today that the United States should proceed at once with the development of an entirely new type of space transportation system designed to help transform the space frontier of the 1970s into familiar territory, easily accessible for human endeavor in the 1980s and 90s.

> President Richard Nixon, Weekly Compilation
> of Presidential Documents

The similarities between the Air Age when men had begun flying and the Space Age were striking. Aviators had been considered stuntmen until they began to carry the mail. The Apollo flights with their vaguely circus air had struck many people the same way. The Space Shuttle promised to change all that.

> Tom O'Toole, *The Washington Post*

Encore! Encore!

With the completion in November 1969 of Apollo 12, the second Moon landing, NASA began to look to the future. Where should it go next? When it came to deciding the agency's future plans, the previous administrator, James Webb, had been a man of caution. In his opinion, the president should enunciate post-Apollo goals, not the space agency.

On the other hand, the new administrator, Thomas Paine, believed NASA ought to aggressively advocate for bold initiatives for the future. Paine was an active and vocal member of the recently formed President's Space Task Group. Chaired by Vice President Spiro Agnew, the group was formed to study future directions for the post-Apollo era.

A robust agenda was developed, complete with space shuttles, space stations (in both Earth and lunar orbit), a lunar base, and human flights to Mars in the 1980s as "the next logical step" towards our destiny in space.[1] The majority of the public and the political leadership, however, turned a deaf ear on these fanciful and expensive initiatives.

The military-industrial coalition had been knee-deep in the lengthy Vietnam War. That conflict had drained the nation's spirit, not to mention the treasury, and contributed to the anti-technology mood that swept the country. This did not seem to be the appropriate time to ask tax payers to shell out billions and billions for new spaceships, space stations, lunar outposts, or missions to plant flags in the red sands of Mars.

Nonetheless, NASA needed another major national goal to keep its enormous organizational engines running. NASA was responsible for the salaries of over 20,000 in-house, civil service employees and more than 200,000 contractors spread across every state. The agency concluded that if they were to sustain momentum for human space flight, they best go all-in with the most modest and least expensive element of the future options recommended by Space Task Group—the space shuttle.

Since the early 1950s, totally reusable transportation systems had been promoted as the answer to both reduced launch costs and routine access to orbit. From these proposals emerged various concepts for space shuttles, so named because it was intended to "shuttle" crewmembers to and from orbit. With the capability to

carry cargo and deploy satellites, the shuttle was also seen as a substitute for expendable launch vehicles.

While it would initially ferry astronauts, we hoped it might also be available to those who had been waiting in line for the Hayden's Interplanetary Tours or to members of the Pan Am Moon Flights Club.

An article in *Air Force and Space Digest* described the space shuttle as the key to providing economic access to the new frontier "much as the railroads opened a stream of travel into the American West." Space engineers claimed that the new vehicle would usher in the day when astronauts would be as numerous as commercial jet pilots. Flights into space would take off daily, and "virtually any young man who yearns to voyage into space will be able to do so at some point in his life."[2]

NASA's Chief of Manned Space Flight, George Mueller, looked forward to the shuttle's economic benefits. His stump speech routinely told audiences, "To achieve the desired economy, it will be necessary to operate this transportation system in the successful jet transport mode. Our space shuttle will probably take off from major airports with little or no noise."[3]

Mueller believed that economic considerations also dictated that cost per pound had to be reduced to $50 and eventually to $5. He was convinced that the new launch technology would make a positive contribution to the nation's balance of payments: "With a price of perhaps $50 million each, a number of nations could afford to purchase these space shuttles to carry out their own activities in space."[4]

Such a declaration surely aroused space dreamers in America. At the $5 per pound prediction, a 180-pound passenger might fly for $10,000! Mueller's comment that "a number of nations could afford to purchase these shuttles," ignited dreams of people around the world![5]

Even the normally reticent Neil Armstrong seemed optimistic about the future of space travel for the masses. Asked at a press conference on the first anniversary of the Apollo 11 lunar landing if he expected to fly in space again, Armstrong replied, "I'd be surprised if I don't have the option of buying a ticket."[6]

The Astronomical Cost of Astronautics

When Eugene Cernan and science-astronaut Harrison Schmitt returned from the Moon in December 1972, the Apollo Program came to a close. Components and systems from Apollo were incorporated into the three Skylab space station missions between 1973 and 1974. Hardware also made its way into the successful Apollo-Soyuz mission in 1975 that brought America and Russia together for a joint mission and a celebrated astronaut-cosmonaut handshake in space.

NASA continued to work on designs for a new, fully reusable spaceship. At budget hearings in 1970, Dale Myers, who replaced George Mueller as head of the Office of Manned Space Flight, continued to extoll the virtues of the space shuttle and stoked the fire of our dream. At a congressional budget hearing, he promised the Shuttle Era would bring new opportunities to broaden the kinds of people who would be able to experience space travel: "We can carry to the space station people who are not trained as astronauts," Myers told the legislators. "We can carry chemists, metallurgists, physicians, astronomers, photographers—and I have added, since yesterday, Congressmen and Congresswomen."[7] Hey, if members of Congress were going to fly on junkets to orbit, surely flight opportunities for voters wouldn't be far behind.

Space advocates began to refer to the shuttle as a New Age Prairie Schooner and the key to the next industrial revolution. From the beginning, shuttle proponents were exceedingly optimistic about its prospects for economic payback. Who needed expendable vehicles when the space shuttle would launch payloads so much

cheaper? We could save a lot of money by phasing out the expensive expendable rockets like Delta, Titan, and Atlas.

Commenting on shuttle economics in the trade magazine *Aerospace*, Senator Howard Cannon (D. NV) "Hoped that the space shuttle can reduce the present cost of $1,000 or more to put a pound of payload into orbit to only $100—there are some estimates that the per-pound cost may go as low as $50."[8]

In a subsequent issue of *Aerospace*, Texas Congressman Olin Teague pointed out in addition to launching each vehicle *100* times, the shuttle system would save money in other areas such as recovery operations. When the shuttle came back to Earth, it would land on a runway, thus eliminating the need for the multi-ship navy to recover the spacecraft at sea upon reentry. The orbiter's wide cargo bay would allow commercial and military satellites to be bigger and heavier, "permitting designers to use off-the shelf equipment."[9] In the same article, a NASA official proclaimed they would be able to "put the satellites together like an alarm clock rather than a Swiss watch."[10]

Congressman Teague was also impressed with the "anticipated shuttle economies based on a mission model that assumes shuttle usage on 580 missions over a 12-year period . . . an average of 48 flights annually." This flight rate "may even be conservative, because of the potentially greater opportunities for deriving concrete benefit from space operations and because of the likelihood of increased foreign use of U.S. launch services with the shuttle's lower costs."[11] If you combined all these factors—the reusable delivery system, reusable payload, satellite design flexibility, landing operations, and reduced risks—the savings would average more than a $1 billion per year compared to the Saturn V.

Shuttle opponents felt the cost savings estimates were extremely optimistic. After NASA had guaranteed the bargain basement rate

of $100 per pound to a Senate budget committee, physicist Ralph Lapp recommended a complete review of the proposed launch vehicle cost model. According to Lapp's analysis, costs for launching shuttle payloads would be "ten times more expensive than their weight in gold." For the 1979-90 timeframe, he believed a more realistic cost would be $5,100 per pound.[12] As we will see, even Lapp's estimate proved to be quite optimistic.

Despite the discrepancies in economic analysis, with the new spaceship, dreamers were convinced their ship had come in.

In a 1971 interview describing expected features of the shuttle, Alan Shepard evidently mentioned private citizens might fly when the shuttle moved from the test phase to operational flights.

Television personality Hugh Downs leaped at this prediction. A reporter for NBC, Downs wrote to NASA and volunteered for a ride. [13] Acting NASA Administrator George Low replied, "I sincerely hope that the day when it will be possible for a journalist to go along on a shuttle mission as an observer is not too far off. If and when that time comes, your interest and request to be a passenger will be considered." Dr. Low clarified that the "operational flights" mentioned by Alan Shepard would not occur until the early 1980s.[14]

Before anyone could look forward to flights either for tests or operations, NASA needed to gain approval from the Nixon Administration to move from paper studies to the actual development phase. The Defense Department, which initially offered lukewarm support to this civilian undertaking, became a reluctant advocate. All NASA had to do was let military engineers dictate certain design specifications.

For months, NASA officials struggled with personnel from the Office of Management and Budget (OMB) over costs and development schedules. The budget office even tried to get into the business of spacecraft design and instructed NASA to determine the savings that might result from their technical suggestions. Gone was the hope for

a totally reusable system. The new NASA Administrator, Dr. James C. Fletcher, had little patience for OMB's forays into engineering design and took his case directly to President Richard Nixon.

On January 5, 1972, while at the San Clemente-White House, President Nixon announced the long sought "Go" decision. In his proclamation, Nixon stated the development of a space transportation system would "transform the space frontier into familiar territory, easily accessible for human endeavor." Space engineers had convinced him that the true benefits from exploration could not be realized "as long as every trip from Earth to orbit remains a matter of special effort or staggering expense . . . (The shuttle) will take the astronomical costs out of astronautics."[15]

The part of the space shuttle system that really caught our attention was that gleaming white orbiter. This was what we had been waiting for—our covered wagon to the new frontier. Nurturing the seed of the dream that had been planted decades earlier through the visions of Tsiolkovsky, Goddard, and Oberth, President Nixon promised the shuttle would "give more people access to the liberating perspectives of space."[16]

George Low, then deputy administrator, documented the exchange he and Dr. Fletcher had with Nixon on the day the shuttle decision was announced: "The President liked the fact that ordinary people would be able to fly in the Shuttle, and that the only requirement for a flight would be that there is a mission to be performed." Dr. Low's Memorandum for Record further mentioned that although Nixon understood the reasons, he had been disappointed foreign astronauts had not flown on Apollo missions. In the future, the president wanted NASA "to stress opportunities for international cooperation and participation for *all* nations." According to Low, Nixon "understood that foreign astronauts of all nations could fly on the shuttle and appeared to be particularly interested in Eastern Europe participation."[17]

On January 5, 1972, President Richard M. Nixon gave NASA the go ahead to build the Space Transportation System. Pictured here is NASA Administrator James C. Fletcher with the President.
Photo: NASA

The media's reaction to Nixon's shuttle initiative was generally enthusiastic. Based on so many positive reviews, it was easy to imagine our dream was not such a fantasy after all. An editorial in the *St. Louis Globe Democrat* rejoiced, "There is no doubt that if it is completed, space travel for the average citizen may become a distinct possibility in the 1990s."[18] The *Milwaukee Journal* believed, "The shuttle offers the opportunity to make space flight fairly routine, of taking large numbers of people and supplies in and out of space."[19]

High hopes for the new space transportation system spread like an epidemic through the space community. Shuttle capabilities were routinely described in the most robust of terms. In talking with *U.S. News and World Report*, Dr. Fletcher speculated, "Maybe we'll have an every-Monday-morning flight out to space. When we can get into space cheaply, easily, quickly, and routinely, this will open new ventures at present not predictable."[20]

Wernher von Braun, now in charge of long-range planning at NASA Headquarters, was hopeful he might actually have a chance to fulfill his own dream to fly. He assured the *Washington Daily News*, "By the time the first passenger shuttle flies I'll be 68. I think flying into space in a shuttle will be just like being a passenger in an airliner—only smoother."[21]

In a cheery note the previous year to his friend Dr. Mahinder Uberoi, von Braun promised, "I have made reservations for you and me (sic) on a space shuttle departing in 1979. Please put it on your calendar."[22] In a separate interview with the *Washington Evening Star*, von Braun predicted a 50-man U.S. Research Station on the Moon towards the end of the 1970s, and astronauts would "have to stay there at least eight or ten days."[23]

Curiously, towards the end of 1972, von Braun sang a slightly different tune. In *The Goddard Bibliography Log*, he predicted, "I can foresee increasing traffic between Earth and the Moon both for science, utilization, and sight-seeing purposes, probably not in my day, but certainly after the turn of the century."[24]

Although a shuttle ride was expected to be smooth, there was plenty of turbulence from its critics. Minnesota Senator Walter Mondale (D. MN) was especially outspoken against NASA's new spaceship. Raising the either/or argument that is frequently and mindlessly applied to the space program even today, Mondale wondered how the administration could "squander $6.5 billion to fly four people into orbit when it refuses to invest less than one-third that amount to provide desperately needed day care for millions of children."[25]

Chicago Sun Times correspondent William Hines, a frequent critic of NASA, was equally unimpressed with NASA's latest undertaking: "What the President offered . . . was not a completely reusable workhorse aerospace plane at all, but a scaled-down hodgepodge of obsolete, current and avant-garde technology that cannot pos-

sibly meet the stated goal of $100-a-pound payloads in 1980 . . . The sad truth is that the original shuttle couldn't either."[26]

Space advocates felt especially betrayed when former science-astronaut candidate Brian O'Leary defected to the opposition with a commentary in *The New York Times* which he attacked the shuttle as so much "pie in the sky." O'Leary complained:

> The enormous expense, the high risk, the much ballyhooed and grossly exaggerated claims about the pertinence of manned flights to the quality of life on Earth are creating an ever-widening credibility gap between the public interest and a vested interest inherited from the space of the 1960s. The result is the squandering of public funds.[27]

To add insult to injury, O'Leary further recommended that the space shuttle development be postponed in favor of spacecraft dedicated to space science and applications.

Shine on Harvest Moon

For the card-carrying members of Pan American Airlines' First Moon Flights Club, Nixon's blessing of the shuttle fleet came at a fortuitous time. The airline had closed out its reservation list in the spring of 1971, and membership cards were no longer issued. Even though the promised lunar flights would probably not take off until after the year 2000, the Club's 93,000 cardholders were not discouraged. The waiting list included citizens of every state and over 90 foreign countries.

While the Club was originally established to promote lunar excursions, the coming era of space shuttles prompted the company to shift its sights toward the potential of suborbital and hypersonic flights. In an Associated Press story, a Pan Am executive indicated that they would be watching the development of the shuttle even more closely than the Apollo missions: "The possibility of a rocket flying 6,000 miles an hour is being given more serious attention than lunar flights."[28]

The application of shuttle technology for civilian passenger vehicles appealed to other aviation officials as well. Just two years after membership in the Moon Club was halted, Najeeb Halaby, the chairman of the Federal Aviation Administration, addressed the Society of Experimental Test Pilots. Halaby optimistically proclaimed, "The impossible dream we insist on dreaming is of the space shuttle as an air transport, carrying passengers from New York to Tokyo in 45 minutes . . . The key is reduction of the cost per pound of payload . . . There is no reason why shuttle operations should not become as low or lower than that of jets."[29]

A space ride consisting of a few laps around the global gym might fulfill the aspirations of some of the gravity haters in the audience. For others, a 45-minute, sub-orbital flight to Tokyo just to have some extra time to shop along the Ginza was not really what the impossible dream was all about. The dream to fly in space reflected a higher calling.

This higher calling of space was the subject of "New Worlds Week," a national conference I chaired in the spring 1972 for the Committee for the Future (CFF). Held on the campus of Southern Illinois University (SIU), the conference examined how the space program could serve as a catalyst for individuals to take more responsibility for the planet and solve earthly problems through a universal perspective.

"Limits to Growth," a report released earlier that year by MIT, described a global society in decline, running on empty. Rather than timidly accepting the prophesies of gloom and doom outlined in the MIT report, CFF believed that the resources of space could provide an open-loop system of Earth-Space opportunities and unlimited growth.

The conference attracted an eclectic supporting cast of speakers and participants from across the country representing numerous disciplines. The delegates represented NASA and other govern-

ment agencies, aerospace corporations, environmentalists, research scientists, parapsychologists, media representatives, trade associations, futurists, diplomats, the entertainment industry, artists, philosophers, students and seekers of truth. One of my favorite participants was Gene Roddenberry, creator of the television series *Star Trek*. He made a big hit with the other attendees when he treated everyone to a special showing of the outtakes/blooper reel from the series.

To facilitate conference discussions, SIU design students built a 100-foot diameter wheel with six sections and removable walls. There was even a special place outside the wheel for those who dabbled in the field of "non-verified phenomena," where the psychics, parapsychologists, and artists could challenge the status quo. A unique aspect of the conference was the extensive use of an interactive video system. Designed by fellow student Robert K. Weiss, the system featured the live recording of the discussions taking place in each section of the wheel. The content was shared within different sections of the wheel in real-time and was also incorporated into a nightly news show for delegates.

Those attending the conference came together to look to the stars and create a future of unlimited possibilities. At the same time, a large number of students looked to Southeast Asia and demonstrated against the Vietnam war.

One proposal that received a good deal of attention at the conference was "Project Harvest Moon," an international citizens' mission targeted for launch as early as 1976. This private expedition, billed as a "Citizens Mission to the Moon," was designed to establish a small lunar station—complete with an observatory, optical data relay experiments, remote geography investigations, and a closed-loop ecological experiment. Revenues would be generated from the mining of lunar rocks brought back to Earth for commercial sale.

To conduct this mission, CFF wanted the government to donate surplus Apollo hardware, including a surplus Saturn V launch vehicle and Apollo capsule that had been slated for a lunar landing before the program was cancelled. Other countries would be invited to contribute additional hardware, and citizens from non-space faring nations would be able to participate through public subscription. This rather ambitious proposal managed to elicit moral support from a few congressmen. Representative Olin Teague introduced legislation asking NASA to reserve a Saturn vehicle, a Command Module, and a Lunar Lander as well as to provide technical advice on the feasibility of a transnational Moon mission.[30]

After "New Worlds Week," Mr. Teague accompanied Colonel Whiteside and Barbara Hubbard to a meeting at NASA Headquarters with Dale Myers and Rocco Petrone, the director of Apollo. According to CFF documents, "Petrone stated that Harvest Moon was possible, but too dangerous."[31]

This prompted Colonel Whiteside to come up with an alternative proposal called Mankind I. Instead of sending people to the Moon, Mankind I involved an orbiting space station similar to Skylab and "would be a cultural mission expressing the unity of mankind," and demonstrate global systems that could benefit all people.[32]

NASA, space professionals, and the media ridiculed both Harvest Moon and Mankind I. The concepts were perceived as (and I suppose were) naïve. A true visionary, however, might have admired this early stab at space commercialization for its chutzpah alone.

Princeton University's Gerard O'Neill was also discontented with simple trips around the Earth. In the early 1970s, he introduced a concept of space colonies, self-contained cities located at stable "libration points" between the Moon and Earth. Colony designers promised that a 1.5-kilometer-wide wheel-shaped "city in space" could be built "with available technology" for $100 billion.[33]

Up to that point, we hadn't seemed to be getting any closer to the space colonies predicted by Konstantin Tsiolkovsky back in 1903, but O'Neill's vision attracted considerable attention. For those who felt Wernher von Braun's earlier idea for a 50-person space station was overly ambitious, they must have felt Dr. O'Neill was suffering from the after effects of an acid trip when he said his colonies would support a population of 10,000.

Whereas Hubbard and Whiteside of the CFF were criticized for lacking the technical expertise to back their vision for New Worlds, Dr. O'Neill was a certified professor of physics. Over the course of several years, he and Princeton graduate students carefully laid the engineering groundwork for his theories. The plan, which relied on the space shuttle to deliver people and cargo to orbit, calculated that one colony could be constructed within 15 to 20 years. Since transporting all the necessary cargo from Earth would add tremendous costs to the project, they proposed using building materials manufactured from lunar resources and exported to the orbiting construction site.

Former NASA Administrator Thomas Paine became an ardent supporter of O'Neill and his goal for human migration into space. Asked what the future of space would bring, Paine predicted:

> By the end of this century men and women will be living and working in extraterrestrial space stations and in small colonies on the Moon. The first few will have reached Mars. By then the first children will be adapting themselves to new worlds. A new sociology of extraterrestrial societies will evolve . . . in novel environments beyond Earth.[34]

Although Paine's aggressive and robust post-Apollo recommendations met caustic opposition, he had not lost his zest for bold space initiatives.

Our Ship is In

Since the facilities of the Air Force Eastern Test Range and Cape Kennedy (later renamed the Kennedy Space Center) had been the launch site of choice throughout Mercury, Gemini, and Apollo, one would have thought NASA would automatically retain the spaceport for the upcoming space shuttle missions as your future point of departure. However, the agency determined the Cape lacked a suitable landing strip, processing facilities, and a few other "shuttle unique characteristics."[35] Given these operational character flaws, NASA decided that other locations needed to be considered. Over a half billion dollars' worth of new construction contracts was at stake.

Alternative launch sites included the Flight Research Center in the Mohave Desert of California (which in 1976 was renamed the Dryden Flight Research Center and renamed again in 2014 as the Armstrong Flight Research Center), the White Sands Missile Range in New Mexico, and Utah's Dugway Proving Grounds.

Governor Dewey Bartlett thought the spaceport should be located on the sweeping plains of Oklahoma. The governor told the state legislature, "Based on the launch azimuth and the orbital inclinations . . . Oklahoma provided both a desirable launch and recovery location."[36] I suppose the astronauts would arrive at the launch pad in "The Surrey with the Fringe on Top." No doubt the surrey would be shiny and little.

The *Wall Street Journal* chided politicians for "squabbling" over the location of the launch site: "There's a lot to be learned from the space shuttle, we have no doubt. The scientific results will be greatest, though, if NASA manages to locate the project where it can be managed most efficiently—and not merely where local Congressmen are most adept at gathering spoils."[37]

In April 1972, NASA put an end to the squabble and announced the Kennedy Space Center (KSC) and the Vandenberg Air Force Base (VAFB) in California as the ports of call for shuttle launches. The VAFB site was to be phased in towards the end of the decade and be used for flights requiring high-inclination and polar orbits.[38] The Greater Cocoa Beach Chamber of Commerce breathed a collective sigh of relief.

While a launch site was selected and public enthusiasm for mass migrations to celestial condominiums grew, flight opportunities for NASA astronauts were actually scarce. Four months after the San Clemente shuttle directive, Astronaut Chief Deke Slayton again griped that he had "three times as many people as needed." In the view of the Mercury-era veteran, "It's just a fact of life . . . we have only one Apollo, three Skylab and (the Apollo-Soyuz) flights ahead of us"[39] With fewer mission opportunities and budget cuts, reductions to the astronaut corps were inevitable.

According to one endangered space pilot, "Slayton really feels that he doesn't need any more than fifteen men" for the upcoming missions and shuttle preparation.[40] On top of that, experts predicted the coming age of space shuttles would require a new kind of space explorer.[41] The diminishing flight opportunities did little for the morale of the league of super heroes; veterans and rookies alike began to head for the nearest exit.

As if scarce flight opportunities weren't bad enough, it turned out the life of an astronaut was not all glamour and fame. The intolerable pressures on their personal life were described in the "Women's World" section of the *Washington Evening Star*. Such pressures were inherent in the astronaut job description:

> The intensive training, the danger (eight had died in accidents), the brutal competition for mission assignments and the hot glare of public scrutiny, creates a pressure-cooker existence for space frontiersmen. When astronauts were held hostage to the

heavy work and travel schedule, their wives had to learn to cope on their own. Mrs. Astronaut had to learn to get along without them—especially when the lawn needs mowing or there's trouble with the plumbing.[42]

Later that year, *The New York Times Magazine* also examined the changing image of astronauts. Many of the men who had left the corps went on to successful business and government careers: "But in the behavior of others there is more than a touch of the eccentric, and a large dose of trouble, almost a mythological element: the wandering hero back among his tribe, after stealing the sacred fire and grappling with terrifying demons."[43]

Given the expected shift in emphasis of future space missions, the article postulated that Apollo-era astronauts might be an endangered species: "The hotshot pilot seems destined to be replaced in the space stations of the near-future with scientists given training of shorter duration for their flight duties."[44]

Since 1959, 73 astronauts had been selected, but by the end of 1972, only 39 of our "wandering heroes" continued to wear the blue astronaut jump suit. Their uniforms made for nice portraits, but most of them were all dressed up with no place to go.

The Presidential Silence Was Deafening

It was one thing to have received permission to proceed towards the new Space Transportation System; it was quite another to move from the drawing boards to the launch pad. Both Congress and OMB kept a close eye on escalating development costs.

Presidential leadership would have been most helpful in the critical opening rounds of the shuttle's development, but Richard Nixon was unavailable. Rather than lead the charge into the new frontier, the president was focused on more pressing foreign policy issues. First came his historic visit to China, then a strategic arms summit meeting in the U.S.S.R. with Secretary Lenoid Brezhnev. In May,

these dramatic breakthroughs were muted when the public protested his approval of the massive bombings of the city of Hanoi in Vietnam. But the event that dominated the president's time and energy for the next two years occurred in the summer of 1972, when five men were apprehended during a "third-rate burglary" that became known as Watergate.

After Nixon was forced to resign and Gerald Ford replaced him in August 1974, there was hope that presidential leadership would return to the space arena. Whereas Nixon had been highly inaccessible, Dr. Fletcher reported that he had no problems at all in reaching President Ford.[45] Unfortunately, while Ford seemed to be more favorably disposed towards the space program, his tenure in the Oval Office was too brief to make a significant impact on Congress.

Almost from the beginning, Congress failed to provide the necessary base of stable funding so critical for a project of the scope and complexity of the shuttle. Rather than draw a line in the sand, NASA officials continually redesigned the blueprints to match the latest budget appropriation. Within this environment of instability, it was inevitable that the projected 1978 inaugural launch date was "pushed to the right."

In the absence of presidential leadership, skeptical members of Congress were anxious to fill the political and rhetorical vacuum. In particular, Senator William Proxmire (D. WI) let it be known he had little use for NASA's new spaceship. Over the years, NASA was a frequent recipient of the "Golden Fleece Award," Proxmire's personal publicity machine to highlight programs he deemed unworthy of taxpayer support. In March 1975, citing a General Accounting Office Report, he postulated the entire space shuttle program "might be on the verge of a financial breakdown." Convinced cost overruns would be the only thing going into orbit any time soon, the Senator encouraged his colleagues to consider "cheaper launch alternatives."[46]

Shuttle E-R-A

In a January 1970 issue of *UNESCO* magazine, Russian space veteran Valentina Tereshkova-Nikolayava spoke up for sisterhood in space. "A woman can stand all the conditions of space flight as well as a man," claimed the first woman to have been there.[47] Her flight proved that women could endure the isolation and weightlessness of space just as well as men, and in fact, could adapt more quickly. Takeoff and landing, however, "should be timed to consider a woman's menstrual cycle."[48] (The mind races with opportunities for marketing tie-ins for women's hygiene products.)

Tereshkova-Nikolayava evidently stood alone among fellow cosmonauts in her overall assessment. Ten months later during a ten-day American tour, her husband Andrian Nikolayev and Vitaly Sevastyanov told reporters that the training program for females had been disbanded.[49] Rumor had it that Valentina had panicked during her flight and endangered the mission.

In January 1972, the unrequited Jerrie Cobb was back in the headlines. After her dream back in 1961 to fly a Mercury capsule and the X-15 had been thwarted, she retreated to South America to fly humanitarian supply missions in the Amazon Basin. She made news in December 1971 for a dramatic, 15-day search of the Peruvian jungles for the 92 victims of a plane crash. Cobb rescued the sole woman survivor and flew her to a nearby mission.

In commenting on the rescue, Reuters news service reminded readers (incorrectly) that Cobb had been the "No. 1 choice to be the first woman to fly an Apollo mission until the space program was cut back and it became clear that no woman would be selected by NASA."[50] At least some progress had been made in the women's movement, as the article focused entirely on the daring-do of the rescue mission and never once mentioned her measurements.

The press may have finally managed to write stories about women

without revealing their chest size, but the Federal Government was still stuck in the dark ages. In a 1972 report, "Human Factors in Long-Duration Spaceflight," the Space Studies Board of the National Academy of Sciences admitted that sooner or later, a woman would squeeze into a space suit:

> Admission of women to the space crew at this time would undoubtedly create serious problems in the masculine world of space operations. However, broad trends in the 1960s toward increased penetration of masculine occupations and roles by women may accelerate in the 1970s to a degree that research oriented toward operations in the 1980s might well include an objective review of the merits of female participation.[51]

MS magazine thought the boys over at NASA could benefit from a gender sensitivity training session or two. An article relating the attempted Mercury coup by Jerrie Cobb, Jane Hart, and the rest of those FLATS terrorists, made NASA's Director of Life Science Dr. Charles Berry look a tad chauvinistic.

Feminist Joan McCullough quoted remarks made by Dr. Berry at the 20th Congress of the International Academy of Aviation and Space Medicine (IAASM). Berry had told the audience:

> For long duration flights such as Mars, the crews would be confined inside their spacecraft for nearly a year. With so much time on their hands . . . they'd want sexual diversion. It is therefore unrealistic to plan future flights without coming to grips with the problem of women. Naturally, the women would be fully operational crewmembers . . . not only there for sex.[52]

Naturally.

Although *MS* ridiculed Dr. Berry's consciousness and his inability "to come to grips with the problem of women," his attitude didn't seem to have ruffled too many feathers among the space medicine men. At the IAASM conference the following year, Berry was elected president of the academy.

Apollo astronaut Walter Cunningham, who left the corps in 1971, would have been another nominee for the *MS* hit list. In his memoir, *The All-American Boys*, Cunningham complained that although "astronettes" might be able to perform many tasks in space as well as men, it would "cost more, create new risks, and further complicate the operation." Social pressures would force us to fly a woman "long before the time is right."[53] To his way of thinking, that was no way to operate the American space program: "To those . . . who bought the tickets and took the rides in the first ten years of the manned space program, it never occurred that it had to be *socially* relevant."[54]

Women must have gone ballistic when they read Cunningham's vision of long-duration co-ed space flights. While he expected all crewmembers for such missions to be qualified in special areas of science, honesty compelled him to point out:

> The most eminent women scientists are not renowned for their *Playboy* centerfold bodies or their sophisticated views on sex . . . the beginnings of a conflict basic to human experience. After a year in space, your average male astronaut could fall in love with an avocado. But the idea of being used, or even thought of, in romantic ways is frequently unacceptable to the liberated woman's view of equality.[55]

In the meantime, back in the U.S.S.R., comrade Tereshkova-Nikolayava still hadn't gotten the maleman's message. Touring India in January 1973, she told the press she was preparing for another space mission: "I am working for it and am keen on it because it is my work, but no date has been fixed for it yet."[56] Former cosmonaut General Gregory Beregovoy was not amused when he learned of her meditations in India. Director of the Center for Cosmonaut Training, the general told the Polish newspaper *Express Wiexzerny*, "We train only young men, not women."[57] So much for Clare Booth Luce's infatuation with communism's "inherent equality of men and women."[58]

147

Once again Tereshkova-Nikolayava couldn't even count on her husband, Andrian Nikolayev, for support. A few years later, he told *Parade* magazine that the Soviets had quit training females because "We love our women very much, and we spare them as much as possible. In the future they will surely work in space stations, but as specialists." A true cosmonaut had "to be a pilot, a commander, an engineer, and a scientist."[59] And it seemed, a man.

The dream of American women in space finally started to be taken seriously in 1973 as a result of research at NASA's Ames Research Center in California. Dr. Harold Sandler, of the Biomedical Research Division, undertook a study with a dozen female volunteers to determine whether there were any physical or psychological reasons why women shouldn't be considered for space flight. Dr. Sandler concluded, when you get right down to it, women might be *better* suited to weightlessness than space men. Just as Dr. Randy Lovelace had discovered over a decade earlier, the female test subjects experienced no show-stopping physical or psychological problems.[60]

In a weightlessness environment with its equalizing effect on the gender, brute strength was not required for the majority of work in space. Indeed, women proved to be superior when it came to performing delicate movements. And by the way, if you consider that it cost thousands of dollars per pound to put something into orbit, those "little ladies" offered a substantial economic benefit over their heftier brothers.[61]

Dr. David Winter, who had replaced Dr. Berry as NASA's director of Life Sciences, saw "no barrier whatever to healthy women being among the scientists who will carry out investigations on shuttle missions."[62] In Dr. Winter's view:

> Because our objective for shuttle missions is to get the best qualified scientists, it is impossible to predict what size, shape, age, or sex, these scientists might be. The purpose of the shuttle is

to permit anyone with a legitimate need to go into space; there-
fore, NASA's approach will be to broaden the selection criteria as
much as possible.[63]

NASA finally offered equal rights to women in 1976 when it an-
nounced, "1,000 scientists, engineers and technicians may have
the opportunity" to fly on the shuttle during the decades of the
eighties.[64] You would no longer be required to sport a crew cut and
possess a penis to pass through the gates of gravity; women would
be welcomed. No doubt, the female dreamers on the list for Pan
Am's Moon Flights Club were shouting, "It's about friggin' time!"

6 NEW KIDS ON THE BLOCK

*The great pioneers of spaceflight wanted to perfect the spaceship so
we could go to the planets, plant outposts and even colonies, and
perhaps explore the stars. The promise of space has not been fulfilled,
and at the close of the second decade of the Space Age, we do not yet
know if it ever will.*

William Bainbridge, *The Space Flight Revolution*

*It is pathetic that the public desire for drama in outer space has not
been killed by the mundane discoveries on Mars, Venus, and the Moon
. . . Nothing will happen with the real life Enterprise, even though the
naming confirmed a public desire to associate space with adventure
and suspense.*

Editorial, *Washington Star*

*The space adventure of our age cannot be the jealously protected
preserve of astrophysics, brilliant engineers and brave astronauts, it
must also be the concern of people with ordinary social and artistic
vision and the program we are considering could be a splendid step in
realization of that broader participation.*

James Michener, Letter to NASA

An Experiment Which Failed

Looking forward to the day when a variety of sizes, shapes, and
genders would go aloft on the space shuttle, NASA began brief-
ing its endless number of advisory committees around town. These
bodies of wise men were either sanctioned by NASA or by external
organizations, primarily the National Academy of Sciences (NAS).
They were intended to provide an unbiased sanity check on the
agency's proposed plans and programs. The stamp of approval

from one of these committees went a long way in shoring up the necessary political and public support necessary to sustain NASA's programs.

In early 1975, space shuttle managers met with the Aeronautics and Space Engineering Board (ASEB). A committee of the NAS, the board members were briefed on activities that NASA planned to conduct on the shuttle's six Orbital Flight Tests. In follow up discussions with Deputy Administrator Dr. George Low, the board felt none of the planned activities was especially exciting or useful. They recommended that something more dramatic be included by the fourth test flight.

Both Administrator James Fletcher and Low were "intrigued by this suggestion."[1] Dr. Low instructed shuttle manager John Yardley to "convene a small group of the most innovative people in NASA to come up with one or more ideas for a relatively inexpensive, dramatic, and useful payload for an early shuttle flight."[2]

Yardley, the associate administrator for Space Flight, agreed that they "should be more imaginative" in demonstrating the shuttle's capabilities. However, he cautioned that they should "remain realistic in thinking about the complexity of payload activities" that might be attempted during the flight tests.[3] For many engineers, an Orbital Test Flight should remain exactly that—a test of the flight characteristics of the unproved vehicle. Demonstrations of "something more dramatic" should be left for operational missions.

Phil Culbertson, Yardley's director of advanced planning, was instructed to set up a group to brainstorm new ideas. When the assignment was completed the following spring, the group had examined 45 "shuttle unique" demonstration projects. Ideas that were discussed but would *not* be seen on a flight test included: capturing and repairing/returning an American Explorer-class or Soviet Cosmos-class satellite (with U.S.S.R. permission, one assumes); allowing

political figures to name flights; deploying a radio telescope for the Search for Extraterrestrial Intelligence; demonstrating diffusion rates and atmospheric effects from controlled external explosions; conducting high resolution imagining of Earth (for fear it might ruffle military feathers); or flying a non-astronaut. Suggestions for tether demonstrations and search and rescue activities also failed to make the cut.[4]

Only seven ideas were "recommended for further study." One suggestion was to send the shuttle for a visit to the still-orbiting Skylab space station. The success of the high school student experiment program conducted on the Skylab prompted the idea for a similar contest on the shuttle. A multi-spectral imager could be flown to help Federal regulators locate oil spills or to help farmers detect corn blight. Another project involved ozone analysis, and if you could come up with a scientifically valid reason, a gas cloud released from the cargo bay would provide Earthlings with one heck of a spectacular display. Ham radio operators around the globe could be invited to tune-in for star-side chats with the astronauts. Finally, the list proposed deployment and performance analysis of a large structure for solar power satellite application.[5]

Culbertson felt this list represented a virtual smorgasbord of significant demonstrations of the shuttle's unique capabilities. Upper management, however, was not impressed. In a March 24, 1976 memo titled "An Experiment Which Failed," Low informed Fletcher that "not many exciting things" had come from the first brainstorming effort, and he had instructed Culbertson to try again. For the next go-around, Low suggested that "some less inhibited outsiders" be added to the group. Additionally, Culbertson was to consider two of Dr. Low's pet projects.[6]

Low's first project involved a demonstration of the often-promised benefit of manufacturing drugs in space. He wanted to investigate the feasibility of an electrophoresis experiment, which would produce

"enough urokinase (an enzyme to dissolve blood clots) to save a million lives."[7] A related memo revealed that Low hoped "to get a headline on the first Shuttle flight . . . as a result of (this) medical happening."[8]

Low's second idea, to fly a non-astronaut, had been discussed during the first brainstorming session of the task force but hadn't made the "further study" list. Culbertson was instructed to explore the possibility of "flying Philippe Cousteau on an early Shuttle flight and letting him document on film what he sees."[9] The oceanography television specials produced by Cousteau and his famous father Jacques had impressed NASA officials. Perhaps the Cousteaus could work their magic from the ocean of space.

In an interview the previous year with the Kennedy Space Center's *Spaceport News*, CBS broadcaster Walter Cronkite had made known his interest to fly on the shuttle. He assured NASA employees that "newsmen will go on the shuttle . . . just as soon as we prove out the equipment . . . I would guess that somehow or other we're going to see that a pool man gets aboard, and I hope it's me."[10] The chance to broadcast one of his "You Are There" episodes from the middeck of the shuttle almost came sooner than expected. In Low's memo suggesting the flight of Cousteau, Cronkite's name was mentioned as an alternate documentarian "to let him report what he sees from space."[11]

Before we see what happened with the suggestion to let Cousteau dive into the new ocean of space, let's take a look at what another ad hoc group had to say about the future.

Earlier that year, NASA released "Outlook for Space," the report of a study team that had been asked to identify and examine "various possibilities for the civil space program over the next twenty-five years." The twenty-five-year time period was selected because it represented "a horizon broad enough to permit bold predictions

but close enough to the present to demand realistic technical judg-ment." The report recommended that the nation commit to a broad agenda of space activities in the areas of astronomy, life science, Earth applications, remote sensing, and orbiting industries, to name but a few.[12]

In a section titled "Commercial Space Transportation of People and Goods," the report predicted that by the turn of the century, the cost to place a pound of payload into orbit "might come down to 50 dollars per kilogram" (approximately $100 per pound) and eventually down to 10 to 20 dollars per kilogram. It would then be reasonable to think of such transport in terms of passengers with operational costs of 1,000 to 2,000 dollars each . . . We cannot ignore the possible eventual use of space travel for entertainment and recreation." The study team pointed out that exotic terrestrial tours, such as trips to the Himalayas or the Arctic regions, cost be-tween $5,000 to $10,000. The coming of heavy-lift launch vehicles (the next evolution beyond the space shuttle) could place tourists in orbit "for a reasonable stay at similar prices."[13]

Observers in Space

When President Eisenhower conceived the policy to conduct Amer-ica's space activities in full public view, space journalists became our storytellers. From the agonizing failures of Vanguard launches through the salute to Apollo, we came to know America's space program through the words and pictures of the print and broadcast media. Little wonder that when the non-astronaut flight rumors be-gan to circulate, journalists eagerly elbowed their way to the head of the line.

Journalists who covered the space program assumed it would be natural and appropriate for one of them to tell a story from the flight deck of the shuttle. You'll recall the suggestion back in 1965 to send a *National Geographic* photojournalist when spaceship land-ings still made a splash. In March 1976, *Geographic* correspondent

Ken Weaver wrote to Dr. Fletcher to express his interest in flying on the shuttle. Since journalists would fly sooner or later, Weaver had a keen interest in being the first to go. Plugging the merits of his magazine, Weaver could "think of few experiences that would interest *Geographic* readers more, and I can think of no publication that could give such a story wider circulation or better treatment."[14]

At the time, *National Geographic* reached an audience of over nine million; only *TV Guide* and *Reader's Digest* could boast larger circulations. In a reply dated March 24, 1976, NASA assured Weaver that he would be considered when the opportunity arose. "I personally believe," Dr. Fletcher added, that "someday spaceflight will be available to people from all walks of life and will not be restricted to scientific and technical personnel only."[15]

The Public Affairs Office received the assignment to draft the response to Weaver. In the margin of Weaver's incoming letter Fletcher had scribbled: "He's right you know. P.S. Maybe we ought to start an 'observer' program to go along with Spacelab investigators."[16] As far as the public affairs staff was concerned, "an observer" meant journalist, and they interpreted Fletcher's note as marching orders to develop a selection process.

A month later, public affairs officer Dave Garrett pulled together what was considered to be "an excellent analysis of the initial considerations inherent in developing the plan" to select a journalist for space flight.[17] This first look at the complex issues surrounding a selection process for a "citizen in space" made it clear that this would be no simple task.

First, Weaver's letter was not novel—Garrett had a drawer-full of requests from reporters. How would you decide who gets to go? A lottery would be simplest, or a peer review system would keep NASA from being accused of playing favorites. Should foreign media participate? What about women? If a newspaper reporter goes

first, would the electronic press be assured of the second flight? Would a journalist's account be covered under "pool" coverage rules? Should there be a financial charge for the six months of training, room, and board? Who would determine qualifications? Garrett indicated a personal preference for a "hard core science/space correspondent."[18]

More important, Garrett believed that NASA could "realistically assume that not everyone will agree that taking a reporter into space is a good idea." The agency needed "to be alert to questions like 'if a reporter can go, why not an artist, or poet?'" Therefore, it was imperative that NASA establish a sound rationale for sending an observer.[19]

Garrett's memo worked its way up the system. The only modification to his original plan concerned the question of the print press versus broadcast media. Senior public affairs officials determined that a peer review panel "representing various interests (print, radio, TV, etc.) would establish criteria to serve the needs of all media in some manner."[20] This was designed to put the "pool" in "pool reporter." By the beginning of the summer, the Office of External Affairs was ready to pitch their proposal to Administrator Fletcher.

He's Not Very Good Looking, But He's Got a Unique Personality

Notice that Dr. Fletcher's response to Ken Weaver is dated the same day as the Low memo on the "Experiment Which Failed." Despite the similar subject matter of the correspondence (non-astronaut flight), the subsequent "action item" assignments were sent to two separate offices. While the public affairs staff within the Office of External Affairs had zeroed in on a selection process for a journalist, the Office of Space Flight had been instructed to examine the suggestion to fly Philippe Cousteau.

The idea to fly on a shuttle mission was presented to Cousteau by Apollo astronaut Rusty Schweickart, who was serving at Headquarters

as director of User Affairs and was acquainted with Philippe and his father Jacques. The Cousteaus were intrigued, but as Schweickart reported back to Low, they had the "perception that NASA's commitment (for Philippe's flight) is integrally tied to your personal dedication and initiative." Since it had been announced that Low was leaving the agency, Cousteau was concerned that support to fly his son might evaporate. Schweickart felt that Administrator Fletcher should personally reassure the Cousteau of NASA's serious interest in the endeavor.[21]

Because one of the reasons Philippe was selected to fly was his known ability to communicate, it was a bit disappointing that Schweickart also told Low, "There is no guarantee of NASA focused films (resulting from the flight), but rather we cooperate in jointly sponsored, legitimate research or demonstration projects of mutual interest which Cousteau will film and perhaps use."[22] It was the word "perhaps" that raised red flags. Why send Cousteau if he wouldn't guarantee a post-mission product to tell the public what the flight was like? This would not be the last time the issue of "guarantees" would be raised concerning a non-astronaut's post-flight activities.

The primary responsibility to further pursue the Cousteau concept passed from Phil Culbertson to Office of Space Flight engineer John Hammersmith. He established an Ad Hoc Study Team with representatives from other NASA offices including Legislative Affairs, Public Affairs, General Counsel, Space Medicine, and his own Office of Space Flight. They began their work with a review of the 1965 Martin Company proposal to sanction a National Geographic Expedition for the Gemini Program. With the Martin suggestion as background, the committee decided to expand their review beyond the consideration of Cousteau to include people they considered "Unique Personalities."

To justify flying a non-astronaut on a shuttle flight, the study team

locked onto a function specified in the Space Act of 1958 that created NASA. The act established the ground rules for the agency's operations and directed NASA to "provide for the widest practicable and appropriate dissemination of information concerning its activities and the results thereof."[23]

A non-astronaut should come back from a flight prepared to share the experience eloquently with the public, an area in which most people didn't think professional astronauts excelled:

> By virtue of his occupation or organizational affiliation the best communicator would be someone like: a News Reporter; a Popular Scientist, not to be confused with an Eminent Scientist; a Politician, not to be confused with a Prominent Statesman; a Layman; a Space Science Student; a Prominent Transportation Figure; an Artist, which included Poets, Painters, and Writers; a Humanitarian; or an Entertainer.[24]

Citing nearly the same rationale as the Martin Company had offered eleven years earlier, the Hammersmith team arrived at a consensus. In its "Preliminary Report," the team recommended that the leading flight contender should be a writer-photographer from the National Geographic Society. In their estimation, "Pooling arrangements would probably be necessary," unless National Geographic put up money for a share of the flight. In that case, "They might legitimately claim proprietary (information) or first rights."[25]

A personality from other news organizations was ranked second on the queue; a newsman "might not yield the depth of coverage as the first choice, but might yield greater public exposure."[26] A member of Congress was also considered a viable option, though the report admitted, "This choice was fraught with undesirable difficulties involving partisan politics."[27] NASA already had more undesirable difficulties involving partisan politics than it needed.

Hammersmith's "Preliminary Report" did strike several notes of caution. Taxpayers and government budgeteers might consider the

whole idea a misuse of funds. There was also the fact that test flights were risky: "In the event of a catastrophe, the public may view the flying of a <u>non-test</u> pilot on a <u>test</u> flight as irresponsible."[28] Hammersmith had previously expressed the opinion that "If we lost him (a non-astronaut), it would not only stall/stop the Space Shuttle Program, but could drag the whole Agency down."[29] The report's conclusion cautioned, "The actual selection may prove to be one of the most troublesome aspects. Wrongly handled it could set an undesirable precedent for future flights."[30]

The report was forwarded to John Yardley, and most of the members assumed the initiative would die. After all, shuttle officials had a multitude of problems to occupy their time: they were behind schedule, underfunded, in deep trouble with certain Congressmen, and still tinkering with design changes. The fact that some people were of the opinion that astronaut personalities were too un-unique to give speeches wasn't considered a high priority. Despite these assumptions, Yardley discussed the topic at a meeting with the directors of NASA's field centers.[31] Following the meeting, Hammersmith was told to continue with his unique search.

The Office of Public Affairs didn't think much of the "Preliminary Report" for a Unique Personality. Robert Shafer, deputy assistant administrator for Public Affairs, thought the report was "nonsense."[32] In his judgment, the unilateral selection of a journalist from *National Geographic* would undoubtedly be protested by other reporters; let them compete like everyone else. If the magazine was really willing to pay for a flight, it could wait until the operational phase.

In order to have these views represented, Shafer arranged to have Dave Garrett added to the Hammersmith team. When the final report was released in July 1976, a "Media Person" topped the recommended list. The report also advised that a "Personality" not be allowed to fly until after the completion of the scheduled six Orbital Flight Tests.[33] The ground rules for a Unique Personality were established none too soon.

The Viking 2 science spacecraft landed on the surface of Mars just a few days prior to the release of the final Hammersmith report. Among the stack of letters that poured in to congratulate the Viking mission was an offer from one of the many unique personalities who followed the space program.

A resident in Michigan offered to "serve as a single-man, non-return explorer on a manned mission to Mars or other planets in our solar system." Affiliated with the Center for Social Science Research, this volunteer possessed several unique qualifications that Hammersmith's team had overlooked: "At the age of forty-five, unlike a younger person, I am no longer concerned about my future on this planet . . . I am an inventive, research scientist with an insatiable curiosity . . . can reduce my current 145 pounds to 125-pound level . . . play golf daily and have a 4 to 7 handicap." Whereas the life of an astronaut was known to cause family stress, this social scientist was convinced he and his wife "would be able to adjust to this kind of separation with a minimum amount of problem."[34] Heavens, if golf scores were going to come into play as a selection criteria, the rest of us better head to the driving range pronto.

Another request, which even the sender admitted was "somewhat unusual," came from Stuart Oken of the Chicago-based theatrical group, Apollo Productions. As executive producer of the group, Oken revealed that most of the company's operation related in some way to images of the Moon and the Apollo Program. He was about to develop a new exhibit that would display scale models of theaters on the Moon, and demonstrate how vital art would be to a lunar society. To lend credence to the exhibit, Oken wanted to display a letter from NASA that guaranteed when a theater was established on the Moon, Apollo Productions had the stage rights to present the first production.[35]

Though NASA agreed that "the performing arts should constitute an important part of the cultural life" of a lunar community, Oken

did not receive a performance contract. The response explained that NASA was not a regulatory agency and didn't have the authority to grant the request . . . but "your interest in our space program is appreciated."[36]

These Are the Journeys of the Star Ship Enterprise

On September 17, 1976, with theme music from the TV show *Star Trek* blaring in the background, the first Space Shuttle, Orbiter Vehicle (OV) 101, was rolled out of the hangar for public display. Even though NASA had originally named the vehicle Constitution, President Gerald Ford decreed that OV 101 would henceforth be known as Enterprise. The change came after the Oval Office was inundated with 100,000 letters from "Trekkies" demanding that the name of

NASA Administrator Dr. James C. Fletcher and the cast of *Star Trek* were on hand for the roll-out of Space Shuttle Enterprise in Palmdale, California, September 17, 1976.
Photo: NASA

the first orbiter mimic the space ship from their favorite television show. President Ford was no fool—it was an election year. He decided to let life imitate art.[37]

When the shuttle bus was towed out of the terminal for the ceremony, six members of the *Star Trek* crew stood shoulder-to-shoulder with the real astronauts who would pilot the Enterprise for landing tests. Republican Senator Barry Goldwater assured the 2,000 guests that the shuttle was "probably the best investment the U.S. Congress has ever made."[38] (Tell that to Senators Proxmire and Mondale). Administrator Fletcher promised, "This day we enter a new era . . . the evolution into the age of man in space; not just astronauts and cosmonauts, but medial beings, willing to leave their planet for brief or extended periods."[39]

College students were among the "medial beings willing to leave their planet." At the time, I was president of the Forum for the Advancement of Students in Science and Technology (FASST). Leonard David, our aerospace director, and I had spent months urging NASA officials to establish a national competition to select college student experiments to be performed on shuttle missions. Senator Frank Moss (D. UT), chairman of the Committee on Aeronautical and Space Sciences and a member of FASST's Advisory Board, wrote to NASA to suggest that the student competition idea be considered.[40]

Shortly after the Enterprise ceremony, Dr. Fletcher informed Senator Moss that NASA was already working with FASST and that a program for both college and high school students was under review. What really caught the interest of our FASST members was this comment in Fletcher's reply: "As the Shuttle program advances into future years, it is possible that outstanding students would be selected to serve as actual payload specialists aboard Space Shuttle Missions."[41]

...it is possible that

outstanding students would be selected
to serve as actual payload specialists...

That's One Giant Leap For Students

Members of the Forum for the Advancement of Students in Science and
Technology (FASST) were thrilled with Dr. James Fletcher's prediction that
students might fly on the space shuttle.
Photo: NASA and FASST News

Tom Rogers, a member of NASA's Space Programs Advisory Coun-
cil, also made the case for us medial beings. The week after the
Enterprise made its debut, Rogers wrote to Dr. Fletcher concerning
the "proper contemporary and continuing role for human beings in
space." Rogers thought was ironic. By the time we reach the point
where people can venture into space with confidence, "space ac-
tivities will continue to be, and be perceived to be, the province of
. . . technicians. What a shame that would be," sighed Rogers.[42]

As chairman of the Advisory Council's Applications Committee,
Rogers believed that the most fundamental role for humans in
space was "simply to be there," to be there, "not only as scientists,
engineers or pilots, but also as curious, impressionable, creative

individuals who could incorporate the essence of the flight experi-ence into their lives and careers on Earth."[43] To accomplish this objective, Mr. Rogers thought the neighborhood of space could benefit from a new breed of tenants and believed:

> Consideration should be given to allowing some few individu-als schooled and practiced in the arts and humanities, and cul-tural and political leaders to visit space for short periods of time . . . Visits by artists, philosophers, poets, lawyers, theologians, writers, composers, dancers, historians, playwrights, educators, journalists, etc. could be provided at relatively low risk and at modest additional costs to the present program.[44]

Rogers' passion for expanding spaceflight opportunities beyond the traditional astronaut corps was an inspiration to me. At this early stage of the development of the space shuttle, no one was more vocal in challenging the status quo and advocating on behalf of space dreamers.

In his response to Rogers, Dr. Fletcher referred to the Unique Per-sonality study group that he had formed to consider how NASA could provide a capability to fly the kinds of individuals Mr. Rogers had in mind. Fletcher asked for Rogers' help "in having this idea germinate" with the other members of the Space Program Advisory Council: "In this way we might be able to see these ideas coalesce into new national policy."[45]

The Carter Malaise

Space interest groups were initially optimistic when Jimmy Carter won the 1976 presidential election. After all, this was a president with a degree in engineering; surely, he would be sympathetic to the needs of a research and development agency like NASA. How-ever, Carter's Science Advisor, Dr. Frank Press, stated that precisely because the president was technically minded, a hard case would have to be made for NASA's programs. Press cautioned that "It is extremely important to (the President) to balance the budget by

1981, and any threats to that will be hard to approve."[46] Additionally, the Carter Administration introduced the concept of "zero-based budgeting," so every expenditure had to be justified from scratch.

With the arrival of President Carter, engineer James Fletcher resigned as administrator and was replaced by scientist Dr. Robert Frosch of the Woods Hole Oceanographic Institute. Shortly before Fletcher left the administrator's suite, he received a request from space author Ernest Gann to fly on the shuttle. Fletcher admitted that while it was still a little early, he, too, had the dream. "In fact," confessed Fletcher, "I join the group in wishing that I might be one of those fortunate few."[47]

Not suffering from a malaise was Timothy Leary, the former high priest of LSD and acid trips. He became an advocate for the natural high of space exploration, and while addressing college students in Washington, DC in January 1977, Leary proclaimed that he was now "selling hope—not dope." He believed that hope for the world could be realized in the 1980s when NASA would become like Amtrak and offer regular runs into space: "Soon people will find it cheaper to build a new world (in space) than to fight over an old one." Since we were being squeezed out of our Earthly nest, space travel would solve the exploding population problem.[48]

Perhaps experiencing an acid-flashback, Leary predicted that it would cost less to build on three or four acres in space than a three-bedroom house in Washington, DC, something on the order of $100,000. He also believed space exploration was a way to end war and to support cultural diversity. "Think of it," he speculated. "There will be communities for bi-sexual vegetarians and for ski enthusiasts." When asked by a member of the audience when space migration might become a reality, Leary quipped, "Ten years after people stop laughing about it."[49]

NASA's expectations for the shuttle were nothing to laugh about; they meant business. When President Carter came to town, NASA

was planning almost 600 shuttle flights between 1980-90, a whopping 60 launches a year. Gene Krantz, of the shuttle's Mission Control Center, calculated the first ten flights would require fifty controllers, but by 1981, the work force could be cut down to seven or eight.[50]

Agency officials were quick to point out that researchers would be willing to pay $3,000 for simple automated payloads, while satellite customers would pay up to $20 million to reserve space in the orbiter's cargo bay, making the shuttle a money-making machine. NASA bean counters had determined that in addition to the income from satellite deployments, the shuttle program would realize a savings of 40% over expendable vehicles on operations alone.[51] How could space dreamers not help but be happy and hopeful?

Well, for one thing, there was the ghost of Apollo. When it came to our evolution in space, NASA officials and space advocates refused to accept the fact that the Apollo Era was the exception and not the rule. The program to land a man on the Moon owed much of its existence to unique global political circumstances, which in turn created unique opportunities. During those good old days of the Moon race, space and national security were inseparable. Therefore, our march to the Moon, for the most part, enjoyed unwavering presidential and congressional support. When they ran into trouble, Apollo managers could go to the White House or Capitol Hill and come back with a check of sufficient size to buy a solution: "Whatever you need boys, just don't let the Russians get there first."

The "Let's beat the Russians" attitude was absent during the development of the shuttle. Although the Soviets were said to be developing a similar spaceship known as Buran, no one believed they could launch before we did. Without compelling competition from the Soviets, both the Carter Administration and Congress were less generous with the government's checkbook. The luxury of rapid, fleeting accomplishments in the name of political expediency was no longer desirable, replaced instead by the burden of a growing

bureaucracy. There were even rumors that NASA might be merged with a department-level agency, perhaps Commerce, or Defense.[52]

In the meantime, President Carter seemed more interested in telling agencies to turn down their thermostats than to turn up their vision. When Carter went on a VIP tour of the National Air and Space Museum, *The New York Times* noticed he didn't even mention the space agency, which had been responsible for most of the exhibits and was located right across the street.[53]

There was an attitude among some space explorers that future flight experiences would never come close to the glory of Apollo. In a *Clear Lake Citizen* article on the expected capabilities of the space shuttle, Enterprise test pilot Charles Fullerton noted, "The Apollo program was better than anything even Hollywood could produce. It was the ultimate; everything else has to be anti-climactic."[54]

Finally, for all its technical challenges, the shuttle was seen as just a program to build a vehicle; it wasn't a national goal like Apollo. Even the name of the program was criticized for being uninspiring. Ann Bradley, an assistant to George Low, suggested they go back to the drawing boards for a better name. At the time, the word "shuttle" described small planes scooting from Washington's National Airport to LaGuardia Airport in New York City. Dr. Low should have listened.

The *Today* newspaper in Cocoa Beach complained, "Space Shuttle is as dull as saying train instead of Silver Meteor. In the early days, we had dramatic names for programs like Mercury Atlas, Thor, and Titan. NASA should take a clue in 'merchandizing' from auto manufacturers: Ford and GM . . . don't sell cars, they sell Mustangs, and Firebirds."[55] Clearly, NASA should have come up with a snazzier moniker.

Swinging on a Star

When Wernher von Braun left NASA in 1972 for private industry, the message in his space sermons began to shift. Instead of promis-

ing the coming of routine space flight, he began highlighting space applications to earthly problems. In 1974, concerned about the growing public apathy towards the space program, he founded the National Space Institute (NSI). In soliciting members for his board of directors, von Braun noted that there was a "need to provide the public with a voice in (determining) the direction of the space program . . . (which can) help resolve some of the pressing energy, food, economics and balance of trade problem."[56]

He wrote to prospective members asking, "How do you partake in the greatest adventure in the history of mankind if you're not an astronaut? By partaking in a vast national forum for the discussion and direction of space policy."[57] Partaking in a discussion was not exactly how we had hoped to participate in what von Braun himself had once called the greatest adventure in the history of mankind.

During an appearance on NBC's *Tomorrow* show, von Braun told host Tom Snyder that even with the shuttle, human space flight opportunities would be limited. Snyder had asked if we could soon expect "to go to a counter and buy a ticket" into space. "Let's put it this way," von Braun responded. "At the moment space is outrageously expensive and even with the shuttle it will be pretty expensive still." He thought human activity in orbit would evolve much the way as in Antarctica: "It will be available to those who have a job to do there, but it may payoff for certain (other) people."[58]

Von Braun never saw the coveted shuttle reach the Promised Land. On June 16, 1977, just two days before the Enterprise was taken aloft for its first drop test, he died of cancer. Over the previous 30 years, no other man had devoted so much time to the promotion of human space travel. As one tribute to von Braun noted, "You can think of him as a hired gun if you like. But you can also think of him as he apparently thought of himself—as a man indentured only to a dream."[59]

NASA Searches for That Special Someone

As we have seen, it wasn't easy to get a foot in the door of the astronaut frat house. Scientists had been grudgingly accepted into the corps, but it took considerable outside pressure to get NASA to send one of them to the Moon. Women weren't needed—there were plenty of men. Besides, the thought of babes in joyland made some people sick. And as for African Americans, well, they needed to get used to the back of this bus, too. Fortunately, in the 1970s, revisions to the astronaut by-laws radically changed the intellectual interests, shapes, and complexions of America's future space envoys.

Two weeks after the Enterprise test flight, NASA began to select the next generation of hired guns who were willing to be indentured to their dreams. These individuals would be selected to fly on shuttle missions into the next century.

Plans called for the selection of a new category called "mission specialist," MS for short. These mission specialists would be "skilled in the operation of STS systems related to payload operations."[60] They would be trained to conduct experiments, deploy satellites from the cargo bay, and perform space walks to retrieve or service satellites. These positions were to be initially filled by true-blue Americans, but foreign crewmembers were also to be considered for future shuttle flights.

Recruitment posters for the new class of astronauts encouraged women and minorities to apply. "There's no question," Selection Chief George Abbey told the press, "some women will be selected" for non-pilot crew positions.[61]

When applications for astronaut positions from African Americans only trickled in, NASA decided it had better implement a more robust affirmative action plan. They sought the help of actress Nichelle Nichols, *Star Trek's* Lt. Uhura. She was active in working with space advocacy organizations such as the Committee for the

Future, the National Space Institute, and NASA's education office. Nichols taped a recruitment video to encourage minority participation in this new opportunity. The results were impressive. Quicker than you could say, "Beam me up, Scotty," 1,000 applications arrived from minorities.

In January 1979, from the 8,000 dreamers who applied, NASA announced 15 pilot astronauts and 20 mission specialists for the eighth astronaut class. The new class included six women, three African American men, and one Asian American man. Given the depth of competition, this was one impressive bunch of civil servants. Until they completed two years of astronaut training, they were designated "astronaut-candidates" and anointed themselves Thirty-Five New Guys (TFNG).

Thankfully, the incumbent space men had finally dropped their opposition to women in the corps. What the heck, the shuttle was going to launch so often that everybody would get a chance to fly. Veteran astronaut Alan Bean couldn't wait for the shuttle flight opportunities that were in store for him and the new recruits. "You'll really have to peak up for each mission," Bean told reporter John Noble Wilford of The New York Times, "like doing a Super Bowl three or four times per year. Think about that. I've been an astronaut thirteen years and only flown twice. With the shuttle I may be flying three or four times a year."[62] As it turned out, Bean's Apollo 12 walk on the Moon and a stint on Skylab completed his indentured service; he left the corps in 1981 having never flown the shuttle. In his post-astronaut career, he became famous as an artist of fabulous space imagery.

Maybe Bean's paintings would someday be exhibited at one of the space colonies, which were promised to be "coming soon." In an article on space colonies in National Geographic, Isaac Asimov predicted that by 2016 we would witness 10,000 colonists floating about the L-5 starship, munching on hot dogs made from rabbit meat and gulping from tumblers of goat's milk.[63]

170

Women were finally accepted as astronaut candidates in 1979. Left to right: Margaret R. (Rhea) Seddon, Anne L. Fisher, Judith A. Resnik, Shannon W. Lucid, Sally K. Ride, and Kathryn D. Sullivan.
Photo: NASA

A year later, as NASA narrowed the list of 8,000 shuttle astronaut applicants to 35, journalist Michael Gold predicted that the first space colony would be ready sooner than predicted by Asimov. He saw the coming of colonies, "fabricated by lunar materials mined on the Moon and filled with pioneering colonists like those who followed the Italian explorers to the new world. In the following decades, several larger colonies could be established leading to a space community of millions, living in pollution-free worlds with plenty of jobs and living space." He predicted this could take place by 1992, the 500th Anniversary of the voyage of Christopher Columbus.[64]

For the time being, a couple of astronauts conducting landing tests with the good ship Enterprise would be as close as we would get to colonists in space. Had the *Star Trek* fans thought it through a little

more, they might have saved their "name the orbiter campaign" for one of the other vehicles in the shuttle fleet. Although it was the first orbiter off the production line, Enterprise was not equipped to achieve orbit. Its destiny was to fly to a mere 30,000 feet on the back of a Boeing 747 named Fat Albert, and then be dumped off over the Mojave Desert for Approach and Landing Tests. On August 12, 1977, astronauts Fred Haise and Gordon Fullerton guided the Enterprise to a perfect landing on the dry lakebed at Edwards Air Force Base. Though it would never reach space, Enterprise successfully performed its earthly mission.

At an official "Space Day" symposium, California Governor Jerry Brown said the Enterprise and its sister ships would usher in "a new era . . . like closing the transcontinental railroad. It links us up with space and it lifts off from limits to unlimited possibilities." For the governor, the space program offered "a mixture of poetry, technology, ecology, and profits."[65] That doesn't sound so outrageous, but Brown's frequent speeches addressing his space aspirations, not to mention his interest in acquiring California's very own communications satellite, earned him the nickname "Governor Moon Beam." Take heart, Governor; remember what those smarty pants in the press once said about Robert Goddard's Moon rocket.

One editorial praising the first Enterprise drop test predicted: "If all goes well, launches and landings of these Buck Rogers-style craft will be everyday affairs in less than a decade. NASA is already talking in terms of weekly flights and is beginning to round-up business for them."[66]

The writers at *Time* magazine were equally impressed with the exploits of the Enterprise:

> Space flights just for the fun of it are well within the realm of possibility. NASA has yet to print up tickets for the day when a jaded jet setter walks into the Agency's office and tries to discover the latest 'in' place for an outer space trip. But agency officials have,

in fact, discussed just that possibility: the OV 101, after all, carries a 3-man crew and accommodates 4 passengers.[67]

In a *Reader's Digest* article titled "Come Ride the Shuttle," we were told: "A significant feature of the orbiter will be its ability to open space travel to non-astronaut passengers— scientists, physicians, artists, journalists . . . you and me."[68]

Mechanix Illustrated magazine looked forward to the day when we would "board the sprawling space giant and take a seat among the other passengers, ranging from fellow tourists to working scientists." This could occur on one of the 500 shuttle flights departing the Cape by 1990. "Roughly one per week. There are towns where the bus doesn't leave that often."[69]

ABC News President Roone Arledge had designs on one of those passenger seats. On the same day in September when Joe Engle and Richard Truly "flew" Enterprise for the second free-flight landing test, Arledge fired off a letter to Administrator Robert Frosch to secure a future seat for his space reporter, Jules Bergman.

The innovative Arledge wanted to send Bergman and a new micro-miniaturized TV camera on the earliest possible flight and was "prepared to do this on any basis . . . as a newsman observer to sit in the rear of the cockpit and buy any circuit time he may use transmitting signals back to Earth." Arledge rushed to point out that Bergman had already spoken to John Yardley about their "intention to fly on the first shuttle mission and was told that he was the first broadcast media reporter to make this request."[70] Not that first come-first served mattered, but Hugh Downs and many other broadcasters could challenge that last assertion.

While journalists slugged it out to be first to fly on a shuttle flight, a couple of long-range planners believed that space tourism opportunities weren't far off. In a report on the "Long Term Prospects for Developments in Space," the Hudson Institute encouraged NASA

to use visionary images and scenarios for planning purposes. With the assumption that a second-generation shuttle would become operational in 1989, the report's co-authors, Herman Kahn and William Brown, presented a range of scenarios for the evolution of the space program.

One scenario described the benefits of flying politicians and movie stars to highlight the shuttle's utility for commercial space tours. On such a flight, "NASA's Director, the Governor of Texas, two Senators, six Congressmen, the French Ambassador and twelve other VIPs, together with Marion Scott and Elizabeth Welsch, the best-known movie actor and actress in the U.S." would embark on a three-day voyage to an international space station.[71] Roone Arledge needed to take notice; this future scenario didn't place a single journalist in the passenger lounge.

Arthur C. Clarke came to Washington DC in October 1977 to take politicians for a ride into the next century at a forum sponsored by the Congressional Clearinghouse for the Future. Speaking in the Rayburn House Office building (which he had obliterated in his last novel), Clarke warned the legislators, "If you take my predictions seriously you'll go broke, if you don't take my predictions seriously your children will go broke."[72] He then outlined a range of "extrapolated trends" that were waiting for us in the future.

Clarke praised the recent Enterprise Approach and Landing tests and believed the shuttle would do for space what Lindbergh did for aviation. But like von Braun, Clarke began to change his tune on the time schedule. For all the excitement the orbiting Hilton Hotel had caused in *2001: A Space Odyssey*, Clarke personally didn't think space colonies would be feasible "for 50 to 100 years." When asked if Congress should spend its limited funds on planetary or interstellar travel, he responded, "neither." He believed that space applications programs, such as remote sensing, Earth observation satellites, and solar power platforms, were far more important.[73]

P.S. I Love You

If you were one of the 8,000 applicants who didn't make the grade as a shuttle pilot or mission specialist, there was always the chance that you might be accepted for another new astronaut category—payload specialist (PS). Announced in 1978, this category had been designed to allow "major users" of the Spacelab to "accompany their experiments and conduct their own measurements and observations when their presence can be justified by unique circumstances." A "major user" was defined as a customer who purchased more than 50% of the services and capacity of a Spacelab mission. Although the NASA office in charge of marketing shuttle research capabilities hoped that customers would materialize from the commercial sector, most Spacelab flights ended up being sponsored by the government-supported science research community.

NASA officials estimated that the number of flights of the Spacelab, a research module that fit inside the orbiter's cargo bay, would grow from two to five or ten by the mid-'80s. In any case, a PS investigator would "fly as a passenger." As such, they "will not be trained as an astronaut, and will not be required to commit more than one or two years of his or her time to a particular mission."[74]

What kind of training would payload specialists experience during the one or two years of training? As stated in a payload specialist brochure, "Like a musician who has signed on with a ship's orchestra and must practice with the band and also learn to live aboard an ocean liner, the payload specialist must undergo dual training." This included learning the procedures necessary to operate the equipment and perform experiments in zero-gravity, as well as "flight familiarization . . . referred to as mission independent training."[75] This familiarization included basic shuttle operations such as how to open the hatch, prepare meals, where to stow underwear, how to use the toilet, and what to do and not do in case of an emergency. Most important, you would learn what *not* to touch.

According to the payload specialist brochure, any of us might qualify to perform the role of payload specialist: "Anyone is eligible . . . regardless of sex, race, color, age or national origin." You could "be employed by universities, private organizations, or government agencies, either U.S. or foreign. You may even be self-employed." [76] That certainly created a universe of aspirants. This was almost too good to be true. There must have been a catch; there was.

Selection of payload specialists was determined by an entity called the Investigators Working Group (IWG). Membership of the group was comprised of researchers whose experiments had been approved for a flight. Guess who they were likely to tap? You've got it, one of their own kind. So to qualify as "anyone," you had best be a scientist who had proposed an experiment that had already been selected for a flight. Even then, the experiment had better be so incredibly complex that it required a unique set of skills that quick-study mission specialists couldn't easily master. And don't forget, those MS-types had just survived a process where they had beaten out 7,980 other scientists and engineers.

If the experiment did require your special blend of uniqueness, there would be scads of flight opportunities. Office of Space Flight policy stated that the normal flight crew consisted of three astronauts: the commander, the pilot, and one mission specialist. As many as four payload specialists could accompany a Spacelab mission, and they planned to fly dozens of those. But if you were selected to be a PS, you shouldn't even have considered bragging to your friends that you were an astronaut. Technically, payload specialists were "not considered professional astronauts. Unlike astronauts, NASA does not select them."[77]

With so many people buzzing about in space, we probably wouldn't get to know them on a first name basis the way we did with the early gods of Mercury. On the other hand, look at who was going to be up there: heroes of Apollo; women and minorities; researchers from private companies, universities, and government agencies

besides NASA; and citizens from other nations. With an announced shuttle manifest now down to 48 launches per year for 20 years, each crewed by astronauts, 6,720 seats would be available. Even with some lucky stiffs sailing more than once, someone from your neighborhood was bound to get into orbit sooner or later.

The Captain Has Asked That You Return to Your Seat and Fasten Your Safety Belt

With the completion of the Approach and Landing Tests in early 1978, the next port of call for Enterprise was the Marshall Space Flight Center in Alabama. Located down the road from the cow pastures and cotton fields on the outskirts of Huntsville, the orbiter was scheduled to undergo a series of vibration tests. The Johnson Space Center sent out a short press release announcing that in March, on its way to Alabama, the Enterprise would make a layover at Ellington Air Force Base in Houston. Since the conventional wisdom said public interest in space was floundering, NASA officials were pleasantly surprised when over 240,000 visitors came over the weekend to behold the Enterprise. The State Police was amazed that people sat in stalled traffic and walked miles just to gawk at a spacecraft parked unceremoniously along the runway.

Charles Biggs of the JSC press office verified that no special efforts had been made to draw a crowd. There were "no bands, no celebrities, no giveaways, just an orbiter sitting there."[78] One of NASA's tour guides may have come up with the best explanation: "I think this is different than Apollo and going to the Moon. I think the Shuttle is coming closer to the people; it is something they can relate to. They wanted to know when they could go on it."[79]

At a public viewing of Enterprise the previous year in California, 17-year-old John Zrimc explained what was so inspirational about the experience: "I wanted to see it for once—some spectacular event, you know, something big—and I wanted to see it for the first time close-up."[80]

Plans for when "they" would get to go on the shuttle continued to circulate around the halls of NASA Headquarters. During the transition between NASA Administrators Drs. Fletcher and Frosch, the Unique Personality initiative was placed on hold.

The public affairs staff, however, was still pressing for a member of the news media to be the first passenger. They proposed a competition to begin in March 1978 that would lead to the selection of the journalist candidate the following year. The newsroom staff hoped the first byline from orbit could be filed from a shuttle flight in early 1980. It was anticipated that additional mission opportunities for a journalist would be available, but shuttle managers pointed out that other passengers were likely to get a chance first. In any case, it was widely agreed that the journalists who made the first flight "should not be eligible for additional flights until all bona fide media representatives have had the opportunity to fly."[81] Given the hundreds of reporters that covered the space program, this seemed more than a bit obvious.

On May 18, 1978, in response to Congressional instructions, NASA officially shifted the date of the first shuttle launch from March to June 1979. The next day, a draft version of procedures for "Passenger Flight on Space Shuttle" worked its way to the administrator's office. This document merged the public affairs' plan for a journalist with similar procedures to select individuals from the arts, industry, labor, education (including students and teachers), government, social scientists, and the unaffiliated.

Selections of the individual to represent these various groups would be conducted by appropriate professional societies. The "unaffiliated" (general public) category would be selected by an ad hoc committee comprised of judges from groups such as Common Cause, the Center for Science in the Public Interest, the Federation of American Homemakers, and other advocates for the disenfranchised among us.[82] Given the delays in boosting the first shuttle off the launch pad, Administrator Frosch quietly shelved the proposal.

Another study that was being conducted concerned the feasibility of having private companies manage the shuttle system once it became operational. With flights expected every two weeks, some people felt a commercial company would do a better job of managing the system than a government research and development agency like NASA. Day-to-day operations, like those required for commercial airlines, should be transferred to a private company.

An article in *Cocoa Today* revealed that in addition to these feasibility studies being "quietly conducted" by NASA, major aerospace contractors had initiated reviews of their own. Among those companies "taking a cursory look" at the project were Boeing, McDonnell Douglas Astronautics, and the shuttle's prime contractor, Rockwell International. Financial benefits and a positive public image were most often mentioned as the reason a company would be interested in acquiring the management rights for operational shuttle flights.[83]

Proponents of a private management system also believed that space tourism would be introduced more quickly if the government didn't have a monopoly on the program. With the shuttle in the private domain, the *Cocoa Today* article predicted "that 10 years from now, people standing at the passenger counter at the Kennedy Space Center might hear the following words: All those ready for boarding Space Shuttle Flight 308 please hand your ticket to the flight attendant."[84] This notion of a private operator always sounded tempting on paper, but the devil was in the details. Serious proponents usually disappeared once the subject of reimbursing the government for the billions of dollars in development costs was mentioned.

Even though articles appeared about privately owned space shuttles flying passengers, we didn't want a repeat of the 1978 incident involving Soviet cosmonauts Yuri Romanenko and Georgy Grechko. Another example of the dangers of space flight and despite Soviet efforts to suppress the incident, Romanenko was almost lost in space during a mission to the Salyut 6 space laboratory.

According to western sources, during the 96-day record-breaking flight, only Grechko was scheduled to make a tethered spacewalk. However, while he was doing his chores, an unattached Romanenko suddenly popped out of the hatch. Fortunately, Grechko grabbed the safety line just in the nick of time and reeled Romanenko back into the spacecraft. Who knows why Romanenko had this sudden compulsion to achieve a perpetual state of weightlessness? One U.S. space official speculated the cosmonaut was struck with a serious case of "space rapture or something."[85]

In the meantime, the rest of us who wanted to achieve a state of weightlessness anxiously looked forward to the launch of the first shuttle and the promised "routine" flights. We were told to be patient; the first launch of Columbia had been postponed yet again and pushed into 1980. As the decade of the '70s came to a close, we dreamed of the day when we would have a chance to join the ranks of the envoys of mankind and be "struck with a serious case of space rapture, or something."

7 WE'RE GOING TO THE STARS

We're really not too far, the human race isn't, from going to the stars.
John Young, Post STS-1 Press Conference

Our fact finding indicates that it is feasible for NASA to fly individuals on the shuttle beginning in the mid to late 1980s.
Citizen in Space Task Force Report

It is an unabashedly utopian dream, a return to the old pioneer ideals of limitless expansion and the perfectibility of mankind, and a chance . . . to start over. Be tadpoles, not frogs.
Stewart Brand, *No Joy Riding Around*

Everybody Is Lining Up for Space

The 1970 and '80s are frequently referred to as the "Me Decades." Conventional wisdom felt Americans placed individual selfish desires ahead of the greater public good. For selfish space advocates, it was the decade of confidence that one of "Me" was going to trip into orbit. Unfortunately, as the decade began, we were off to a turtle-speed start.

The first shuttle launch had been delayed again . . . and again . . . and again, from December 1979 to June 1980, then to November, then to March, and finally, April 1981. At times, it seemed as though the only thing going into orbit was the shuttle's budget. The development costs of the Space Transportation System had escalated from the 1971 estimate of $5.2 billion to $8.7 billion.

Vice President Walter Mondale was not amused by the cost overruns. In a *Parade* magazine article titled "Everybody is Lining Up for Space," Mondale referred to the shuttle as "a senseless extrava-

ganza."[1] But the article also noted the public didn't concur with the vice president's bleak assessment. As "the first opportunity the public has had to get involved personally in a NASA project," the shuttle had very much captured America's imagination.[2]

NASA's Johnson Space Center received over 1,200 letters per week from volunteers looking forward to the 60 flights per year. Astronaut Selections Manager Greg Hayes noted that 88 percent of these new pen pals were serious, technology-based professionals, 10 percent were interested youngsters and patriotic senior citizens, and two percent were, "let's say, eccentrics."[3]

The end of the Parade article noted that NASA was accepting $500 deposits for "Getaway Special" reservations. This was not some kind of weekend excursion for newlyweds, rather the ability to purchase a garbage can-size canister known as a GAS can. For a price of $10,000, you could place a scientific experiment in the canister that would fly in the shuttle's cargo bay.

Bleary-eyed Sunday morning readers misinterpreted the reference about "deposits" to mean NASA was accepting reservations for passenger flights. Over the next few months, the agency was flooded with hundreds of checks and reservation requests and had to issue a special press release to clear up the misunderstanding.[4] Chet Lee, the director of Space Transportation Systems, told the Washington Evening Star, "Non-astronauts may be aboard some missions to conduct experiments, but we're not ready to book tourists. There is absolutely no provision or thought for non-working passengers."[5] Well, actually, there had been a lot of thought about flying passengers; it just wasn't being publicly discussed outside the halls of NASA.

A few months earlier, subscribers of the Beijing newspaper Wen Hui learned the People's Republic of China (PRC) might soon send working passengers into orbit. An article in the paper reported photographs would soon be published showing Chinese pilots "in

space clothes in a simulated spacecraft." Although this was the first public announcement that such training was underway, a government official was quick to point out, "a manned space program was not one of China's top priorities."[6] Not a top priority was putting it mildly. China wouldn't launch a person into space until 2003.

Manned space flight may not have been a priority in China, but it was still a primary driver of the Soviet agenda. Cosmonauts Vladimir Lyakhov and Valery Ryumin had recently spent a record 175 days on board Russia's Salyut Space Station. When it was announced that cosmonaut Ryumin would return to the station to extend his duration record, American space watchers speculated that the Soviets had their sights set on dispatching cosmonauts to Mars.

Since a round-trip mission to the Red Planet could take up to 18 months, there were numerous medical questions to be resolved. In an interview with the western press, Director of Training Vladimir Shatalov revealed cosmonauts who had remained in space for long periods experienced a decrease in muscle volume. The Soviets thought this problem, plus recorded losses of calcium in the bones, made it necessary for a trip to Mars to be a *man's* adventure. Shatalov believed he "had no moral right to subject the better half of mankind" to such conditions; therefore, female cosmonauts would not be considered for Martian journeys.[7] This was actually an insult to both men and women—to men for being considered expendable, and just plain patronizing to women.

While Russian doctors were focusing on long-duration medical issues, NASA's lawyers were delving into issues of orbital law and order. According to a March 1980 press account, "If a barroom brawl breaks out in space," a shuttle commander would be authorized to use "any reasonable and necessary means" to keep the peace.[8] The new regulation gave the commander the authority to arrest lawbreakers and fine them up to $5,000, sentence them to a year in prison, or both. Goodness, what kind of crewmembers were they planning to fly?

When asked what he thought of the new law, Apollo 17 Commander Eugene Cernan admitted, "I never felt the need for a written regulation or the need for brute force to get things done."[9] Well, that may have been true during Apollo when professional astronauts were the only people allowed on space missions. But in the Shuttle Era, there would be new suspects roaming among the stars. After all, shuttle missions could carry a crew of seven, and up to four of them could be those dreaded civilians. If flying *civilians* wasn't bad enough, up to three could be *foreigners*. With all those greenhorns floating around, someone was bound to get into trouble. If they did, it was comforting to know the mission commander was authorized to arrest them on the spot.

In May 1980, the second crop of shuttle pilots and mission specialists was selected from an applicant pool of 3,500. The 19 new candidates brought the total number of astronauts to 81. Included in the new class were another African American, two more women, the first Hispanic, and two representatives of the European Space Agency—the first "non-Americans." The corps also gained its first husband-wife team, as Dr. William Fisher joined his wife, Anna, who had been selected two years earlier. The voyeurs among us looked forward to the day when a married couple might be assigned to the same flight.

While the new candidates patiently waited for their turn to fly, the Carter Administration was "running out of patience" with the space shuttle.[10] The president's men were irritated with the rising development costs, the numerous launch delays, and the recent announcement that the flight rate was being trimmed again, this time from 60 to 30 launches per year.

The administration's critics believed Carter had no one to blame but himself. Had he been more supportive with funding, the shuttle wouldn't have had to cope with so many problems. Former NASA Administrator Thomas Paine felt the president was indecisive when

it came to space policy. On one hand, Carter offered rhetoric calling for U.S. space leadership; on the other hand, he demanded budget and program cutbacks. In Paine's estimation, you couldn't have it both ways.[11]

William Gregory, editor of *Aviation Week & Space Technology*, seconded Paine's critique of the administration's record. According to Gregory, the shuttle deserved more support because it was "the foundation for a transitioning and expanding space effort in the last two decades of this century."[12] It was also supposed to be the foundation to build opportunities for non-astronauts to fly.

In addition to funding shortfalls, NASA managers struggled with technical issues that added to delays. Development of the shuttle's reusable main engines proved to be a bigger challenge than expected. The liquid-hydrogen volcanoes burned at temperatures 1,000 times hotter than any previous rocket engine. On more than a few occasions, engines caught fire or exploded on the test stands.

The shuttle's thermal protection tiles also proved to be troublesome. Each orbiter was covered with over 30,000 tiles, each custom-made for a specific location. Problems developed when the adhesive used to cement the tiles refused to bond properly to the outer skin of the orbiter. This required the replacement of hundreds of tiles, a significant problem since it could take up to 25 hours to install a single tile.

Between the launch delays and the technical difficulties, NASA was in no hurry to respond to a proposal from the Aviation/Space Writers Association (ASWA) that had been sitting around since 1978.[13] A professional society for space scribes, ASWA offered yet another proposal to select an orbiting reporter. Under their scheme, membership in the association was not mandatory, but you did have to be a journalist of the print persuasion to qualify for the coveted assignment.

ASWA even submitted a list of potential judges, including Ken Weaver of *National Geographic*, Tom O'Toole of *The Washington Post*, and John Noble Wilford of *The New York Times*, each of whom had already expressed an interest in flying. Since the newspaper expected a reporter to take a lot of photographs, Time Inc. agreed to commission Polaroid to design a new camera for the flight. They even offered to teach the selected journalist which end of a camera to look through.

A week after Ronald Reagan's 1980 landslide victory over Jimmy Carter's attempt for a second term, Dave Garrett of NASA's Office of Public Affairs was instructed to respond to the ASWA proposal. At the moment, he explained, his office lacked clear direction from top management regarding plans for a journalist in space. Garrett's response noted, "Jim Fletcher was quite enthusiastic about flying media reps on a fairly early flight," but under the administration of Administrator Robert Frosch, "the enthusiasm waned to a sort of 'Let's not rush into anything until the Shuttle is well into the operational era.' Now, of course, Frosch has resigned, and we await the naming of a new Administrator."[14]

Lift Off! We Have Lift Off!

While NASA waited for President Reagan to get around to naming a new NASA administrator, preparations for the first shuttle launch were underway. The press looked forward to this historic event as eagerly as the rest of us. Writing in *Time* magazine, Roger Rosenblatt captured the difference between a *program* like Apollo and a *capability* like the space shuttle: "In short, the future rides with this vehicle, unlike its predecessors, Columbia is not a one-shot deal. It represents the long haul, and it will be responsible for settling the territory (of space)."[15]

In the *Washington Star*, aerospace correspondent James Schefter wrote of the pioneers who might help settle this territory. Excited that "up to four, non-interfering" passengers could be accommodated in

the shuttle's commodious quarters," Schefter predicted within the next five to ten years, high school student science fair winners, poets, movie stars, and artists would fly in space. "After all," added a NASA spokesman, "the shuttle is quite benign. It's not designed for athletes in the pink of condition, so anybody in reasonably good health can fly in it."[16] The article also reported things were looking so promising even the ASWA proposal had been dusted off for serious consideration. Although he didn't mention it in the article, it was Schefter himself who had submitted the Association's proposal.

On April 12, 1981, the 20th anniversary of Yuri Gagarin's rendezvous with history, STS-1 (Space Transportation System-1) finally

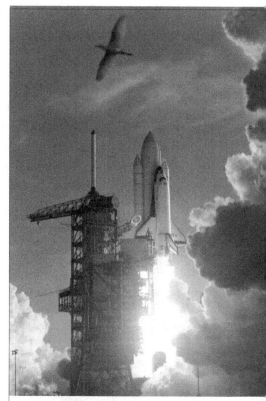

The launch of the first space shuttle took place on April 12, 1981. We thought it was our ticket to ride.
Photo: NASA

rocketed into orbit. As the engines of the Space Shuttle Columbia thundered above the Atlantic Ocean off the shore of the Kennedy Space Center, you couldn't help but feel the dream was very much alive!

Columbia was named after a frigate launched into service in 1836, one of the first Navy ships to circumnavigate the globe. The Navy was also well represented in navigating this latter-day Columbia. Two Navy flyers had been training for this day since March 1978. The STS-1 commander was Navy alumnus John Young, a veteran

of two Gemini and two Apollo space flights. The pilot was Navy Captain Robert "Crip" Crippen, who was participating in his first space mission.

Never before had astronauts been asked to fly a vehicle that had not first been tested without a crew behind the wheel. When Columbia broke through the atmosphere, it traveled four times faster than any previous winged vehicle. Never before had a spacecraft been designed with such versatility: part rocket, part spacecraft, part launch platform, and part aircraft. Never before had a space vehicle been designed to be refurbished to fly again. NASA and its contractors frequently mentioned that the shuttle was the most complex spaceship ever assembled, so there was justifiable pride in STS-1's near-perfect test drive. Except for a few missing tiles and a malfunctioning toilet, Columbia passed its test objectives with flying colors.

STS-1 Space Shuttle Commander John Young and Pilot Robert Crippen are greeted by ground crew at Edwards Air Force Base.
Photo: NASA

An exuberant crowd of 250,000 migrated to the Mojave Desert in California to hail Columbia's return, while millions more around the world watched the live television coverage. When the spaceship touched down on the dry lakebed of Edwards Air Force Base, a voice over the intercom advised us to "prepare for exhilaration." In recognition that this shuttle would fly again, Commander Young asked flight controllers, "Do you want us to take it up to the hangar?" Mission Control replied, "We're going to dust it off first."

At the post-landing reception, John Young, the nation's most experienced astronaut, confidently announced to the throng of excited well-wishers: "I think we have now got a fantastic and remarkable capability . . ."[17] A rousing round of cheers from the crowd enthusiastically seconded that notion. The mission might have come two years behind schedule and billions over-budget, but according to rookie Robert Crippen, Columbia "worked as advertised." In Crip's opinion, "We've got something that's really going to mean something in this country and the world."[18] Well, it certainly meant something to the dreamers who had been told they could expect to fly on future shuttle missions.

To space advocates, this meant America was again Number One in human space flight. Oh sure, the Soviets had set endurance records by cramming cosmonauts into their little Salyut Space Station, but they didn't have anything half as classy as the space shuttle—certainly not in the eyes of those who had worked on its development for the last ten years.

The press praised the successful flight, and editorial upon editorial offered more bold predictions of passenger flights to come. An article from *The Washington Post* commented:

> While it will be a while before the shuttle becomes the airline of space, the idea that ordinary people—not just super-trained astronauts—can orbit the Earth is no longer a dream. It is only a matter of time, if the government properly develops this great

new tool, until the shuttle opens to travel the near reaches of space in the same way the airplane has opened the air immediately above the Earth.[19]

Similarly, the *Chicago Tribune* looked forward to routine shuttle flights, "whizzing around the Earth every 90 minutes . . . In the end, that is the whole purpose of the shuttle: providing man with an airline service to the heavens."[20] Picking up on the "airline service" analogy, *Time* magazine noted, "If commercial clients sign up in sufficient numbers, NASA plans to launch more than 400 shuttle missions in the next ten years. It has even considered subcontracting shuttle operations to airlines, and United Airlines has expressed an interest."[21]

The New York Times asked aerospace executive Peter Glaser to comment on the significance of the shuttle's first mission. "Even if the shuttle had only gone up and down and landed," explained Dr. Glaser, "it would have been equivalent to what the Wright brothers did. Its significance surpasses that of the Moon landing."[22]

Dr. Glazer happened to possess a vision that went far beyond the flags and footprints left by the Apollo missions. He saw a day when the shuttle fleet would ferry workers and supplies to orbit to construct Solar Power Satellites to transmit energy to power grids on Earth. Conceptual studies by the Boeing Company and Rockwell International concluded as many as 450 "space hard hats" would be required to assemble these celestial power stations.

Two weeks after the STS-1 landing, President Reagan nominated General Dynamics executive James M. Beggs to be the new administrator for NASA. With an impressive resume of high positions in both government and industry, Mr. Beggs was seen as the perfect choice to lead NASA into the Shuttle Era. In addition to his executive experience, he was an articulate speaker with a knack for seasoning his speeches with appropriate lines from Shakespeare. With James Beggs at the helm, we didn't worry if our dream to fly was "to be or not to be."

We Are Without a Procedure

The second test flight of Columbia blasted off on November 12, 1981, with Joe Engle and Richard Truly at the controls. On the second day of the journey, Ronald Reagan became the first U.S. President to visit Mission Control at JSC while a flight was in progress. The administration's interest in space was further demonstrated just two days later on November 15 when Vice President George Bush also paid a visit to the space center. The vice president saluted the employees as "a national treasure," but also told them not to expect any relief regarding NASA's financial concerns.[23] This was a major disappointment, to say the least. With Carter gone and Reagan's expressed interest in space, NASA hoped the days of fiscal austerity were behind them. Vice President Bush made it clear; some things weren't about to change.

While government agents fretted over money, the public started to jockey for a seat on a future shuttle flight. Columbia's two successful missions had unleashed another flurry of correspondence to NASA, and Administrator Beggs was besieged with requests from adoring fans. "There had been a whole series of letters from various and sundry individuals . . . (and) a number of people visited me," Beggs recalled. "They suggested they would like to fly, they or somebody from their organization . . . everybody from the Boy Scouts on."[24]

For a moment, the idea of sending a brave, thrifty, clean, and reverent scout into orbit appealed to the new administrator. "The Boy Scout story, I think, is compelling, or was to me," admitted Beggs. "Someone from the national headquarters came by. His point was that Boy Scouts had participated in any number of exploratory activities . . . with Admiral Byrd on his polar expeditions . . . and others."[25] The individual who came by may have been Sanford N. McDonnell, chief executive officer of the McDonnell Douglas Corporation and president of the Boy Scouts of America. He had written to Beggs recommending that an Eagle Scout be given "serious

consideration" to fly on the shuttle.[26] You have to admit, being assigned to a crew of a space shuttle mission would qualify as one heck of a merit badge.

The Boy Scouts weren't the only ones who offered compelling reasons to fly. Once again, the 21-year-old idea of flying a *National Geographic* reporter made it to the desk of the administrator. It looked as though the Geographic expedition might actually get off the ground this time around. Beggs indicated he had originally thought of sending a photojournalist from *National Geographic*. "But as we discussed things," he recollected, "it became clear that there should be a selection process."[27] Managers from the public affairs office had convinced him other publications were sure to raise a ruckus if a Nat Geo reporter were to be singled out for the coveted flight.

Weary of the growing stack of requests and pleas for personal meetings from individual citizens, heads of organizations, and self-appointed VIPs, Beggs decided it was time to establish a formal mechanism to address the issue of passenger flights. In February 1982, he turned to the NASA Advisory Council (NAC) for assistance. He told NAC Chairman Daniel Fink, "As we approach the operational phase of our shuttle system, we are going to be confronted with difficult problems of selecting from a very large list of private citizens and those who will be permitted to fly on the shuttle. Indeed, the applications are already coming in and we are without a procedure to handle them."[28]

To develop a set of procedures, Fink established the "Informal Task Force for the Study of Issues in Selecting Private Citizens for Space Shuttle Flight." This bureaucratic mouthful became more simply known as the Citizens in Space Task Force.

The Citizen in Space Task Force began its work in July 1982, just as the fourth Orbital Flight Test concluded and as the shuttle was declared "operational." (As previously noted, NASA originally planned

six flight tests of the new spaceship, but reduced the requirement to four.) To mark the end of the successful test flights, President Reagan and half-a-million shuttle patriots were on hand at Edwards Air Force Base for the July 4th landing ceremony of STS-4. There seemed to be shuttles everywhere. Columbia was on the landing strip surrounded by a convoy of service vehicles to detox the orbiter. Across the field on top of the Boeing 747 shuttle carrier aircraft was Challenger, waiting to be ferried to the launch site in Florida. Even the non-orbiting Enterprise was towed out of the hanger for the occasion. With royal blue carpet tacked to its wings, Enterprise was transformed from an impotent spacecraft into a presidential platform.

From this impressive perch, Reagan declared the Space Transportation System to be "operational" and "authorized" Challenger's departure. If you didn't feel a surge of optimism for the dream of space flight in the middle of this Michael Deaver production, you had to be made of stone. (Deaver was Reagan's deputy chief of staff and known for his excellence in staging memorable presidential hooplas.)

Commenting on the success of the four Orbital Flight Tests, the *San Diego Union* proclaimed, "NASA's present goal of 26 shuttle missions per year may still be some time away, but Columbia's success shows that achieving this benchmark is well within the bounds of existing technology."[29]

Did they just say 26 flights a year? What happened to the previously revised projected annual rate of 30? The higher flight rate had given way to the restricted budget environment and the longer than expected turn-around time to prepare an orbiter for a subsequent flight. At the STS-4 post-landing press conference, Shuttle Program Manager Glynn Lunney even admitted that the rate of 26 flights per year wouldn't occur until the late 80s. He told reporters that for the time being, NASA would do well to accomplish *one* launch per month.[30]

The decreasing flight rate was of no concern to the Citizen in Space Task Force. They focused their attention on four other considerations: how to select a private citizen, the rationale for flying a non-astronaut, the passenger's role during a mission, and the medical and training requirements.

Dr. John Naugle, a former chief scientist of NASA, served as leader of the Task Force. Having played a key role in the development of the selection criteria for mission specialists, Dr. Naugle was no stranger to the delicate issue of expanding flight opportunities beyond test pilots. Additional Task Force members included author James Michener, NASA historian Dr. Sylvia Fries, political pollster Florence Skelly, and Lockheed engineer Willis Hawkins.

Based on his experience with the mission specialist campaign, Dr. Naugle was quick to enlist the cooperation of the Astronaut Office. To represent the views of the corps and gain their early buy-in, astronaut Richard Truly, the pilot on STS-2, was added to the team. Naugle also recognized the need for additional expertise in understanding NASA's policies on public access to space operations. To cover these issues, Julian Scherr, the coordinator of the agency's public affairs activities during Apollo, was brought on board.

Over the next six months, the Task Force traveled to NASA's field installations for briefings from shuttle managers, medical personnel, and astronauts. Throughout these presentations, they found no insurmountable obstacles to prohibit the participation of a citizen on a shuttle flight. With no showstoppers to the basic concept, the Task Force next turned its attention to the question, "Was it desirable?"

Send in The Clowns

Florence Skelly suggested the Task Force consult the nation's opinion leaders to determine the desirability of sending civilians into orbit. In December 1982, letters were sent to over 200 "recognized leaders in aerospace; science and technology; business, finance,

and labor; media; the arts; history and the social sciences; university administration; exploration and outpost management; politics and government; philosophy and religion; and public opinion and public relations."[31] An impressive 60% of those contacted responded to the Task Force request.

The solicitation identified several possible purposes a citizen flight might serve: "the expansion of human knowledge; contribution to human culture; education of the public; and stimulation of interest in the use of the space shuttle." These purposes could be accomplished with the "selection of persons from the media or of authors, artists, musicians, educators, business people and leaders from other professions . . . "[32] What did the opinion leaders think?

NASA's first administrator, Dr. T. Keith Glennan, believed the whole idea of flying passengers by the mid-'80s was premature because "no single manned flight as yet flown has been trouble-free." Since "the shuttle is not yet a 'common carrier,' Dr. Glennan thought the Task Force should first determine "the flight reliability criteria that must be met before serious consideration be given to the problems of selecting possible passengers."[33]

Another former administrator, Dr. Robert Frosch, supported the general concept but felt NASA should consider two separate programs for passengers. He suggested the "general public" be given an opportunity to participate through a national lottery. A second "special invitation program" could be established for individuals in nontechnical positions who could "use the experience as material or inspiration for a creative act." This category was intended for "authors, poets, artists, sculptors or dancers (A Zero-G dance might be an interesting and useful performance to attempt to put on video)."[34] Frosch thought this category could also be geared to journalists, media people, sociologists and psychologists. In return for the flight, these special-invitation passengers would be expected to produce a creative work for public consumption.

Dr. Frosch also felt before NASA committed itself to a flight program for civilians, it had better have a clear plan for flying the professional astronauts: "If we were to fly many private citizens in a general way before giving flight opportunities to our trained personnel, I think we would have put the program in a very peculiar position."[35] There were astronauts who had been waiting in the wings since the 1960s, and it was understandable that they might not think much of some ballerina cutting in line to perform *Swan Lake* in zero-g.

In his response, Princeton physicist Freeman Dyson said the objective of the citizen flight opportunity ought to be to have fun! "The primary purpose should be for public education and entertainment," he advised, "and these things are better done together than separately." Professor Dyson thought "the ideal passenger would be Charlie Chaplin or Woody Allen, somebody who could convey a sense of the greatness of space indirectly by focusing upon human absurdities. Above all, pomposity and solemnity are to be avoided. A good clown is what you need."[36]

Explorer Thor Heyerdahl seconded Dyson's emphasis on humor. The Kon Tiki captain based this opinion on his "considerable experience in keeping men together in cramped quarters for months at a time." He believed a shuttle passenger might experience "expedition fever," which he described as a "mental state of unbalance and nervous tension that in some cases may change the normal behavior of even the most amiable person if he finds himself in an abnormal situation unable to return home to the daily routine, diet, and family." Solid leadership and proper training could help lessen the impact of expedition fever, but in Heyerdahl's opinion, "The best medicine is a good laugh." He had learned that "a sense of humor is more important than almost any other mental or physical feature to look for when one selects long-time travel companions in cramped quarters under conditions of stress."[37]

Author Norman Mailer felt the "proposed civilian program is what

we have come to expect from NASA, and that is fine, detailed preparation, thoroughness, and that high degree of competence which is fairly called excellence." However, he thought one element of the plan might "boomerang in the press." Mailer was concerned about the requirement for passenger candidates to undergo an FBI investigation. What was NASA afraid of? Being concerned about "sabotage by people so evil-intentioned as to wish to wreck the program is certainly a most paranoid vision," and might bring back "unhappy memories of the . . . McCarthy period." He believed NASA already suffered from an image of being "stuffy, bureaucratic, hidebound and overcautious." Requiring civilian loyalty checks would only add to that impression. Mailer further believed one reason Americans were losing interest in the space program was that NASA was perceived "as a private and intolerably starchy club."[38]

In his 1969 Apollo 11 chronicle *A Fire on the Moon*, Mailer looked forward to a day when a non-astronaut, like himself, might venture into space: "If space was benign . . . and artists would yet be voyaging with the astronauts, think of the happy day when he would nominate himself to be the first writer to visit the Moon. (Not a chance! NASA would opt for (John) Updike!)."[39]

Scientific America editor Dennis Flannigan thought Mailer was exactly the kind of writer who should go. In his letter to the Task Force, Flannigan expressed the belief that Mailer had "been exposed to a fair amount of science and technology in his education" and surmised, "His imaginative account will be an informed one."[40]

Former Apollo astronaut Bill Anders advised the Task Force to "Be wary of PR gimmicks; e.g. poster child zero gravity, punk rock star in orbit, creationist over the firmament, poet at apogee, etc." A true believer in keeping the club intolerably starchy, Anders felt a good case could be made for sending senior NASA and DOD managers, key members of Congress, and aerospace executives "for the experience and perspective they would gain."[41]

An equally exclusive idea came from Dr. Riccardo Giacconi, a prominent space scientist from Johns Hopkins University. He thought NASA could encourage private enterprise in space by fostering the creation of Shuttle Clubs, similar to the New York Yacht Club. "What I have in mind," suggested Giacconi, "is to attract wealthy individuals who may be in position to raise significant funds, and to send some of their numbers up in space much as they succeeded in providing sailing ships to compete in the Americas Cup."[42] This might expand flight opportunities beyond test pilots, but only if you happened to be in the top one percent. As we will see, Giacconi's idea also proved to be extremely foretelling.

Space historian Melvin Kranzberg concluded that the described citizen opportunity leaned toward "a promotional effort rather than a true contribution to the Shuttle's manifold missions." The Georgia Tech professor preferred flights be presented to "someone who is of a scientific and technological bent and whose professional development would be furthered by a voyage on the shuttle." He believed someone like Carl Sagan might satisfy a scientific-technological emphasis as well as a public relations program. "Alas," wrote Professor Kranzberg, "there are not enough Carl Sagans who can satisfy both the scientific and the public relations requirement."[43]

Joseph Gavin, former president of the Grumman Corporation and responsible for the development of the Apollo lunar module, looked beyond the selection criteria and offered advice that was also prophetic. Commenting on the risks of space flight, Gavin advised NASA to determine the limit of the government's liability in the event of a catastrophe, and instruct passenger candidates to check their insurance policies.[44]

Aerospace executive Arthur Kantrowitz didn't think the flight of private citizens should be pursued—period. He believed, "Opponents will seize on the passenger idea as evidence of the bankruptcy of the space program. They will find that the opportunity had to be

given away because it was so expensive that it could not be sold. This will add to the erroneous notion that expansion of the space effort is not economical."[45] Given the rising costs associated with space flight, Kantrowitz's concern wasn't such an erroneous notion; a trip on the space shuttle was expensive, and it could *not* be sold.

The opinion leaders were also asked to comment on whether a lottery or a peer review process might be employed for the selection process. The idea of a national lottery had been frequently proposed in the past as an impartial way to select a passenger. Not only was it viewed as being fair to all who were interested, but millions of dollars could be raised to support the space program by charging a modest fee for a ticket (never mind the proceeds would go into the federal general fund and not directly to NASA). Freeman Dyson liked a lottery because "we have peer review in science and it is far more trouble than it is worth. It generally favors mediocrity and it is not perceived to be fair."[46]

Most of the opinion leaders, however, opposed the idea of a lottery drawing. Dr. Glennan thought, "A national lottery would be expensive and enormously difficult. What a circus would result."[47] U.S. Chamber of Commerce President Richard Lesher advised not to resort to gimmicks like a lottery, which appeared to make the program seem "less than serious."[48]

Other lottery opponents were worried about the pedigree of the lottery winner. Harvard astrophysicists George Feld opposed the space raffle "on the grounds that it could lead to the flight of an unemployed, undereducated, ne'er-do-well, whose comments on his/her experience would be useless to all but gag writers for TV commercials."[49] *The New York Times* science writer John Noble Wilford believed drawing numbers from a hat was "less likely to result in persons flying who had a particular aptitude for conveying the experience based on background of knowledge as well as a facility for expression."[50] While the shuttle belongs to the American people, let's not get carried away with letting just any schmos on board.

The most frequently mentioned concern of the opinion leaders was ensuring the space program not be trivialized by the flight of a non-astronaut. Respondents cautioned NASA not to allow the program to become "a spectacle" or be viewed as a "publicity stunt."[51]

Was the achievement of a certain degree of publicity necessarily such a bad thing? Task Force member James Michener didn't think so. In his letter to Dr. Naugle, Michener observed, "I think that what NASA will always need badly is some respectable media event to keep reminding our citizens of what is happening in space . . . Even the noblest of man's aspirations can profit from a properly guarded media event now and then . . . "[52]

My former boss, Barbara Hubbard of the Committee for the Future, was reluctant to offer specific selection advice because she personally wanted to experience space flight. In her response she stated, "It would be inappropriate for a candidate such as myself to be setting selection criteria, since I would without question be thinking of someone just like me!"[53] She did, however, want to bring to the attention of the Task Force that "It is not only the qualifications of the individual, but the purpose of the event that must be considered."[54] She believed the first passenger could be a stimulus for a profound planetary experience of potential and hope. She was determined to take us all on a leap up the evolutionary spiral.

Not all of the opinion leaders contacted by NASA felt comfortable weighing in on the topic. Political strategist and advisor to presidents Robert Strauss offered a rare and refreshing admission: "It finally occurred to me that the best thing I can do is simply tell you I don't feel confident in offering an opinion in a subject where I have no competence."[55]

While numerous journalists were eager to offer their views, *The Washington Post* columnist Meg Greenfield declined to participate in the solicitation. Greenfield felt her job "is one in which dispensing counsel to government would be a very poor idea."[56]

The opinion leaders consulted by the Task Force were not the only ones offering advice on the idea of citizens in space. My former FASST colleague Leonard David recommended that the deliberations of the task force "be scoped to consider the far-term prospect of multiple passenger spaceflight, e.g. space tourism."[57] He attached several articles highlighting near-term predictions for a time when up to 68 people might fly in a special module in the shuttle's cargo bay.

In *Space World* magazine, David wrote an article about Tom Rogers' recent thoughts on the need for broader public participation on shuttle missions. Still carrying the torch he lit in 1976, Rogers proclaimed, "We must not end up perceiving the shuttle as NASA's shuttle. It isn't. I helped to pay . . . the public helped pay, not only in our taxes, but we deferred other things in this society to foster this capability."[58]

The editors of *Space Age Review* also supported Rogers' opinion. In its "Space Shuttle Passenger Project Design Study," the magazine concluded: "The space shuttle belongs to the American people. We should play a major role in determining how it is utilized . . . It is time we assert ourselves and make a commitment: space is for all people, pursuing peaceful, progressive, and productive purposes. The shuttle is our only present means of pursuing these goals."[59]

While the Task Force was hard at work, the public's optimism continued to grow, and not just in the U.S. Asked to comment on the notion to expand shuttle opportunities for the public, Eric Burgess of the British Interplanetary Society said that the "great beauty of getting more people into space would be to get the entrepreneurs out there. These will be the real people who will develop space. Space will not be developed by governments in the final analysis."[60]

The same article reflected the robust optimism that the American Society of Aerospace Pilots (ASAP) had for the demand of future

space flights. Formed in 1981, ASAP predicted 1,000 shuttle pilots would be required in just a few years. Given NASA's plan to have a fleet of four space shuttles and one launch a week, the agency would "soon run out of pilots."[61]

The shuttle may indeed *belong* to the American people, but we were going to have to wait for the Task Force to complete its work to find out if space was truly *for* all people. While we cooled our jets, a milestone occurred in November 1982 when mission specialists took their seats next to test pilots on a shuttle mission. Doctors Joe Allen and William Lenoir, both selected as science-astronauts way back in 1967, were assigned as mission specialists on STS-5. Finally, and from then on, astronauts who had been selected specifically for their science or engineering expertise would routinely fly on shuttle missions.

STS-5 achieved another milestone: the first "operational" space shuttle flight. In the operational phase, astronauts began to deploy satellites and conduct experiments on behalf of paying customers. Two communication satellites were punched out of the cargo bay during the mission. On a television hook-up following the successful deployment of the two satellites, the crew proudly displayed a sign with NASA's new motto: "We Deliver," a proclamation which made it clear the Space Transportation System was open for business.

Our Fact Finding Indicates . . .

A year after they began their work, the Citizens in Space Task Force submitted their final report to Mr. Beggs. Their review had been guided by the assumption that a non-astronaut could fly when the shuttle was operational and routine. Through the course of their study, the members had been briefed by dozens of NASA officials, had polled hundreds of opinion leaders, and had discussed their subject in considerable depth during private meetings. The idea to send non-astronauts into space may have been reviewed before, but no group had been as comprehensive as this Task Force.

Aspiring dreamers and volunteers who had been waiting for the report were ecstatic when they read the key resolution: the flight of non-astronauts on the shuttle was "both feasible and desirable."[62] Provided the opportunity was undertaken to disseminate information on the experience to the public, the Task Force believed the idea of citizens in space was A-OK:

> Ultimately humans expect to live, work, and vacation in space or on the moon or Mars," proclaimed the report's introduction . . . Many want to do so immediately; others recognize that technology and economics will limit such an experience to all but a small fraction of their compatriots, but hold out hope that their children or grandchildren may participate.[63]

NASA had attempted to satisfy this widespread interest in space flight by "providing the maximum possible human participation" in its missions.[64] For the most part, this had consisted of gaining vicarious thrills through the astronauts' exploits. We would finally enter an era when some of us would experience the journey beyond the vicarious.

While the first astronauts were highly trained test pilots, the report pointed out, "The Shuttle opens a new era for human participation in space flight." As part of this era, "A modest program to fly private citizens as observers" could be initiated as a first step, which would help determine "how to make the best use of further opportunities."[65] These observers would participate in a shuttle flight and then come back to communicate what a mind-blowing experience we knew it must be.

For the initial program, the Task Force recommended three examples of observers:

- Observer/communicator, such as a television broadcaster to provide a comprehensive visual history and real time report from orbit
- Observer/communicator category to included print journalists or

writers to provide a narrative and interpretative history of the experience.

■ Educators who could use the shuttle experience as a classroom to teach science, engineering, and biological principles of space flight.

The Task Force recommended an evaluation process for candidates, and if necessary, a lottery could be instituted to select the finalist.

In agreement with the group that examined the Unique Personality program back in 1976, the Task Force also based its rationale to choose a communicator on the direction in the Space Act "to provide for the widest practicable and appropriate dissemination of information concerning its activities and the results thereof."[66]

After a few of these communicators had the chance to fly, the Task Force recommended that NASA consider sending people for other purposes and from a broader spectrum of the public. In their estimation, it seemed reasonable to fly three or four passengers on missions in the mid-to late-1980s.

What We Have Here is a Failure to Communicate

In addition to the direction in the Space Act, there was a reason the Task Force focused so strongly on communications as the compelling rationale to fly a civilian. Since the beginning of human space missions, astronauts had collectively given thousands of speeches, Congressional testimony, and media interviews. Despite this extraordinary track record of public outreach activities, some critics felt astronaut travel logs were boring and lacking of emotion. Why were they so damned reserved?

Commenting on the narrow dimension of space flight as described by astronauts, historian Bruce Mazlish reflected on the early astronauts:

They never quite captured the American imagination . . . Backed up by an indispensable team of thousands, (the astronauts) were

themselves utterly interchangeable, like ball bearings, or members of the Rockettes. In space, moreover, the astronauts somehow seemed dehumanized, their language at once bland and arcane, their humor forced, their behavior programmed.[67]

Robert Sherrod, one of the *Life* magazine writers who had been covering astronauts since Mercury, described them much the same: "The astronauts came out, as usual, deodorized, plasticized, and homogenized, without anybody quite intending it that way."[68]

In short, when it came to describing the actual experience of space flight, the astronauts came up, well, short. We wanted them to inspire us with their stories of the glory of space—to bring us stirring prose, not just one-word descriptors like "fantastic." Where was the poetry? In supporting the notion of citizen flight, James Michener was "Mindful of the fact that the Portuguese poet Camonens gave real significance to de Gamma's explorations in Asia and that St. Exupery told us what early aviation flight was all about."[69]

Thomas Tuley, editor of *The Evansville Press* may have perfectly summed up our expectations when he admitted, "Although I have read many fine accounts by astronauts . . . I can't say I've honestly read a single one that conveys the feelings that must be there when man sheds his earthly shackles and steps into that twinkling world."[70]

Joe Allen made a bold attempt to account for his feelings as an astronaut in his book, *Entering Space*.[71] Selected as a science astronaut in 1967, Allen reflected on his two shuttle flights, including a mission when he single-handedly captured a communication satellite and wrestled it into the shuttle's cargo bay for repairs. Despite Allen's valiant attempt to share his feelings, high school English teacher Noelle Wyckoff of Liverpool, New York felt his account was too scientific. "Even his degree is in the sciences, not the arts," complained Ms. Wyckoff, "and his tendency is to look at the experiences as a scientist. The wonder and awe are there, but a non-literary background hampers his descriptions."[72]

Cartoonist Berkeley Breathed offered further justification to send a communicator. In his Sunday comic strip, "Bloom County," Breathed depicted Opus the penguin and Steve Dallas the lawyer on the flight deck of the shuttle. When asked by Mission Control to describe the scene, Dallas replies, "Super! Just incredible! . . . Man oh Man . . . really . . . uh . . ." "Super?" suggests Opus. ". . . Super . . . looks like a great big globe." Opus sighs, "We'll get some poets up here yet."[73]

Not everyone wanted the astronauts to come across as disciples of the New Age. Years earlier, while commenting on the success of the first shuttle mission, conservative columnist R. Emmett Tyrell Jr. saluted astronauts John Young and Robert Crippen for not coming back as a couple of delicate flower children. As Tyrell decreed in *The Washington Post*:

> They climbed into space on a rocket still untried. After 800,000 nautical miles, they burst back into Earth's atmosphere and guided the Columbia to a runway landing—the first of its kind . . . Not once did they assail us the bizarre oratory of the New Age, the personal confessions, the embarrassing auto-psychologizing, the inane gibbering how one's life is now changed or how one is growing and experiencing. Phew![74]

With a professional communicator destined for flight, the burden to ignite our spirits and fuel our imaginations would now be passed to someone other than those stuffy astronauts. Would a journalist, television news reporter, or a teacher succeed where the Messengers of God had failed? Whether they would come back with New Age oratory or new metaphors, a communicator would at least offer a view through non-astronaut eyes. During their post-flight tours, they had better come packing better prose than "fantastic" or "neat."

You've Come A Long Way, Baby

The Citizens in Space report was delivered while the seventh shuttle mission was in orbit. The first space flight to carry a crew of five,

STS-7 was billed as "the largest human payload in the history of the Space Age." More significant, however, was the fact one of those humans was Dr. Sally Ride, the first American woman to boldly go where only American men had gone before.

This milestone to femininity quickly overshadowed the actual mission objectives, which included the deployment of two satellites and the first demonstration of Canada's Shuttle Remote Manipulator System, better known as the Canadarm. Dr. Ride's job was to operate the robotic appendage designed to toss and retrieve instruments and satellites from the cargo bay. At a preflight briefing, the press asked her the same kinds of inane questions Jerrie Cobb heard 20 years earlier. What was she trying to prove? How did it feel to be working in a man's world? Did she cook? Did she weep during moments of crises?

After her flight, Ride confirmed what we already assumed: "Weightlessness is fun! The best way to describe it personally was that I felt like that's where I belonged."[75] Jacqueline Cochran had not lived to see a woman achieve orbit, but Jerrie Cobb, Jane Hart, and the remaining members of the FLATS sorority must have watched Ride's exploits with some degree of satisfaction. They had known all along that women "belonged" in space. It had taken 22 years to break through the gender barrier, but soon no one would give a second thought to seeing women on shuttle crews. As Astronaut Anna Fisher had promised shortly after the first women were selected as mission specialists, "We're just the beginning: In the future we will see women as shuttle *pilots*. We're here to stay!"[76]

A little more than a month after Sally Ride became "a footnote in history and a trivia question," Guion Bluford Jr. became the first African American to fly in space on STS-8. Just as Dr. Ride's flight had been viewed as a boost to the women's movement, Bluford's blastoff brought tremendous pride to African Americans. They had waited a long time to see their reflection in orbit.

207

During the STS-8 mission, the crew participated in the first on-board press conference. ABC reporter Lynn Sherr asked mission Commander Richard Truly how he "would have liked having a passenger on board." Truly's response was encouraging: "I do think in the future we can safely and easily fly private citizens in space with proper introduction and preparation. I don't think on this flight we would have any problem with one. As a matter of fact, this probably would have been a nice one to have a passenger, a citizen, with us."[77]

STS-8 pilot Dan Brandenstein later recalled that they lacked significant experience in conducting shuttle missions: "STS-8 was a transition point between the early flights where we didn't really know what we were getting into, to the later flights where we were really starting to pack them full of scientific experiments and on board activities . . . Looking back at STS-8, we did have a fair amount of free time . . . Everything was going well and we weren't taxed too much."[78]

The New York Times didn't think the shuttle was taxed too much either. Despite the successful missions to date, the *Times* considered the Space Transportation System as a technical marvel without a decisive mission: "Until it has more serious work to do, why not expand the passenger function?" From their perspective, "The idea of citizen astronauts should appeal to more than those who want to try it. All the public knows of space so far has been conveyed by an elite corps of technical experts . . . What would a poet say . . .? What would a painter see . . .? Let it nurture human imagination."[79]

One frightening "first" received considerable scrutiny in the months following the STS-8 mission. It was discovered that the three-inch coating inside the nozzle of one of the shuttle's Solid Rocket Boosters had burned down to .2 inches. In an interview with CBS News, Dan Brandenstein hypothesized that had the engines fired 2.7 seconds longer, it would have "spelled curtains for the crew."[80] A senior NASA official asserted that Brandenstein's prognosis was "conjec-

ture," but did admit that a burn-through might have occurred in another 20 seconds.[81]

In the meantime, the aperture had further widened for payload specialists. NASA decided that the category created a unique marketing tool to entice customers to use other shuttle services. In October 1982, Administrator Beggs informed a congressional oversight committee that the payload specialist policy would be expanded beyond Spacelab missions and offered as an incentive for domestic and foreign satellite customers.[82] If a company signed a contract to launch a payload on the shuttle, it would be entitled to send a representative of its choosing along on the mission as a payload specialist.

This incentive was deemed necessary for a couple of reasons. First, the Reagan Administration had served notice: Now with an operational shuttle, human space flight would become more cost-effective and self-supporting. Revenues from satellite customers would be earmarked to supplant congressional appropriations for NASA's budget. This provided NASA with encouragement to fill the shuttle's cargo manifest with lots of satellites. Second, the space shuttle faced competition from Ariane, a new expendable launch vehicle developed by a consortium of European countries and their sales representatives who were aggressively courting NASA's traditional customers. With revenues of up to $52 million per satellite at stake, the competition between the two launch systems was robust.

Equipped with the payload specialist offer, NASA's launch service managers were armed with a marketing tool the competition could not match. Ariane might be able to offer a competitive launch price, but as an expendable vehicle, it couldn't possibly provide its clients with a bird's eye view of Earth from orbit. Chet Lee, who headed NASA's Customer Service Office at the time, believed the payload specialist gratuity made the difference in winning launch contracts with customers from Canada, Mexico, the United Kingdom, and the Arabsat League.[83]

For the foreign satellite customers, the allure of flying a payload specialist was easy to understand. A flight of one of their citizens in space provided recognition and prestige previously reserved for the United States and the Soviet Union. Over the previous few years, the Russians scored political points by flying non-Soviets through a Guest Cosmonaut Program. When the Soviet program reached out beyond the Iron Curtain to invite France as a guest, America's payload specialist opportunity took on a new dimension as an instrument of foreign policy.

Brazil was the first beneficiary of the foreign policy incentive. Speaking in December 1982 before an audience of businessmen in Sao Paulo, President Reagan proposed "a Brazilian astronaut train with ours so that Brazil and the United States can one day participate in a shuttle launch together as partners in space."[84] Brazilian President Joao Figueiredo was extremely enthusiastic over the invitation. In keeping with the zeitgeist of the Me Decade, President Figueiredo informed Secretary of State George Schultz, "I know just who the first astronaut is going to be: me!"[85]

The positive reception from Brazil prompted NASA to recommend that a similar offer be extended to the People's Republic of China (PRC). A background paper prepared for Secretary of State George Schultz concluded, "With the potential 'warming' of Sino-Chinese relations . . . the Space Shuttle Program may offer an attractive diplomatic initiative for the President. That initiative is to offer to fly one or more Chinese payloads and Chinese astronauts on the Space Shuttle as early as 1984."[86] The paper indicated this would offer "a highly visible gesture of friendship and technical cooperation without the military implications that make U.S. relations with Taiwan more complex."[87]

In a letter transmitting the background paper to Secretary Schultz, Administrator Beggs commented, "I would like to underscore that if this option serves the nation's interest and is agreeable to the PRC,

NASA could easily implement it immediately, with a dramatic, public display of a foreign policy initiative . . . "[88] It took a while for the proposal to work through all the diplomatic hoops and hurdles, but the offer to China was eventually announced in April 1984.

Italy also received a payload specialist invitation. The White House had directed the Department of State to identify options "to reward Italy in a visible way for their cooperation on several sensitive issues affecting NATO."[89] Working with NASA, the diplomats determined a payload specialist opportunity could be worked into a joint U.S.-Italian Tether Satellite experiment scheduled to fly in the mid-1980s. Maxwell Rabb, the U.S. Ambassador to Italy, was "extremely pleased" with the initiative and felt that America and Italy hadn't taken such "brave steps" since World War I.[90]

Our neighbors to the North ended up with invitations to send citizens on three shuttle flights. One seat was offered as part of the marketing incentive to deploy a Canadian communication satellite, while two additional opportunities were awarded in recognition for the development of the shuttle's Canadarm. Confident additional flight opportunities would be forthcoming, Canadian space officials established their own astronaut corps and selected six candidates for training.

The first non-American to fly as a payload specialist was Ulf Merbold of West Germany. On STS-9, Merbold performed experiments on the first flight of the Spacelab module. The mission carried six crewmembers, the largest to date. Merbold, however, didn't find this to be an equitable distribution. He believed since the European Space Agency had developed and built Spacelab, they were entitled to more significant representation.

Not long after his mission, Merbold called for more European crewmembers on future missions. In his estimation, "The politicians . . . will not be able to sell European participation in the future because

there is not enough balance . . . The Memo of Understanding called for joint space flights by Europeans and Americans, not _one_ European and _many_ Americans. I think America has to re-think this agreement to make it fairer."[91] America had no interest in rethinking the agreement, and U.S. astronauts continued to dominate the crews of Spacelab missions.

The responsibility to manage shuttle missions and train the crews rested with government and contract workers at JSC. They began to get very uneasy over the number of payload specialist commitments being tossed about to countries and companies. Managers in Houston were concerned that the weenies in Washington were not giving sufficient consideration to the "practical problems" of flying non-astronauts. These considerations involved mission timelines, crew selection and compatibility, training requirements and schedules, and the availability of training facilities.

JSC reminded NASA Headquarters that the number of non-astronaut "seats" available on each mission had been modified. Prior to STS-1, shuttle managers assumed three astronauts could handle mission operations, leaving four seats for "passengers." Actual flight experience demonstrated the need to increase the number of professional astronauts to four.

A memorandum from JSC's Associate Director Henry Clements to Acting Associate Administrator Robert F. Allnutt advised Headquarters:

> We define the crew of the shuttle as four people, two pilots and two mission specialists, all four American astronauts. We agree that the other three positions on the shuttle can be passengers, payload specialists or payload specialists with mission specialist training. We do not agree that any of the latter three should be substituted for the four crew members.[92]

In time, this seating "agreement" was further modified bringing the number of professional astronauts for each mission to five, there-

by reducing the number of slots for passengers to two. As far as dreamers were concerned, the number of reserved seats for non-interfering passengers was moving in the wrong direction.

Leave the Driving to Us

A month prior to NASA's 25th anniversary in 1983, it implemented a series of internal goals and objectives in support of the National Space Policy. Each of the agency's 21,000 employees received a personal copy of the goals so "all the people in our organization know the things we most want to do in a given period so we can unite and concentrate our efforts to do them."[93]

Employees in NASA's Office of Space Flight paid particular attention to the goal to "make the Space Transportation System fully operational and cost effective in providing routine access to space." They were challenged with the objective to fly a total of 21 missions in 1984 and 1985. NASA officials believed the successful accomplishment of this goal would go a long way toward the Reagan Administration's desire to transfer a larger share of space shuttle operations to the private sector.

Since shuttle missions absorbed the lion's share of NASA's resources and management attention, there was much support for privatization. Once the flight rate built up to 20 or 24 launches per year, it was going to become more and more difficult to devote appropriate attention to NASA's other goals such as science research, technology development, and aeronautics.

Management alternatives for shuttle operations had been bandied about for years. The options ranged from quasi-government entities to the establishment of a strictly private company. Regardless which option was adopted, NASA hoped a private company could demonstrate an operational capability and complete a transition by the mid 1980s. Lt. Gen. James Abrahamson (USAF Ret.), the head

of the Office of Space Flight, indicated, "We are trying to build a good solid business. We feel we'll be able to make the transfer to some kind of (private) entity in the 86-87 timeframe."[94]

The NASA Advisory Council was skeptical that this transfer of operations was going to be this easy. Their report on "The Effective Utilization of the Shuttle" cautioned that much remained to be done before the STS could be considered fully operational.[95] Much more operational experience was required to provide reliable and routine launch services. The report also argued the Reagan administration should back off on its insistence that the shuttle pay for itself. The Council believed the preoccupation with commercializing the shuttle distorted more pressing national priorities in space. The "ability to support ancillary commercial ventures in space is of substantial but not overriding importance at this time."[96] These substantial ventures were primarily related to the handful of proposals to advance materials processing experiments in space. For years, this field of research had been hyped, many say over-hyped, as the next breakthrough for space manufacturing and commercialization.

Entrepreneurs such as Planet Earth Productions were interested in commercial space opportunities. Toward the end of 1983, the Canadian company approached NASA with the idea to fly a 40-passenger module in the shuttle's cargo bay.[97] Company President Dean Taylor hoped to finance the venture and the $100 million launch fee through an international lottery. For each flight, he expected to sell two million tickets at $50 apiece. The target date for the first mission was 1986—in time to offer passengers an in-orbit, ringside seat to view the much-anticipated fly-by of Halley's Comet.

Planet Earth was so confident there was money to be made from their venture, they promised, "Any revenues which would normally be construable as profit . . . will be channeled to NASA to support civilian passenger travel on the space shuttle."[98] Despite this generous offer, NASA informed Taylor while the idea had been seriously con-

sidered, "It is not prudent to accept the proposal at this time."[99] The agency told Taylor, "Under NASA's present charter . . . its primary missions are concerned with scientific, technical, and educational endeavors in space. Any other purpose for space flight would have to be subordinated to such purposes."[100]

Orbital passenger service wasn't one of the goals of the National Space Policy.

8 TEACHERS GO TO THE HEAD OF THE CLASS

This agency lives and dies on whether we can attract top talent. A good teacher can have an impact on an individual, not only in his formative years, but all through his life.
James M. Beggs, Teacher in Space Press Conference

The Teacher in Space Program should be the start of a decade-long commitment to upgrade the teaching profession.
Ernest Boyer, *Education Daily*

I have a teacher for the job! It is Mrs. Schweikert. She's smart and loves science. One good reason that I think you should pick her is because we don't want her here.
Florencio Ortiz, Letter to James M. Beggs

The Longest Day

While NASA's Office of Space Flight focused on how to make space shuttle flights "routine" and mulled over options to privatize operations, space dreamers were still cooling their heels at the bar next to the departure gate.

After the Citizen in Space Task Force submitted their recommendations, Administrator Beggs established an internal headquarters committee to develop procedures and policies for the Citizen Observer opportunity. Comprised of senior NASA managers, the first thing that the new committee did was change the name to the Space Flight Participant Program (SFPP). (Appendix A)

The Space Flight Participant Evaluation Committee began its work in February 1984, just after the tenth space shuttle launch. Designated as STS-41B, the flight was considered by many to be the

most ambitious mission to date. Two communication satellites were deployed, though both failed to achieve orbit. Scientific experiments featuring a large balloon were to be performed. Unfortunately, the balloon exploded during inflation in the cargo bay. Five Getaway Specials, those garbage can-size canisters that had raised everyone's hopes years earlier as passenger modules, were mounted on the walls of the cargo bay.

The most memorable event from the mission was mission specialist Bruce McCandless' untethered test drive of the Manned Maneuvering Unit (MMU). With the jet pack strapped to his back, McCandless looked like a modern-day Buck Rogers, zooming some 100 yards away from the orbiter. Some of us still hadn't been able to find a way to fly cargo-class, while McCandless was out there on a five-hour solo flight as a traveling human satellite.

That same month, the plan to fly a non-astronaut began to be thought of more seriously within the agency. Thirteen shuttle missions were identified as potential flights to include a space flight participant. The earliest was STS 41-F, scheduled to launch in August 1984, while the latest was a mission in October 1986.

In March 1984, Lt. Gen. James A. Abrahamson, the head of the Office of Space Flight in charge of the shuttle program, left NASA to lead President Ronald Reagan's "Star Wars" Initiative. Having served as the general's executive officer, I needed a new gig. Fortunately, new Associate Administrator Jesse Moore approved my request to remain with the office and manage the new program to fly a citizen.

Professional journalists continued to assume they would be the automatic choice for the first citizen flight. After all, hadn't they been doing such a great job of chronicling the adventures of the astronauts all these years? Isn't it through the print and broadcast media where most of us receive our minimum daily dose of space news?

Aviation Week & Space Technology magazine writer Craig Covault

shared a rumor regarding an alleged interest by the White House to send a journalist on a space flight as early as STS-7, the flight where Dr. Sally Ride became the first American woman to fly in space. According to his sources, Covault and four other journalists were on a short list. However, due to the aftermath of a minor medical issue with mission specialist Bill Lenoir on the STS-5 mission, shuttle officials decided not to proceed with the flight of a scribe at that time.

I was now the executive secretary of the Space Flight Participant Evaluation Committee, having taken the reigns from Nathaniel Cohen, who had led the effort during the Task Force deliberations. One of our first duties was to review the public comments that had been received on the proposed rules and procedures for the program.

NBC reporter Jay Barbree was among those who responded. Having covered the space program since the Mercury missions, he objected to the idea that any category other than journalist be considered for the first flight:

> I can't help but wonder where these people doing the selecting were when a handful of us were camped out on the beaches getting sand blown in our eyes by Air Force helicopters before we were permitted on the Cape in 1958? . . . We are the handful of journalists who have paid our dues, who have earned the first seat on the Shuttle.[1]

An engineer involved in manufacturing and launching space shuttles was concerned that special interest groups or superficial public relations purposes would improperly use the flight opportunity. He felt it "would be unfair to give some private citizen selected for political purposes the opportunity when there are thousands of engineers and scientists who have worked . . . to make the program a success won't have the opportunity to go into space."[2]

A police sergeant from Stroudsburg, Pennsylvania believed a college

degree wasn't necessary, but common sense was. Age should not be a factor, and applicants should be team players. In his estimation, "Military service should be a determining factor and all war veterans should be given the utmost consideration."[3]

The SFPP committee also consulted with the senior leadership of other agency offices and programs to solicit ideas and proposals regarding the selection process. A Working Group on Education from NASA's Academic Services Division, of which I had been a member, had already given the topic much thought.

In January 1984, the Working Group's final report, "New Initiatives for 1985 and Beyond," recommended that NASA "fly a teacher early in the Citizen Observer Program and in the process, develop a corps of approximately 200 elementary and secondary school teachers who will spend a year or more traveling through the country" educating the public about space.[4]

The idea to fly an educator quickly gained momentum and surpassed any notion of flying a journalist first. In my first print interview with Gannett News in April, 1984, I confirmed that despite rumors, NASA was not keeping "a list" of potential celebrity flyers. I also stated that I'd be disappointed if a celebrity were chosen. Showing my own bias, I mentioned a personal preference for a teacher to fly first. I clarified this was strictly a personal opinion, as the SFPP Evaluation Committee had yet to submit a recommendation on the first category to the administrator.[5]

That month, *Life* magazine also expressed interest in the program, as it initiated research for an article about the kind of training a space flight participant would experience and examples of who it might be. At first, *Life* was going down the tired and inaccurate road that the first participant would be selected from a pool of celebrities. It planned to highlight movie stars and well-known public figures. Since the magazine wouldn't hit the stands until the fall, I

hinted they might want to include a teacher in the lineup. The author of the story, David Friend, took the hint.

Ultimately, the SFPP Committee reached a unanimous decision to recommend that the first participant be selected from among the nation's teachers. On April 4, 1984, Chair Phil Culbertson sent a decision memo to the administrator seeking approval of the committee's recommendation.[6]

Meanwhile, the Sunday supplement magazine, *Family Weekly*, featured a story about the flight opportunity and my role as manager under the title "NASA's 'Travel Agent' Want to Fly With Him?" Since I never missed an episode of one of my favorite TV westerns, *Wagon Train*, I got a kick out of this line in the article written by Howard Rosenberg: "Ladwig is supposed to make sure it all runs smoothly —just like Ward Bond easing homesteaders across the prairie in *Wagon Train*."[7]

The next day, ABC reporter Lynn Sherr dropped by headquarters for my first TV interview on the program. A few years earlier, Sherr had conducted my first national TV interview on the Shuttle Student Involvement Program, so I was glad she was assigned to the citizen in space story. Additional interest by the press began to build with much speculation and requests to share our thinking on who would be first. We scrambled to be responsive without committing to a specific category.

While waiting for Beggs to respond to the Culbertson memo but confident the teacher would be approved, the committee turned its attention to the development of rules, eligibility requirements, schedules, and contracting with a respected external organization to conduct the selection process. The Council of Chief State School Officers (CCSSO) was carefully chosen to be our external partner. With its nation-wide network of senior education officials, they were a natural to manage a selection process. CCSSO's Executive

Director William Pierce served as the senior representative, and staff member Terri Rosenblatt was designated as my counterpart to manage the program.

Before things got too far along, there were significant legal issues to address. In June, Robert Berman of NASA's General Counsel Office was anxious to draft a legal agreement for the eventual participant, but felt it couldn't be done properly without knowing the specific category. This was yet another reason why we were anxious for a decision from Mr. Beggs.

Frustrated that he still had not heard back from the administrator, Culbertson sent another memo. He reported that opportunities had been identified for a participant mission in late 1985 and stressed a decision was needed to prepare for the flight. "If you agree," Culbertson wrote, "please sign on the concurrence line. If not, give us further guidance."[8]

On June 21, 1984, Beggs finally concurred on the recommendation that a teacher be the first space flight participant. At the bottom of the memo, Beggs scribbled, "Longest day of the year." Initially, I thought this referred to what a hard decision it must have been for him to make. It wasn't until a few years later, and much to my embarrassment, a friend reminded me that June 21 *is* the longest day of the year.

Although a teacher would go first, an announcement of the decision was withheld. NASA's political appointees felt this would be a wonderful opportunity to gain visibility for the agency with their patron, the president. Other than the STS-4 ceremony, Ronald Reagan's administration had not been significantly involved with NASA activities. As Administrator Beggs reflected years later, "The Reagan White House didn't exercise a strong hand on NASA. They had no real science or technology expertise on the staff so they never interfered."[9]

None of the previous astronaut categories had required a presidential proclamation. Even though he was instrumental in deciding the first astronauts would come from the ranks of test pilots, President Eisenhower didn't announce the search for the Mercury Seven. The announcements for the opportunities for scientists, mission specialists, and corporate payload specialists didn't require an Oval Office proclamation. However, the political appointees believed the historic nature of SFPP justified a decree from Reagan. Besides, the president was up for re-election, and the National Education Association (NEA) had endorsed his rival, Senator Walter Mondale. Being able to announce a teacher for the first citizen flight overflowed with great optics and a chance to show his support of educators.

As soon as it was decided the president would make the announcement, we were not allowed to pursue significant planning for fear the category would be leaked to the press. Getting ahead of a presidential proclamation was frowned on. The modest level of planning by NASA and the CCSSO was pursued on the quiet.

While waiting on the White House, NASA announced payload specialist assignments for a Navy oceanographer, a Frenchman, and a citizen of Mexico. Several corporate payload specialists were also named, including two from the Hughes Corporation and one from McDonnell Douglas. For the first time, a flight was specifically identified as a possibility for the spaceflight participant—STS-61-C, then scheduled for launch in December 1985.

America's Finest

Finally, the White House found a suitable venue for the declaration. On August 24, 1984, Beggs convened a meeting of the SFPP Evaluation Committee to develop an announcement strategy. He had been informed President Reagan would reveal *his decision* at a Secondary Recognition Program in Washington, DC sponsored by the Department of Education. Immediately following Reagan's speech, NASA was to host a press conference at headquarters to describe the details for the search.

On the morning of August 28, the president traveled across town to Washington Jefferson High School to present an award to the school. Principal Vera White told Reagan that the parents of the students were concerned about the school's aging facilities. He brushed off their concerns by stating the schools he attended had been in worse condition and none had libraries. With no commitment to assist Principal White, he retorted, "I think the facilities aren't nearly as important as the humanity in the facilities."[10]

On that supportive note, they proceeded to the gym where the award was to be presented. At the end of his presentation speech, Reagan proclaimed, "It has long been a goal of our space program to some day carry citizen passengers into space. Until now, we had not decided who the first citizen passenger would be. But today, I am directing NASA to begin a search in all our elementary and secondary schools and to choose as the first citizen passenger in the history of our space program one of America's finest—a teacher. When the shuttle lifts off, all America will be reminded of the crucial role teachers and education play in the life of our nation. I can't think of a better lesson for our children and our country."[11] So let it be written, so let it be done; a teacher just zoomed to the head of the class.

Meanwhile Administrator Beggs, Jesse Moore, and I watched the president's announcement on a large video screen along with members of the press in the NASA auditorium. As soon as the president completed his remarks, Beggs kicked off the Teacher in Space (TIS) press conference.

Beggs explained the rationale for selecting a teacher was "to help improve the quality of education in the U.S. These efforts are vital to our future economic leadership in an increasingly competitive and technological world."[12] By the middle of the decade, he hoped NASA would have 15 to 20 shuttle flights a year, which would mean two to three or even four Space Flight Participants. Subsequent flight opportunities might include journalists, artists, and workers from the line.

223

We explained the interested teachers would have to wait to apply until October when the application packet would be available, so there was no need to apply before then. When asked how many teachers might apply, I came up with an estimate of 80,000, given the two million teachers in the country. Ultimately, 40,000 requested the application packet.

We also announced that the selected teacher would receive eight weeks of training along with the other crewmembers. After the flight, the teacher would be expected to work with NASA for a year to visit schools, lecture to education groups, and appear on radio and TV programs.

The following day at the Kennedy Space Center (KSC), we piggy-backed a TIS press conference with the briefings for the STS 41-D mission. During my remarks, several journalists made it clear they were highly irritated that the first participant wasn't going to be a reporter. The most vocal critic was NBC reporter Jay Barbree, who demanded to know what possible good could come from flying a teacher: "The thought of flying a teacher hits me like a cold fish." "Well," I replied, "they must have done something good in their classrooms—just look at the bright journalists in this room."[13]

The 41-D crew included the first corporate payload specialist, Dr. Charles Walker from McDonald Douglas. Walker was on the mission to operate the company's materials processing unit known as the Continuous Flow Electrophoresis System. This experiment was similar to the idea George Low had mentioned years earlier as an attention-grabbing candidate for flight during the Orbital Flight Tests. Experiments performed with the device would hopefully lead to commercial pharmaceutical products.

This was no marketing kickback scheme to entice satellite customers or symbolic gesture like those foreign policy freebies. This was what the payload specialist program was supposed to be about:

a private sector scientist or engineer conducting research in space to create new products for consumption on Earth. As the chief engineer and designer of the experiment apparatus and procedures, Dr. Walker possessed unique skills and knowledge for which a NASA mission specialist could not be easily trained. Because of the nature of the agreement, McDonnell Douglas was not charged for the experiment's transportation costs, but did pay a $78,000 fee to train Walker for the mission.

With his assignment to the mission Walker fulfilled his long-standing dream of space flight. In the mid 1970s, *Co-Evolutionary Quarterly* published a special edition dedicated to the topic of space colonies. Among the essays, speech excerpts, and interviews on the pros and cons of colonizing space appeared a letter from a Bedford, Indiana

In August 1984, McDonnell Douglas engineer Charlie Walker became the first corporate payload specialist to fly on a space shuttle mission.
Photo: NASA

college student. Advocating a progressive space program, the student observed, "A journey of 1,000 miles does not end with the first step. My mind is not Earth-bound, my body doesn't want to be either."[14] That student was Charlie Walker, and his dream and his body eventually caught up with his mind on three separate shuttle missions.

The 41-D mission had been postponed from June when the launch attempt was halted four seconds before liftoff due to a fire in a fuel line—yet another example of the risks associated with space flight.

Teachers Pro and Con

Selecting a teacher wasn't meant to be a cure-all of the nation's education problems. It wouldn't address low teacher pay, deteriorating facilities, or escalating classroom violence. It would, however, bestow long overdue recognition on the importance of educators to the country.

Opinions on flying a teacher were mixed. The National Education Association (NEA), the largest teachers' union that had recently endorsed Walter Mondale for the upcoming presidential election, was underwhelmed. "We don't need to send one teacher into outer space," said Mary Hatwood Futrell, president of the NEA. "We need to send all teachers into their classrooms fully equipped and ready to help students learn."[15]

Scott Widmeyer, a spokesman for the rival American Federation of Teachers who had taken temporary leave to work for Mondale's campaign, conceded that the president's decision to put a teacher in space "certainly isn't a bad idea. Teachers involved in science and technology certainly have the wherewithal to participate in the shuttle program," he said. "But we would certainly question the timing of the announcement, coming as it did two months before the election."[16]

The Boston Globe also saw political relevance to the selection. An op-ed noted that public opinion showed that "education was still something of a national totem. Americans were not as quick as right-wing ideologues were to denounce teachers as taxpayer subsidized ne'er-do-wells."[17] The selection of a teacher honored the totem.

NASA and President Reagan received more than a few letters to protest the selection of a teacher. Most felt a different category should have been given the inaugural nod. Ms. Terry Hashu of Hammond, Indiana explained, "I don't feel a teacher should be the

first to receive this great honor. It is the blue-collar workers that keep this country great."[18] Writing from Bayonne, New Jersey, Peter Sudimack didn't believe a teacher would be a good communicator: "It should be an average type American, not a school teacher. Someone who could explain what he or she really felt in a way that everybody could understand. School teachers have a way of exaggerating things out of proportion."[19]

Many of those who sent in letters felt the first flight opportunity should not single out a specific occupation, but be open to *all* citizens who wanted to fly. Figuring out how to fairly administer a competition open to all comers still makes me weak in the knees.

The nation's educators were, of course, thrilled over the announcement. The White House was besieged with mail from grateful teachers that countered the letters of condemnation. Many teachers must have assumed the president was going to pick the first participant because they attached their resumes to their letters of thanks.

One letter to President Reagan that captured the true essence of the teacher flight came from Robert Stephens of Whitefish, Montana: "To send up an elementary educator on one of these beautiful chariots is to instill and honor the future in our young . . . for them to emulate the first civilian who will be a far voyager is the ultimate encouragement in those young minds, so they may have hope and drive to embrace all the magic that freedom brings."[20]

An editorial in the *Elkhart Truth* also captured the value of sending a teacher: "Somebody is sure to say this is purely symbolic, and complain that riding on a shuttle is no substitute for a raise in pay. That's true, but it is not the point. This isn't meant to settle the discussion about how much teachers ought to be paid."[21] The editorial went on to say:

> A society's symbols do matter. This one is intended to recognize the role of teachers. By the nature of their work, classroom teachers don't produce celebrities. It's a profession often criticized for

its mistakes, but without many channels of recognition for its successes. The visibility will be a morale-booster for people who are thinking about it. Students in classrooms will see a teacher among the TV heroes. How often does that happen? Quibbling about this is hard to understand. It's a strikingly good idea.[22]

More than a few critics felt the whole idea of flying a citizen was nothing but a public relations gimmick. Writing in his *Observer* column for *The New York Times*, satirist Russell Baker complained, "A good teacher would probably be lost to students for an entire year. Worse, the media malarkey in which this wasted schoolteacher would be draped would turn a good schoolteacher into another useless celebrity, adept at breakfast time chatter with David Hartman and Jane Pauley . . ."[23]

Syndicated columnist, Joseph Kraft addressed the "gimmick" complaint from a different perspective. In his view, "The President's decision to make a school teacher the first American civilian in space is a gimmick, but it's a good gimmick. It ties high technology to basic education in a way that can advance the whole society."[24]

Mr. Beggs later admitted, "It obviously had a PR factor, but even Congress asked about it and other groups were supportive. My own view was that the public is paying for the flights and deserved to participate."[25]

Even Mercury astronaut Scott Carpenter, who you will recall was not all that supportive of the idea of women astronauts in the '60s, was now in favor of flying a teacher and other professions. According to Carpenter, "A teacher is a good first choice, but cinematographers should go, musicians should go, poets should go . . . I do my best, but they'd be able to relate it in terms that are more understandable."[6]

Take My Teacher, Please!

Editorial cartoonists had a field day with the selection of a teacher.

Newspapers across the country carried single panels featuring everything from a teacher telling astronauts to sit up straight to correcting their grammar. Showing astronauts bringing an apple to the teacher was drawn more than a few times. Another favorite theme depicted a female teacher standing in front of the classroom, while kids were at their desks writing letters to the president and NASA begging them to take her into space.

The letters to NASA from students nominating their teachers displayed a combination of humor, ill will, and sentimentality. Toni Harrell of Crawfordville, Florida felt his teacher should go because, "She should fill the position on the shuttle so her body can join her mind. It's about time, it's about space, it's about time her body joined her face."[27]

Firth grader Tony Tsao thought his teacher should be selected because "she is very interesting. I can tell because she keeps walking like she is on the Moon . . . On the trip she would keep saying, 'Oh my hair is so greasy,' but who cares? Trust me NASA, she's perfect."[28]

Heather Hardin from San Bruno, California suggested we send her instructor: "This teacher has many talents. She loves jokes and she likes to laugh and she likes to say, 'Oh my stars, oh my stars,' a three-word sentence that shows she should be sent to outer space."[29]

In a nod to equal rights for women, Tiffany Campbell of Phoenix, Arizona reminded us, "Men are not just the ones to go just because they are strong, but women have the same rights as men now, and I say Mrs. Stockett goes."[30] A fellow student also vouched for Mrs. Stockett's character: "She doesn't want to go for the fame, but for America. I think she wants to go because of her loyalty, not like other teachers who are greedy."[31]

While cartoonist were actively poking fun at the antics of students nominating their teachers for a flight, a special opportunity for educators was created at the Huntsville, Alabama-based Space and

Rocket Center, aka, Space Camp. Normally the launch pad for the dreams of young people, the education attraction sponsored a space-training weekend at the end of October 1984 for forty teachers from around the country. Although the Teacher in Space entry rules had not yet been announced, this group of hopefuls was looking for an edge to support their eventual applications.

The Space Camp leadership invited me to come along as an observer-participant. We took turns operating various space simulators. We were also bused down the road to the Marshall Space Flight Center for briefings by shuttle engineers and to tour research and operation facilities.

The New York Times sent a reporter to cover the weekend's activities. In addition to interviewing the participating teachers, the reporter asked me to comment on the broader implications of the first space flight participant opportunity. In a prediction that turned into an eventual reality, I anticipated NASA would want to achieve benefits beyond the flight of one teacher and engage the state finalist beyond the competition. As I informed the reporter, "I hope we will be able to involve them as ambassadors for our educational programs back in their respective states . . . If they make the cut at the state level, it is obvious they are top notch."[32]

Hollywood Squares

As soon as the results of the Citizen in Space Task Force were released, self-anointed VIPs again started banging on the administrator's door. While journalists ranked highest in terms of the profession that thought they deserved to be the first citizen in space, movie stars and celebrities were a close second. If they didn't ask personally, their adoring fans submitted their names to NASA on their behalf.

The previously mentioned article in *Parade* magazine titled "Everyone is Lining Up for Space" predicted, "NASA's first 'Star Wars,'

was likely to occur when the time came to select the first passengers." Herb Rowe, the head of NASA's External Affairs Office, was quoted in the article claiming the agency had maintained a list of people it was considering for the first passenger mission.

If you weren't a celebrity, you didn't need to bother to look for your name on the informal list. Rowe insisted, "The list sort of grew, (and) included Lowell Thomas, Walter Cronkite, Zsa Zsa Gabor, John Denver, Jane Fonda, Barbara Marx Hubbard, Hugh Downs, Robert Redford, Carl Sagan, Sen. Barry Goldwater, James Michener, and Jacques Cousteau."[33] Zsa Zsa Gabor? Ms. Gabor's closest qualification was having starred in the space fiction film *Queen of Outer Space*. She said she would love to go, "but of course it depends upon how many handsome astronauts" would be on the flight. But of course, dahling.

Given the fact that Administrator Beggs had appointed a committee to establish rules for the selection process of the first citizen, Rowe's list was a nonstarter. It only proved that too many NASA managers were infatuated with the hope of meeting celebrities and could have cared less about the dreams of regular people to fly.

Karate Kid actor Robbie Benson wrote to the NASA administrator to ask for a lift, as did the zany TV personality Tiny Tim.[34] The latter wanted permission to marry his fiancé, Miss Vicky, on a future shuttle flight. John Williams thought his brother, singer songwriter Paul Williams deserved to go. In addition to his musical abilities, John promised Paul was in outstanding physical condition and with 400 jumps as a skydiver, he was the ideal candidate. Cartoonist Jim Davis called with an offer to go and tell his story through the eyes of the Sunday funnies cat character *Garfield*.[35]

Bob Hope once talked with Beggs about a flight. However, when he learned it involved eight weeks of training, he said he didn't know where he'd find the time. *Rolling Stone* editor Jann Wenner wanted

NASA to fly *Right Stuff* author Thomas Wolfe "on assignment."[36] I actually thought Wolfe's credentials as author of *The Electric Kool-Aid Acid Test* made for a more compelling rationale.

Omni magazine dispatched reporter Barbara Rowes to identify a potential list of celebrities for NASA to consider. The magazine recommended that candidates be selected not only for their physical qualifications but also for their vision and intellectual range. In an August 1982 article titled "Flight of the Stars," Rowes published her proposed "first passenger list." It, too, included Cronkite and Clarke but also put forward the names of jazz musician Miles Davis; the future Prime Minister of Canada, Pierre Trudeau; Senator William Proxmire (D. WI), who had called the space shuttle a colossal waste of money; Pope John Paul II, who wanted to spread God's message to the firmament; Hollywood producer George Lucas; space colony advocate Gerard K. O'Neill; comedian Richard Pryor; and actors Kate Jackson and Dudley Moore. The list even included the fictional J.R. Ewing of the TV show *Dallas*, and Kermit the Frog's main squeeze, Miss Piggy.[37]

Star Wars producer George Lucas actually did send a letter to NASA. While he recognized we were not yet accepting applications for flights, he wanted us to know "how much it would mean to be a part of the program." He was interested in making a film about the Space Flight Participant Program to "help promote and enhance public awareness of this vital enterprise."[38]

The Lucas letter arrived at the same time we were receiving hundreds of requests a day, and his was overlooked in the deluge. Given the mounting logjam, we could no longer send individual responses and had to revert to a standard form letter. It was therefore somewhat understandable that Lucas was miffed when he received an impersonal reply with no acknowledgement of his offer of help. After he contacted a senior official in NASA public affairs, I was told to follow up with a more appreciative response. Since it was

unclear if he wanted to make the film about a flying citizen or as a shuttle passenger himself, I asked Lucas to clarify what being "part of the program" meant.[39] We never heard back.

Perhaps the most tenacious, not to mention annoying, celebrity was singer John Denver. In September 1982, he wrote to Administrator Beggs outlining "with all modesty," his many qualifications to be the first participant. He was an entertainer, pilot, photographer, scuba diver, TV star, and runner with a name recognized by 97 percent of the country.[40] The administrator told Denver the committee reviewing the feasibility of a citizen in space program would review his letter—and thanks for your interest in the space program.[41]

Clearly on a Rocky Mountain high, he wrote again in 1984, worried that the task force doing the study might not include the category of "Entertainer." Would his interest in the environment, love of the wilderness, concern for world hunger, and belief in world peace not be the perfect fit for the first private citizen in space?[42] He was again told he'd have to wait for the official rules to be established to see if he qualified to apply. But hey, "On a personal note, your upcoming schedule seems exciting and should prove deeply rewarding."[43]

A couple of years later, Denver told anyone who would listen that the entire citizen in space program was his idea. He claimed, had NASA not decided to send a teacher, he would have been a member of the STS 51-L crew. After hearing Denver make this claim numerous times, I asked James Beggs if he ever kept a list of VIPs and if he ever promised a flight to Denver or anyone else. He assured me he did not.[44]

By far, my favorite personal VIP-related encounter had to do with a telephone call from Jack Barish who told me he was a Hollywood press agent. He claimed to have recently met with the manager of singer Michael Jackson regarding a shuttle flight. During the 15-minute conversation, Barish let me know how thrilling it would be to let

Jackson perform an outer space concert. He not only wanted NASA to allow Jackson to sing but also to don a space glove and suit to perform the Moon Walk in the cargo bay of the orbiter. With great gusto and stereotypical Hollywood-agent zeal, he ended the call by asking: "So, what do you say Al, have we got a deal?"[45]

I Pray That NASA Spokesman Is Never a Patient in My Unit

Once the Space Flight Participant Program became official, we heard from and responded to pleas to fly from every profession, age group, and country you can imagine. Given the volume, it is not possible to share excerpts from the thousands of people who submitted their heartfelt appeals. As mentioned, in the beginning we sent individual responses, but before long, we had to switch to a more impersonal form letter rejection. In most cases, the person who submitted the petition seemed to have accepted the rebuff. A few wrote back to ask that we reconsider because perhaps we didn't appreciate all their qualifications or understand their offer to volunteer was quite sincere.

One profession that was not at all happy being left out as an initial SFPP category was America's nurses. As a result of an extremely short article that appeared in the December issue of *RN* (Registered Nurse) magazine, I became embroiled in a prolonged exchange with a considerable number of dreamers from this segment of the health profession. The mini-article noted, "More than 100 nurses have asked to ride on the space shuttle, making nurses one of the professional groups most eager to go into space." The article also mentioned it was unlikely that nurses would get their wish because NASA wanted a passenger who could communicate the space experience. An unnamed NASA spokesman was quoted as saying, "Nursing is not a profession you equate with communication skills."[46]

Letters to the editor in the January issue expressed outrage over the statement that nurses lacked "communication skills." The "misconception" left nurses "speechless." The NASA spokesman

"needed to get the facts straight." One nurse warned, "I pray that NASA spokesman is never a patient in my unit. Please publish the name and address of the NASA spokesman so we can register our objection."[47] They did print the name and address—it was I.

I can't imagine I used the word "skills" when being interviewed for the article, and I certainly didn't believe nurses lacked the ability to communicate. Nurses do an exceptional job of conveying information to patients every single day. My intent was to convey that nurses weren't *usually* compared with communication professionals in the same way as teachers, TV reporters, or journalists. (Talk about someone lacking the ability to communicate.) In any case, the damage was done.

For the next two months, my mailbox runneth over with letters from outraged *RN* readers. I became a reluctant pen pal with over 250 nurses who let me know I was "stupid," "ignorant," "narrow minded," and "not very intelligent." In the diagnosis from one writer, "Obviously a glitch has occurred in a synapse or two in your brain." I was told I owed the nation's nurses an apology and should do all I could to provide a chance for nurses to participate on a future shuttle mission. I shudder to think of the responses I would have received had social media been in use at that time.

I did submit a mea culpa letter to *RN*. In a complete passing of the buck, I explained that none of the internal or external committees that studied the citizens in space "concept over the past 10 years offered the nursing profession on their list of candidate categories for the program."

To let nurses know they were not alone in feeling left out of the process, I explained,

> I hear from a wide range of individuals and professions who believed they were entitled to a shuttle ride. From 9 to 99 year-olds, from barbers to blacksmiths, from journalist to jugglers, from

nurses to nuns—the dream to fly is a shared aspiration of millions. They all believe, incidentally, that they, too, would make excellent communicators."[48]

The apology letter didn't stop the hostile epistles, but the volume did begin to taper off. One nurse even wrote to apologize for all the mean-spirited mail sent my way.

While attending a picnic a few months later, I managed to separate my shoulder while plunging across the finish line during a wheelbarrow race. This required a visit to the emergency room of a nearby hospital. Talk about instant karma! The threat to "never end up in my Emergency Room" suddenly loomed large. In an extreme case of paranoia and misplaced self-importance, I feared my photo was posted on the inside wall of the receptionist's booth like a Most Wanted poster. Fortunately, the nurse on duty did a wonderful job of patching me up and sending me on my way. She was a most excellent communicator.

The Ultimate Congressional Junket

The partnership with the Council of Chief State School Officers (CCSSO) proved to be invaluable in solidifying a plan of action. We couldn't have found a more efficient, effective, responsive collaborator. Once the cat was out of the bag, Terri Rosenblatt, my counterpart at CCSSO, quickly formed an advisory committee of representatives from the states to help establish eligibility requirements, selection criteria, and application and judging procedures. She also recruited the hundreds of volunteers in each state that were needed to review applications and select state finalists. We planned to have the process established and announced in November 1984.

Now that the launch pad was open to civilians, entitled politicians let it be known they were not to be left behind. Since the first launch, various senators and congressmen had lobbied NASA for a seat on a space shuttle mission. They reasoned that since they

had oversight responsibility for the agency, a familiarization flight was appropriate and *required*. This was standard practice for flights on military jets or when they went for a submarine cruise 20,000 leagues under the sea.

Certain members of Congress really loved the space program and were desperate to fly. Utah's Republican Senator Edwin "Jake" Garn routinely badgered NASA officials asking when he would get to take a ride into space. At a NASA budget hearing, Garn pressed Acting Administrator Alan M. Lovelace: "When is the Chairman of the Appropriations Committee going to get to ride on the space shuttle?"[49]

At another hearing in 1984, Garn insisted that the record reflect "my continuing desire sometime in the future to personally check out the space shuttle so that we can provide appropriations."[50] Talk about strong-arm tactics. With a straight face, he attempted to justify his participation with the rationale that he needed to get facts firsthand: "I do really think that it is a necessity that Congressmen check things out that they vote for and make certain funds are being spent adequately. It might be necessary to have a Senator kick the tires."[51] Of course, no one had the spine to ask if this meant Garn didn't believe the sworn testimony of NASA officials and astronauts on whether "funds are being spent adequately." Only through his participation could he trust and verify

In October 1984, just weeks before we planned to announce the application process for the Teacher in Space opportunity, rumors began to circulate that Garn was going to get his wish. While I was not privy to the official discussions, I learned later that Mr. Beggs and the Office of Legislative Affairs were developing a letter to invite Garn to fly.

The *Deseret News* of Salt Lake City, Utah seemed to have been tipped off about the possible flight. In a letter to the NASA adminis-

trator, reporter Gordon White suggested, "A flight by a Utah senator would appropriately be covered by a member of the press, and who better to be a pool reporter than the senior correspondent in Washington from the *Deseret News*."[52] Everybody wants in on the act.

Late Night with David Letterman

The previously mentioned feature story about the Space Flight Participant Program for *Life* magazine hit the newsstands the first week of October 1984. While they had gone down the path to primarily feature celebrities, I was glad they included a teacher as a potential candidate.

Among the article's illustrations was a photo of eighth-grade science teacher, Sue Cox, sitting on the floor with nine space shuttle training manuals required for a civilian participant. Standing next to the teacher was an astronaut in a flight suit behind a five-foot stack of 200 training manuals, a stark reminder of the difference between training requirements for a civilian and for a "real" astronaut.

Also featured in the article were Walter Cronkite, my buddy John Denver, actress Jane Fonda, and artist Robert Rauschenberg. The inclusion of Rauschenberg was prophetic since an Artist in Space was being considered, though not yet approved, for a future flight category.

Up to this point, most of the publicity regarding the Space Flight Participant Program in general, and the Teacher in Space in particular, had been reactive. Edward Campion, the public affairs officer assigned to the program, worked overtime and with great efficiency to respond to the numerous media appeals for interviews and comments. Given the volume of requests, we had little time to be proactive in seeking additional outreach venues.

The feature story in *Life* changed that approach. The article's author, David Friend, asked me to appear on several national TV shows to talk about the participant opportunity. *Late Night with David*

Letterman was first on the schedule. At the time, this was a distinctive way to reach a large audience beyond people that typically followed space activities. *Life* also arranged for appearances on the *CBS Nightwatch*, *Mike Douglas Show*, *PM Magazine*, and the local Washington, DC NBC station.

The Letterman Show appearance was scheduled for November 7, 1984. On my way out the door to travel to New York for the taping, a senior NASA public affairs official cautioned me to "Be professional; remember, you're representing NASA. Don't screw around."

The other guests for that evening included the first appearance of Whoopi Goldberg (who brought her sweet, little dog to the Green Room), and sex therapist Dr. Ruth Westheimer. That was also the night Letterman dispatched his representatives to select a random person off the street to appear on the show as "Mr. November." The guy they selected spoke an unrecognizable foreign language and broken English that made it hard for the crew to understand. Therefore, it was a surprise when Dr. Ruth immediately started to chat away with him in his native tongue.

While waiting backstage, I received an urgent call from my office colleague, Chris Burroughs. A senior manager told her to give me a heads-up that Senator Garn was indeed getting his flight. She had no details on when this would be announced or when he would fly. While surprised at the urgency of the call, I didn't think Garn could possibly go before the teacher. How wrong a boy can be.

Despite the "Don't screw around" warning flashing in the back of my mind, the taping went well. Letterman seemed to have fun reading the letters from kids nominating their teachers. He also munched on the space food I had been asked to bring. When Letterman asked how to eat the freeze-dried "astronaut" ice cream, I cracked, "I'm no astronaut, but I'd put it in my mouth." Letterman didn't laugh.

Back at headquarters the next morning, I read the front-page story

in *The Washington Post*: Garn was going to get to fly. I was flabbergasted and immediately requested a meeting with Jesse Moore to understand how this came about and what it meant for the teacher flight. Moore reassured me that since a specific mission had not been identified for the senator, there was no conflict with the Teacher in Space flight schedule.

What made it smart even more was his clarification that this was not a spur-of-the-moment decision. In other words, the deal had been in the works for a while on a need-to-know basis, and I didn't have the need to know—so there. However, fearing a backlash from the public, senior management concocted the excuse that Garn would not fly as a space flight participant but under the payload specialist category. Despite the fact that the public was mostly clueless as to the intricacies of astronaut categories, this was supposed to make everything all right.

The invitation letter Mr. Beggs sent to Garn was dated November 7, the same day I was on the Letterman show. To justify the offer, Beggs wrote: "Given your NASA oversight responsibilities we think it appropriate that you consider making an inspection tour and flight aboard the shuttle."[53] A copy of the letter didn't reach my office until November 9.

Since routine email was not in use at this time, it was remarkable that Garn's hard-copy acceptance letter was also dated the 7th. Talk about greasing the skids. Clearly, lots of pre-planning had been in the works on both sides.

In his response, the senator made it known that he wasn't satisfied with a flight just for himself. He thought it would be appropriate for his fellow lawmakers to join the CODEL (Congressional Delegation): "Even setting my personal interest aside—and I admit that's hard to do in this case—I agree in concept with the value of such an inspection flight and hope others of my colleagues with oversight

will have an opportunity to participate."[54] Although Mr. Beggs had sent similar invitations to three other congressmen with budgetary oversight of NASA, none accepted the invite.

The news about Garn's opportunity almost torpedoed the press conference scheduled for November 8 where we planned to announce the application procedures for the Teacher in Space competition. CCSSO felt double-crossed and resented not being told in advance. Consequently, their team almost didn't show up for the announcement. They were especially upset when Garn indicated he planned to fly as early as February 1985, months before the teacher. A CCSSO official angrily told me that the Garn deal was "A kick in the balls." It took calls from three senior NASA officials to convince the organization to come and participate in the press conference.

The Office of Public Affairs prepared a Response to Inquiry (RTQ) for the inevitable questions about Garn's big break. If asked whether his trip would affect the Teacher in Space going first, the official RTQ answer was: "No. A time will be worked out that will not affect the first citizen passenger flight." If asked whether Garn might fly before the teacher, the official response was: "We simply do not know. The specific flight is yet to be worked out." If that was true, why was the senator claiming he'd fly in February 1985?

Newspaper editorials were critical of the decision to fly Garn. In a review titled "The Ultimate Junket," *The New York Times* noted:

> We're well aware of legislators' proclivities for free travel to exotic places and know few will turn down the ultimate junket. And how could anyone not consider a junket so publicly conferred as a bribe? But that's what it is . . . Is space just a carnival and NASA its barker? If Senator Garn believes there are serious goals to pursue there, he'll keep his feet on the ground.[55]

The Baltimore Sun also felt Garn's flight was inappropriate. In their editorial, "Shabby Shakedown," the paper opined:

Senator Garn has confused Disney World with KSC . . . While some called it a political stunt when Reagan decided to send a schoolteacher, we see it as public relations in the best sense—an effort to encourage and inspire our nation's youth in their studies . . . Now it appears that this senator will beat the teacher into space. The message it will send is clear though tragic: it's not what you know, it's who you know.[56]

Under the proposed criteria, Representative Don Fuqua, chairman of the House Committee on Science and Space, was also eligible for a shuttle flight invitation. However, he let Beggs know, "I was not pleased in hearing of NASA's intent to fly members of congress. I am well aware of the military flying members on aircraft, but these flights are orientation and not operational missions. More importantly, the apparent usurpation of the President's well intended choice that an educator be first is quite presumptuous on NASA's part."[57]

Fuqua went on to complain, "The cavalier manner in which this episode was handled is almost insulting to the many women and men of NASA who have contributed so much to NASA's success together with the astronauts who train under rigid disciplines for hundreds of hours to assure mission success."[58]

One of Garn's constituents wrote to Utah's other senator, Orin Hatch. In her letter, she complained, "I do not believe that Senator Garn should be allowed to go on a space mission. It will set a precedent, and more and more senators and congressmen will request outer-space junkets. We don't elect and pay their salaries and benefits for thrill-seeking on space ships."[59] Senator Hatch referred the letter to James M. Beggs. While I don't have the documentation, I imagine I answered that letter, too.

The constituent's letter to Senator Hatch with the inference that Garn's flight would set a precedent for other members of Congress was spot on. Just after the letter was mailed, Representative Larry Hopkins (R. KY) wrote to Beggs to also request a shuttle flight. The congressman "was interested to learn of NASA's invitation to sev-

eral Members of Congress to travel as advisors on a space shuttle mission"[60] As a member of the House Armed Services Committee (with zero oversight responsibilities of NASA), he felt his request deserved consideration. Mr. Hopkins advice was not required so he didn't receive an invitation.

Senator Garn was not without support among his Hill colleagues. His state neighbor to the south, Senator Barry Goldwater (R. AZ), came to his defense and wanted to know, "Why is it wrong for a member of Congress, the body that is responsible for authorizing and funding the whole space program, to engage in a flight if for no other reason than to get a better idea of how the whole operation works?"[61] If Congress couldn't gain a sufficient understanding of "how the whole operation works" from their endless hearings, staff-prepared questions, and visits to NASA installations, what made them think sending one of their own on a shuttle boondoggle would provide improved illumination?

NASA's head of External Relations and Republican political appointee Pat Templeton tried to quiet the criticism of Garn's flight by telling the Associated Press, "Senator Garn is going up on an inspection flight in a management role as a mission participant. The difference between what the teacher would do and what Garn would do on a shuttle mission is the difference between observation versus management."[62] This absurd rationale fooled no one.

My Dog Ate the Application

Hiding our collective resentment, the press conference to announce the formal TIS application process went ahead as scheduled.

To be eligible for the first space flight participant opportunity, an applicant had to be a full-time elementary or secondary teacher with five years of experience. This was a blow to school administrators, part-time teachers, principals, and educators at the college level. There was no age limit, and teachers of all disciplines were welcome to apply. The competition was open to all 50 states, the

District of Columbia, U.S. territories, and Department of Defense schools. Each could nominate two educators for judging at the national level.

My prediction that 80,000 teachers would apply for the opportunity proved to be overly optimistic. However, a respectable 40,000 educators requested the packet, with 10,460 returning the 15-page application by the January 31, 1985 deadline.

Believe it or not, we actually received pleas for extensions to the deadline because "My dog ate the application," and "My application burned up in the car." I wonder if these teachers gave a break to their students who came up with similar imaginative excuses for not turning in their homework on time.

My favorite excuse was a letter from a principal who alerted us to a spelling error in correspondence he had sent to nominate one of his teachers: "In regard to my letter . . . please be advised that my secretary inadvertently referred to NASA as NASSAU. I am sending this corrected letter so that you will perhaps lend more credibility to my recommendation for the first space passenger."[63] Sorry pal, calling NASA, NASSAU was automatic grounds for detention.

The application included questions to assess the teacher's originality, creativity, communications skills, commitment to their profession, and community involvement. With the help of the hundreds of volunteers drafted by CCSSO, each state conducted its own competition, which produced two finalists per state by May 1985. The applications and a video taped interview of each finalist were forwarded to the offices of CCSSO.

The local and state media reported extensively on the applicants during the state selection process. Since one of the project goals was to increase the recognition of the teaching profession, it was encouraging to see so many applicants featured on front-page stories and on TV and radio programs. It was their time to shine.

Alan Ladwig introduces the 114 state finalists at the Teacher in Space National Awards Conference held in Washington, DC in June 1985. *Photo: NASA*

The 114 state nominees came to NASA Headquarters on June 22, 1985, for a five-day Teacher in Space National Awards Conference and the next phase of the selection process. The teachers ranged in age from 27 to 65, and represented a broad spectrum of grade levels and academic disciplines. The selection pool was deep.

Since only one nominee would be able to achieve space flight, it was important to provide appropriate recognition and educational opportunities to all of the highly qualified nominees. In addition to judging activities, they received in-depth briefings and materials on all of NASA's activities and programs.

At the opening banquet, Dr. William Pierce from CCSSO let it be known that this would be a festive week: "We celebrate the fact that when you leave, you will be the 114 most knowledgeable teachers in the country about the space program and how to relate that information to students. In that spirit, I welcome you and let the celebration begin."[64]

Next, Administrator Beggs surprised the teachers with a special announcement:

> You are all winners, whether you fly or not. That is why tonight we are appointing you all Ambassadors for the space program in your states, your districts, and your schools, at home and abroad—wherever you can reach young minds. As our Ambassadors to young America, we hope you will spread the word that space has become not just a place we visit, but a place where we are learning to do new, exciting and useful things to benefit life on Earth.[65]

By then, it had been confirmed that the selected Teacher in Space would join the crew of STS mission 51-L, scheduled for launch in January 1986. The captain for the flight, Mike Smith, followed Beggs' remarks with a slide show on shuttle missions in general and the crew of STS 51-L in particular.

To prepare the Space Ambassadors for their new role as NASA disciples, and to equip them with the tools to ignite the imaginations of their students, the weeks' agenda included presentations and workshops dedicated to the agency's programs. Key NASA senior officials and the president's science advisor gave the presentations. Marcia Smith, the executive director of the recently formed National Commission on Space, reviewed the capabilities and plans of other nations. They also heard from mission specialists Joe Allen and Judy Resnik (another member of the 51-L crew), who received a standing ovation for their presentation on what it's like to live and work on the shuttle.

With support of NASA's Office of Legislative Affairs and sponsorship by the National Space Club, a reception was held in the Dirksen Senate Office Building for the state finalists to meet their members of Congress. Large posters were set up with photos identifying the name and state of each of the teachers. A large image of a space shuttle launch served as the perfect background for a Kodak mo-

ment of the nominees with their members. No representatives from New Hampshire were able to attend the reception, so I was honored when state finalists Christa McAuliffe and Robert Veilleux asked me to be photographed with them.

In a previous meeting to discuss a separate White House reception for the teachers, I asked if we should bring over the same display of photographs of the state finalists and of the space shuttle that we planned for the congressional reception. One White House staffer demanded to know why we were even having a reception on the Hill. I explained it was to give the teachers an opportunity to meet their members of Congress. The staffer became incensed and accused Congress of trying to "horn-in" on the "President's program." "Listen Buster," she screamed, "don't you forget, this was Ronald Reagan's idea!" At first I thought she was joking. It was hard to tell if she was a dedicated loyalist or a revisionist historian. In any case, both receptions were successful, and a good time was had by all.

President Reagan spoke about "his" idea at the eventual White House reception. In his remarks, he proclaimed, "When one of you blasts off from Cape Kennedy next January (It hadn't been called Cape Kennedy for years), you will be representing hope and opportunity and possibility—you'll be the emissaries to the next generation of American heroes."[66] While wine and cheese are normally served at White House receptions, the wholesome image of teachers was preserved with a spread of punch and cookies.

The National Air and Space Museum hosted yet another reception and treated the guests to a premier showing of the latest IMAX film shot on location during recent space shuttle missions. Titled *The Dream Is Alive*, the film was joyfully received.

The main focus of the week was the judging process to narrow the 114 state winners down to ten finalists. For this task, Terri Rosenblatt of CCSSO established a diverse National Review Panel that

included four Apollo astronauts, academicians, business leaders, professional scientists and engineers, a sports figure, and an actress. (See Appendix A for complete list.)

During the week, the judges interviewed the nominees individually, reviewed pre-recorded videotapes of the applicants, and met informally with the teachers during receptions and meals. The selection committee then convened as a group to perform the difficult job of deciding which ten teachers would be named finalists.

Ann Bradley, the chair of the internal Space Flight Participant Evaluation Committee and NASA's number three top-ranking official concluded the conference. She challenged the teachers to return to their respective states and participate actively in their new roles as Space Ambassadors. She referred to the assembled group of nominees as "The Class of 51-L," in honor of the mission identified for the teacher's flight.[67] Bradley also invited all the applicants to come to KSC to watch the 51-L launch and to participate in a follow-up education conference. Astronaut Robert Overmeyer joined Bradley to present the teachers with a certificate recognizing them as their state's nominee for the Teacher in Space Program.

The ambassadors received lovely parting gifts: an extensive collection of 23 NASA publications, a video tape of highlights from space shuttle missions, 100 slides covering NASA-wide activities, and a computer software package. Remember, this was a time before the Internet, and hard copies of such hard-to-get materials were highly valued.

Making a List, Checking It Twice

With the desire that all the nominees return home feeling like winners, NASA specifically did not announce the ten finalists until July 1. At that time, the ten were notified and returned to NASA Headquarters for a press conference, individual press interviews, meetings with

their members of Congress, and the final phase of the judging process. The ten finalists included:

- Kathleen Beres, Maryland
- Robert Forester, Indiana
- Judith Garcia, Virginia
- Peggy Lathlaen, Texas
- David Marquart, Idaho
- Christa McAuliffe, New Hampshire
- Michael Metcalf, Vermont
- Richard Methia, Massachusetts
- Barbara Morgan, Idaho
- Niki Wenger, West Virginia

While in town, the ten traveled just beyond the Washington Beltway for a VIP tour of the Goddard Space Flight Center (GSFC) in Greenbelt, Maryland. They received briefings on science satellites, including the in-progress Hubble Space Telescope, Landsats, and preparation of Getaway Special canisters.

The positive press coverage the ten finalists and the other state semi-finalists were receiving for the teaching profession encouraged a change in heart by the National Education Association (NEA). While initially critical of sending a teacher into space, NEA president Mary Futrell had changed her view and invited the finalists to come on stage at their National Convention being held that week in Washington, DC. The greeting from the fellow teacher delegates couldn't have been more receptive and genuine. The NEA even followed up, asking to establish a formal contact within NASA to "cooperate and significantly increase promotion of the project."[68]

I had an excellent opportunity to get to know the ten finalists even better over the next few weeks. We gathered at my house for a barbecue and impromptu birthday party for Christa McAuliffe. The level of camaraderie and mutual support that developed among the teachers was quite special.

The ten then traveled together to tour the three NASA centers affiliated with space shuttle operations: Kennedy Space Center (KSC) in Florida, Marshall Space Flight Center (MSFC) in Alabama, and Johnson Space Center (JSC) in Texas. These visits allowed the group to get up close and personal with line workers and managers of all aspects of the shuttle. This class trip was truly unique.

While each center offered highly informative and special tours, the trip to JSC to undergo medical examinations and space flight suit-

The ten Teacher in Space finalists toured the Johnson Space Center. Top of stairs to bottom: Niki Wenger, Barbara Morgan, Richard Methia, Michael Metcalf, Christa McAuliffe, David Marquart, Peggy Lathlaen, Judith Garcia, Robert Forester, Kathleen Beres.
Photo: NASA

ability testing was the most memorable. Center Associate Director Dr. Carolyn Huntoon, who was also a member of the Space Flight Participant Evaluation Committee, welcomed the teachers and reviewed the week's schedule.

In addition to being given top-to-bottom physical examinations, they heard from managers and astronauts on protocols related to space flight operations and safety regulations. The teachers experienced a simulated high-altitude flight in a hyperbaric chamber exposing them to hypoxia, decompression, acceleration, and space disorientation. Throughout the week, there were ample opportunities for media coverage, especially of the briefings and their participation in aspects of astronaut training conducted in the shuttle mockups.

Perhaps the most exciting portion of their time at JSC was the chance to experience weightlessness during parabolas on NASA's KC-135 aircraft. The converted Boeing 707 enabled passengers to experience brief periods of weightlessness during parabolic maneuvers. On the flight, the teachers tumbled and somersaulted during 27 parabolas, each providing 25 to 30 seconds of free-floating ecstasy. Astronauts Dale Gardner and Judy Resnik accompanied the teachers and brought along an assortment of rubber balls, paper airplanes, a Frisbee, and water containers to demonstrate how these reacted in a microgravity environment.

What wasn't discussed much was the stack of parachutes secured under a tarp on the floor in front of the seats. In the event of an emergency, passengers presumably were to grab a chute, head for the nearest exit, and jump out yelling *Geronimo!* Are you kidding me? I thought it was terrifying when I did my first skydive from 3,000 feet. The thought of having everyone strap on a parachute for the first time and plummet from 30,000 feet seemed ludicrous, at best.

Fortunately, the parachutes weren't needed on our excursion. The teachers all performed splendidly, and the flight was definitely the highlight of the trip. We concluded the outing with a post-flight visit

to Petey's, a local Bar-B-Que joint, for a traditional feast of ribs and smoked brisket. Nothing like chowing down on a hunk of beef and a couple of bottles of Lone Star beer after having your neurological system and internal organs turned upside down.

During their last afternoon at JSC, the teachers were invited to sit in the viewing room of Mission Control to observe operations for the nineteenth space shuttle launch, 51-F. Unfortunately, the countdown was halted at T-3 seconds due to a main engine ignition malfunction—another reminder that space flight could be dangerous.

We returned to Washington, DC for the final phase of the judging process to be conducted by the Space Flight Participant Evaluation Committee. The committee members had already viewed the videotapes that each teacher submitted as part of the state-level judging process.

I was able to observe the no-holds barred sessions as the seven-member jury separately interviewed each candidate. Upon Dr. Huntoon's recommendation, the questions for the interviews were quite similar to those asked of individuals during the selection process for astronaut candidates:

- What are your impressions of what you have experienced in the tours and experiences thus far?
- Have you been in situations that require working in close quarters?
- How do you spend your vacations?
- Has your philosophy of teaching changed during this process?
- If selected, how do you think you and your family will be affected by the notoriety you will receive?
- Give examples of stressful situations you've dealt with.
- Are you a team player? Give examples.
- What are your plans for the future?
- What price are you willing to pay to become a shuttle crewmember?

After the interviews and considerable deliberations, the evaluators made a decision and forwarded their recommendation to Adminis-

trator Beggs. He concurred, and Christa McAuliffe, the secondary school social studies educator from Concord, New Hampshire was to be the first space flight participant and Teacher in Space. Barbara Morgan, an elementary school teacher from McCall, Idaho, was selected as the backup.

One Body, But Ten Souls

Since President Reagan had made the initial TIS proclamation, the NASA political appointees again pushed for White House involvement in announcing the winner. It was determined that a ceremony would take place at the White House on July 19. Since President Reagan was in the hospital for a medical procedure, Vice President George H.W. Bush was tapped to host the event. White House staff insisted that NASA refrain from telling the teachers in advance who would be the space-bound designee. We were told it was Bush's personal desire to have the notification be a last-minute surprise.

The atmosphere surrounding the day of the big announcement was a combination of relief, accomplishment, pride, and utter chaos. After all they had been through together, these ten premium individuals had become extremely close. This was quite obvious to those of us who had been with them throughout the judging process. Even in his remarks at the White House later that day, Mr. Beggs noted the bond that existed among them:

> Over the past few weeks, our ten finalists have lived and worked together. They have endured exhaustive and really extensive medical and physical tests and a battery of interviews. They've been interviewed more times than you can imagine. And, just as we have come to know them inside and out, they have gotten to know each other as well. They were competitors of course, but have now become family."[69]

As a family, they came to me the night before the White House ceremony with a request. They made it clear "This is not the Miss American Pageant. What if one of us breaks down? What if it's one

of the men?" They were kind of half-kidding, but they were sincere in wanting to know who would represent teachers on the flight before going over to the White House.

I passed along the request to Ann Bradley, who in turn went to the administrator to ask for approval to spill the beans. As Bradley recounted in an interview a couple of years later, Beggs agreed to let her make the big reveal, but insisted the teachers not be told until the very last minute and not to let anyone else know.[70]

We had gathered the ten teachers in a conference room in the administrator's suite for a bite to eat before heading over to the ceremony. Because a reporter was hanging around the entry to the suite, we shuffled the group out the back door into a nearby office. While nibbling on chips and sandwiches, Bradley overheard McAuliffe commenting on the fact that back home, her husband, Steve, had been performing as *Mr. Mom*, and he and their kids were eating lots of pizza and corn flakes.

Bradley picked up on this comment and at that moment told the group, "Christa, you'd better tell Steve he is going to be eating a lot more corn flakes, because you are the one."[71] The room erupted into a great deal of emotion with kissing, hugging, and crying. McAuliffe wanted to call her husband immediately, but Bradley told her he would have to find out from the vice president like everyone else.

After things calmed down, Bradley then said, "Now the important next thing is your backup, and that will be Barbara Morgan." More hugging and handshakes followed this announcement, and if any of those not selected were hurt or disappointed, they certainly maintained their composure.

The event at the White House was planned for the Roosevelt Room, which meant only a skimpy number of people could attend. Since the room was so small, the spouses of the finalists weren't allowed to come, nor, with exception of me, were any of the working-level

staff from CCSSO or NASA. We crammed into a government station wagon and drove over to 1600 Pennsylvania Avenue.

In scheduling the Roosevelt Room, the White House communications staff totally underestimated the press interest. The room was jam-packed with reporters and camera operators jousting for position. I could now understand the circus atmosphere that must have existed years earlier when NASA introduced the monkey astronauts Able and Baker to the media hordes. Gentlemen, gentlemen, a little decorum, please.

The teachers were led into the room to be greeted by Vice President Bush, Department of Education Secretary William Bennett, and Administrator Beggs. It was a fluke that Christa McAuliffe ended up standing right next to the podium, but it became an issue later.

With his typical eloquence, Mr. Beggs told the assembled crowd:

> Some succeed by what they know; some by what they do; and others by what they are. Clearly our ten finalists have succeeded in all three categories. They've demonstrated that they are winners. We are very proud of these ten young men and women. I'm confident that when the shuttle lifts off, our winning candidate will soar into the hearts and minds of young people around the country and, indeed, around the world. At NASA we have always believed that we must aim high if we are to reach the stars. We're continuing that tradition with the Teacher in Space project. With it we hope to communicate the wonders and mysteries of space flight to millions of young people. We also hope to restore prestige for the teaching profession, something of which it has been robbed a little bit in recent years. [72]

Vice President Bush then stepped up to the podium. "We're here today to announce the first private citizen passenger in the history of space flight . . . NASA, with the help of the heads of our state school systems have searched the nation for the teacher with the right stuff. There are literally thousands of them that have the right stuff. They're committed to quality and education."[73]

Bush then moved on to the big news of the day. "Let me tell you now who our teacher in space will be. Let me say that I thought I was a world traveler, but this tops anything I've tried. First, the backup teacher who will make the flight if the winner can't, Barbara Morgan . . ."

In watching a video replay of the ceremony, I was struck by the restrained reaction of the other nine teachers in response to the vice president's identification of Morgan. While a few looked over at her and smiled, compared to the joy expressed earlier at NASA, their reaction didn't rank high on the emotion's meter. Since we had let the cat out of the bag ahead of time, this shouldn't have been all that surprising. They had already given at the office. After all, they were here because of their superior skills as educators, not as actors.

After presenting Morgan with a trophy, Bush continued, "And the winner, the teacher who will be going into space is Christa McAuliffe." He seemed a bit surprised when he realized that she was standing right next to him.

In her original application, McAuliffe had promised to keep a journal of her experiences in space, "just as the pioneer travelers of the Conestoga days kept personal journals of their journey." Bush exclaimed he was "personally looking forward to reading that journal someday."

The vice president surprised us with an announcement of his own: "And by the way Christa, while you're in the program, Concord High School will obviously need a substitute teacher to fill in so it's only right that we provide one of these substitutes. Glancing to his right, Bush promised, "The first class you'll miss will be taught by my dear friend and the President's Secretary of Education, Bill Bennett."

Bush then turned the microphone over to a visibly moved McAuliffe. In an emotional and halting voice, she admitted, "It's not often that a teacher is at a loss for words, I know my students wouldn't think so. I've

made wonderful friends over the two weeks, and when that shuttle goes, there might be one body, but there's going to be ten souls that I'm taking with me." For someone who knew in advance that her name would be uttered, she came across as incredibly genuine.

Vice President George H. W. Bush announced Sharon Christa McAuliffe as the Teacher in Space at a ceremony at the White House on July 25, 1985. Bush said Education Secretary William Bennett (left) would be a substitute teacher for Christa's class.
Photo: NASA

Following the ceremony, we were led out to the front lawn of the White House where the teachers were swarmed by the press. Not only did McAuliffe field questions, but reporters from their states also sought out the other nine teachers.

As this was going on, the White House staffer who at an earlier meeting had called me "Buster" and reminded me the Teacher in Space

was Reagan's idea, came at me again. She incorrectly surmised that we had purposely arranged to have McAuliffe stand right next to the podium. It was clear to her that we had told the teachers who won in advance. This time she yelled, "They knew! You've embarrassed the Vice President of the United States." I couldn't understand why she was so enraged. Yes, "they knew," but if McAuliffe's acceptance sentiments and tears hadn't come across as heartfelt and sincere, I don't know what else she could have done.[74]

Rather than create a scene in front of the press, I handed the out-of-control staffer over to Ann Bradley, who in turn referred her to Mr. Beggs. With her chutzpah in full rage mode, the harried staffer continued her rant to the dignified administrator. He simply advised her, "If the Vice President has any problem with what we did, please ask him to give me a call." Vice President Bush never called.

After the press scrum subsided, we piled back into the station wagon. As we headed down the driveway, *Concord Monitor* reporter Robert Horner jogged alongside the car shouting questions to McAuliffe. Beginning with her selection at the state-level, Horner had written several stories about the New Hampshire state winners and the competition. McAuliffe asked to stop the car and let Horner jump in. As he wedged into the very back of the station wagon, we pulled away with the feel of a Shriners' car full of clowns.

Back at NASA Headquarters, Dr. Robert Brown and Frank Owens of the Office of Education were on hand to greet the teachers. The next phase to prepare the "Ultimate Field Trip" was now in their capable hands.

My last official act with the teachers occurred on September 9 when I escorted McAuliffe and Morgan to JSC to report for training. A space flight participant was to receive the same kind of training as given to payload specialist candidates. Up to this point, the backups for the payload specialist opportunities did not generally

receive the full training regime. Thanks to Dr. Huntoon, Morgan would be able to experience the same training as McAuliffe. This was a big deal.

I last heard from McAuliffe on December 5, 1985. In a handwritten note, she thanked me for sending her an article from *Space World* magazine about the program: "We miss your smiling face down here. There were many opportunities when a little comic relief would be most welcome." Toward the end of the letter, she noted, "January 22 is not too far away—Barb and I are scrambling trying to prepare some post flight presentations while we have access to all the materials."

The next part of the letter still gives me chills to this day:

> The training is still fascinating—we had emergency egress yes-
> terday and threw ourselves out of the orbiter . . . I have bruises
> in the most unusual places! . . . I'm hoping to get a little skiing in
> over Christmas. I think I'll stick to cross country and leave down-
> hill until after the flight. Keep in touch, Love, Christa.[75]

I was happy to hear how well she and Barbara Morgan were doing and looked forward to being at KSC for the launch. In the mean-time, I turned my attention to the Journalist in Space competition, investigating criteria to select an artist and continuing to manifest payload specialists.

9 JUNKETS, DATELINES, AND ARTISTS IN SPACE

NASA gave the term "stinks to high heaven" a new meaning when it tossed a paying customer overboard and assigned Congressman Bill Nelson his seat.
Alcestis R. Oberg, *Florida Today*

I was so jealous of the astronauts. Why you and not me? You are going with no eyes to look, no ears to listen. No tongue to tell. I would have gone upstairs with all my eyes, all my ears, all my tongues.
Oriana Fallaci, *RTNDA Communicator*

From the ancient past, artists have formed images and dreams, fired the imagination, built structures of aspiration to give the world wings to fly and the vision to see new societies in the sky.
Sky and Space Artist Manifesto, MIT

Ultimate Congressional Junket Redux

By the time the Space Flight Participant Evaluation Committee turned its attention to the next flight category, Senator Garn had already been to orbit and back. He flew on STS-51-D in April 1985. This was well before the teacher flight scheduled for January 1986. Despite much criticism, he managed to join the mission with minimal training. Originally slated for launch two months earlier, NASA had to make crew changes to accommodate the senator's schedule. In the process, Hughes payload specialist Greg Jarvis was bumped from 51-D to a later mission.

A pre-flight article in *The Washington Times* noted, "The program directors, hard put to find anything a politician can do well in space, have decided to turn the senator into a medical guinea pig, letting him self-administer a dazzling series of physical exams."[1] Thus, in

260

addition to his "management" responsibilities, Garn participated in a series of space motion sickness experiments. Despite the constant mention of his 10,000 flight hours as a Navy pilot, Garn became quite nauseated during the mission. He quickly was tagged as "Barfin Jake" by the press and featured in the *Doonesbury* cartoon series.

For all the ballyhoo over his flight, Garn's participation failed to impress *The New York Times*. While the senator was still in flight, the paper ran an editorial highlighting the quid pro quo nature of the whole thing: "Having pressured NASA to give him his space trip, Mr. Garn is now indebted to the agency. That's a pity for those whom he represents in supervising NASA's budget and its request to build an $8 billion space station."[2]

But Garn was not the last member of Congress to demand a shuttle flight. Representative Bill Nelson (D. FL) had also pestered NASA officials early and often for a flight. In April 1983, shortly after the release of the Citizen Observer Task Force Report, Nelson wrote to Administrator Beggs to again proclaim his interest: "We have talked about the possibility of my flying on a future shuttle flight, and I've decided my request should be presented, in writing, for the record." Attached to the letter was Nelson's weekly column to his constituents where he announced, "I would like to be the first member of Congress to fly on the Space Shuttle. As the ranking member of the Space Subcommittee and the Congressman whose district includes America's Spaceport, the opportunity for such a space experience would be extraordinary."[3] Notice there is no mention of the experience being valuable for any particular reason, just providing him with an extraordinary experience.

In his low-key response to the "for the record" letter, Mr. Beggs told Nelson, "I am studying the recommendations made by the NASA Advisory Council. If the decision is to go forward with the Observer Program . . . be assured you will be informed of the decision and the

details. We at NASA are well aware of your enthusiasm and support for the space program, and it is appreciated."[4]

By fall 1985, Nelson's enthusiasm and support was about to be rewarded. Rumors began to circulate that he would be invited to fly, and fly soon. On September 4, JSC's Associate Director Dr. Carolyn Huntoon called to ask if there was any decision on whether Nelson would actually get a flight. On September 6, NASA confirmed that it had, indeed, invited the congressman to join an upcoming space shuttle mission. Just as in the case of Senator Garn, the Public Affairs RTQ stated, "No specific mission has been made," and Congressman Nelson will not fly before the teacher."[5] While McAuliffe and Morgan had reported for training just three days after the Nelson announcement, the latter part of that answer turned out to be a lie.

My office notes of September 25, 1985 record that Administrator Beggs told Nelson he would fly in late 1986. However, the congressman said this would be inconvenient for his schedule. And what do you know? Just six days later, he was assigned to STS-61-C, then scheduled to launch on December 18, 1985. On October 2, 1985, I was instructed to again ask the Hughes Corporation if they would mind switching their payload specialist Greg Jarvis to yet a later mission, this time from 61-C to the next available flight.

Placing Nelson on a flight before Christa McAuliffe was again roundly criticized. Writing in *Florida Today*, space correspondent Alcestis R. Oberg chastised the decision: "The mendacious space agency promised not to fly another VIP before the teacher. Forget that. It promised after Jake Garn's joy ride in April that the 'program' to fly politicians was over. Forget that. It had promised all paying customers that they could fly a representative with a major payload. Forget that."[6]

Since my earlier protest to senior management about Garn flying before McAuliffe was not appreciated, it didn't seem career enhancing to gripe about Nelson's flight.

Just as Garn did for his mission, Nelson went through an accelerated level of training. He went to JSC when it was convenient for his schedule. A few years later, one astronaut admitted to me off the record, "They went through an accelerated course, and that's something we shouldn't do. As a result of the (Challenger) accident, we wouldn't do it again."

Nonetheless, on January 2, 1986, Nelson launched on STS-61-C. The next mission was 51-L and the flight of the Teacher in Space.

Putting Logic Aside

This was also the year that Acting Air Force Undersecretary E. C. "Pete" Aldridge was approved to fly as a payload specialist on an upcoming Department of Defense shuttle mission. He began his campaign to fly in 1984 when he wrote to Air Force Secretary Verne Orr to volunteer for a mission.

His memo to Orr referred to Administrator Beggs' interest in flying an Air Force official on a shuttle flight. Aldridge thought it was "a good idea to smooth the relationship between the Air Force and NASA. He (Beggs) would like for us to suggest who that might be—either an Air Force officer or civilian." Aldridge didn't think an Air Force officer was the right solution since several had already been assigned to shuttle missions, and flying another "may give an overly strong military 'weapons in space' connotation." He concluded, "Putting logic aside—I volunteer! But realistically, since I have been the focus of weakening support for the Shuttle . . . maybe such a solution may get us on a more positive relationship with NASA and Congress."[8]

That was one bizarre justification. Let me get this straight; Aldridge was the source of uneven relations with NASA concerning military involvement with the shuttle, but flying him would make everything all better. He was right about one thing; this was definitely putting logic aside.

Air Force General Lawrence A. Skantze also asked Beggs to let him represent the military on a flight: "In light of our growing commitment to the Shuttle, I would think it quite appropriate that the Commander of the Air Force Systems Command, who is responsible for all research, development, and acquisition of Air Force systems, be afforded an opportunity to fly on the Shuttle."[9] Everybody has an angle.

Skantze didn't get his wish. Just after the general made his request, then Acting Secretary of the Air Force Aldridge sent NASA a letter outlining procedures he established for "flying non-astronauts, Department of Defense personnel, both military and civilian, on board the Shuttle." This was intended to provide guidance on how to handle "out-of-channel requests" NASA received for Shuttle flights.[10] Since Skantze's request was considered "out-of-channel," Beggs had an easy out to deny the general's request.[11]

Not long afterwards, Aldridge was assigned to the crew of STS-62-A, a military flight scheduled for launch from Vandenberg Air Force Base (VAFB) in July 1986. Unfortunately for the acting secretary, due to budgetary and operational issues, the VAFB shuttle launch site was never completed, and the mission was cancelled.

The aggressive efforts of members of Congress and senior government personnel to insert themselves ahead of professional astronauts, payload specialists, and the approved space flight participants were not well received.

On September 13, 1985, just after the decision to fly Congressman Nelson, the *Houston Post* ran an editorial critical of congressional and government officials elbowing their way onto flights. It referred to the flight assignments of Senator Garn, Representative Nelson, and Acting Secretary Aldridge as "an unfortunate lapse in judgment" that had to stop:

> Those officials are cutting in front of scores of astronauts, hundreds of scientists, and thousands of rank-and-file workers who have given more of their lives, intelligence and dedication to the

264

space program than has any politician. The shuttle is a national resource . . . It's purpose is perverted when it is used for political junkets. The idea of flying a private citizen—a carefully selected teacher is to go next January—is a good one that has none of the repugnance of blatant carrying of influence.[12]

Extra, Extra, Read All About It!

As we have seen, the community of journalists believed that they had a divine right to be onboard an early space shuttle mission. Had it been up to them, one of their brethren would have certainly gone before the teacher.

Ever since the Gemini missions in the 1960s, big name correspondents and TV news reporters begged to submit a byline from space. The agency had heard multiple times from television stations such as ABC and CBS, newspapers including *The Washington Post* and the *Los Angeles Times*, magazines like *National Geographic* and *Time*, news bureaus like Reuters and UPI, and journalistic associations, including the Aviation Space Writers Association and the American Society of Magazine Photographers. The reporters who wrote the letters either wanted to volunteer to fly themselves, nominate someone from their organization, or tell NASA how to manage a selection process.

Professional journalism societies and individual publications had submitted several unsolicited proposals on approaches to select a journalist. A January 1985 letter signed by James Schefter, the West Coast Editor of *Popular Science* registered concern with NASA's strategy for the Space Flight Participant Program. He thought the agency should abandon all future competitions and felt selections based on occupations was the wrong approach.

Schefter included the suggestion that instead of picking one space flight participant at a time, NASA should continue the policy it had followed for 25 years: "It should select a class of Participants—perhaps 10—and assign each of them to the available mission more

appropriate to their skills and experiences."[13] While there was merit to this approach, setting up a fair selection process for such a large universe of potential applicants would have been daunting.

Shortly after the June 1985 Teacher in Space National Awards Conference, the journalist profession was finally going to see its wish granted. NASA's Space Flight Participant Evaluation Committee recommended that the next flight opportunity be for a member of the fourth estate.

Even before the administrator officially approved the category, and just as CCSSO had performed with the teacher program, we wanted an independent external organization to manage the competition and selection process.

Frank Johnson, NASA's director of Public Affairs had been quietly meeting with a range of professional journalism societies that could help us conduct a competition. He ultimately found an appropriate partner with the Association of Schools of Journalism and Mass Communications (ASJMC—an impossible acronym to pronounce) operating from the University of South Carolina (USC). The association represented 176 colleges and collaborated with 45 other professional journalism societies. USC's Journalism Dean Emeritus Albert T. Scroggins accepted the reigns as the chief program officer with Executive Director Jennifer McGill and staff member Eric Johnson handling the day-to-day management of the competition.[14]

ASJMC moved quickly to set up an advisory committee of volunteers to establish eligibility criteria and application guidelines. They arranged to have 25 schools of journalism involved in the selection process and divided the country into five regions. The judges for each region consisted of journalism and communication professors and professional reporters and broadcasters.

The association benefited from recommendations previously drafted by an informal task force of professional journalists led by Mark

Brender, chairman of the Radio-Television News Director Association's Media in Space Committee. The task force made it clear that a space-flying scribe must have more independence than the Teacher in Space. The journalist must be imbedded in a mission with full access to all aspects of flight preparations and operations. In a letter to Frank Johnson, Brender suggested, "NASA should adopt the policy that no conditions will be imposed on reporting from space except those which NASA specifies before final selection of the journalist."[15]

Representatives from ASJMC also made it clear that journalists had no intention of participating in the types of pre-selection workshops or conferences that had been subscribed for the teachers. Following the flight, they had no desire to become cheerleaders or Space Ambassadors to spread the gospel of NASA.

On October 16, 1985, I attended a meeting of the advisory committee ASJMC had formed to establish the selection criteria and the application process. The committee had members from 17 professional societies representing every conceivable journalistic venue. At the meeting, they presented their recommendation for eligibility and justification for the flight. They believed, "As a shuttle crew member, the journalist selected will view the space program from a position heretofore unavailable to professional reporters and commentators. As a trained observer and communicator, the journalist will be qualified to bring a new perspective to real time reports and mission history."[16]

The committee determined that the applicant must be a U. S. citizen with five years of professional experience as a working print or broadcast journalist on a full-time basis. Applicants also had to have the support of their employer and be able to pass the physical requirements established for the Space Flight Participant Program.

Eight journalists would be selected from each of five designated regions of the country. These 40 regional nominees would attend an

evaluation program in Washington, DC to be judged by a National Selection Panel of journalists. This panel would then narrow the list to five finalists for an ultimate selection by the NASA Space Flight Participant Evaluation Committee.

The journalist would be encouraged to freely report anything seen or experienced during a shuttle mission. Throughout all phases of the program, the selected individual would operate under press pool rules (sharing reports with other journalists). This would be effective from the date of selection as a regional candidate to 30 days following return from the mission.

In a decision memorandum dated October 17, we asked for the administrator's approval to enter into a contract with the ASJMC and to move forward with an announcement of the Journalist in Space Program.[17] This time, Mr. Beggs approved the memo quickly, and a press conference was scheduled for that week.

On October 24, 1985, the Journalist in Space Program became official, and the nation's 125,000 journalists were finally given their chance to apply for a ride in space. In making the announcement, Mr. Beggs joked, "Now I know there are those who would like to put some journalists into orbit—permanently. But I can assure you that our winning candidate will not only get a round-trip ticket, but a first-class, unforgettable ride." The selected journalist was slated to fly in September 1986. A back up would also be named in case the crowned journalist would be unable to perform the required duties at the time of the flight. Beggs hoped the winner would "create a book, or a series of magazine articles, possibly a radio or television series, or a traveling photo or editorial cartoon exhibits."[18]

Beggs also speculated that perhaps a journalist could succeed where "a quarter of a century of astronauts had failed to communicate the space experience to the American people."[19] This observation reflected years of criticism of astronaut travelogues, but the remark

immediately struck a raw nerve with Gene Cernan and Harrison Schmitt, the last two astronauts to walk on the Moon. While they had both been judges for the Teacher in Space competition and were supportive of the Space Flight Participant Program, they wrote to Beggs to protest the implication that astronauts were lousy communicators.

In his letter, Schmitt hoped that Beggs had been misquoted on his comment about the ability of astronauts to communicate. In his judgment, astronauts had not failed in communicating with the American people. Schmitt claimed he "had never heard a complaint from the quarter of a million people I have spoken to directly or the tens of millions who heard or read my descriptions . . . I am certain you will make sure that this negative twist is not used as a justification for the flight of a Journalist-Astronaut."[20]

Gene Cernan echoed Schmitt's sentiments and added, " . . . with the caliber of individuals you have in the program today, I believe you can be additionally assured that the ability to communicate in the future is not a short-fall of NASA—at least not in the Astronaut Corps."[21]

The action to respond to the two astronauts came to my office. In letters for Ann Bradley's signature, we assured the Messengers of God that Mr. Beggs meant no offense. The members of the corps were, of course, "excellent good will ambassadors who gained pride and respect for the U.S. space program throughout the entire world . . . The manned space program has seen its way through many phases and it is now embarking on a new era. You were a trail blazer for the space flight participants of today."[22]

Most journalists welcomed the opportunity to select a member of their tribe. A surge of articles and commentaries written by reporters in local and national media outlets expounded on why they should go or didn't want to go. They also recommended someone

who they thought would do the best job. Some of the articles were humorous, while others were not-so-veiled applications.

Quoted in a *Time* magazine article, author Thomas Wolfe again weighed in on the merits of sending up a reporter: "The value of having a journalist in space is that he can become the central nervous system of everyone who has ever wondered what it is *really like*. He can be completely honest since he has no stake in the machismo of flying or the pilots' code."[23]

In a letter to ASJMC that no doubt ended up in one of the issues of *The Miami Herald's* Sunday magazine, syndicated humorist Dave "Bucko" Barry wrote at length about the value of sending a scribe to orbit:

> As I understand it, you want somebody who can communicate to the general taxpaying public what a swell idea the space program is, because your regular astronauts tend to describe the wonders of space, no matter how profoundly moving they are, as 'real good.' If they were to suddenly encounter a host of angels up there, suffused with the brilliant, multi-colored, ever-changing light of a thousand simultaneous sunsets and singing a song of such sweet sadness that the entire universe seemed to sway, your current astronaut would look at it and say, 'Houston, we got real good angels here.'[24]

Not everyone thought the selection of a reporter would be such a great idea. *Editor & Publisher* magazine cautioned "Some members of the media, both working professionals and educators, are skeptical of the government's plan to send a journalist into space—fearing among other things that the person may become a public relations tool—officials in charge of the program said it was specifically designed to maintain the chosen communicator's independence."[25] The community wasn't interested in becoming a shill for all things NASA and didn't want restrictions on what they could or couldn't report.[26]

Responding to this concern, Dr. Scroggins of ASJMC correctly observed, "Anytime a government agency does something you get that kind of criticism. A number of columns across the country are having fun with it."

While the teachers were eager to cooperate with NASA and soak up as much information about the space program as possible, the community of journalists would bring a more contrary perspective. In addition to a demand for no restrictions in their coverage and refusal to attend "mandatory" pre-selection briefings, there were complaints about the vantage point the journalist participant would have on board the shuttle during the launch.

A year earlier when the SFPP guidelines were established, journalist James Reston Jr. complained about the proposed seating arrangements in the orbiter. He urged NASA to review the plan to stick the journalist in the middeck without a view out a window. In Reston's estimation, a seat on the flight deck was more appropriate: "It serves no purpose to put an observer in a position where he/she cannot observe, as if the passenger is in a closet packed with equipment."[27] Sure, why not? If the commander faints during launch, the journalist could take the wheel.

Some of the articles about the program did question NASA's motive in flying a journalist and wondered how "real" reporting would be accommodated. Most comments focused on three primary areas similar to those outlined in a letter from *Dayton Daily News* reporter Timothy R. Gaffney. He was concerned "what communication resources will be available on the space shuttle . . . how his news reports from space will be disseminated to the waiting media . . . and how will he cope with the flood of demands, requests and suggestions for stories which (he expects) to pour from the nation's news organizations as the flight approaches."[28] That last concern was a hoot. Somehow astronauts and Christa McAuliffe managed to cope with their notoriety, but this was too much for a journalist to handle?

In defense of selecting a journalist, Mark Brender, the ABC editor who chaired the Media in Space Committee, felt there were serious issues involved and complained, "People are taking it lightheartedly, but it's going to set a precedent for the role of journalism in the future . . . If the journalist is restricted in any way . . . there are real constitutional issues involved."[29] Brender seemed concerned that if normal journalistic standards weren't incorporated from the very beginning, the participant would not achieve the full potential of the intended purpose.

The journalist opportunity generated a great deal of publicity, but most of the coverage was devoted to celebrity journalists. The anchors of the then Big Three evening news shows—Peter Jennings of ABC, Dan Rather of CBS, and Tom Brokow of NBC—were frequently mentioned as men who deserved the nod, as did CBS anchor-emeritus Walter Cronkite. And again remember, this was in the pre-Internet days when we primarily received our daily news from newspapers and the three evening TV news stations.

Time magazine captured one of the funniest lines regarding the flight of a journalist in an interview with the 69-year-old Walter Cronkite: "There ought to be a great advantage to prove that any old fart can do it."[30]

The heavy focus on big names didn't sit well with lesser-known reporters. We received several comments like the one from a journalist in Mt. Pleasant, Iowa. In writing to ASJMS, she was "somewhat disturbed over the availability the national media has for 'campaigning' for their chances in your program . . . I am not 'whining' or claiming a foul. I would simply like to explain that, as a local journalist in a rural, midwestern area, I have not had the opportunity to publicize to the wire services or major networks that I, too, have applied for your program."[31]

While I sympathized with her frustration, there wasn't much NASA could do about who and how the media chose to cover the pro-

gram. One had to have faith in the process that the eventual selection would be based on the stated judging criteria, and not how much air time or how many column inches someone received about their application.

The significant reporting on the highly esteemed Cronkite drew mixed reactions. His name had been floated as a candidate for a shuttle flight for years. He was also one of the celebrities featured in the *Life* magazine article about the Space Flight Participant Program. However, other CBS employees complained they were discouraged from applying because top management would not endorse anyone other than Cronkite.

Administrator Beggs received one endorsement for Cronkite that said NASA "should be ashamed of yourselves. There is no need for a selection process. There is only ONE choice. If you do not select Mr. Walter Cronkite as your journalist may you all get to where God will surely send you A.S.A.P."[32] What a novel way to tell us to "Go to Hell."

CBS anchorman Walter Cronkite was a sentimental favorite for the Journalist in Space Program, though not without his critics. Here he demonstrates NASA's Reduced Gravity Simulator.
Photo: NASA

On the other hand, a retired Navy Captain told his senator, John Warner (R. VA) that he absolutely did *not* want NASA to pick Cronkite. A Vietnam veteran, the captain railed against the CBS anchorman's selection because "During the years of our Vietnam involvement, I believe he exerted a great deal of negative influence on our national will . . . I believe his influence prolonged the war, aided and abetted the no-win outcome and caused the deaths of many of the 54,000 Americans who died there."[33] Causing the deaths of 54,000 Americans? That's one load of influence. We received similar complaints from military veterans after Jane Fonda's photo appeared in the *Life* story and whenever her name was incorrectly mentioned as a VIP "under consideration."

Other humorous commentary in the press included a recommendation that ABC's Sam Donaldson should go, but on a one-way trip. Hearing that Geraldo Rivera intended to apply prompted someone to send me a letter commenting, "I guess NASA wants to test the effect of weightlessness on weightlessness."

By the end of that month, plans to send a journalist into space to provide a free flow of information took a tragic and heartbreaking turn.

How Great Thou Art

There was one more category under serious consideration for the Space Flight Participant Program: artists . . . artronauts . . . astro-artists.

Both Russian cosmonaut Alexey Leonov and Apollo astronaut Alan Bean had become serious painters in their post-flight careers. Bean, in particular, became famous for his enthralling paintings of astronauts on the Moon. However, the images they both created were derived from post-flight memories. A growing contingent of professional artists dreamed of spaceflight and thought they should be given the opportunity to capture the magic of space in real time.

There was plenty of support for sending an artist to space. The category was mentioned in the Unique Personality report and was included in public responses to the original Citizen in Space solicitation of thought leaders.

Speaking at a 1983 Sky Art conference, MIT physics professor Dr. Philip Morrison told the assembled space artists, "I feel that one of the most important needs of the world is to extend science and technology from the domain of economics and making war and peace, which is what they do today, into something which is part of the enjoyment, fun, puzzle, and excitement of everyday life. The artist does this better than anyone else."[34] In Morrison's view, an artist would bring forth the excitement of spaceflight.

Artists for the NASA Art Program were granted behind-the-scenes access to space flight preparation activities. Above, Norman Rockwell painting of astronauts John Young and Gus Grissom suiting up for the first Gemini flight.
Photo: NASA

Artificial heart surgeon and Teacher in Space judge Dr. Robert Jarvik threw his support behind those who favored the right side of their brains. Jarvik disagreed with a public comment Senator John Glenn evidently made where he grumbled that NASA couldn't afford to

send an artist to space. In his letter to President Reagan, Dr. Jarvik declared:

> Views such as Senator Glenn's that we cannot afford to put artists in space, are pessimistic and fail to recognize a magnificent opportunity—the opportunity to symbolically lead us to established values which integrate human creativity and expression with our expanding technical horizons. Space must not be seen as the cold purview of machines and experiments conducted by scientists. Space must be seen as an environment in which warmth and the expanse of human creativity can play . . . Please help us as a people to link science and the arts for the enrichment of our potential to be broad human beings—not narrow specialists. Please establish a Presidential Medal of the Arts and annually award the winner a ride on the shuttle.[35]

Pretty bold suggestion: a medal *and* a trip to space.

In a free-ranging interview in *Rolling Stone*, Beat Generation writer and visual artist William Burroughs also advocated for an artist in space. He told reporter James Fox that he regretted never having a chance to fly in space. While Burroughs was most likely referring to the Journalist in Space Program, he told Fox he applied for "something called the Artists in Orbit."[36]

He then questioned whether NASA would ever let an artist in space: "But they don't want any artists up there seeing what they don't want seen. There's never been a dream by an astronaut recorded. Do you realize that? Not one. This, to me, is absolutely appalling. I would say they have been told you don't talk about your dreams; they get very definite instructions."[37]

His stream of consciousness rant then became highly accusatory:

> We're not getting the full account at all. The whole space program reeks of lies, cover-up, and things they're not saying. My feeling is that man must now move from time into space, and the authorities, being firmly based in time, do not want to know

about that, and therefore any indications of such a shift in con-
sciousness must not be reported. And the people themselves
have been chosen carefully for their lack of imagination.[38]

If you ignore his paranoia, Burroughs actually presents a rationale
for why creative and imaginative types should, indeed, be given an
opportunity to fly in space.

I had no doubt that we could justify creating an opportunity for art-
ists as space flight participants. However, given the demands of
the active competitions for teachers and journalists, there was little
time to devote to solidifying the opportunity. This was one of those
ideas that looked good on paper, but coming up with the eligibility
criteria and definition of an artist proved to be perplexing.

How broad should the definition of art extend? Would the competi-
tion only be for "professional" artists, and how is that determined?
What about self-taught or outsider artists? What organization would
have enough respect among the community of artists to administer
the program? And consider this challenge: Would it be feasible to
allow an orbiting painter to whip out a tube of oils or acrylics in the
somewhat pristine shuttle middeck? Quick, grab that glob of paint
before it splatters into the compu . . . whoops, too late.

We already knew there was keen interest within the art community
to participate on a space shuttle mission. Since 1962, the agency
had sponsored a thriving NASA Art Program. Established by Ad-
ministrator James Webb, the program was intended to create an
alternative way for the public to embrace the space experience.
As James Dean, the first program manager, remarked, "The artists
were really missionaries for NASA. They were carrying the message
out like nothing else would."[39]

The message was documented through a wide range of media, in-
cluding paintings, drawings, photography, and eventually music.
The artists created inspirational images of astronauts in training and

Andy Warhol's 1987 *Moonwalk* featured the overlay of his trademark neon imagery.
Photo: NASA

suiting up for flight. They depicted landscapes of towering buildings, hardware, and rocket launches. Unfettered access allowed them to get up close and personal to launch control facilities, prelaunch preparations, and VIPs in the viewing stands. They were allowed to set up their easels, sketchpads, cameras, and musical instrumentals at prime locations for all phases of spaceflight.

The selected artists were given a modest grant, and the creations from their participation became NASA property. More than 350 artists have participated, and today the collection exceeds 2,500 pieces.

Just a few of the better-known artists who contributed to the program include Laurie Anderson, Paul Calle, David Hardy, Annie Leibovitz, Robert McCall, Robert Rauschenberg, Roger Ressmeyer, Norman Rockwell, Andy Warhol, and James Wyeth.[40]

Several of the artists from this space art league felt a flight opportunity should be reserved for those who had been commissioned to participate in the NASA Art Program. After the Teacher in Space Program was announced, Robert Schulman, the program manager of the art program during the Space Shuttle Era observed, "Every artist I had commissioned to be on my teams had one thought in unison: When can I go aboard a spacecraft?"[41] However, restricting the competition to Schulman's constituents would have certainly invoked howls of protest from creative types that had not previously engaged with the agency.

An early formal request to fulfill his space dream came in March 1980 from Mort Kunstler. A professional artist from Oyster Bay, New York, he sent a letter to NASA Administrator Robert Frosh. He explained he was under contract as an artist with Rockwell International and his works were intended to commemorate the significance and importance of the space shuttle. He believed the "space experience should be recorded by an artist some time in the future, and in light of my present involvement with NASA and Rockwell, I would like to be given consideration for such an assignment."[42]

Having received the action to reply, Gene Marianetti of the Office of Public Affairs told Kunstler that NASA was at least a year away from the first shuttle launch. Marianetti also explained that it would "be years before NASA would consider sending people into space who do not have a valid scientific or technical reason to go. Because of this, there are no passenger waiting lists maintained nor are there provisions for making down payments to reserve space for passengers."[43]

Three years later, immediately following the submittal of the Citizen in Space Task Force report that cleared the way to fly non-astronauts, Kunstler wrote to Administrator Beggs to again request a flight. So did many other artists, but NASA had yet to establish the rules of engagement or determine who would be eligible to apply. When the initial letters from artists arrived, the agency could only send negative replies.[44]

In 1983, Chris Robinson, a professor of art and a visual artist from the University of South Carolina had been granted an opportunity to fly on NASA's KC-135 aircraft to experience moments of weightlessness. He then requested "further participation in elements of crew training, mission preparation and general flight activities" and wanted to take the next step and experience a shuttle flight "on a space available non-operational basis."[45] Yet another request we were unable to fulfill.

In his letter to Mr. Beggs, the highly regarded science photographer Roger Ressmeyer asked that his name be "placed on the official list of CITIZEN OBSERVER trainees." If his dream were achieved, his goal would be to "cast a graphically beautiful, politically positive image of life in space."[46] He included samples of his stunning collection of photos that appeared in *Time*, *Newsweek*, *Science Digest*, *National Geographic*, and *The New York Times Sunday Magazine*. His request also included a letter of endorsement from San Francisco Mayor Dianne Feinstein.[47] While Ressmeyer's photos were outstanding, there was no list for trainees and, as usual, I was assigned the action to respond and deflate his dream.

Several artists went above NASA and took their case directly to the president. Sarasota, Florida artist Robert Van Kay, who had sent President Reagan a birthday greeting in 1982, again wrote to the White House asking for approval to be the first artist "to render an oil painting while suspended, or free floating in space, or inside the Space Shuttle." In return for a favorable decision, Van Kay offered

to paint a portrait of the president.[48] We weren't sure how to select an artist to fly *inside* the shuttle, much less *outside*.

NASA Art Program alum Robert A. M. Stephens also contacted President Reagan. Along with a photo of a lithograph he created of the STS-41-D launch, Stephens told the president, "I hope . . . that this incredible Agency (NASA) sends forth a painter up and away to record visually these ongoing events of man's search and embracement of his curiosity, up there in the final void."[49]

Well-known space artist Robert McCall called me about his interest in a flight. Among his many masterpieces, McCall may be most famous for his painting used for the movie poster for *2001: A Space Odyssey*, and for his mural depicting a robust space future painted on the wall of the National Air and Space Museum. He informed me that he was working on a project for *Time* magazine with illustrations of the Space Defense Initiative, "Star Wars." McCall asked what he should do to make clear his desire to be the first artist on a shuttle flight.[50] I could only advise him to sit tight and keep those grand paintings coming.

Among the most persistent and dedicated art league dreamers was Chet Jezierski. A mixed media artist from Saylorsburg, Pennsylvania, Jezierski's motivation to fly in space was to show us "the color of darkness, the weight of weightlessness, and the shape of infinity," as only an artist could. As the first active-duty military artist to participate in the NASA Art Program, he documented activities surrounding Apollo's 16 and 17 and was named "artist in residence" at NASA's Goddard Space Flight Center.

Jezierski's initial requests to be the first space artist were sent to the president and the NASA administrator. The assignment to respond to those letters ended up on my desk where I offered the usual unwanted reply. Not satisfied with my brush off, he then wrote to my boss, the head of the Office of Space Flight, Jesse Moore.

This time he not only proposed a flight for himself but also wanted all those who had participated in the NASA Art Program to be accepted as astronauts in the mission specialist or payload specialist categories.

He submitted a well-documented and detailed proposal to create a flight opportunity for artists. It described supplies that would be needed to create art in space, plans on how to paint during a spacewalk, and why his idea was justified. He explained, "The payoff would be when a NASA Artist "shows us the Earth as it truly is . . . And we may see ourselves reflected in the artist's vision as Archibald MacLeish imagined us: riders on the Earth together . . . brothers who know they are truly brothers."[51]

The reply, signed by Moore but which I composed, restated that the first Space Flight Participant opportunity was for educators and that the agency reserved mission specialist positions for those with science and engineering disciplines.[52] Jezierski was passionate about his dream and had clearly given his proposal enormous and meticulous consideration. It must have been extremely disappointing when he was unable to elicit the hoped-for response to come suit up for a flight.

The latest rejection only made Jezierski more determined. He wrote again and offered a rebuttal to everything in Moore's response. He especially objected to the NASA policy to allow only scientists and engineers to serve as mission specialists: "The American Space Program should be much more than just an arena for gifted scientists and pilots, because it stands at the forefront of our nation's quest for knowledge, human experience and advancement of *all* our peoples." He felt this bias was why he had not been selected when he had applied earlier to be a mission specialist. Jezierski also complained, "We artists did not ask NASA to force us into a position where our only consideration for a flight would come from the Civilian Participant Program."[53]

282

He also reminded Moore that the collective contributions of artists in the NASA Arts Program were worth at least as much as any value garnered from the flights of Senator Garn or the Saudi Arabian Prince (Sultan bin Salman Al Saud flew as a payload specialist with the deployment of an Arabsat satellite on mission STS-51-G). Jezierski was preaching to the choir on that one. I did not disagree with his belief that the Art Program veterans were "more than a special interest group seeking a junket in space."[54]

THE ARTIST AS MISSION SPECIALIST

NASA Artist

A PROPOSAL BY CHET JEZIERSKI
TO THE NATIONAL AERONAUTICS AND SPACE ADMINISTRATION

Chet Jezierski, a frequent participant in the NASA Art Program, submitted a detailed proposal to create a mission specialist category for artists.
Photo: Chet Jezierski

Still not catching on to the fact that all flight requests ended up in my office, he registered surprised to see my signature on the reply to his second letter to Moore. Our exchange continued as he wrote back to complain that the NASA Art Program artists were not getting proper respect: "Now, without apparent regard for our unique longstanding working relationship, we have been placed in a 'bingo-basket' along with highly paid TV journalists and scores of other 'worthy' professionals that NASA has deemed non-technical people."[55]

The most surprising part of his dissatisfaction focused on the eligibility criteria we might employ if NASA ever did create an Artist in Space Program. Just as Jay Barbree felt only the reporters that covered the space program since Mercury deserved to apply for the Journalist in Space, Jezierski felt only those in the bingo basket

of the NASA Arts Program should be eligible for an Artist in Space opportunity. He believed it would be an injustice when "every Sunday watercolorist or self-proclaimed space artist will be coming out of the woodwork and jumping on the bandwagon."[56]

Things got a little personal when he "found it hard to believe [I lacked the] sophistication to recognize the difference in the motivations involved" of artists and that of all the other SFPP categories. In his mind, artists had a higher purpose than others who felt they also deserved to fly. As far as he was concerned, without artists on shuttle missions, "The visual record will once again sustain huge gaps because NASA will not accept that it must actively involve the special talents of those who can best communicate the scale, complexity, and humanity of this great period of space expansion and development."[57] Short of accepting his mission specialist proposal and his subsequent demands, Jezierski was not going to be happy with any plan we came up with to create a process to select an Artist in Space.

(Looking back at this exchange, I do take offense to Jezierski's assertion that I lacked "the sophistication to recognize the difference in the motivations" of artists and the other categories. In addition to my SFPP duties, I managed NASA's Non-scientific Payload Program and was instrumental in manifesting the first artwork to fly on a shuttle mission. Against opposition from the technical side of the house, I championed the "Boundless Cubic Aperture," created by conceptual artist Lowry Burgess that flew on STS-29 in March 1989. During this period, I was also frequently invited to speak at the Sky Art conferences sponsored by the Center for Advanced Visual Studies at MIT. This gathering of creative types was dedicated to the pursuit of the cultural context for sky and space exploration. Finally, it so happens that as an outsider/self taught artist working primarily with space themes, I have created in the mediums of stain glass, ceramics, found art sculptures, and tin mosaics. My works

have been displayed, received awards, and sold in local galleries. There are many areas where I'm sure I lack sophistication (just ask nurses), but I'm quite secure that I know a little something about the "higher purpose" artists seek. But I digress.)

In fall 1985, with Christa McAuliffe in training and the Journalist in Space Program underway, it was time to move forward with the next citizen category. For a minute, it looked like the artist community would finally receive the nomination and recognition they deserved. Since Administrator Beggs and the Space Flight Participant Evaluation Committee were already favorably inclined, it was an easy decision to start planning for an Artist in Space.

If NASA were to proceed with a credible selection process for an artist competition, the assistance of individual artists and respected arts-related organizations was vital—you know, a group that could recognize the difference between the motivations of artists and that of all the other participant categories.

We initially turned to the National Endowment of Arts (NEA), an independent agency of the federal government that offers support and funding for projects exhibiting artistic excellence. It seemed like a good place to start the conversation, but we also intended to consult with professional art organizations, college deans of art, curators at art museums, and, of course, staff and participants from the NASA Art Program.

In winter 1985, I reached out with a call to Murray Welsh, assistant to the NEA Chair. Might they be interested in helping NASA design a program for artists to achieve their dream? Welsh was intrigued and offered to form a peer group to brainstorm how to set up such a competition. We agreed to meet in January after the completion of mission STS-51-L.[58] Unfortunately, given the events of January 28, 1986, the follow up meeting never took place.

10 CHALLENGER AND ITS TESTAMENT

I cannot restart my life as an astronaut, but this is a chance to connect my abilities as an educator with my interest in history, and space is a unique opportunity to fulfill my fantasies.
Christa McAuliffe, Teacher in Space Application

Last night I dreamed of Icarus
And how he flew too high
With wax and feathers for his wings
He tried to touch the sky.
And some say
When we soar with pride
And lack humility
An angry God reminds us
Of the laws of gravity.
Jack Presbury, "Icarus"

It's how you handle adversity that defines who you really are.
Dave Alonso, Personal Conversation

The Dream Team

Rumor had it that when the idea of flying a civilian observer was first proposed, NASA's astronaut corps was not overly thrilled. A space flight participant would just be another interloper to take a seat away that deservedly *belonged* to a card-carrying astronaut. But that was just a rumor.

Successful integration of the participant into a mission would require the solid support from all crewmembers. This would only be accomplished if the individual selected were seen as someone

who would bring a meaningful contribution to the mission—not just some space groupie who would get in the way.

In her preparation to fly on the 25th shuttle launch, Christa McAuliffe fully intended to bring a meaningful contribution to the mission. The mission timeline wasn't overly booked with activities, and the crew of five appeared to be an ideal match for the first participant. Commander Dick Scobee, a no-nonsense shuttle veteran, led the team. Scobee's wife, June, was a teacher, so he had a soft spot for the objectives of the Teacher in Space. Even before 51-L had been designated as the teacher flight, Dr. June Scobee had offered to be a judge for the national teacher competition.

Mission specialists Ellison Onizuka and Ron McNair were quite familiar with NASA's education goals. Both had performed experiments on previous flights for high school students when I managed the Shuttle Student Involvement Project (SSIP). Dr. McNair was considering becoming a teacher in his post-astronaut career. Along with Scobee, Captain Mike Smith and mission specialist Judy Resnik had delivered presentations at the Teacher in Space conference where the initial judging had taken place. They were both exceptionally generous of their time with the teachers and stuck around to answer questions well beyond what had been expected.

Greg Jarvis from the Hughes Aircraft Corporation was ultimately assigned as the seventh crewmember to the flight as a payload specialist. His participation was part of the marketing package NASA provided to companies who paid to launch their satellites on shuttle flights. Jarvis was originally scheduled to accompany a Hughes satellite that was deployed on earlier missions. However, he was bumped—twice—to make room for the flights of Senator Garn and Representative Nelson.

Christa McAuliffe's infectious enthusiasm and charm seemed to have made a favorable impression with the 51-L crew. As her Prin-

cipal Charles Foley had written in support of her initial application, McAuliffe was a "teacher with enthusiasm, verve, poise, the ability to remain calm under pressure, high intelligence, a good sense of humor, organizational expertise, and marvelous training methods."[1] Fortunately, the rest of the crewmembers shared these attributes. Their mix of gender, race, religion, and occupations provided the mission with role models to spare, and school children from around the nation were anxious to tune in for the countdown.

On a visit to JSC in late fall 1985, I ran into Judy Resnik in the hallway outside the 51-L office, and she invited me in for a chat with the crew. With all members present, I had a chance to personally thank McNair and Onizuka for their help with the SSIP experiments. We also had a serious discussion on the crew's thoughts regarding the Space Flight Participant Program. As he had done at the Teacher in Space Conference the previous summer, Commander Scobee again stressed that spaceflight wasn't a game and there were risks involved. If there was any resentment about McAuliffe being on the flight, it didn't show, and they all seemed genuinely excited to have her on the mission.

There may have been a comment or two that McAuliffe was getting the lion's share of news coverage and publicity. One crew member did confess to "feeling like a potted plant," and the mission would always be known as the "teacher flight." I attempted to ease the resentment and replied, "Well, at least it will be remembered for something." Let's face it, there had been 24 previous flights, and what were they remembered for?

The launch was less than a month away. The news coverage of the upcoming flight of a teacher continued to roll off the presses, and McAuliffe was the cover girl for numerous magazines and Sunday supplements. She easily captured the heart of the nation with an added bonus of gaining considerable attention for the teaching profession. Her twelve years in the classroom and her leadership of

The crew of space shuttle mission 51-L.
From left to right: Christa McAuliffe, Greg Jarvis, Judith Resnik, Richard Scobee, Ronald McNair, Michael Smith, Ellison Onizuka.
Photo: NASA

the Framington State College Debate Team had nurtured superior communications skills that she routinely displayed on television and press interviews.

That month, her hometown newspaper, the *Concord Monitor*, produced a 16-page, full-color "Student Guide" as a supplement for one of their Sunday editions. It included comprehensive articles on space history, astronaut training, information on her and her family life, biographies of the other crewmembers, questions from students, and a forecast of future space activities. A sidebar piece titled "Just in Case . . ." described what would happen if there were a mishap. It incorrectly reported, "In the event an orbiter became disabled, a second shuttle would be launched to come to the rescue."[2] Such a capability did not exist.

A feature story about McAuliffe also appeared in the January 5, 1986 issue of *The New York Times Magazine*. Written by science correspondent John Noble Wilford, the article did a wonderful job of focusing on her personality and the fact that despite all the news coverage and her newfound fame, she had managed to stay focused on her role and spirit as a teacher. Wilford noted, "She might

dress and train like an astronaut, but insisted that she remained a teacher first." McAuliffe admitted, "I'll be ready to get back to teaching. Kids have a wonderful way of bringing you back to reality."

When asked about the risk involved with space launches, "She professed to have no fear of the mission: 'I realize there is a risk outside your everyday life, but it doesn't frighten me.' Still, her life insurance policy has been cancelled."[3]

Starship Private Enterprise

Two weeks prior to the STS-51-L launch, the Ft. Lauderdale, Florida newspaper, the *News Sun Sentinel*, produced a five-page Sunday supplement titled "Welcome Aboard the Starship Private Enterprise." The article already looked beyond the Teacher in Space mission and focused on private flights to the stars. I was quoted in the article predicting that while I wasn't sure how long it would take, dreamers were more likely to fulfill their vision through the private sector than from NASA: "Cosmic barn-storming is not what NASA is all about . . . we're not out to be an airline."[4]

The article went on to report that just such a space airline might happen sooner than we thought: "Imagine the possibility someday of a well-to-do space buff plunking down several thousand dollars to take a ride around the Earth in a private space vehicle . . . Pretty far-fetched, you say? Not so; that someday may be less than 10 years away."[5]

Specifically mentioned in the article and ready to sell you a ticket for a flight in the early 1990s was Seattle-based Society Expeditions. This group of visionaries planned to finance research and development of a series of reusable spacecraft capable of taking tourists to orbit. Their flights were not designed for astronauts, politicians, or even a handpicked teacher. They were interested in flying "real" travelers, any average John or Jane Doe who wanted to fly in space.[6]

Real travelers like William and Jeanne Myers of Delray Beach, Florida had already made a $5,000 deposit on a $50,000 Project Space Voyage excursion. But they weren't the only ones; over 186 other dreamers made reservations, raising $650,000 in deposits. The Stanford University Alumni Association requested an entire flight for a reunion of its members.

Known for booking "quality expedition tours worldwide" to exotic destinations, Society Expeditions originally tried to broker a deal with NASA to lease seats on the space shuttle. However, according to their business plan, the price of a ticket would have been at least $1 million. Instead, they collaborated with Pacific American Launch Systems to build a totally new spacecraft and launch vehicle called Phoenix E. This spaceship was designed to take travelers on a 10-hour mission circling the globe five to eight times.

In their promotional materials, Society Expeditions claimed the maiden Phoenix E voyage would launch on October 12, 1992, the 500th Anniversary of Christopher Columbus landing in the Americas. The company also planned to lease two rockets from Pacific American Launch Systems for $280 million and buy ten additional vehicles at an estimated price of $50 to $60 million each. The extra spaceships were needed to meet a projected demand of 5,000 space tourists a year.

You could be forgiven for thinking this was the real deal. The company's board of advisors included a credible list of professional aerospace guides. Among others, the group included Max Hunter, who had predicted the feasibility of inexpensive nuclear-powered spaceflights to the planets. Dr. George Mueller, who once boasted space shuttles were going to be so economical that the launch system would be exported to other countries, was also an advisor. Payload Specialist Byron Lichtenberg, who performed experiments on the first Spacelab mission, STS-9, and later on STS-45, and

Dr. Brian O'Leary, the NASA science-astronaut who turned in his spacesuit because he thought the space shuttle was a scam, were also on the board.

Another space veteran didn't think much of the Society Expeditions' promises in the least. Former astronaut Deke Slayton, then the head of his own commercial launch company Space Services Inc., told the *Chicago Tribune*, "I don't think they have or are likely to have a space vehicle to ride on."[7]

Did Phoenix E make it to the launch pad for the Columbus Day Anniversary mission? Stay tuned.

That Was the Week That Was

The 51-L launch of the Challenger space shuttle had been scheduled for January 22, 1986, but flight preparations and unusually cold weather conditions postponed the mission three times and scrubbed it once. January 28 was the new target date. President Reagan was scheduled to deliver the State of the Union address that night, and NASA officials were confident that references would be made to the glories of space exploration.

We later learned that his remarks would have recognized Challenger and its crew: "Tonight, while I'm speaking to you, a young elementary teacher from Concord, New Hampshire is taking us all on the ultimate field trip as she orbits the Earth as the first citizen passenger on the space shuttle."[8] Perhaps only those involved in the program would have cringed—or cared—when the Great Communicator would have mistakenly referred to high school educator Christa McAuliffe as an elementary school teacher.

Shortly before launch day, Soviet Union President Mikhail Gorbachev caught American politicians by surprise when he proposed a bold schedule to make the world nuclear-free by the year 1999. Political pundits predicted the beginning of the end of the Cold War. Space analysts in both the U.S. and Russia were particularly en-

thused with this breakthrough since it was known Gorbachev favored an initiative to send cosmonauts and astronauts to Mars.

A week earlier, the Space Shuttle Columbia returned to the Kennedy Space Center following the completion of STS-61-C. The mission had been plagued with numerous pre-flight glitches and had experienced seven launch postponements. These delays added pressure to an already tight launch schedule, and technicians had to move quickly to prepare Columbia's next mission in March.

Thanks to electronic snapshots that arrived that week from Voyager 2, NASA's space scientists had a rare chance to bask in the limelight. Knowledge of Uranus was magnified with the return of the first close-up photographs of a bluish-green planet tipped on its side. Voyager's dividends made it necessary to rewrite space science textbooks with the discovery of ten new moons of Uranus and eleven rings when we thought there were only nine.

The preliminary time-line scheduled Christa's "Classroom from Space" on mission day six. Due to launch slips, this would have been on Sunday in the middle of Super Bowl XX with the Chicago Bears and the New England Patriots—not exactly prime time to lure kids to educational TV. Fortunately, the time-line was modified and the lesson was rescheduled for day four of the flight.

Among those most excited about McAuliffe's flight were the 112 state finalists from the Teacher in Space competition. Actively engaged in their role as Space Ambassadors, a large contingent came to the Kennedy Space Center a few days before the mission to attend an educational workshop. They would view the launch from the bleachers of the VIP site along the Banana River. How proud they were that one of their own was getting a chance to achieve the dream.

Having remained close to the ambassadors since the Teacher in Space conference, I didn't hesitate to accept an invitation to speak

at the workshop on the topic of "Astronaut Training." My slide show depicted the facilities and training activities that McAuliffe and Morgan had experienced during their previous four months in Houston.

By this time, professional astronauts had made me well aware of the difference between the training they received and what was required for a space flight participant or payload specialist. Since many of the teachers had become fond of wearing replicas of the blue astronaut flight suit for their home-state appearances, my presentation emphasized the difference in levels of training.

It was obvious that the state finalists had grasped their duties as Space Ambassadors with great vigor. NASA had kept them up-to-date on the agency's plans and activities. This helped fulfill the original objective that the Teacher in Space Program was designed to have a larger impact than just sending one educator into orbit for a few days.

I had been looking forward to attending the launch with the group, but after one launch delay too many, I had to head back to Washington. The organizers of the journalist competition were coming to town; there were other dreams to fly.

Challenger, Go at Throttle Up!

After a series of delays due to weather and technical issues, Challenger was finally set to launch on the morning of January 28, 1986. For many of a certain age, the launch was an event much like the Kennedy assassination; we remember exactly where we were and what we were doing at the time. I was sitting at my desk at NASA Headquarters.

I arrived at work that morning around 8:00 and swung by the Office of Space Flight's conference room to catch the pre-launch coverage and banter. The crew had just arrived at the pad and was beginning to file into the orbiter. Before McAuliffe disappeared through the entry hatch, a pad technician presented her with the obligatory apple

for the teacher. After she settled into her seat in the Challenger's middeck, Mission Control greeted McAuliffe, "Good morning, Christa, hope we go today." She replied, "Good morning. I hope so, too."

Throughout the morning, co-workers popped their heads into the office to offer congratulations, as "my" citizen would soon be on her way. About a half hour before the launch, I went back to the conference room where seats were now in short supply. Someone pointed to an empty chair in the front row, but just as I was about to sit down, the camera focused on the ice-covered engines. It definitely didn't look good. Surely, the launch would again be postponed.

I went back to my office. At T-30 seconds, I ventured into the office next door where a small group had gathered around a television. A few seconds later, Challenger roared off the pad. Normally, once the orbiter cleared the launch tower, we assumed everything was good.

At last, they were on their way.

Just as the applause in the next room began to fade, I received a congratulatory phone call from a friend. At the same time, a colleague stuck his head in and chirped, "Well, you got your teacher off. You must be feeling good." As I was hanging up, another colleague walked in looking pale and shocked. He said something that at first seemed like a bad joke. His words finally sank in: "We lost it! We lost the orbiter."

When I jumped back to the office next door, there was no sound coming from the monitor; everyone was staring at an unfamiliar smoke cloud. There wasn't anything to do but gawk at the screen and wait. Mission Control commentator Steve Nesbitt somberly told us, "Obviously, we've had a major malfunction."[9]

I ran across the street to the newsroom in the other NASA Headquarters building. The room had erupted into a cacophony of ringing phones and a sea of grim faces. Since the majority of the news staff had been dispatched to other NASA facilities to support the

launch, News Chief Dave Garrett was orchestrating a skeleton staff to answer questions from reporters seeking official comments. I pitched in and started answering calls.

As the afternoon progressed, additional bits of information started to fill in the puzzle. We answered the reporter's questions as best we could, but it was clear that space was not the normal beat for many of the callers. More than a few asked how many times the shuttle had gone to the Moon. We could tell there would also be many sidebar pieces on the Apollo-1 fire, the accident that took the life of three astronauts 19 years earlier almost to the day.

At one point in the afternoon, I glanced up to see Dr. Albert Scroggins and Eric Johnson from ASJMC standing in the back of the newsroom. They had come to town to meet on the next phase of the Journalist in Space Program. It didn't look like we would be doing much talking about a reporter in space that day; my hands were full with journalists on Earth.

The Dream Turns into Heartbreak

Officially, the dream took off at 11:38 AM (EST); just 73 seconds later, it turned into a nightmare. According to the investigating commission, "Traveling at a Mach number of 1.92 at an altitude of 46,000 feet, the Challenger was totally enveloped in the explosive burn."[10] The Challenger Commission spent five months studying what went wrong with the launch of mission 51-L. They concluded the cause of the accident "was the failure of the pressure seal in the aft field joint of the right solid rocket motor..."[11]

The State of the Union speech was cancelled. Instead of the planned address from Capitol Hill, President Reagan spoke to the nation that evening from the Oval Office. He offered condolences to the families of the crew and reassured the millions of school children who had witnessed the tragedy that "it's all part of the process of exploration and discovery—It's all part of taking a chance and

expanding man's horizons." He also spoke of the dream and promised that we would continue our quest in space: "There will be more shuttle flights and shuttle crews and, yes, more volunteers, more civilians, more teachers in space. Nothing ends here—our hopes and our journeys continue."[12]

Reagan may have assured us that there would be more teachers in space, but NASA's top priority was to correct the problems that caused the accident and return the remaining shuttles to flight. To no one's surprise, the Space Flight Participant Program was put on hold. It was clear that it would be a long wait before the agency focused on flying teachers, journalists, or anyone else other than professional astronauts.

The Challenger explosion led to a national period of mourning not seen since Kennedy's assassination. The analysis of what went wrong began instantly. A new group of journalists began to cover the space program, sent in to replace those who had become overly familiar with the NASA managers they were supposed to be scrutinizing.

Death and exploration were nothing new. As the National Academy of Sciences had pointed out years earlier:

> The history of geographic exploration on Earth tells us over and over again of the deaths of bold explorers . . . To ignore this in the far more difficult and hazardous areas of man in space is foolish. Men will perish in space as they have on the high seas, in Antarctica, in the heart of Africa and wherever they have ventured into unknown regions.[13]

Syndicated columnist Art Buchwald's normally humorist script turned serious as he addressed Christa McAuliffe and her testament. Her "gift to us is not in the skies, but here on Earth . . . In her death her legacy is to give her fellow professionals new dignity and honor."[14]

President Reagan spoke at the Challenger memorial service in Houston. In his words of consolation, he promised "Dick Scobee and his crew that their dream lives on; that the future they worked so hard to build will become reality. The dedicated men and women of NASA have lost seven members of their family. Still, they too, must forge ahead, with a space program that is effective, safe and efficient, but bold and committed."[15]

In the weeks following the accident, my own emotions surged in many directions. This was the first time I personally knew an entire crew and certainly felt close to Christa, so at times the grief weighed heavy. There were moments of guilt as I wondered if the critics had been right when they said it was still too risky to include citizens on a shuttle flight. I wanted to believe the president's assurance that "nothing ends here," and that the sacrifice of the crew had a higher meaning.

Monday Morning Quarterbacks

On February 3, 1986, the president appointed an independent committee to study the cause of the accident. Eventually, we learned the reason for Challenger's demise:

> The shuttle's right solid rocket booster had failed at liftoff, allowing pressurized hot gas to escape from inside the booster. This vaporized material impinged on the strut connecting the solid rocket booster to the shuttle's huge orange external tank, causing both pieces of hardware to break down. About 72 seconds into Challenger's flight, there was a massive, almost explosive, burning of the hydrogen that was streaming from the failed tank bottom, combined with liquid oxygen leaking from a part of the fuel tank known as the intertank. Under severe aerodynamic loads, the Space Shuttle Challenger broke apart over the Atlantic Ocean one second later.[16]

Ten days after the commission was established, NASA Acting Administrator Dr. William Graham offered his support for the continuation of the Teacher in Space Program. Because of President

Reagan's comments, Graham "asked Dr. Robert Brown, Director of NASA's Education Affairs Division, to continue activities associated with the goals of the teacher program. Those goals reflect NASA's continuing commitment to education and to using the space program as a catalyst to stimulate young Americans to strive for excellence in all they do."[17]

After all the memorial services were completed, the debate over whether citizens should fly on future flights stayed front and center. Numerous editorials and letters to NASA reflected both sides of the issue. As you hear from the critics, remember this: McAuliffe's participation on the mission had nothing to do with the cause of the accident. The results would have been just as tragic had only professional astronauts been on board.

Washington Post columnist Mary McGrory wrote a churlish piece in which she claimed McAuliffe had died pointlessly, "a blood sacrifice to the volcano god of NASA's ambition."[18] Responding in a letter to the editor, one space advocate was having none of that. Dave Brody retorted, "Ms. McGrory would have us believe that Christa McAuliffe was, at best, the unwitting pawn of a nefariously hatched and secretly administered propaganda campaign."[19] McGrory's comments were way off base.

Asked to comment on the accident for an article in *The Washington Post*, author Thomas Wolfe continued his man-crush on the early astronaut fraternity. Missing the truth by an extensive margin, Wolfe claimed, "Support for the citizen program was part of an insiders' battle. NASA civilians, pitting themselves against the professional astronauts, used the program for the dismantling of astropower . . . the political grip the original breed of fighter-pilot test pilots had on NASA."[20]

This was simply a ridiculous accusation with no basis of reality among the senior managers I worked for. If striving to open up the space experience to a wider segment of the population was con-

sidered a coup against "astropower," so be it. However, during that time and continuing to this day, astronauts hold a significant number of senior management positions throughout the agency, including two who served as administrator and several as directors of NASA field centers.

Speaking of astropower, after the accident, former Mercury astronaut Wally Schirra became an outspoken critic of NASA management and bemoaned the fact that all astronauts were not test pilots:

> To get ready for a serious re-launch, NASA will have to go back to using qualified test pilots only for the foreseeable future. It is ludicrous at this early stage of exploration to allow a virtual passenger on the shuttle to become known as an 'astronaut.' Such people have little to offer at an engineering skull session. I was appalled to see young women scientists in mission control acting as liaisons with the shuttle mission commander. This is not a job for a 'show and tell' celebrity.[21]

One might wonder how many years will have to pass until we are beyond "this early stage of exploration." We'd been flying for thirty years. Schirra's slam against "women scientists in mission control" was especially offensive. Did men scientists unnerve him as well? Several of the female mission specialists had logged more hours in space than he had. As for "show and tell celebrities," I guess he didn't consider his paid appearances for Actifed commercials and on-air space comments for CBS as being all that showy.

A *Time* magazine editorial also expressed disdain for even considering sending non-astronauts on future shuttle flights. In their view, "Despite NASA's cheery post-Challenger insistence that another teacher and a journalist will be sent into orbit, the (Rogers') Commission is likely to discourage such public relations ventures . . . Privately, (astronauts) described their civilian passengers as operational liabilities. One astronaut confirmed that Senator Jake Garn was a 'space invalid' on his flight. Florida Congressman Bill Nelson was described as a 'pain.'"[22]

I believe these negative comments about Garn and Nelson were primarily a result of their expedited training. Neither of the gentlemen from Congress devoted sufficient time to normal training protocols nor for bonding with their fellow astronauts, as had been the case with other crews.

Despite those who thought it was still too early, various post-Challenger opinion polls demonstrated that the public still had a "cheery insistence" in support for a civilian on shuttle missions. Four separate polls revealed favorable public support for citizen flights ranging from 56 to 70%. The same polls indicated that the range of people who wanted to fly themselves registered at 57 to 60%.[23]

Mr. Right Stuff, test pilot Chuck Yeager, told a reporter from *UPI* he didn't understand all the controversy about putting civilians, such as teachers, in space: "I have trouble identifying between a civilian guy and a military guy. They both bleed. They both die. And it only takes a stroke of a pen to turn a civilian guy into a military guy."[24]

Planetary physicist and astronomer Robert Jastrow told *USA Today* that though it might have been rushed, SFPP should continue:

> The teachers, the journalists, and the members of Congress are very important. We have to get this operation up to such a routine level that you can persuade a fellow with a screwdriver . . . to go up and fix things . . . What could better symbolize routine operations than a school teacher . . . ? The mistake was in believing we had reached the routine plateau, when we had not done so.[25]

Private citizens who believed we had reached the plateau continued to support sending citizens into space. In her letter to NASA, Jan Talcott of Ithaca, New York wrote, "I hope that this terrible occurrence will not end civilian participation in the space program. I am sure that the majority of Americans still feel that this is a worth-while venture and that any of these Americans, if offered the opportunity, would still ride aboard a shuttle flight."[26]

After the Challenger tragedy, the families of the 51-L crew established the Challenger Center as a lasting memorial, where students are able to gain hands-on, space related training.
Photo: Challenger Center

With a self-effacing commentary, Bob Caltrider wrote to me: "If NASA were to come to me and ask me if I would go up in a shuttle mission tomorrow, I would say yes without hesitation, though I doubt that NASA would ever put a fat man in space, but I would still go without a second thought no matter what the risk."[27]

Even school kids were still anxious to go. One student pleaded: "I'm a 12-year-old 7th grader. If it's my future, if what's done now will affect me later, why can't I be part of it now? This is my dream. Christa McAuliffe always said 'Reach for the Stars,' and that's what I'm doing. Please let me touch the stars."[28]

With the dreams of school kids in mind, National Education Association (NEA) President Mary Hartwell Futrell issued an inspirational statement of hope for the future. She proclaimed that Christa McAuliffe "epitomized our dreams and aspirations for what teaching can be, for what education can be, for what America can be."[29] You

may remember Ms. Futrell initially criticized the Teacher in Space announcement, but once the program was launched, she and the NEA became ardent and valued supporters.

Futrell pledged that NEA members would "continue to strive to become the kind of teacher Christa always strove to be." She asked NASA to match their commitment "with a pledge that future space projects will be infused by the spirit that Christa McAuliffe stamped on the Challenger mission. I am asking NASA to pledge never to forget that it is today's children who will tomorrow carry the space program beyond its childhood."[30] Reading the full statement continues to be a source of inspiration.

NEA again became a vocal advocate later that year when Futrell sent in a formal request to the NASA Administrator on behalf of the its Board of Directors. They asked that "NASA maintain its current priority status of providing that a teacher be the first civilian in space." While it was understood there would be a delay in realizing the request, they wanted to preserve "the honor of the first civilian in space for a teacher."[31]

My Artist in Space sparring partner Chet Jezierski wrote me a most appreciated and heartfelt letter. He wanted to "contribute my statement of hope that the Space Flight Participant Program will continue, and my confidence that concrete rewards for the American people will result from it existence." He also offered a sentimental suggestion that in the future, SFPP be renamed The Christa McAuliffe Flight Participant Program and recommended the primary and backup participants wear a commemorative patch on their jumpsuits and flight suits.

The remaining nine Teacher in Space finalists displayed their continued show of support in a letter "To the NASA Family." They noted that more than half of the Space Ambassadors had traveled to JSC for the Challenger Memorial Service and they were all "ready to rededicate [themselves] to our common goals."[32]

Journalist in Space applicants also remained supportive. Applicant Timothy P. King of WAKE Radio 1500 in Valparaiso, Indiana wanted the ASJMC selection committee to know, "There are still a few people out here that are willing to make the sacrifice needed to explore, not because we are fools or because we invite disaster, but because there is a story to be told; a story that seven people will never be able to share with the rest of us."[33]

Likewise, Richard M. Stanley of the *Austin American-Statesman* was ready to fly and recommended that a journalist be on the shuttle when flights resumed: "Flying another 'ordinary person' would be a dramatic tribute to her memory. If that person was a journalist the tribute would be all the more meaningful, because teaching and journalism are complementary professions."[34]

Despite the accident, futurist William Renfro was optimistic about people eventually traveling in space: "It may be that when we watch the frequent rising and setting of the space station and the regular 3 P.M. launch of the Shuttle, when most of us know someone like ourselves who has been in space, when we are beginning to nurture little dreams of our own, then our spirits will catch fire and our inspiration will guide our way to futures where dreams come true."[35]

Risky Business

Can "someone like ourselves" appreciate the inherent risks of spaceflight? Did McAuliffe understand the risks before she climbed through the hatch of Challenger? Who determines if someone is able to accept the inherent danger?

In *Newsweek* magazine, Thomas Wolfe again stated his belief that only professional astronauts should be going up: "If Space flight still involves odds unacceptable to 'everyman,' then should it be put back in the hands of those whose profession consists of hanging their hides, quite willingly, out over the yawning red maw?"[36]

In their post-accident editorial, *The New York Times* addressed the

odds of space flight accidents: "The risks of space flight cannot be removed altogether and Challenger's crew knew, and accepted, the dangers. Human exploration of space turns on their courage and that of all space crews."[37]

Barbara Morgan also thought she and McAuliffe understood the risks and was able to make an informed choice: "When the closest person is three miles away, I know what the dangers are." She also confirmed that "The very first time Christa and I met Dick (Scobee), one of the first things he said to us was, 'Do you really understand how risky this is?' Christa knew the risks. I knew the risks. I know the risks."[38] When he spoke at the Teacher in Space National Awards Conference, Commander Dick Scobee clearly lectured the assembled educators on the fine points of shuttle missions and potential risks. He reminded them, "This isn't a fire cracker you're sitting on."[39]

In an interview well after the accident, I asked Chief of Astronauts Dan Brandenstein if he thought McAuliffe appreciated the risks. "I personally think she did," he replied. "We make it clear to everyone who flies with us. We make it clear to the people we select for our office. We work diligently to reduce the risk but you're never going to get rid of it all. In my mind we make it perfectly clear."[40]

First American woman in space and Challenger Commission member Sally Ride offered yet another perspective: "Astronauts spend considerable time in simulators where the only thing you do is handle problems—some of which you live through some you don't. Eventually, the message hits home."[41]

She and I disagreed on her further observation that "By virtue of flying a payload specialist or a teacher or a journalist, we are saying to the public it's safe for these people to go. You're giving a different message to the astronauts all through their years of training, that it's risky to go and they really need to understand what they're doing to respond to serious situations."[42]

I disagreed with Ride because the risk involved for space flight participants was thoroughly discussed throughout the deliberations of the original Citizen in Space Task Force. It was highlighted at the Teacher in Space National Awards Conference and reinforced throughout the training McAuliffe and Morgan received. There's only so much you can do to drive this point home, and as Morgan and Brandenstein observed, it was certainly emphasized many times.

Some years later, Lawrence Livermore Laboratory scientist Lowell Wood was even more blunt. When it came to spaceflight, "It needs to be made clear that this is a risky business and not just a scenic cruise. When you're not in danger of dying you're not exploring, you're touring."[43]

A Living Memorial

While still grieving the loss of their colleague, on March 18, 1986, the remaining 112 Space Ambassadors and Barbara Morgan announced the creation of the Teacher in Space Foundation, "designed to stimulate space-aged learning and to reward innovative teachers." The focal point of the foundation was to establish ten annual Christa McAuliffe Teacher Recognition Awards for educators who created space-aged learning opportunities: "The lifeblood of the Foundation will be a plan to continue development of Space Ambassadors."[44]

In her role as the designated Teacher in Space, Barbara Morgan was named president, and Terri Rosenblatt, my colleague from CCSSO during the teacher selection process, was appointed executive director. According to Richard Methia, one of the ten finalists and foundation vice president, the state winners had conceived the organization while they were at KSC for McAuliffe's launch. They hoped that the spirit of the Teacher in Space program would become part of America and planned to designate her as honorary chairperson of the group. The new foundation planned to secure its "funding from traditional sources of support; public support, mem-

bership dues, contributions and gifts from private foundations."[45]

Just a few months later, the family members of the Challenger crew also came together to create a lasting memorial to their lost loved ones. They agreed to focus on encouraging and inspiring students to pursue careers in science and mathematics. With this in mind, they established the Challenger Center. They soon began to open educational franchises in cities across the country. To distinguish them from the national office, these became known as Challenger Learning Centers. Each center was designed to provide hands-on space, science, and technology content for middle school students and their teachers. Their education programs offered space-themed, simulation-based experiences led by trained Flight Directors and were to take place in a fully immersive Space Station and Mission Control.[46] They, too, relied on traditional forms of fundraising.

It quickly became apparent that the Teacher in Space Foundation and the Challenger Center would be competing for the same "traditional forms" of funding. Wisely, in fall 1986, the two organizations agreed to merge under the name Challenge Center. Barbara Morgan was appointed to the board of directors, and Dick Methia joined the staff.

Around the same time, Acting NASA Administrator Dr. William Graham decided to extend the formal role of the ten finalists beyond the planned expiration date of August 31, 1986 for another year. He directed the Associate Administrator for External Affairs to "initiate discussions with the finalists to address the elements of their contracts." He felt the program had been a "resounding success for the nation. The Program's educational goals and objectives are being implemented. Offering the finalists the opportunity to continue on a full-time basis will further the national space program and the President's commitment that the program will go forward."[47] This was yet another action in support of President Reagan's promise that "nothing ends here."

And That's the Way It Is

There was no question that the Challenger accident put the Space Flight Participant Program on the back burner. However, NASA wasn't quite sure what to do about the ongoing Journalist in Space Program. Since the original announcement in October of the previous year, 5,149 applications had been requested, with 1,703 entries submitted by the January 15, 1986 deadline. The Space Flight Participant Evaluation Committee decided to allow the Association of Schools of Journalism and Mass Communications (ASJMC) to continue with the selection process with no guarantees about when or if a flight might be possible.

On March 18, ASJMC sent out a press release announcing that the first round of judging was in the works. They stated the 100 regional finalists would be notified by mid-April. The plan was to then winnow the 100 down to 40 semi-finalists before forwarding five names to NASA to select the primary and backup journalists.

They continued with the next phase of judging, and on May 14, the 40 semi-finalists were announced. The list included "name" journalists and reporters that were not as well known. Given the caliber of the entries, I was confident we would end up with a superior selection to represent this brand of communicators. (Appendix B)

By the end of June 1986, it was becoming obvious shuttles would not return to the launch pad any time soon. While the 40 semi-finalists had been selected, the Space Flight Participant Evaluation Committee met and recommended that the Journalist in Space Program be placed on hold and that we end the ASJMC contract. The association was not to go forward with the next phase to select the final five finalists. In her memorandum to the administrator, SFPP Evaluation Committee Chair Ann Bradley explained, "When it is deemed appropriate to include Space Flight Participants on Shuttle missions, we can initiate a new agreement with ASJMC and resume the selection process."[48]

308

The community of journalists was not thrilled, but what else could be done? On July 14, ASJMC put out their final press release about the program:

> As the delay grew longer and longer, an indefinite suspension of the selection process became a logical option. That doesn't lessen the disappointment, however . . . The idea is still valid and (we) look forward to the time when NASA is able to return to normal launch operations and we will be able to complete the Journalist in Space Project."[49]

While I was disappointed the program was put on hold, cancellation was the only responsible thing to do. The agency needed to be totally focused on understanding the cause of the accident and creating a plan to return to flight. Anything else was an unnecessary distraction.

Leadership and America's Future in Space

Speaking of distractions, in May 1986, the National Commission on Space (NCOS) released its final report. Given the reality of the moment, the timing for the release of a visionary report about a robust space future was not ideal. NASA was working overtime to develop a post-accident strategy and figure out how to salvage thirteen scheduled shuttle missions and "the year of space science."

Former NASA Administrator Thomas Paine led the commission. While he had failed back in 1969 to gain approval for his aggressive space agenda, he was determined to succeed this time around. The report, *Pioneering the Space Frontier*, called for a long-range commitment reaching into the 21st century "to lead the exploration and development of the space frontier, advancing science, technology, and enterprise, and building institutions and systems that make accessible vast new resources and support human settlements beyond Earth orbit, from the highlands of the Moon to the plains of Mars."[50]

Other than dedicating the report to the seven astronauts that perished, there was no reference to the Challenger accident. The commission had been told to assume the Space Transportation System and plans for a space station as givens. Onward and upward!

The NCOS members had traveled around the country gathering advice and ideas from a wide range of citizens. The town hall meetings they sponsored were well attended, and they received notable recommendations for the next big thing in space. It was hard to argue with the primary goals they prescribed for the 21st century, including advancing science, exploring, prospecting, and settling the solar system, and facilitating space enterprise. The NCOS report offered a sensible and affordable phased approach to implement economic rationales for the space program, to conduct an effective science program, to develop government policies to work with the private sector, to promote international cooperation, and to gain the support of the American people.

The report predicted, "Space travel will be as safe and inexpensive for our grandchildren as jet travel is for us." This space super-saver would occur when a new generation of launch vehicles would significantly reduce mission costs and create a "highway to space." The commission members were also "confident that the next century will see pioneering men and women from many nations working and living throughout the inner Solar System."[51] As a supporter of expanding space travel for dreamers, I was encouraged by this prediction, but it was hard to reconcile with the current situation.

While the NCOS findings were widely cheered and discussed throughout the space advocate community, the Challenger tragedy took much of the wind out of the report's sail. When Paine delivered a copy to the White House, the Reagan Administration did little to embrace the recommendations. For the time being, the report with its visionary plans for the future was placed on the bookshelf with all the other optimistic reports about the future of space.

At Reagan's request, Dr. James C. Fletcher returned to NASA as administrator the same month the NCOS report was released. Serving in this position for a second time, Fletcher's charge was to right the ship. Citizens in space weren't a high priority for him, but he couldn't escape the inevitable questions on when shuttle flights might resume.

Speaking at the September 1986 conference of the Radio-Television News Directors Association, Dr. Fletcher predicted that it wouldn't be long before news organizations had bureaus on the Moon and Mars. While he admitted he was "sticking his neck out," he conceded, "Some of you may even be competing to become their bureau chiefs." He predicted we could look forward to live reporting from the Moon by the year 2006. As far as the more immediate interest in how soon the Journalist in Space Program might resume, "Fletcher couldn't offer a timetable . . . But he assured eventually there will be a journalist in space despite the delay."[52]

Even before the Challenger accident, Congress had instructed NASA to "initiate an immediate feasibility study to ensure flight opportunities for a diverse segment of the American public, including a physically disabled American."[53] Just as SFPP was suspended following the accident, one would have thought a study of this type would not be a pressing issue.

However, in September 1986, the House Committee on Science and Technology asked Dr. Fletcher for an update on the review. In his response to Committee Chairman Don Fuqua (D. FL), Fletcher felt, "It is inappropriate to conduct the requested study at this time." He promised to revisit the issue "at such time as we are again flying the shuttle, have experience with any new flight procedures or policies and have crew capacity margin."[54]

"Inappropriate" indeed. As news of the requested study spread throughout JSC, several astronauts were not pleased. They were

especially concerned about on-board safety issues. If the individual were immobile or had physical challenges that made extraction difficult or interfered with other crewmembers, how would they handle egress in case of an emergency?

Thinking this was an issue I was advocating for on behalf of SFPP, one astronaut confronted me in the hallway of NASA Headquarters and demanded an explanation as to what was I thinking. He was clearly upset, and even after I explained I was not involved with the legislation, he sulked away unconvinced.

Actually, I wasn't against the idea of the study. Over the past two years, I had received dozens of requests from dreamers who were paraplegic, blind, deaf, or missing limbs, but all wanted to fly. An official opinion by expert medical personnel and operations managers as to the feasibility of the requests would have been most welcomed in crafting credible responses to their letters.

A year after the accident, Dr. Fletcher again weighed in on flying non-astronauts during an interview with the *National Journal*. "I have a very firm opinion, but it may not prevail in NASA," he confessed. "There ought to be civilians in space when we can do it safely and manage whatever increased costs there might be. The reason is that the humans in space program is part of NASA that gets public attention, and if the tax payer is paying for this, he ought to have some representation aboard the shuttle."[55] Yeah, as opposed to those tax-dodging astronauts!

Following the Challenger tragedy and having completed her work on the commission that investigated the accident, Sally Ride asked the administrator what she could do to help the agency move forward in a positive direction.

In the accident's aftermath, reviews of the nation's space program made its shortcomings starkly apparent. The U.S. role as the leader of spacefaring nations came into serious question. In summer

1986, Dr. Fletcher took Ride up on her offer and appointed her to lead a task force (and there's always a task force) to address appropriate goals for the future. Because Ride needed someone to help her navigate the bureaucracy of Headquarters, Carolyn Huntoon recommended me to be her assistant. Given that the Space Flight Participant Program was then on an indefinite hold, I needed something useful to do.

The Ride task force identified four candidate initiatives for study and evaluation: Mission to Planet Earth, Exploration of the Solar System, Outpost on the Moon, and Humans to Mars. NASA personnel and relevant contractors were assigned to each initiative to assess in detail the implications and requirements of each.

A unique aspect of the undertaking was Dr. Ride's insistence that the younger generation of the agency be represented. Each field center was asked to appoint a rising star, someone under the age of 30. The identified individuals formed what became known as the 1-A Task Group. Years later, all ten members did, indeed, prove to be rising stars and achieved senior leadership positions throughout the agency.

Tom Rogers, who had become my space tourism mentor, stopped by our offices frequently. He continued to advocate for civilians in space and urged Ride to include the topic in our discussions. Rogers thought it was the perfect time to endorse the visionary forecasts of the NCOS report.

Ride's final report, *Leadership and America's Future in Space*, was released in August 1987. As she clarified in the report, the purpose of the task force was not intended to culminate in the selection of one initiative and the elimination of the other three, but to stimulate a discussion: "Each fit comfortably under the umbrella of NASA's charter, each contains visible milestones within the next two decades, and each requires a solid foundation of technology, transportation, and orbital facilities."[56]

The report did not address the future of citizens in space. Tom Rogers was disappointed, but the trauma of the Challenger accident was still too fresh on everyone's mind.

One of the recommendations from the Ride Report was to establish an Office of Exploration. The charter for the new organization was to coordinate studies and develop schedules, trade-offs, and costs for future missions. After the work on the leadership task force was concluded, I was assigned to be its director of special projects. Unfortunately, the new office showed no special interest in the space dreams of non-astronauts. The office primarily focused on scenarios to send handfuls of professional astronauts to the Moon and Mars.

Fortunately, the future of citizens in space was on the minds of advocates outside of NASA. Just nine months after the Challenger accident, a paper presented in Austria at the 37th International Astronautical Congress was bullish on the market for space tourism. Dr. Patrick Collins of the University of Japan and D. M. Ashford of Bristol Spaceplanes described a market demand based on a phased approach. In the Pioneering Phase, ticket prices would set you back $100,000 to $1 million. The Exclusive Phase of $10,000 to $100,000 tickets would follow. During the Mature Phase, things would become more affordable with a ride ranging in price from $2,000 to $10,000.[57] You should start saving your spare change— because when we reached the Mass Market Phase, we'd all be logging onto Ticket Master to snag the dream for only $2,000.

Throughout the 1980s and the 1990s, several commercial companies continued to approach NASA with plans to privatize passenger flights on shuttle missions. Some of the proposals were based on the early and widely optimistic launch projections that were as high as 60 flights per year. These companies wanted to lease the "extra" two to four seats that wouldn't be required for NASA mission objectives. Others looked into the feasibility of inserting a module into the shuttle's cargo bay with seating for up to 80 passengers. Most

of these looked good on paper, but financing was another story altogether.[58] No company was able to come forward with a credible business plan to convince NASA to respond, "Let's make a deal."

A New Beginning

Shortly after the launch tragedy, Congress approved $2 billion to build an orbiter to replace Challenger. The addition of Space Shuttle Endeavour brought the fleet back up to four. On September 29, 1988, 32 months after the Challenger accident, five veteran crew-members (and the first shuttle flight that included astronauts that had all flown before) carried America's spirit back into space with the launch of Space Shuttle Discovery, STS-26.

With the Return to Flight, NASA committed to a renewed culture of safety. Workers at all levels were encouraged to come forward if they saw something they didn't think looked right. Even with an increased emphasis on safety, we still held our collective breath on every launch until the solid rocket boosters and external tank were safely jettisoned from the orbiter. It was a relief when Mission called out, "Discovery, go at throttle up!" and Commander Fred Hauck replied, "Roger, go."

When they landed on the dry lakebed of Edwards Air Force Base four days later, astronaut CAPCOM Blaine Hammond Jr., proclaimed, "A great ending to a new beginning!"

Most news coverage focused on the successful Return to Flight and the relief that Discovery made it safely to orbit and back. Nonetheless, the danger of spaceflight was still in the back of our minds. As the *Times-News* of Hendersonville, North Carolina cautioned, "Let's not mince words: more people will die in space. That's just the way it has to be, and we might as well get used to the idea. How many sailors and civilians died opening the new world?"[59]

There were more than a few editorials that took the occasion to slam any notion that citizens in space might still be under consideration.

The *Gazette-Telegraph* of Colorado Springs, Colorado published an editorial noting, "The toughest lesson taught by the shuttle disaster may be that space remains a hostile frontier. It is no place, yet, for schoolteachers, journalists, or singer/songwriters. Manned space flight should be reserved for trained professionals willing to accept the risks of riding a flaming torch into the vacuum of space."[60]

While Space Shuttle Discovery regained the high ground of space for a "new beginning," the space dreamers holding reservations with Society Expeditions were informed of a new ending. Over the past three years, over 200 people had sent $5,000 deposits for an orbital excursion on the promised Phoenix E rocket ship. However, in January 1989, CEO T. C. Swartz told those in the waiting line that things hadn't gone as planned: "Since we cannot give you an exact target date, and since it is so far behind our original schedule, we no longer feel comfortable in having your deposit in escrow."[61]

The would-be space tourists were offered options to get a refund, let the money stay in escrow indefinitely, or apply the deposit to a separate Private Jet Expeditions venture. This latter opportunity took participants to destinations of "extraordinary interest." Guess those who were looking forward to a space flight on the 500th Anniversary of Columbus discovering the Americas would have to find some other way to celebrate.

In his role as chairman of the National Space Council and just three years after the Ride Report, Vice President Dan Quayle established yet another committee to evaluate the long-term future of NASA and a new beginning for the civilian space program. Norman Augustine, the well-respected CEO of Martin Marietta, chaired this group. Among many topics, the committee addressed the inherent dangers of space flight.

In December 1990, the *Report of the Advisory Committee on the Future of the U.S. Space Program*, (The Augustine Report), deliv-

ered sobering news regarding the question of risk and the chances of another accident. The report offered a cautionary note that ended up being tragically prophetic: "The statistical evidence indicates that we are likely to lose another Space Shuttle in the next several years."[62] The committee concluded the shuttle is unlikely to escape the fate of most rockets, which averages one explosion for every 20 flights. NASA should explore alternative launch capabilities.

In a related article on the statistical evidence regarding shuttle accidents, William J. Broad from The New York Times observed, "The spaceship became a metaphor for an uplifting of the American spirit." He also included a quote President Reagan delivered to Congress in 1981: "The Space Shuttle did more than prove our technological abilities. It started us dreaming again." With the Augustine committee's recommendation to move away from the shuttle, Broad predicted, "It is the beginning of the end for one of the space age's most bittersweet dreams."[63]

But was it really the end of the dream? Clearly, if people wanted to fly in space, they were going to have to look beyond NASA for their ticket to ride. As I told CBS reporter, Buddy Nelson in 1986, "Fortunately, there are things on the horizon, as entrepreneurs plan to build their own spaceships. It may not happen as quickly as we'd like, but eventually many, many, many people will get to experience spaceflight. The Space Flight Participant Program was just a very, very small step in the evolution to make that happen."[64]

Ah, but would space entrepreneurs be able to successfully boost us up the next evolutionary step.

11 KEEP YOUR EYES ON THE PRIZE

Faith is believing in something when common sense tells you not to.
Miracle on 34th Street

The space program was great as far as it went, which was the outer limits of our imagination. It lost us when it didn't come across with fulfillment to provide each and everyone of us with a chance to go.
Tom DeVries, *Los Angeles Times*

The next thing you know you're a new millionaire with your own personal Moon rocket. Everyone has a dream.
Maryland Lottery Advertisement

Teacher in Space Redux

In the years after the Challenger accident, a decision on whether or not to restart the Space Flight Participant Program remained controversial. The merits of allowing civilians on future shuttle missions were hotly debated within NASA, in newspaper editorials, in the halls of Congress, and among space advocates.

In December 1990, Japanese journalist Toyohiro Akiyama of the Tokyo Broadcasting System (TBS) became the first reporter to fly in space. Akiyana spent eight days on the Russian Space Station Mir as the first commercial space passenger. This milestone led to renewed pressure to allow U.S. citizens on shuttle missions. American journalists in particular were none too pleased that a reporter from Japan achieved the first byline from orbit. If it's any consolation, I doubt many people remember Akiyama's name or have a clue what he reported while in space.

318

Even before Akiyama's flight, NASA periodically revisited the state of space operations and pros and cons of honoring a commitment to fly Barbara Morgan. Official policy in 1989 regarding crewmembers for shuttle flights confirmed that the agency remained "committed to the long-term goal of providing space flight opportunities for persons outside the professional categories of NASA Astronauts and Payload Specialists . . . [however] flight opportunities for Space Flight Participants are not available at this time."[1]

In a 1991 memorandum to NASA Administrator Admiral Richard H. Truly, Margaret "Peggy" Finarelli, the head of the Office of External Relations, recommended that he convene "the first of the promised annual NASA reviews to determine whether it is time to schedule a Space Flight Participant opportunity for Mrs. Barbara Morgan who is the Teacher in Space Designee."[2]

Admiral Truly was the first astronaut to serve as NASA Administrator. He was the pilot on the second space shuttle launch. You might also recall he was also commander of STS-8, and was asked if he would have liked having a passenger on board. At the time, Truly thought that in the future, we could safely and easily fly private citizens on shuttle missions.

Nonetheless, as administrator and despite recommendations from review committees, Truly was never quite comfortable enough to push the launch button and restart the program. However, in February 1992 on his last day in office, he proclaimed, "As you know, I'll be leaving NASA very soon, but there is one more thing we need, I believe, to inspire our young people. The time has come to begin a formal program of teaching from space."[3] He recommended that his successor, Daniel S. Goldin, follow through with the agency's commitment and fly Barbara Morgan. Hey, Dan—go deep!

When Goldin arrived, he was understandably chagrined that his predecessor had tossed him this hot potato. President George H.

W. Bush had brought Goldin to NASA to shake up the middle-age bureaucracy and focus on plans to return humans to the Moon and then onward to Mars. No one was surprised that a reboot of the Teacher in Space Program was not the new administrator's top priority.

It may not have been Goldin's top priority, but the issue to fly the teacher wasn't going away. The President of the National Education Association submitted an endorsement to fly Morgan sooner than later; dozens of teachers and private citizens did, too. For over a year, Representative Larry LaRocco (R. ID) from Morgan's home state sent letters to President Bush and to NASA asking for updates on when his constituent was going to be assigned to a flight.

In one letter to the president, the congressman noted, "While I am certain that career astronauts can teach physics very well, America's teachers and their students need to be reconnected to NASA by seeing one of their own fly. Ms. Morgan remains an ideal candidate for a shuttle mission, and I believe NASA would be remiss in failing to act quickly in using her skills and training as both teacher and astronaut."[4]

In an interview with *Education Week*, Administrator Goldin admitted he had originally expected to act quickly whether to follow through on the commitment to fly the teacher. However, since coming to headquarters, his expanded awareness of operational and safety issues of human spaceflight caused him to consider the issue in a different light and take more time on a verdict. "In the end, this is a decision I have to make. I can't put it off on anyone else."[5] (Like you-know-who did.)

Although I had resigned from NASA in January 1990 to work in the private aerospace sector, I returned to headquarters as a political appointee in 1993. Immediately after the 1992 presidential election, Sally Ride asked me to saddle up again as her sidekick, this time on the Clinton-Gore Transition Team. This brief stint provided

a pathway to return to the agency as one of a handful of political appointees. My first assignment was to be a special assistant to Administrator Goldin to focus on policy and communications.

In 1992 and again in 1994, Goldin established internal review groups of senior managers to obtain advice about the SFPP issue. The charter of the latter group was to determine if the objectives of the Teacher in Space program could be accommodated within NASA's policy to support education, but at the same time was consistent with the policy to only assign mission-critical personnel to flights.

While I was initially designated as chair for the 1994 review, it was determined that having someone with more operational and technical experience would enhance the credibility of the group's findings. Someone who was more detached and less biased in favor of flying Morgan was also preferred. NASA's Chief Engineer Wayne Littles filled the bill and took over leadership of the review.[6]

Official records and memories of the results from the two-review groups are scarce. During this period, I was busy reestablishing the policy and plans function at the headquarters' level, and in fall 1994, I was named associate administrator for the new office. This assignment promoted me to the ranks of senior management and reduced my direct interactions with the issue of rebooting SFPP. On the other hand, I was able to significantly participate in the development of a new space policy for the Clinton Administration and help guide the creation of NASA's Strategic Plan called for under the Government Performance and Results Act.

Even while the Littles' committee was conducting its review, an editorial in *The Christian Science Monitor* urged NASA to "fish or cut bait with the teacher-in-space program." The editorial felt given Barbara Morgan's dedicated representation of the agency at educational events over the past years, "She deserves to know if she will ever make it to orbit."[7] The editorial recommended that Morgan

should get her chance to fly. The editorial admitted, "Spaceflight was as risky as ever" but went on to observe, "More shuttle missions have been safely conducted since the Challenger accident than prior to it. Furthermore, as Morgan points out, many teachers face more day-to-day risks than do astronauts."[8]

Barbara Morgan may have deserved to know if she would ever make it to orbit, but the wheels of the bureaucracy moved slowly. The administrator had a full plate of other pressing issues. Since he was originally appointed by President George H. W. Bush, Goldin wanted to be seen as a team player for his new boss, President Bill Clinton. He needed to gain the support of Congress to adequately fund the development of the space station, and to bring the Russians in as a partner per the desire of the White House. He was also busy shaking things up with his spacecraft design philosophy of "faster, better, cheaper," to replace the "Battlestar Galactica" science satellites favored in the past.

With so many other pressing priorities, a decision on whether to fly the Teacher in Space was once again shelved.

X Marks the Spot

Even though the shuttle was back in business, it was clear a reboot of the Space Flight Participant Program was not in the cards any time soon. If NASA was reluctant to reconsider flight opportunities for a teacher, journalist or artist, what hope was there for the rest of us? What happened to all those companies that tried to make deals to fly commercial passengers?

Like all things space, the creation of a spaceline wasn't going to be easy. A viable and commercially feasible space tourism operation would require a reliable, safe, and reusable rocket launcher and spaceship, an acceptable level of risk for passengers, the ability to obtain insurance coverage, government certification, and a sufficient volume of traffic at an affordable price. Progress on these

areas would require new thinking and new ways of doing business. Conventional wisdom did not think NASA was either capable, or for that matter, interested in providing leadership to make the necessary advances in the name of space tourism.

Although NASA continued to drag its heels and numerous aerospace professionals cautioned that orbital travel was still too risky, the subject of space tourism was a routine and serious topic at space advocacy and adventure travel conferences. At these gatherings, you no longer heard snickers from the audience when tourist flights were mentioned.

One of the conferences where space tourism was a common agenda item was the annual gathering of the National Space Society. This was the advocacy organization established by Wernher von Braun in 1974 as the National Space Institute. In 1987, it merged with the L-5 Society, a separate advocacy group focused on the space colonization gospel of Gerard O'Neill. The merger created the National Space Society (NSS).

At the May 1995 NSS-sponsored International Space Development Conference in Cleveland, Ohio, an innovative aerospace contest called the XPRIZE was introduced as a means to usher in a new era of space travel for the rest of us. According to its creator, Dr. Peter Diamandis, this new space sweepstakes "was designed to lower the risk and cost of going to space by incentivizing the creation of a reliable, reusable, privately financed, manned spaceship that finally made private space travel commercially viable."[9]

Diamandis envisioned the award of a $10 million prize to the first non-government organization to successfully launch a reusable spacecraft. It had to be capable of carrying three people to an altitude of 62 miles (100 kilometers), perform a suborbital arc, land safely, and perform an encore within two weeks. Other than taking a pilot, it was not necessary to carry the additional two passengers.

An uber-dreamer who previously co-founded the International Space University, Dr. Diamandis, had studied how aviation prizes had advanced the technology and popularity of early airplane flights. In particular, he was inspired by the $25,000 Orteig Prize, a contest to fly non-stop between New York City and Paris. Proposed in 1919, the prize wasn't claimed until 1927 when Charles Lindberg piloted his Spirit of St. Louis on the first non-stop flight between the two cities. Diamandis thought the same kind of prize could incentivize innovators to design new spaceships capable of carrying passengers into space.

At a ceremony under the Gateway Arch in St. Louis, the XPRIZE was officially announced on May 18, 1996. In addition to Diamandis, Apollo astronaut Buzz Aldrin, spacecraft designer Burt Rutan, and NASA Administrator Goldin were on hand for the big reveal. To give the announcement more credibility, Diamandis felt it was important to have NASA at the event. However, given the criticism Rutan routinely lobbed at NASA, we were not eager to participate in a venue where the agency was on the receiving end of his invectives. Nonetheless, Goldin accepted the invitation and added his own slant to the talking points I had prepared for the event.

In his remarks, Goldin explained NASA was "returning to being a premier research and development agency that focuses on cutting edge science, technology, and exploration—those things that no one else can do." On his copy of the prepared text he inserted, "We look to the private sector to open up the space frontier for commercial and tourism opportunities."[10]

While NASA was not allowed to endorse a private initiative or show favoritism for one commercial concept over another, the administrator referred to responsibilities in the Space Act that would allow the agency to make services available to companies that would compete for the prize. This support included sharing technologies, participating in studies, making government facilities available,

purchasing space services, and providing advanced computational codes for design analysis and simulations. In his uplifting conclusion, Goldin proclaimed, "On behalf of the NASA Team, we wish the XPRIZE organizers and the New Spirit of St. Louis Committee much success in this endeavor. We encourage the Prize participants. Let the contest begin!"[11]

In a press interview after the announcement, Diamandis predicted that someone would win the XPRIZE in three to five years: "And one to two years after that, we will have commercial tickets available for sale."[12]

During the subsequent years of the competition, 26 teams from seven countries threw their rockets into the ring and attracted the attention of space dreamers around the globe. The space trade and advocacy magazines closely followed the progress and wrote optimistic articles about the teams and their chances of success.

When in Doubt, Form a Study Group

About six months after Diamandis rolled out the XPRIZE at the NSS conference, the Space Transportation Association (STA) came knocking on NASA's door with a proposal to conduct a comprehensive study of space tourism. Tom Rogers, the godfather of space tourism, was president of STA and still trying to get the agency and the commercial sector to invest in capabilities to support public flights. To his delight, NASA agreed to the study idea and signed a Space Act Agreement with STA.

In a press release announcing the agreement, the association declared, "Space Tourism could provide a large transportation market, one that should attract significant private sector investments into the space transportation area. This area will be improved sharply as a consequence of the cooperative space industry—NASA X-33 program."[13]

For the next year, STA dove into the details of what it would take to create a viable space tourism industry. They consulted with experts

from aerospace companies, experienced astronauts, terrestrial tourism and theme park managers, finance and insurance executives, environmental scientists, government regulation and policy personnel, and health and medicine professionals. Representatives from these areas were appointed to a National General Public Space Travel and Tourism Study Steering Group.

A General Public Space Travel and Tourism Workshop was also convened. Held on the campus of Georgetown University in Washington, DC, the purpose of this gathering "was to define what must be done in order to allow this new and potentially large space-related-market to develop and to generate preliminary strategic concepts, milestones and organizational constructs toward that end."[14]

In February 1997, NASA and STA released the findings of its study: "Serious and detailed consideration was first given to the possibility of space being opened up to the general public three decades ago, and some initial attempts to do so were made a dozen years ago. But the difficulties were great and the Challenger (accident) put an end to them."[15]

The report referred to the numerous and recent marketing studies that revealed tens of millions of us would like to take a trip to space if we could do so with safely, reliably, comfortably, and affordably. Initial businesses would address the desires of those willing to pay a greater price and accept a greater risk. Predictably, space advocates felt that "serious national attention should be given to activities that would enable the expansion of today's terrestrial space tourism businesses, and the creation of in-space travel and tourism businesses."[16]

The report also suggested that NASA and the Department of Commerce cooperate with private aerospace companies "to hasten the creation of a sound and potentially very large space-related business." This could be done "by supporting space tourism merchandizing, by developing early and appropriately beneficial vehicles,"

and supporting research and development activities for both ve-
hicles and space hotels to reduce the cost per passenger, "by sev-
eral factors of ten." The study participants were especially enam-
ored with work underway at NASA for the new and promising space
transportation development programs underway on the X-33 and
X-34 programs.[17]

NASA did not go out of its way to publicize the STA report. Higher
priorities included keeping a close watch on the ongoing safety of
space shuttle missions and other research and development priori-
ties. These included the much-heralded X-33 and X-34 programs
referenced in the STA report. Administrator Goldin was also still re-
covering from the shock of being told the International Space Sta-
tion was facing a $4 billion cost overrun. I was present when he
was informed. Someone else in the office deadpanned, "Did no one
notice when the overrun hit the first billion?"

The space tourism report captured the attention of sympathetic
members of Congress like Representative Dana Rohrabacher (R.
CA), head of the House Subcommittee on Space and Aeronautics.
He was a strong space advocate and a supporter for expanding
flight opportunities to the public. In response to the report's recom-
mendations, Mr. Rohrabacher felt the country "should follow the ex-
ample of 'empire hotels' built by the British in exotic corners of the
commonwealth. Just as the empire hotel industry profited by Great
Britain's naval and technical supremacy, so will space tourism busi-
nesses of the next few decades depend on the investments we're
making today in the X-33 and the International Space Station."[18] I
guess Barron Hilton's 1960s prediction of opening a hotel on the
Moon wasn't so crazy after all.

The main contribution that emerged from the two-year space tourism
study was to bring the subject into the mainstream of serious space
policy discussions. Through his Sophron Foundation, Rogers put
his money where his mouth was and funded several initiatives to

conduct market studies and to investigate regulations and laws that would enable a thriving space tourism industry. In 2000, the foundation supported an especially useful study prepared by Rand Simberg of Interglobal Space Lines. It provided an update of space tourism requirements and a status report on proposed vehicle concepts.[19]

Though he passed away before he saw his vision fulfilled, Tom Rogers will be remembered as a tireless advocate who promoted space tourism for the masses. It was now up to the commercial space companies to advance the ball and help make Mr. Rogers' dream a reality.

A Hero's Return

Shortly after the 1996 rollout of the XPRIZE, former Mercury astronaut and Senator John Glenn (D. OH) let it be known he yearned for a return trip to space. He reached out to his fellow Marine buddies at NASA Headquarters to support his quest. This included General J.R. "Jack" Dailey (USMC, Ret.) the acting deputy administrator, and Goldin's Chief of Staff Mike Mott. Suddenly, consideration of flying someone other than current professional astronauts was back on the table.

Administrator Goldin said he would only consider a flight for Glenn if there was a scientific rationale for his participation and if the senator could pass the same physical examination as the other astronauts.

To improve his chances, Glenn offered himself as a sacrificial test subject for medical experiments on loss of bone and muscle mass that astronauts experienced during spaceflight. During his Mercury days, astronaut Glenn was not fond of being poked and probed by medical technicians. It was therefore somewhat ironic that he wanted to justify a flight based on medical experiments. Even though the results would produce a measly single data point, enough medical personnel deemed it sufficient to validate the senator's addition to a mission.

Even with the medical test rationale, the pros and cons of allowing Glenn to fly was topic one for numerous meetings for the rest of the year. Now in his mid-70s, was he too old to join a mission? Would other veterans from the Apollo Era want to fly as well? Would it be seen as a political payoff in return for supporting legislation preferred by President Clinton? And my favorite question: What about Barbara Morgan?

At a meeting in October 1997, Goldin gathered several senior managers, including me, to make a decision. The Marines in the tent were certainly in favor of letting Glenn fly because he was a an American hero, a fellow jarhead, and "he deserved it." The representative from JSC was concerned how the astronaut corps would view a flight for Glenn, but said they would salute whatever decision headquarters made (practically a first).

Because I had received letters from thousands of citizens who thought they, too, deserved to go, I pushed back on the "he deserved it" rationale. What were the criteria to determine who qualified as "deserving" of a flight? Did Apollo astronaut James Irwin deserve to fly? Back in 1985, he had formally asked for his "second chance" to return to orbit. He applied "as a former astronaut, former cardiac patient, chaplain, and in whatever capacity [he] might be used."[20] Remember the "first astronette" Jerrie Cobb? There was a national petition demanding that if Senator Glenn was getting a chance to fly, NASA should send her to the launch pad, too. Cobb herself showed up at headquarters in an attempt to convince Mr. Goldin she deserved a flight.

When it was clear the consensus was to let Glenn go for launch, I brought up the commitment to Barbara Morgan and the Teacher in Space Program. While some senior officials claimed Glenn's flight was a horse of a different color, I argued that the senator was now a civilian and hadn't been in an operational space environment in over 34 years. Yes, he had prior space flight experience, but he had

no experience with the shuttle. There was no doubt that with proper training, Glenn would perform admirably on a mission. However, with the same training, Morgan could become flight qualified just as well. As you might imagine, my emotions on this issue ran a tad high.

Thankfully, astronaut Frederick Gregory, then head of the Office of Space Flight, came up with a win-win suggestion. Instead of flying Morgan under the banner of Teacher in Space, enroll her in the astronaut corps and train her as a mission specialist. That way she would receive the same kind of scrutiny, familiarization, and length of training with shuttle systems as other astronauts. Blessings on Fred Gregory.

On January 16, 1998, the administrator announced that John Glenn would be added to the STS-95 crew scheduled to fly later in the year. Support for his flight was not unanimous within the space community. Off-the-record, a few astronauts wondered if his participation truly satisfied the requirements within the "mission critical" policy. As had been predicted, there was also external criticism within the Washington Beltway that the senator's flight was a political payoff to support the Clinton agenda.

A number of scientists and space policy experts questioned the value of the much-ballyhooed medical experiment rationale. John Pike of the Federation of American Scientists remarked, "If he was a normal person, he would acknowledge he's a great American hero and that he should get to fly on the shuttle for free. He's too modest for that, and so he's got to have this medical research reason. It's got nothing to do with medicine."[21]

If the other STS-95 crewmembers were concerned that their flight would be remembered only as "John Glenn's mission," they never said so publicly. What the critics and cynics felt didn't change anything. In October 1998, at the "ripe old age" of 77, Glenn returned to space and was again heralded as the national hero he was.

As for Barbara Morgan, in January 1998, she was accepted along with 32 other candidates in the Group 17 astronaut selection. During the two decades since the Challenger accident, Morgan worked diligently for and collaborated with NASA on dozens of education activities in her roll as the Teacher in Space in Waiting. She couldn't have been more evangelical on the agency's behalf or a better role model for educators. Nonetheless, she would now have to pay her dues performing the standard ground-based activities assigned to all pilot and mission specialists astronauts before they could be eligible for a flight. She would need to wait a bit longer to get up close and personal with the launch pad.

Ze Plane! Ze Plane!

The STA space tourism study referred several times to the X-33 and X-34 as promising spacecraft to enable flights for the public. Given the high costs of development and testing, the research had to be underwritten by the government.

The X-33 was an experimental reusable spacecraft designed to improve flight safety, bring down launch costs, and perhaps replace the space shuttle. NASA hoped this new vehicle would reduce launch costs from $10,000 for the shuttle to $1,000 per pound.

Lockheed Martin secured the NASA contract to develop the X-33. Christened as Venture Star, this single-stage-to-orbit spacecraft was designed to launch vertically and land on a runway like the shuttle. Unlike the shuttle, Venture Star would not have external boosters and instead would rely on never-before-used aerospike engines. While the original requirement called for a cargo-only vehicle, Lockheed Martin included an option to eventually accommodate passengers.

The contract called for the construction of two full-scale versions of Venture Star. Building the new rocket encountered numerous problems, including exploding fuel tanks, manufacturing challenges, and

the kiss of death to numerous space development projects—major cost overruns. After one too many failures of the subscale test vehicle, the program was cancelled. With the withdrawal of NASA funding, Lockheed Martin would need to invest its own capital to work out the problems if the vehicle was to come to the marketplace. Despite the enthusiasm of the STA study participants and Representative Rohrabacher, this was not the vehicle dreamers had been waiting for. The $1 billion-plus NASA investment produced nada.

The other new spaceship gaining attention was the X-34. It, too, proved to be a non-starter for the space tourism market. Under a $70 million NASA contract, an Orbital Sciences-Rockwell team designed another reusable spaceplane, the X-34. This vehicle was designed for launch either under the wing of a L-1011 or on top of a Boeing 747 aircraft and to land on a runway.

Although NASA's primary interest was to gain a less expensive means to deploy small satellites into orbit, the X-34 designers had an eye on space tourism as a way to recoup the investment they needed to make in addition to the NASA funding.

Orbital's Chief Engineer, Antonio Ellas, told *Florida Today's* Jim Banke, "The X-34 is like a Swiss Army knife. It has many uses for both us and the government."[22] He believed the vehicle could be adapted to carrying up to 10 passengers for a 15- to 20-minute flight into space. In this scenario, the spacecraft would take off on top of a modified Boeing 747 from the Kennedy Space Center and be ferried over the Gulf of Mexico. The X-34 would then be deployed from the 747 and ignite its rockets to send the spacecraft on a *sub-orbital* arc. The ticket price for this quick trip to space would be approximately $150,000.

Your average dreamer wasn't the target market for these trips. As Lynda Weatherman of the Space Coast's Economic Development Commission noted, "These are going to be the captains of industry and major investors. People who are the movers and shakers of corporate America."[23]

Members of Congress continued to be optimistic about space tourism. In the same *Florida Today* article about the future of the X-34, Representative Newt Gingrich (R. GA) was quoted as believing tourism would become the second largest industry in space. At a 1995 space conference, Gingrich told the audience that he was willing to "bet anybody, that if we're daring enough, by the year 2015, a major profit center in space will be operating a hotel."[24]

Unfortunately, the high rollers wouldn't be taking a suborbital flight or checking into space hotels from the tailgate of the X-34. Due to unacceptable risks and to free up funding for other launch initiatives, NASA also cancelled this program. The test version of the spacecraft eventually ended up rusting away in a back yard in California.[25]

Back in the U.S.S.R.

While NASA didn't seem to have a strong interest in promoting space tourism, it was a different story over in Russia's Star City, home of the Yuri Gagarin Cosmonaut Training Center. In search of additional rubles and ways to extend the life of its aging space station Mir (launched in 1987), RKK Energia, the entity that managed and operated the station, looked for new sources of financing.

In 1999, American space entrepreneurs Walt Anderson, Rick Tumlinson, and Jeffrey Manber formed MirCorp to promote and manage commercial activities on the Russian space station. The U.S. investors owned 40% of the company, while RKK Energia controlled the other 60%. Up to this point, Russia had planned to de-orbit Mir and focus its resources on a partnership with NASA for its space station initiative. Therefore, it was not surprising that NASA opposed MirCorp's plan to boost the Russian station into a higher orbit and extend its life.

During their brief partnership with RKK Energia, MirCorp accomplished several notable firsts. This included the first commercial lease of an orbiting human-tended space station; the first privately funded human expedition, sending cosmonauts Sergei Zalyotin and

Alexandr Kaleri to a space station; the first privately funded cargo space resupply mission; the first privately funded spacewalk; and the first contract for a Citizen Explorer with American multimillionaire Dennis Tito. Following the success of the Zalyotin/Kaleri mission, the company also completed a deal with Hollywood producer Mark Burnett to create *Destination Mir*, a proposed reality TV show to send the winner to the space station.[26] Not bad for a bunch of guys the traditional space community derided as "fringe" players!

Despite these notable accomplishments and with just a couple of years' worth of commercial activities, Mir came to a fiery end. It became a challenge to maintain sufficient financing and to maneuver around the ongoing and vehement opposition from NASA for Mir's continued operations. Russia finally bent to the demands of the George W. Bush administration and NASA to de-orbit Mir and instead devote its energy and resources to the International Space Station partnership.

The end to Mir was not without a rousing and attention-grabbing finale. Taco Bell introduced a promotion to float a 144-square meter target in the vicinity of the Pacific Ocean where Mir was expected to land. A sign on the target proclaimed, "Free Taco Here." Had Mir hit the target, the fast food company promised a free taco to everyone in the U.S. While it was a swing and a miss, the promotion successfully generated worldwide publicity and drew tremendous attention to Mir's de-orbit ballet.

Fortunately, the demise of Mir did not end Dennis Tito's dream to fly in space. He quickly sought Manber's help to transfer his agreement with MirCorp over to an opportunity on the International Space Station. It was not an easy sell. While RKK Energia was willing to send the first "tourist" to the station on a Soyuz launch, NASA displayed what one policy professional called "incorrigible opposition" to the idea.[27]

The notion of providing a flight for Dennis Tito to the ISS caused great angst amongst the status quo. Feeling it was too early for

such activities, Administrator Goldin was very much opposed to Tito's tourist ambitions. Even though the multimillionaire Tito was a frequent contributor to the Republican Party, the Bush White House was also against his flight. Tito even received a threatening message from Los Angeles politicians that said, "Fly and we will not consider you part of the LA Republican Party!"[28]

NASA's ISS Manager Tommy Holloway complained there was "little NASA [could] do to prevent (Tito's) flight beyond pressuring Russia to reconsider . . . The Russians have the key to their spaceship . . . so from a physical point of view, I don't have any way of keeping Russians from launching a rocket with something else in it."[29] Take that Dennis Tito. You're not even a person, NASA considers you *"something else."* In a real display of pettiness, the agency threatened to prohibit Tito from floating over from the Russian modules to mingle with the astronauts within the U.S. and partner real estate. I guess they would post "No Trespassing" signs in both English and Russian.

Jorg E. Feustal-Buechl, director of Manned Spaceflight for ISS-partner the European Space Agency (ESA), also railed against Tito. He griped, "Russia had no right to send amateurs to the orbital complex until its safety and security were fully assured . . . Imagine that something happens, something like the Challenger accident, when NASA sent a school teacher aboard the shuttle. It dealt a real setback to the space program."[30]

Ah yes, the old "what if something happens" canard. Never mind the fact that having a schoolteacher on board had zero to do with the Challenger accident or the resulting "setback." The old guard just didn't want a bunch of inexperienced dreamers wandering around where they weren't welcomed.

Despite the naysayers, Manber's persistence paid off. He secured approval for Tito's visit to ISS and even transferred the money that had been deposited with MirCorp over to the Russian Space Agency for the launch to ISS. At an event several years later, Tito told the

audience, "One of the most selfless things done in business was when Jeffrey (Manber) transferred my money to the Russian government without any pushback."[31] At a ticket price of $20 million, it was, indeed, a selfless act.

Manber was not interested in being a broker for tourists, so the responsibility to conduct the day-to-day aspects of Tito's flight arrangements was transferred to the American space tourism company Space Adventures. Tito went on to train for his mission at Star City, and in April 2001, he launched on a Soyuz spacecraft and spent seven days as the first space tourist on ISS.

While space advocates were ecstatic that a tourist finally achieved passage into space, booking a ride through Space Adventures was hardly a path for most dreamers seeking a personal flight opportunity. Such flights were clearly reserved for the very highest of high rollers and over the next nine years, and for some at a price as high as $40 million, six other people of extreme wealth booked flights to ISS through Space Adventures. These included South African Mark Shuttleworth; American Gregory Olsen; Iranian-born tech mogul Anousheh Ansari; Charles Simonyi, a Hungarian-American computer executive who flew twice; computer games inventor Richard Garriott, (His father was Skylab astronaut Owen Garriott, making Richard the first offspring of an astronaut to travel to space); and the Canadian co-founder of Cirque du Soleil, Guy Laliberte.

American astronauts and the paying customers had to get used to the way the Russians conduct a launch countdown, or actually didn't count down. Describing the difference in procedures between the U.S. and Russia, Richard Garriott reported, "You know, the 10, 9, 8, 7, 6, 5 . . . well in Russia, they don't do that. You are just going through a check list and you get down to the point in the checklist where there is a Russian word 'pusk,' which basically means, 'start.'"[32] So, on your marks, get set, pusk!

Legalizing Recreational Spaceflight

The flight of Dennis Tito truly captured the public's imagination. Despite the lack of spaceships for public conveyance, articles predicting that recreational space flights were just around the corner again became the mainstay in the space press and general interest publications. Wealthy, risk-taking individuals and space-investing angels were popping up everywhere. The interest of the private sector was churning up public interest in the latest schemes to break gravity's surly bonds.

Even Congress began to focus on the growing constituent interest in space tourism. The House Science Subcommittee held a hearing in 2001 after Tito's flight to address commercial human spaceflight. Buzz Aldrin testified and put in a plug for space tourism. Since the space shuttle could carry up to eight people, Aldrin thought NASA should sell tickets. Proceeds from the sales would help offset the high costs of shuttle launches. Congressman Dave Weldon (R. FL) "calculated the amount of revenue NASA could receive if it were to fly two tourists on seven shuttle missions per year: $1.4 billion, or 35 percent of the $4 billion space-station overrun . . . If NASA is strapped for cash, why shouldn't we do it?"[33]

Unfortunately, there was a chance the funds would end up in the General Fund, and, there was no guarantee that NASA would be allowed benefit from the initiative. Besides, other members of Congress would no doubt want to use the funds to offset a favored program of their own.

Congressman Dana Rohrabacher (R. CA) wasn't all that enthusiastic about selling seats. He felt the predictably high-ticket price would be unfair to citizens who did not enjoy discretionary wealth and wouldn't be able to afford a ticket. Both he and Aldrin favored holding a lottery, an idea that was shot down during the original Citizen in Space Task Force. If NASA senior management and profes-

sional astronauts weren't supportive of flying successful, wealthy tourists, they would hate it if some lucky, non-vetted, uncouth yokel won the draw and showed up at the gates of JSC for flight training.

On July 10, 2001, a month after the ticket sales hearing, Representative Nick Lampson (D. TX) introduced House Resolution 2443, the Space Tourism Promotion Act of 2001. It was quickly referred to the Committee on Science and the Committee on Ways and Means.

The proposed legislation included kudos to the idea of helping private citizens eventually make it into space. It recognized that humans have long had a yearning to travel in space and acknowledged tourism could become a significant and economically important industry. The legislation also stated the Federal Government could stimulate the industry with loans, tax credits, a favorable regulatory structure, and a focus on research and development of technologies to enable the private sector to build passenger-carrying spacecraft. In addition, it noted that while it was appropriate for the Federal Government to encourage space tourism, it was inappropriate for the government to compete with the private sector in providing vehicles and facilities for space tourism.

One aspect of the bill earned a thumbs-down from space tourism advocates. Under the section on Use of Federal Facilities, the legislation prohibited space vehicles to be available for "individuals other than those engaged in or supporting the conduct of official business."[34] In other words, it would be harder to justify allowing private citizens on the remaining space shuttle flights.

This provision also put the kibosh on space tourists visiting the U.S. portion of the International Space Station. While this did not affect Russian modules on the station, one of those ultra-rich Space Adventure-types best not float across the Lampson Maginot Line. Don't forget about the NASA regulation that gave a space commander the authority to arrest law-breakers, fine them up to $5,000,

and sentence them to a year in prison—or both! I can imagine an exchange with the ISS commander and a Russian-sponsored space tourist: "Just remember pal, we don't care how much you paid for your ticket. Stay on your side with your Russian buddies." Although the bill never made it out of committee, the lexicon of "Space Tourism" had been officially uttered in the hallowed halls of Congress.

Several years later, legislation introduced by Representative Rohrabacher enjoyed considerably more success than the Lampson bill. His U.S. Commercial Space Launch Amendments Act introduced procedures for regulating commercial human spaceflight under authority of the Federal Aviation Administration (FAA). For the majority of dreamers, this bill dealt with the minutia of government blather that they'd rather not have to hear about. Nonetheless, the legislation was important because the language set the stage for regulations and authorities that would enable private companies to sell the long-coveted ticket to space.

Especially relevant was the directive that FAA would not be permitted to impose safety regulations regarding space tourism until 2012, except in the case of a serious accident or series of incidents. Operators were required to inform clients in writing about the safety of their launch vehicle(s) and the risks inherent with launch and re-entry. The participant also had to indicate they were willing to fly at their own risk.

President George W. Bush approved the legislation in December 2004. The new law provided a degree of protection to launch providers from mega-lawsuits in the event of a catastrophic accident. This was critical in order to attract investors to the nascent space tourism industry. This did not mean stricter regulations might not be proposed in eight years, but at least the startups wouldn't drown in restrictive guidelines before they even began to fly their first passengers.

Space Travel 2.0

As we've seen, predicting when tourism for the masses would become a reality is hardly an exact science. Historically, the forecasts have been overly optimistic, and, in many cases, just plain silly.

Those supporting optimistic start dates often thought the slow pace of human space travel should be expedited to match the much more rapid progress that occurred for passengers in the aviation sector. In a December 2001 op-ed for *Aviation Week & Space Technology* magazine, we again heard from space tourism scholar Professor Patrick Collins. He pointed out that in the first 100 years of aviation, passenger travel grew from zero in 1901 to 1.5 billion passengers a year in 2001. Meanwhile, in the first 50 years of human space flight, fewer than 600 individuals have achieved a rocket ride.[35]

Collins believed this disparity existed because government and policy makers ignored the potential economic value of space tourism. He proposed that governments "redefine space agencies' objectives to aiding the growth of commercial space travel, rather than performing their own missions. This will lay the foundations for rapid growth of private space activities."[36]

If his advice were followed, Professor Collins was confident that "by 2030, some 5 million passengers could be taking trips to a necklace of hotels in low-Earth-orbit." He also believed that in that time frame, "Numerous ancillary industries will be operating in orbit, and the leading edge will be tourism to the Moon where the first flying sports stadium could even be under construction." These new industries would generate revenues of $100 billion per year, offering greater value than a taxpayer-funded enterprise to send a few government employees for a short visit to Mars.[37]

Given the capabilities, technologies, and business plans when Collins stated this in 2001, his prediction of 5 million people in orbit by 2030 seems mighty optimistic. Nonetheless, the space faithful

In September 2006, Iranian-American Anousheh Ansari became the first self-funded woman "tourist" to fly to the International Space Station. *Photo: Space Adventures*

keep promising that launch costs would soon radically drop and that such scenarios would become feasible.

Collins' suggestion that NASA focus its resources on the development of advanced technologies to boost commercial enterprises rather than on its own parochial missions was not new. Over the years, there have been numerous calls for the space agency to readjust its mission to push cutting-edge technologies, like its predecessor the National Advisory Committee for Aeronautics had done for aviation. NASA resisted such recommendations and continued to develop its own rocket and spacecraft either in-house or through government-funded contracts. It preferred to create its own plans for missions to send a handful of astronauts to Mars. However, as you will see, it is possible to redirect the course of an ocean liner; it just takes time to complete the maneuver.

Business plan presentations to angel investors became a staple at space advocacy conventions. The new players pitched single- and multi-stage propulsion systems that landed vertically and horizontally, with wings, parachutes, and even propellers. They shared the doctrine that the mentality of the Apollo Era was yesterday's news and were fond of the term "disruptive innovation." These budding

341

entrepreneurs were confident that they could become a real honest-to-goodness business if they could just make the next payroll, afford to pay that overdue bill for the latest weight-saving gizmo, or figure out a legal way to accept deposits for future flights. They became uncomfortably familiar with the space proverb: "How do you make a little money in space? Start with a lot of money."

Not quite to orbit, but a parabolic flight provides periods of weightlessness. Author Alan Ladwig and ZERO-G cofounder Peter Diamandis enjoy a G-Force-1 test flight
Photo: Zero-G Corporation

Would You Settle for a Superman Photo Op?

For dreamers without millions in their savings account, there is a less expensive way to gain a free-floating microgravity experience, courtesy of the Zero Gravity Corporation—ZERO-G. XPRIZE founder Peter Diamandis, former astronaut Byron Lichtenberg, and aerospace engineer Ray Cronise formed the company in 1993.

Similar to one of the training exercises for NASA astronauts, parabolic flights provide up to 30-seconds of weightlessness. During

the flights, astronauts practice getting in and out of spacesuits, conduct test runs on experiments they would later perform in orbit, and learn how to corral and eat floating food.

I joined ZERO-G as chief operating officer in 2002 during the start-up phase. I became a stockholder and remained part of the team until 2005 through the first 27 flights. The initial staff also included a cadre of young professionals full of spit and vinegar with their own dreams of space travel. The initial staff included Marketing Director George Whitesides (now CEO of Virgin Galactic); Flight Coach and Yuri's Night Co-founder Loretta Hidalgo; Flight Coach Maraia Hoffman (now CEO of Star Harbor Space Training Academy); and Flight Coach Allison Rocket (currently head of NewSpace Global). Flight Director Tim Bailey, who also serves as executive director of Yuri's Night, and Robert Ward (now a pilot for a major airline), remain active with ZERO-G.

One of the reasons it had taken 11 years to get up and running was the need to modify a Boeing 727-200 aircraft suitably to gain certification from the Federal Aviation Administration (FAA). ZERO-G eventually found an airline partner to work through the FAA approval process. Florida-based Amerijet was in the business to provide cargo flights for the commercial marketplace and agreed to let ZERO-G use its plane during down times.

Another reason for the prolonged approval process was the lack of regulations for airplanes to perform parabolic operations with people on board. Since as a government agency NASA didn't require FAA certification for its KC-135, there was no precedent. There were regulations for passenger planes, there were regulations for cargo planes, but there were no regulations for flying passengers on parabolic maneuvers on cargo planes.

Robert Ward, ZERO-G's Vice President for Flight Operations, performed a minor miracle in collaborating with FAA's regional offices and headquarters to hammer out an acceptable set of requirements

to begin commercial flight operations. ZERO-G's diligence paid off, and its G-Force-1 aircraft received certification under Part 121 of the Code of Federal Regulations, the same regulations that commercial airlines have to meet.

Ward also was able to gain an exemption from stacking the useless parachutes in the middle of the plane's floating space. ZERO-G asked NASA to support our request for the exemption, but a safety officer declined with the excuse that they were "unfamiliar with ZERO-G's operations." That may have been true, but it would have been useful had they at least confirmed that in over four decades of parabolic flights, they never had occasion to break out the parachutes. Guess the safety guy was unaware that NASA was supposed to be supportive of commercial activities.

The company conducted its first commercial flights in 2004 with a cross-country tour sponsored by Diet-Rite Cola. The first two flights were reserved for contestants from Richard Branson's reality TV show *Rebel Billionaire: Branson's Quest for the Best*. This was followed by flights in 12 cities across the country.

The price to fly was $3,000. Passengers received a half-day safety briefing and training on how to get the maximum value and fun from 15 parabolas of weightlessness. During takeoff and landing, 35 passengers and crew sat in seats in the back of the plane. Just before the pilot began the parabolic maneuvers, flyers were positioned in one of three different zones in the open, padded area upfront. The thrill of floating began once the plane went over the apex of the climb. Mounted cameras and video photographers recorded the joy of the experience. You wanted to make sure you were captured in the "money shot" of pushing off the front wall and flying like Superman to the back of the plane.

While we aggressively avoided the term *Vomit Comet*, a small number of passengers on the early flights experienced the dreaded ef-

fects of "space sickness." Initially, flyers were positioned on their knees during the ascent and before free fall. Fortunately, once we switched the procedure to have participants lie on their backs during the climb, the complaints of nausea dropped dramatically. We also advised taking anti-nausea medication, which proved effective for the vast majority of flyers.

My favorite flight occurred when I performed as a flight coach for octogenarian Astar Daniels. We became pen pals in the early stages of the Space Flight Participant Program when she volunteered for a space shuttle flight. After I appeared on C-Span's *Washington Journal* to discuss the program, Astar sent a portrait sketch she made of me while I was on the air. As self-taught artists, we created a mutual admiration society and corresponded with each other for many years. Although she was beginning to lose her eyesight, Astar signed up for a parabolic flight when she was 82 years old. I will never ever forget the look of joy on her face when I helped her complete her first free-floating summersault and gave her a push for her Superwoman photo.

Experiencing a parabolic flight is loads of fun, and so far, there have been no serious accidents. Serving as a coach, I had a moment of trepidation when the plane experienced decompression while everyone was floating about. Positioned in front of the seating area, I gave my best impression of a goalie trying to stop passengers who were sent sailing toward the back of the plane. It only lasted a few seconds, but it was a reminder that things happen and why it's always critical to pay attention to the safety briefing.

With a ticket price of $5,400, ZERO-G continues flights to this day. Over the years, they have conducted hundreds of flights with thousands of parabolas. They have performed research flights for over 50 companies and universities, and for a time were under contract to conduct flights for NASA. *(Full disclosure: I remain a stockholder of ZERO-G Holdings.)*

Among its more noteworthy passengers were physicist Stephen Hawking, film director James Cameron, *Star Trek's* William Shatner and George Takei, skateboard champ Tony Hawk, astronaut Buzz Aldrin, magicians Penn & Teller, and *Sports Illustrated* swimsuit model Kate Upton. In addition to Branson's show, ZERO-G has also flown participants for other reality shows, including *The Bachelor* and *The Biggest Loser.* Even more noteworthy than the celebrity participants are the thousands of passengers who may have come as close as they ever will get to the ecstasy of weightlessness.

Meanwhile, Back at the XPRIZE

Since a $40 million ticket to ride to ISS via Space Adventures was out of reach for most dreamers, where else could we go? What was up with that XPRIZE thing?

Burt Rutan (black jacket on left) accepts $10,000,000 check from Robert K. Weiss and Peter Diamandis for winning the The Ansari XPrize on October 4, 2004.
Photo: XPRIZE Foundation

Peter Diamandis was working overtime to help make it happen. In addition to getting ZERO-G up and running, he was also managing the XPRIZE competition and always in a fundraising mode. Although a number of companies, foundations, and individuals contributed money toward the XPRIZE purse, the full $10 million wasn't secured until May 2004. Technology entrepreneur and recent ISS space flight participant Anousheh Ansari and her brother-in-law, Amir Ansari, made a multimillion-dollar donation to top off the tank. Because of their generosity, the competition was renamed the Ansari XPRIZE.

XPRIZE officials estimate that the participating companies invested more than $100 million in new technologies and systems. An early odds-on favorite to grab the brass ring was the Mojave Aerospace Ventures team led by spacecraft designer Burt Rutan and funded by Microsoft co-founder Paul Allen.

On October 4, 2004, the 47th Anniversary of Sputnik and eight years after the kickoff in St. Louis, the Rutan-Allen team claimed victory. On its second flight, civilian pilot Brian Binnie guided SpaceShipOne to an altitude of 69 miles (112 kilometers) and landed successfully before a crowd of thousands at Edwards Air Force Base. Two weeks earlier, test pilot Mike Melvill had completed the first of the two flights required to claim the $10 million reward.

For spaceflight dreamers, the success of the Ansari XPRIZE was a big deal. The participation in the contest by such significant and enthusiastic non-government entities provided a new shot of hope. But steady, boys and girls; you would have to wait a bit longer to buy a ticket.

Waiting is the Hardest Part

Although Barbara Morgan had joined the astronaut corps in 1998, it took another 16 years before she was assigned to a space shuttle mission. In April 2002, NASA Administrator Sean O'Keefe an-

nounced that Morgan would fly to the space station "as part of a plan to refocus agency goals on science, exploration, and education." The administrator went on to declare, "NASA has an unfinished mission. It began in 1986, and ended for seven families. It's time for NASA to complete the mission to send an educator to space."[38] At a subsequent event at the Maryland Science Center the following December, O'Keefe *formally* announced that Morgan would fly to ISS on STS-118, then scheduled to launch in November 2003.

Just a month later, O'Keefe further demonstrated NASA's support of education when he announced the creation of the Educator Astronaut Program. "NASA has a responsibility to cultivate a new generation of scientists and engineers," he declared. "Education has always been a part of NASA's mission, but we have renewed our commitment to get students excited about science and mathematics. The Educator Astronaut Program will use our unique position in space to help advance our Nation's education goals."[39]

While educator astronauts would have expertise in teaching grades K-12, O'Keefe clarified that they would be fully qualified members of the astronaut corps and expected to perform the same activities as the current mission specialists. Like other mission specialists, educator astronauts would help coordinate crew activity planning and operations, assist with science experiments, and participate in International Space Station assembly and operations.

Educator astronauts were also expected to motivate students and educators to study STEAM, attract more people to the teaching profession, and enable leading educators to reach beyond their local community and affect a larger, national audience. To qualify, a teacher had to be willing to leave the classroom and complete one to two years of training at JSC in Houston. More than 1,000 educators applied for the 2003 astronaut call. The following year, teachers Joseph Acaba, Ricky Arnold, and Dotty Metcalf-Lindenburger were among the eleven candidates announced for Astronaut Class 19.

Originally selected as the backup to Teacher in Space Christa McAuliffe, Barbara Morgan became an astronaut and flew to the International Space Station on STS-118 in October 2007.
Photo: NASA

In the meantime, Barbara Morgan trained for the STS-118 mission. Due to changes in flight schedules and requirements for ISS, the anticipated 2003 mission did not launch until August 2007. By that time, Michael D. Griffin had become NASA Administrator. In a pre-launch press conference, Griffin went out of his way to explain that Morgan had trained as a regular mission specialist and was not flying as an educator astronaut. It was unclear why it was necessary to create such distance from Morgan's teaching background.

Over 80 Teacher in Space finalists, all who were still serving as Space Ambassadors, returned to KSC for Morgan's launch and to cheer their colleague into orbit. They were treated to another educator's conference and brought up to speed on NASA's plans for the future. Astronaut Joe Allen came for a repeat performance from his appearance at the 1985 Teacher in Space National Awards Conference. Working for the Zero Gravity Corporation at the time, I was

invited to the party to talk about commercial parabolic flights and to extol the glories of free floating in microgravity.

Morgan's responsibilities for the mission included managing the transfer of cargo from Space Shuttle Endeavor to the station and operating the Canadarm for several external operations. Her time was also occupied with a Q & A amateur radio broadcast exchange with students at the Discovery Center in her home state of Idaho. Along with crewmate Alvin Drew, she conducted a second broadcast for students and teachers at the Challenger Center for Space Science Education in Alexandria, Virginia. June Scobee-Rodgers was the host.

During the year following her flight, Morgan traveled around the country promoting the space program and again engaging in educational activities. She left NASA in August 2008 for a teaching assignment at Boise State University. As she frequently reminds students in her post-flight appearances, "Never give up on your dreams."

12 WAGONS HO!

The shuttle is always going to be a reflection of what a great nation can do when it dares to be bold and commits to follow through. We're not ending the journey today . . . we're completing a chapter of a journey that will never end.
> Chris Ferguson, STS-135 post-flight comments

These days, keeping the dream alive is like performing open-heart surgery on yourself without anesthesia.
> Michael Kelly, *Business Week*

Making dreams come true is both a poetic and an accurate definition of progress.
> Daimler-Benz Advertisement

End of an Era

With the July 21, 2011 landing of Space Shuttle Atlantis, STS 135, the Space Shuttle Era came to an inevitable end.

The spectacle of a rocket launch is almost a spiritual experience. Because the last launch of the space shuttle was especially reverent, an estimated crowd of 750,000 came to watch the shuttle "flex its muscles one last time."[1] I was head of public outreach at NASA Headquarters at the time and was fortunate to collaborate with the extraordinary Guest Operations Team at KSC as they hosted 36,000 special guests at on-site VIP viewing stations.

Since the first launch in 1981, the shuttle fleet had carried 355 astronauts from 16 countries to low Earth orbit and traveled a total of 540 million miles. The missions deployed and repaired satellites, tested and demonstrated new technologies, conducted countless scientific

experiments, and were the backdrop for innumerable hijinks with floating food and flyaway hair. We witnessed the evolution of flight opportunities from test pilots to scientists, from mission specialists to payload specialists, and finally to educator astronauts.

The track record of the space shuttle was not without moments of tragedy. In addition to the Challenger accident, another crew perished in 2003 on STS-107. As it was gliding in for a landing at KSC, the orbiter disintegrated in the skies over central Texas. All seven crewmembers perished, including Rick D. Husband, Kalpana Chawla, William C. McCool, David M. Brown, Michael P. Anderson, Laurel B. Clark, and Ilan Ramon. That risk thing again.

The shuttles could withstand the extreme vibrations of a launch and the searing heat of reentry, but it could no longer survive the grievances of escalating operational costs, ongoing safety concerns, and ultimately, politics. With estimates as high as $10,000 per pound, shuttle launch costs never came close to the promised price of $100 per pound.

While the final flight occurred during the tenure of President Barack Obama, the decision to suspend the shuttle program was made by the previous administration. In 2004, President George W. Bush announced the program would be cancelled in 2010 to free up funds for his Vision for Space Exploration (VSE) and develop a new, improved, and less expensive launch capability to deliver astronauts to orbit.

The new capability was necessary for VSE's Constellation Program with goals to send astronauts to the Moon and Mars. To support these goals, a Crew Exploration Vehicle (CEV) was designed to replace the shuttle orbiter. This capsule was originally planned to launch astronauts on a rocket called Ares I. Cargo to support the missions of exploration was to be sent up on a second, heavy-lift Ares V. It would take at least a decade before the replacement launch system would be available.

With the cancellation of the shuttle, America had no spaceships to send astronauts to ISS. The only alternative was to purchase seats on Russia's Soyuz capsules at $75 million a pop. They had been planning for NASA as a customer since 2010 when they suspended flights of private citizens to ISS. Russia realized seats on the Soyuz spacecraft would be needed to ferry cosmonauts and astronauts to the station and there would be no room for space tourists. Besides, NASA was willing to pay a higher price per seat.

Almost immediately, the Ares rocket ran into budget and technical challenges. A prototype Ares I-X was launched in December 2009 and did manage to achieve its primary test objectives. However, the first stage booster was damaged when it slammed into the ocean as a result of failures with the parachutes. With higher than predicted development costs and escalating estimates for eventual operations costs, the Obama Administration attempted to cancel the entire Constellation Program. In a 2011 compromise with Congress, Ares I and V were scuttled, but the CEV, then called Orion, was spared.

There was a growing demand for NASA to switch tactics away from developing its own hardware and instead collaborate with the private sector for commercially operated capabilities. This led to programs for commercial crew and cargo spacecraft, intended to spur innovation and reduce costs. In the event the private sector did not succeed, NASA continued to fund the Orion crew capsule and at the insistence of Congress, the development of yet another rocket, the Space Launch System (SLS). Orion and SLS were planned to be operational by 2018, but with the usual delays and technical challenges, it is more likely to be 2020 before astronauts climb aboard. Until then, or until the private sector can deliver a suitable substitute, NASA will continue to pay the Russians for Uber rides to ISS.

The demise of the shuttle program was another nail in the coffin for the public's dream to fly. Not only that, flights for citizens never

made the list of requirements for Orion or SLS. Would we ever get off this planet?

It's time to turn our attention to the handful of space tourism entrepreneurs who do care about your dream. Some of the providers are already accepting deposits and are ready to measure you for a flight suit for a suborbital excursion. While "See You in Suborbit" doesn't pack quite the punch as several laps around the globe, at least you'll experience weightlessness and see the curvature of the Earth. Still other companies are promising trips around the Moon and stirring up volunteers with visions of communities on Mars. They are building rockets that promise reduced launch costs and present serious competition to NASA's SLS.

True space advocates are already familiar with the fearless leaders of these commercial entities. For the past ten years, there has been endless coverage of their exploits in magazine articles, profiles on the evening news, and postings on numerous social media venues. In his recent book about the growing influence of commercial space companies, Christian Davenport refers to these entrepreneurs as *The Space Barons*.[2] You might also check out *Rocket Billionaires* by Tim Fernholz.[3]

We've learned how they have invested personal millions and billions to create new spaceships and alternative extraterrestrial futures. We even know about their dating habits and divorces. Rather than relay more about their personal stories, the remainder of this chapter will focus on the spaceflight services their companies plan to offer and whether or not they are likely to finally send you into space.

The British Invasion

Buoyed by his success of winning the Ansari XPRIZE in 2004, Burt Rutan quickly went to work to modify his SpaceShip1 and White Knight1 vehicles for the tourism market. He declared, "Manned space flight is not only for governments to do. We proved it can

be done by a small company operating with limited resources and a few dozen dedicated employees." Rutan predicted, "The next 25 years will be a wild ride; one that history will note was done for everyone's benefit."[4] Now all he needed was someone with deep pockets to finance the wild ride.

Rutan found a willing investor and customer for his new spaceships in British billionaire Richard Branson. Sir Richard's entry onto the field was a game changer. Creator of the well-known "Virgin" brand, Branson brought a reputation of success from his numerous global enterprises. He also had a fine-tuned flair for marketing and creating excitement in the media.

Branson began shopping for a spaceship as early as 1999 when he established Virgin Galactic Airways. He was interested in obtaining a reusable launch system to meet the demands of both the space tourism and small satellite markets. In an interview with *Space News*, Virgin spokesperson Will Whitehorn explained, "Space tourism in its own right may not be justifiable. But if the private sector develops a reusable launch vehicle on its own, the possibility of leveraging some sort of space tourism could be real."[5]

Branson's representatives began to meet with small companies developing new, reusable launch vehicles (RLV). One such company was the Rotary Rocket of Redwood, California. There they were briefed on Gary Hudson's Roton RLV, a vehicle that employed rockets for the launch phase and spinning rotor blades for landing. The company predicted launches at $1,000 per pound. With its fuselage built by Rutan's Scaled Composites, Rotary Rocket had a degree of credibility. However, its test vehicle made just three hover flights in 1999, and by 2001, the company exhausted its funds and went out of business.

In 2004 Branson formally established Virgin Galactic to operate his space tourism endeavors. After additional window-shopping, Branson partnered with Rutan's Scaled Composites, and in 2005,

they created The Spaceship Company as the manufacturing arm of Virgin Galactic. Priority number one for the new enterprise was to manufacture and prepare the SpaceShip2 and WhiteKnight2 vehicles for commercial service. Virgin Galactic planned to purchase as many as five replicas of SpaceShip2 to meet the anticipated tourism market.

Once SpaceShip2 is dropped from beneath WhiteKnight2, the two pilots up front guide the craft through the suborbital hop. The spacecraft provides sufficient room for six passengers to float around and enjoy the thrill of six to seven minutes of weightlessness. It features large windows to sneak a peek at the Earth below and gaze at the thin layer of the atmosphere beyond. The pilots then guide the ship back to the runway for a glider landing.

With an initial ticket price of $200,000, the well-to-do, early adopters wasted no time to send in deposits to reserve a boarding pass. Even after the price increased in April 2013 to $250,000, people made reservations and over 800 dreamers are on the wait list.

At a ceremony at the Mojave Spaceport in July 2008, the new WhiteKnight2 was rolled out of the hanger before a throng of admirers. The vehicle was named Eve in honor of Branson's mum. He announced the first passenger flight would take place in the mid-2010 time frame. Clearly having had his Wheaties for breakfast, Sir Richard went on to proclaim: "Let's go 20 years forward, if all of this goes to plan, I hope that we will have a hotel in space; and in that hotel I hope we will have small spaceships that can go around the Moon for an excursion."[6]

The rollout of SpaceShip2, christened VSS Enterprise, didn't make its public debut until December 7, 2009. At this ceremony, Branson informed the audience, many of who had already booked a flight, that the first passenger flights would be pushed to mid-2011 when members of his family would join him on the maiden voyage.

Ever since Scaled Composites suffered a test stand accident in 2007 that killed three employees, safety was a top priority in moving forward with space tourism. Beginning in March 2010 and continuing since, Virgin Galactic conducted an exacting series of rocket and flight tests of its vehicles both separately and mated. VSS Enterprise flew 20 captive flights with WhiteKnight2 and 31 glide landing tests.

As with the development of any new space transportation system, there have been setbacks and delays. The mid-2011 launch premiere was pushed back another 18 months to October 2012. October came and went. In an interview in May 2013, Branson promised he would dress up as Father Christmas for the first flight that coming December. Ho, Ho, Ho! That promise resulted in coal for his stocking. In a September 2014 appearance on *Late Night with David Letterman*, Branson told viewers they would be able to witness the vanguard flight in February or March of 2015.

On October 31, 2014, the schedule was again modified, but this time for tragic reasons. While on a test flight and at an altitude of 50,000 feet, VSS Enterprise was successfully deployed from White Knight2. However, just 90-seconds into its rocket-powered climb, the spaceship encountered a malfunction and crashed into the Mojava desert. The co-pilot Michael Ashbury was killed, and pilot Peter Siebold was injured.

An investigation by the National Transportation Safety Board (NTSB) concluded that the accident was caused when Ashbury prematurely activated a braking device prior to reentry. The board also determined that Virgin Galactic's protocols lacked adequate oversight by the FAA and the pilots weren't sufficiently trained. If the death of a pilot doesn't make it clear space travel is a dangerous business, you're not paying attention.

Virgin Galactic management and engineers immediately went to work to respond to the heartbreaking calamity and to address

357

the deficiencies cited by the NTSB. In February 2016, the second SpaceShip2, VSS Unity, was rolled out to carry on with the test flights. Over the next two years, the vehicle underwent a series of ground, glide, captive carry, and powered demonstrations.

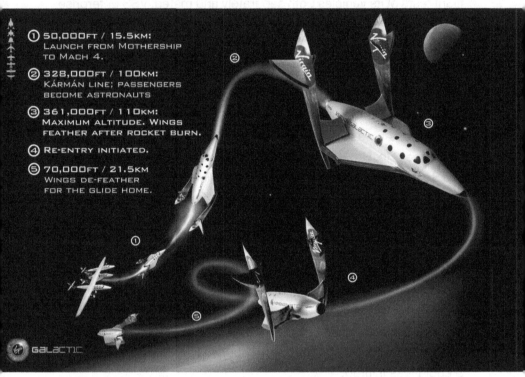

① 50,000FT / 15.5KM:
LAUNCH FROM MOTHERSHIP
TO MACH 4.

② 328,000FT / 100KM:
KÁRMÁN LINE; PASSENGERS
BECOME ASTRONAUTS

③ 361,000FT / 110KM:
MAXIMUM ALTITUDE. WINGS
FEATHER AFTER ROCKET BURN.

④ RE-ENTRY INITIATED.

⑤ 70,000FT / 21.5KM
WINGS DE-FEATHER
FOR THE GLIDE HOME.

GALACTIC

Depiction of flight profile for Virgin Galactic's suborbital excursions.
Photo: Virgin Galactic

Despite the setback but buoyed by Unity's progress, Branson remained optimistic. In November 2017, he announced that Unity would be in space within three months and he'd be on board just three months after that in May 2018. While he wasn't on board in the predicted three months, Unity did reach the boundary of space for the first time during a test flight in December of that year.

Pilots Mark Stuckey and Rick Sturckow put the spaceship through its paces to an altitude of 52 miles (82.7 kilometers) to earn their as-

tronaut wings. Fellow pilots David Mackay and Mike Masucci joined the fraternity when they reached 55 miles (90 kilometers) for Unity's second trip in February 2019. They also took along Virgin's astronaut instructor Beth Moses, making her the first "official" passenger and the first time three people flew on a commercial spacecraft. Moses' flight experience provided valuable insight and information relevant to the company's safety and training protocols for future passengers. For their achievements, the FAA awarded Commercial Astronaut Wings to the Virgin Galactic pilots and to Moses.

After Unity's second successful trip into space, Branson made yet another prediction for the first commercial flight. In post-flight media interviews, he proclaimed he intended to be on board for a July 19, 2019 mission to commemorate the 50th Anniversary of the Apollo 11 launch to the Moon.

Then again, maybe not. At the June 18, 2019 opening of the Spaceport America Cup, Virgin Galactic pilot David McKay told the assembled media, "We have every expectation we'll be in commercial operation next year (2020)."[7]

In the same press briefing, Beth Moses shared her feelings on her record-setting flight as the first commercial passenger. "I can tell you firsthand," gushed Moses, "the view is stunning, being weightless and stationary—coming to a peaceful stop at altitude, it's something everyone should experience."[8] We know, we know; get on with it already so we can experience a peaceful stop, too.

For the space-traveling fashionistas in the audience, you'll be glad to know your microgravity frolics on a Virgin flight won't be restricted by a bulky flight suit. Branson signed a deal with athletic clothing manufacturer Under Armour to design a suit that will make you look cooler than cool while floating about. As described on Virgin's website, "The custom-fitted Under Armour spacesuits will inspire confidence through comfort and practicality without compromising the natural desire of every Virgin Galactic astronaut both to feel

good and look good during this unparalleled life experience."[9] For you dreamers who have been waiting 50 years to claw your way into space, you'll be happy to know your desire to feel and look good is part of the package.

In May 2019, Virgin announced its development and test flights would transition from the Mojave Spaceport in California to Spaceport America in Truth or Consequences, New Mexico. The plan is for the New Mexico site to be fully operational in time to support the expected first commercial flights and ongoing operations.

The really high rollers and dreamers overseas will also have an option to take off from the Al Ain Airport in Abu Dhabi, United Arab Emirates (UAE). In March 2019, Virgin and the UAE Space Agency signed an agreement to use the airport as a spaceport for future Virgin Galactic flights. According to the UAE officials, the new site will be available to accept passengers "in the next few years."[10]

Hopefully, 15 years after its founding, and at least 10 years later than predicted, Virgin Galactic is on the cusp of sending dreamers on suborbital adventures. When Branson departs and lands at Spaceport America—hopefully in 2020—I have no doubt a justifiably jubilant crowd of thousands will be present to cheer yet another milestone on the long and winding road for space tourism.

How Many Billionaires Does It Take to Get Us to Space?

Whereas Richard Branson never met a camera he didn't like or turn his back on a venue to share his vision for the future, fellow billionaire and Amazon CEO Jeff Bezos is a different story altogether. While he's become more visible over the past few years, when Bezos established his Blue Origin aerospace company in 2000, mum was the word. Although Blue Origin was up and running four years before the creation of Virgin Galactic, we heard little about Bezos' intentions in space. Maybe really quick Amazon package deliveries overseas?

We eventually learned that Blue Origin shared the same goal as other NewSpace companies—significantly lower launch costs and increase opportunities for more people to fly in space. Blue Origin didn't seem to be in a rush and adopted a step-by-step development philosophy. They focused on new launch vehicles, propulsions systems, and spacecraft capable of carrying passengers. In their view:

> Launching passengers is not a race, and there will be many players in this human endeavor to go to space to benefit Earth. Blue's part in this journey is building a road to space with our reusable launch vehicles, so our children can build the future. We will go about this step by step because it is an illusion that skipping steps gets us there faster. Slow is smooth, and smooth is fast.[11]

Company management also shared the belief that it was unproductive to make bold announcements and schedule predictions before milestones were actually achieved. Bezos didn't want to feed cynical reporters with ammunition to be criticized over aggressive and unachievable schedule predictions.

With completion of a series of successful engine and vehicle tests, we began to learn what Bezos and his $1 billion investment were determined to achieve. Engine tests at their facilities in West Texas were occurring as often as every other day.

Blue Origin is taking a different approach from Virgin Galactic for the launch experience. Instead of Virgin's horizontal launch and landing, Blue Origin's 60-foot-tall New Shepard launch system is designed for a vertical takeoff and return. The passenger capsule is capable of taking six passengers for a suborbital ride.

New Shepard will launch its passengers at Blue's Texas launch site. If you buy a ticket with Blue Origin, you can look forward to this experience:

> As the main engine cuts off, your capsule will separate from its booster and perfect stillness will surround you. You'll release

your harness and experience the freedom of weightlessness. Now you can enjoy the view of the Earth's curvature and reflect as you experience the overview effect first hand.[12]

On a New Shepard flight, the rocket will ascend to an altitude of 62 miles (100 kilometers) where the booster and capsule separate. The booster then reignites its rocket engine and descends to land at the launch site to be refurbished and launched again. Once the mission profile to provide weightlessness is completed, parachutes will deploy on the passenger capsule for a ground landing, much like the Russians have done for decades. Hopefully, the landing of the New Shepard capsule will not be as harrowing or as jolting as the return of the Soyuz capsules.

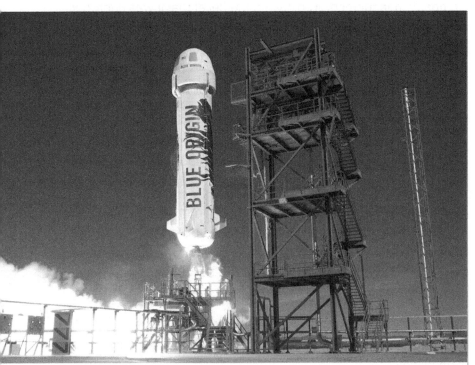

Launch of Blue Origin New Shepard Rocket and passenger capsule.
Photo: Blue Origin

On May 2, 2019, the company successfully completed the 11th test flight of New Shepard. While the mission carried no passengers, it did include 38 experiments. The fifth flight of this version of the rocket reached an altitude of 66 miles (106 kilometers). Both the rocket and the capsule returned to the launch site to complete pinpoint, controlled landings.

During a webcast of the flight, a spokesperson declared they were aiming for customer flights before the end of the year. Despite the prediction, additional test flights are scheduled, and the company officials promised they wouldn't compromise safety in a rush to begin commercial flights. While they have yet to announce a ticket price or accept reservations, don't count on Blue Origin being the Spirit Airlines to the stars. It's likely a trip on New Shepard will set you back the same $200-$250 grand as a flight with Virgin Galactic.

Bezos and space advocates frequently compare suborbital missions to the early days of barnstorming in this way: "a practice in the early days of traditional aviation, when pilots would fly around the country, touching down in farmers' fields and giving the local kids a ride on a plane, selling tickets and bringing in interest and money to the new industry."[13] The community may want to find a different comparison for space tourism. Media coverage of local barnstorming events reported on the numerous "stunts" performed by pilots and wing walkers. You never want to see your serious business plan referred to as a "stunt."

Also, while crowds will turn out by the thousands to watch suborbital spaceships launch and land, it's doubtful local kids will be invited to come along for a ride. Finally, the perceived, though not real, number of accidents when passengers went along for a loop de loop with barnstorming pilots led to stifling restrictions passed by Congress. Though designed to protect the public, the laws were largely responsible for putting flying circuses out of business.

Up, Up and Away

While you might have to forfeit your kid's inheritance for a flight with Virgin Galactic or Blue Origin, you won't need quite as much wealth to hitch a ride with World View. Another entry to the space tourism arena, World View's Voyager Human Spaceflight Experience will give you a pretty good high, but its lift to the stratosphere won't earn you an astronaut badge.

World View, which describes itself as a stratospheric exploration company, was founded in 2012 by the wife-husband team of Jayne Poynter and Taber MacCallum. The two also spent two years as Biospherians in the sealed, artificial space analog experiment known as Biosphere 2 and co-founded Paragon Space Development Corporation. Former NASA Astronaut Mark Kelly and Alan Stern, principle investigator of NASA's New Horizon mission to Pluto, are also co-founders of the company.

While rockets power the ascents of VSS Unity and New Shepard, the Voyager Human Spaceflight Experience will take you up, up and away in a pressurized capsule dangling beneath a helium-filled, polyethylene balloon. The two pilots and six crew members will ascend from the Tucson, Arizona Spaceport to an altitude of 100,000 feet (30 kilometers) and sail along the silver sky for a five-hour, start-to-finish flight. When it's time to come home, the pilot will detach the capsule from the balloon and glide it back for a soft touchdown. For a ticket price of $75,000 (within the range of high-end adventure experiences) passengers will float "into the blackness of space and gaze at the curvature of the Earth below."[14] The "spacecraft" even has a bathroom and a minibar.

The company has conducted numerous tests of flight technologies for its Stratollite un-crewed flight systems and for the Voyager capsule. The Stratollite missions have launched science experiments for private companies and universities. One flight even carried a sandwich as a promotional spectacle for Kentucky Fried Chicken.

In March 2018, they completed a mission sponsored by NASA's Flight Opportunities Program Office that carried two radiation-detection experiments.

Balloon flights are considered much safer than space missions. Nonetheless, in December 2017, World View experienced a significant accident during a ground test of one of its stratospheric balloons. While they normally used helium as fuel, the balloon for this test was filled with flammable hydrogen. Toward the end of the test as the balloon was being deflated, a rupture occurred, causing an explosion and a 300-foot-high fireball. Thankfully, only minor injuries to two employees were reported along with superficial damage to nearby buildings. Following an investigation, safety procedures were put in place, and company officials believe a repeat of the mishap is unlikely.

In April 2019, World View indicated that they were focused on the Stratollite side of the business rather than sending up passengers for the Voyager Human Spaceflight Experience. They declined to provide an estimate of when the first commercial flight with passengers might occur. If and when they do resume testing for Voyager missions and you take a balloon flight, you can refer to yourself as a Voyager. I wonder, since customers will be able to live stream from the gondola during the stratospheric sail, will that make the rest of us voyeurs?

How High Is the Sky?

As the billionaires-in-chief battle to gain control of the suborbital space tourism market, two side arguments have emerged. The first concerns what constitutes a true trip to space. Is it the 50-mile (80-kilometer) demarcation advertised by Virgin Galactic? Although Branson often claimed his space vehicles would eventually reach 62 miles (100 kilometers), the official agreement with his customers only promises to reach 50 miles.

Or does space begin at the 62-miles (100-kilometers) Karman Line favored by Blue Origin and the Federation Aeronautique Internationale (FAI). The latter, also known as World Air Sports, maintains records for aeronautical activities and oversees definitions for human spaceflight. However, they complicate the debate because FAI also considers reaching the 50-mile altitude sufficient to earn astronaut wings.

There's actually a fair degree of physics wrapped up in how best to answer the question. It involves scientific blather that would only make your head spin—questions like at what height do the laws of aeronautics no longer apply, how thin is the atmosphere, what's the temperature variation at different altitudes, and what's the impact from radiation blasted out from solar flares. I'm surprised they don't factor in your astrological birth sign. Who knew it was so complicated?

The issue has taken on a "Mine is bigger than yours" connotation among the space barons. Shortly after one of his New Shepard test flights crossed the Karman Line, Jeff Bezos fired a rare insult across the bow of the VSS Unity. The Amazon titan declared:

> One of the issues that Virgin Galactic will have to address, eventually, is that they are not flying above the Karman Line, not yet. We've always had as our mission that we wanted to fly above the Karman Line, because we didn't want there to be any asterisks next to your name about whether you're an astronaut or not . . . For those who fly on New Shepard, there'll be 'no asterisks.'[15]

Boom . . . mike drop. On the other hand, that dig may have been a bit bold for a company that at the time of his statement had yet to put a person on board a test flight. Maybe that deserves an asterisk as well.

After you spend over $200,000 on a flight of fancy, I'm not sure the 12-mile-high difference between the two spaceships is going to be that big of a deal. You'll float the same at 50 miles as at 62, and at

either altitude, you will be eligible for FAA's Commercial Astronaut Wings. More likely, customer feedback as to the overall enjoyment of the flight experience will have a bigger impact on which ticket counter you decide to approach.

Naming Rights

The boundary line of space also impacts the second argument underway within the space community. This involves what you get to call yourself in front of your family, friends, and neighbors when you come home after a suborbital flight. Even though both providers will take you to the accepted altitude to earn astronaut wings, will you dare call yourself an "astronaut?"

What to call people who travel beyond Earth's boundaries has been a dynamic topic since the beginning of human spaceflight. As you may recall from Chapter 1, originally all those who worked in the field of aeronautics were referred to as "astronauts." Once the Original Seven boys were announced, you no longer heard such slander.

When the first science guys were allowed to join the flight club, the pilot astronauts referred to them as "hyphenated-astronauts," not quite worthy of being considered as full-fledged members of the astronaut fraternity. It took a while before "science-astronaut" lost the hyphen and they became just good old astronauts. The introduction of the payload specialist category was just as confusing. These clowns trained for a single mission and didn't put in the years or pay sufficient dues to be called astronauts. And for goodness sakes, some of them were foreign!

Then there were the traveling millionaires who paid their way to the International Space Station. They were highly irritated when NASA and the media referred to them as space tourists. It was said in a tone as though the term "space tourist" was something to be scraped off your shoes before coming into the house. Each of these dreamers went through extensive training in Star City, some of them

as much as two years. They didn't go up just to look out the windows. They designed and conducted their own science or technology experiments during their missions.

In response to a snide remark about the status of ISS-bound customers of Space Adventures, CEO Eric Anderson growled that Dennis Tito was "no more of a tourist than someone who spends months training to climb Mount Everest. He's an adventurer. Tito is not an amateur. He's a trained cosmonaut."[16] The first woman "tourist," Anousheh Ansari, preferred the moniker of space flight participant. Nonetheless, many within the traditional space community found ways to carp about the flights of rich people, and NASA never completely embraced their participation or presence at ISS. If you were walking the halls of the agency, none dared call them "astronauts."

According to the FAA, which has authority to regulate commercial space travel of humans, non-crew members should be called "space flight participants."[17] This includes passengers on both suborbital and orbital missions. Referring to a person as a space flight participant doesn't seem like a horrible insult, but it really lacks pizazz. Just like the early days of human space flight, calling someone a "space cadet" seems frivolous *and* insulting. "Space traveler" is a bland noun, not a title of virtue. We've already seen that "space tourist" lacks sufficient gravitas.

In his excellent article on the subject of name identification, space reporter Eric Berger put the question to each of the companies planning to offer commercial flights. Berger may have also been the first to use the term "astro-not" in an article, no doubt to the delight of professional astronauts.[18]

Virgin Galactic told Berger that during pre-flight training they intend to call their customers "future astronauts," and "astronauts" when they return: "Why? Because throughout history, any human who has flown above a certain altitude, regardless of whether it's orbital or

sub-orbital, [has] been called astronauts, cosmonauts, or taikonauts. Nonetheless, as a proud U.S. and European brand, we're delighted to stick with astronaut and follow the tradition set."[19] With the same logic, Blue Origin also intends to call their flyers "astronauts."[20]

Astronaut and ISS Commander Terry Virts is A-Ok with the astronaut label for weekend flyers: "If someone straps on a rocket and launches themselves into space and then survives re-entry and landing on Earth, I think they have earned the title of astronaut."[21] Virts was quick to point out that there is a difference between sub-orbital hops and orbital flights, but he didn't feel it should "take away the fact that they flew in space."[22]

Dozens of celebrities have signed up for the suborbital experience. Given this, I'm willing to bet there are plenty of other astronauts, especially Apollo Era pilots, who would rather walk on broken glass than refer to the likes of Katy Perry, Ashton Kutcher, or Justin Bieber as astronauts. Well, I like her music, so maybe Katy is okay, but I'd be running across the glass track alongside the boys of Apollo before I would feel comfortable referring to the Bieb or *Punk'd* creator Kutcher as bonafide astronauts.

Astronaut Nicole Stott, who waited nine years to be assigned to a flight, had the most sensible view of the discussion. Weighing in on the side of the commercial providers, she agrees it's fine for Virgin and Blue to call their passengers astronauts: "I don't mean to discount the significant difference in preparation and requirements associated with the professional versus visitor, because I don't believe that can be argued. I just don't think there's any value in debating the name."[23]

Stott makes a good point because in the end, someone who shells out a quarter of a million dollars to fulfill a dream will call himself or herself whatever they want. As for the rest of us, perhaps we'll adopt the suggestion Tweeted to me by @max1xavier: "Call them what they are: wealthy!"

The Scent of Musk

Where to begin with a discussion of Elon Musk and his most innovative aerospace company SpaceX? Not satisfied with taking dreamers on 1960s-era suborbital hops, Musk wants to send you on orbits around the Earth and the Moon and on to settlements on Mars. If you are unfamiliar with his exploits and don't know about the creation of the numerous companies that made him a multibillionaire, or aren't in awe of his many accomplishments, you clearly have already been living on another planet.

Originally from South African, he also holds citizenship in the U.S. and Canada. He's the 54th richest person in the world. He burst onto the space scene in 2002 with the creation of his space transportation company, SpaceX. His goal was to design a reusable rocket that would reduce launch costs and improve reliability by a factor of ten. Just two years after he began, he told a Senate hearing that lowering launch costs to "$500 per pound or less was achievable."[24] Where have we heard that before?

In just seventeen years, the 48-year old techno-prodigy has become the 21st century's Wernher von Braun and space visionary deity. His dedication to "disruptive systems" has made him the high priest for all those who worship "out of the box" thinking and are tired of waiting on NASA to fulfill their dream. Not content with being the change agent chairman of space, he is also disrupting the auto industry (Tesla), high-speed transportation (The Boring Company), solar cell development (SolarCity), and even electric jet travel.

Because so many books have been devoted to his star power, it's unnecessary to repeat his complex and compelling personal story here.[24] Instead, let's focus on his vision for space tourism and his many predictions for how soon you can expect to go to a local travel agent and purchase a ticket to one of his announced destinations.

The SpaceX family of reusable Falcon rockets has launched over 70 times to deploy satellites and approaching two-dozen deliveries of

cargo in its Dragon capsule to the ISS. The reusable components of the rockets have landed in the ocean and made controlled, soft landings on floating docks at sea and on dry land.

Not all SpaceX operations have been trouble-free. Early attempts to land upper stages on floating docks crashed and burned, but subsequent landings have been remarkably trouble-free. During a pre-launch fueling operation in September 2016, a Falcon 9 rocket exploded on the launch pad. The blast destroyed a commercial satellite already mated to the upper stage with some damage to the launch pad. The problem was identified quickly, remedies were implemented, and a Falcon 9 launched again in January 2017. Longtime space safety experts were not necessarily enamored with such quick turnarounds.

Most pertinent to the narrative about your dream to fly in space and without getting into the weeds of SpaceX operations, we ask what are their intentions regarding space tourism?

Not wanting to put all its eggs in one basket, NASA's Commercial Crew Development Program has funded multiple companies to find a replacement to the space shuttle and develop a capability to transport cargo and crew to the ISS. Since 2010, the SpaceX Dragon capsule has been a recipient of $2.4 billion in NASA funding. The space advocacy community has followed the development and flights of the SpaceX Dragon cargo vehicle and the human-rated Dragon2 space capsule with significant interest.

The cargo version of Dragon has launched and mated with ISS twenty times. More important to dreamers was the first hook up of Dragon2 with the ISS in March 2019.

While the primary purpose of Dragon2 is to deliver astronauts to the station, the capsule can carry seven people including non-astronauts.

At a press conference following the first Dragon2 launch, Musk mentioned the possibility of paying passengers going along for the

ride to ISS: "People have gone to space station on Soyuz and I think it'd be pretty cool if people went to space station on an American vehicle as well." With a wink and a nod to wealthy dreamers, he promised, "I think that's something that we'll do, and NASA's very supportive of that."[25]

Unfortunately, another major setback occurred on April 20, 2019, when the test version of the Dragon2 capsule exploded during a static engine test on a Cape Canaveral launch pad. Initially, company officials referred to the incident as an "anomaly;" thankfully, no one was on board, and no one on the ground was injured. Both the company and NASA assigned investigative teams to understand the cause of the explosion. Despite this incident, SpaceX and NASA remain on a path to plan—not approve—a launch of Dragon2 on November 15, 2019. This assumes the root cause of the pad accident is identified and remedies are implemented to the affected systems.

In 2011, SpaceX projected the first crewed launch would occur by 2014. The fact that they are at least five years behind schedule only confirms when it comes to rocket launches, stuff happens. Musk's powers of prediction have proven to be no better, though no worse, than previous visionaries. Regardless of the delays, the Dragon2 launch will represent the first time NASA crewmembers head to ISS on an American-built rocket since the shuttle program ended in 2011. Better late than never.

"OldSpace Means Quality," said the Captain to the Bosun

NewSpace companies like SpaceX, Virgin Galactic, and Blue Origin may have captured the public's imagination, but OldSpace is ceding nothing to the young whippersnappers. While their executives may lack the flare of Branson and Musk, and their bureaucracies may not be as nimble as the newbies, traditional companies like Boeing, Lockheed Martin, and Northrop Grumman have a combined 300 years of experience in the aeronautics/aerospace sector with combined revenues of more than $300 billion. They have been

to this dance before and have a history of playing a leading role in America's leadership in space.

Boeing, the world's largest aerospace company, has also been working with NASA through the phases of the Commercial Crew Development Program on a spacecraft to send cargo and crew to the ISS. Since 2010 and with agency contracts worth $4.2 billion, they've been building the CST-100 (Crew Space Transportation). They finally got hip in 2014 and dubbed the spacecraft "Starliner." I mean, really—would you rather have the word "Starliner" splashed across your t-shirt or "CST-100?"

The Starliner spaceship is similar in shape to the Apollo capsule and is compatible for launch on the Atlas-V and Delta-IV rockets from the United Space Alliance (ULA) as well as on the SpaceX Falcon-9. It can accommodate up to seven people and is designed for ground-based landings via parachutes.

Starliner has completed a series of ground and drop tests, but like SpaceX, not without problems and setbacks. Boeing confirmed that in June 2018, a propellant leak during a test of Starliner's emergency launch abort system shut down the engines. In a statement released a month after the anomaly, Boeing reported, "[We are] confident we found the cause and are moving forward with corrective action. Flight safety and risk mitigation are why we conduct such rigorous testing, and anomalies are a natural part of any test program."[26] The incident would cause a delay in "moving forward," as the first scheduled flight test without crew members on board was pushed from the end of 2018 into spring 2019.

Once Starliner is approved to ferry astronauts to ISS, Boeing is also interested in flight opportunities for paying passengers. In 2010, they teamed with Space Adventures to sign up space flight participants to fly in extra-capacity seating on launches to the space station. You'll recall it was Space Adventures that facilitated the flights of the seven "space tourists" on the Russian Soyuz capsule for stays at the ISS.

A Boeing press release on the arrangement stated, "Potential customers for excess seating capacity include private individuals, companies, non-governmental organizations, and U.S. federal agencies other than NASA."[27] Once again, a ticket price was not announced, but it was estimated to be in the neighborhood of $40 million, similar to the amount charged by the Russians.

At the time the partnership with Space Adventures was announced, the first test flights of Starliner were projected to occur in 2015. The first uncrewed launch slipped from September 2019 and jeopardizes the planned November 30 launch piloted by two Boeing astronauts. Again, these are planning dates, and not yet official. Until they successfully complete flight tests and are certified to fly humans, it's doubtful that space tourism is a high priority for Boeing.

Will either SpaceX or Boeing meet the "planned" launch dates by the end of 2019? Christina Chapman, a director at the U.S. General Accountability Office, recently completed a review of NASA's Commercial Crew Program. When asked if the proposed November 2019 launch dates for both vehicles were credible, she replied, "My feeling is these dates may likely be optimistic but the companies should get there fairly soon *if they don't suffer any major setbacks*." (her emphasis)[28]

Chasing the Dream

Sierra Nevada Corporation (SNC) is the third company developing a spaceship to send cargo and astronauts to low-Earth orbit. Whereas the Dragon2 and Starliner employ a capsule design, SNC's Dream Chaser is a reusable lifting body. It looks like a pint-sized version of a space shuttle orbiter (one quarter the size). Like the shuttle, it can carry a crew of seven and is capable of landing on a runway. Not to scare you away, but if you ever watched the opening sequence of the TV show *The Six Million Dollar Man*, the vehicle that crashed on the desert runway injuring fictional astronaut Steve Austin was a Northrop M2-F2 lifting-body spacecraft.

Originally designed for human orbital flights, the immediate focus of Sierra Nevada's Dream Chaser is to deliver cargo to the International Space Station. *Photo: Sierra Nevada Corporation*

Anticipating much better results, SNC began work on Dream Chaser in 2005 as a space shuttle replacement. Beginning in 2010, the company received NASA funding under the first phase of the Commercial Crew Development Program. Contract awards continued through the next two phases until 2012. SNC received a total of $363 million towards the estimated $1 billion development cost for Dream Chaser.

Dream Chaser experienced a mishap following an automatic, unpiloted landing test in 2013. After the spaceship was dropped from a helicopter, it completed a successful approach and landing. Unfortunately, once it touched down, the left landing gear collapsed, and the vehicle skidded off the runway. There was no need to call in the bionic repairman since no one was on board.

When NASA awarded contracts in 2014 for the Commercial Crew Transportation Capability Program, SNC didn't make the cut. Only SpaceX and Boeing were selected to continue with flights of astronauts to ISS. Not to be deterred, SNC directed its efforts to redesigning Dream Chaser as a cargo transport. They improved the

375

autopilot landing capability and upgraded the flight software, avionics, flight controls, and other subsystems. As a result, they were selected for the Commercial Resupply Service (CRS-2) contract in January 2016. Under this arrangement, SNC is guaranteed payment for at least six cargo missions to ISS. The subscale version of the spaceship has been undergoing a series of tests and completing milestones as stipulated in the contract.

In December 2018, NASA gave SNC the authority to proceed toward full production of the Dream Chaser. The first flight to the space station was originally slated for fall 2020, but is now planned for September 2021.

In January 2018, the United Nations Office for Outer Space Affairs announced it would partner with SNC to offer countries the opportunity to participate in an orbital space mission utilizing the Dream Chaser: "The mission will be open to all Member States of the United Nations, and developing countries are particularly encouraged to participate. The mission will carry experiments, payloads, or satellites provided by institutions in the participating countries."[29] Seventy-five countries responded to the Request for Proposals for the initiative. While preparations for a flight are underway, a launch date has yet to be scheduled.

Given Dream Chaser has yet to achieve orbit and so much as deliver fresh laundry to the ISS, it's too early to predict if the spaceship will be a viable cosmic wagon for commercial space tourism. According to SNC's Kimberly Schwandt, the company "is still dedicated to eventually building a crew version of the Dream Chaser and we have been looking at ways to finish funding that capability, but for now our complete focus is on successfully getting our cargo vehicle in service."[30] Despite the near-term focus on cargo, I wouldn't be surprised if the little spaceship that could may yet sell you a ticket to space.

13 BEYOND EARTH'S BOUNDARIES—WAY BEYOND

The successful creation of a large U.S. space tourism business would also be a direct way of enlarging and institutionalizing the general public constituency for our Federal space program.
Tom Rogers, Letter to Daniel S. Goldin

We want to build colonies on the Moon, Mars, the Moons of other planets, and even nearby asteroids. We want to make space tourism and commerce routine.
Daniel S. Goldin, Speech,
International Automation Roundtable

I would like to die on Mars. Just not on impact.
Elon Musk, Keynote Address, SXSW

Fly Me to the Moon

Just five months after the September 2016 Falcon 9 explosion on the launch pad, Elon Musk confirmed a deal to send two unnamed customers for flight around the Moon. The passengers had already made a down payment for a proposed late 2018 launch, with training to begin in 2017. The ticket price was not revealed, but it was no doubt significantly more than the $75 million NASA pays to fly its astronauts on Russia's Soyuz capsule to the ISS.

An article in The *Verge* reported, "Musk believes these private missions could be a 'significant driver of revenue' for the company and expects to have at least one or two a year, possibly making up 10 to 20 percent of SpaceX revenue."[1] Due to a change of plans with launch vehicle development, SpaceX cancelled this particular Moon mission.

However, by September 2018, a lunar mission was back in play. This time, the client would travel on a new, though not yet built, rocket called the Big Falcon Rocket (BFR). The insider story was that BFR really stood for Big Fucking Rocket, but family-oriented mass media couldn't print such a name. Maybe this is why the passenger-carrying part of the system is now known as Starship, while the first stage booster is called Super Heavy. The retro 1930s design finally delivers a rocket straight out of an episode of Flash Gordon, the way a rocket ship is supposed to look.

Japanese billionaire Yusaku Maezawa stepped forward as the primary customer for the trip (and yes, it seems it's always millionaires and billionaires). The founder of Zozotown, a Japan-based online retailer, Maezawa plans an altruistic mission and intends to take along eight artists for a one-week trek around the Moon. Again, the price being paid to SpaceX was not revealed, but according to Forbes, Yusaku is worth $3.6 billion and is the 14th richest person in Japan.[2] Between 2016 and 2017, he paid over $265 million on art for his Contemporary Art Foundation, so I'm betting ticket price is not an issue.

According to Maezawa's website for the endeavor, #dearMoon, he hopes the mission will inspire the dreamer within each of us (as if we need any more inspiration). He wonders, "If Pablo Picasso had been able to see the Moon up-close, what kind of paintings would he have drawn? If John Lennon could have seen the curvature of the Earth, what kind of songs would he have written? If they had gone to space, how would the world have looked today?"[3] Hard to imagine Picasso getting any more far out than *Guernica*, or Lennon giving us a bigger dose of an orbital perspective than his little ditty "Imagine," but who knows what they would have done if they had a good reason to be day-trippers around the Moon?

The artist selection process is currently underway, and the final candidates are to be identified before 2021. I hope Chet Jezierski

and other alumni from the NASA Art Program will apply and be accepted for the trip. After selection, Maezawa's lunar art league would begin training and preparing for the proposed 2023 excursion. Upon their return, the artist-astronauts will devote time to creative pursuits inspired from their journey and contribute to a #dearMoon Exhibition on Earth.

We look forward to their cosmic creations—if the flight takes place. In May 2019, Maezawa announced he was selling many of his art works because, as he said, "I have no money. I spend it so quickly."[4] This could spell trouble for his artesian Moon flight. According to *Bloomberg*, Maezawa's down payment to SpaceX "had a 'material' impact on the development of the project, which is estimated to cost about $5 billion."[5] Neither SpaceX nor the Japanese billionaire would comment on whether there's a balance due. Given his current financial challenges, the jury is out as to whether or not Maezawa will have the wherewithal to complete the transaction or instead become an artful dodger.

The Case for Mars

One would think that all of Musk's initiatives—the rockets, the spaceships, the electric cars and jets, the hyper tunnels—would be enough to keep a person occupied and gainfully employed. Does Extra Strength Tylenol even make a dent in the level of headaches and challenges this whirlwind of activities must create? These projects employ thousands of workers, contribute to the nation's economic growth, and advance a positive human agenda. Musk creates a media buzz for science and technology not seen since Carl Sagan introduced the phrase "billions and billions" into the national lexicon. All his endeavors would be enough for most people, but Elon Musk ain't most people.

If history is a guide, the ability for Musk to succeed with everything on his plate is a challenge of galactic proportions. It is not unusual for an aerospace company to admit defeat due to schedule slips,

technical problems, major cost overruns, mishaps (hopefully none lethal), or just plain bad luck. Stuff happens. But clearly, Musk don't know much about history. Admitting defeat does not appear to be in his makeup.

Let's assume SpaceX is able to fly astronauts to ISS on Dragon2 by the end of 2019. By some miracle, the new mega Spaceship is certified to launch cargo by 2022. Then, Yusaku Maezawa saves enough yen to ferry his art league for a week's worth of laps around the Moon in 2023 and return to create mind-blowing art. Then what?

Then—we're going to Mars, baby . . . The Red Planet . . . Fourth rock from the sun. For the past 40 years, a coalition of aging hippies called the "Mars Underground" has dreamed of a new Messiah to popularize their case for Mars, and by golly, Musk has answered the call.

Why Mars? Though no human has ever been there, we're told it beckons. We love the planet because of the fascinating data and scouting reports the squad of anthropomorphic rovers have transmitted back to the Jet Propulsion Laboratory. These glorified Roombas robots are as small as a breadbox or the super-sized equivalent of a Mini Cooper. We've learned Mars used to be like Earth until it wasn't. It's overflowing with H20 on the ground, underground, at the equator, and at the poles. It's slush, it's dry ice, or it's a methane malt. The liquid gold is trapped in cracks where the sun don't shine and hiding in plain sight. Thirsty colonists will be able to drink from a potential oasis. If you thought turning water into wine was a miracle, wait until engineers turn Martian water into rocket fuel.

The planet is scorching with dust storms and freezing with snow days. Scientists believe it's full of fossils of dead things that once roamed the red plains. If the landing doesn't kill you, the radiation probably will. Don't worry about global warming or an atmosphere that will make your head explode without a helmet. In the same manner astronaut Mark Watney (Matt Damon) faced overwhelming

NASA is planning to approve the SpaceX Dragon2 capsule to ferry astronauts to ISS perhaps by the end of 2019.
Photo: SpaceX

odds in the movie *The Martian*, Musk is "going to have to science the shit out of this." Musk plans to set off nuclear explosions above the planet to cause mindboggling climate change. Then he's going to terraform all that dust, gravel, and the mini atmosphere into a galactic paradise. He is bound and determined to make us a multi-planet species, and Mars is the first stop toward his personal galactic New World Order.

The advertisements for the SpaceX Starship claim it will carry boat-loads of supplies and equipment or 100 people at a time. Testing on sub-scaled versions of the Spaceship and engines began in early 2019. On June 24, 2019, Musk Tweeted he was "Accelerating Starship development to build the Martian Technocracy." Supposedly this is related to his prediction of a 60 percent chance that he will be able to dispatch two cargo flights to Mars in 2022, followed by two launches of colonists in 2024. In the long run, Musk wants to launch 100,000 Starships, adding one million souls to the Martian population. When Musk throws out phrases like "Martian Technocracy," I can't help but envision people in brown robes scurrying around in underground gothic temples.

If you'd like to sign up for his Martian conclave, you'd best start saving up. In response to a question on the ticket price, Musk previously posted on his Twitter account that the price is, "very dependent on volume, but I'm confident moving to Mars (return ticket is free) will one day cost less than $500k & maybe even below $100k. Low enough that most people in advanced economies could sell their home on Earth & move to Mars if they want."[6]

Musk also told the online information website Axios, "It gets to the point where almost anyone, if they saved up and this was their goal, could buy a ticket and move to Mars—and given that Mars would have a labor shortage for a long time, jobs would not be in short supply."[7] So just sell your house and join the fun. In addition to its other attributes, Mars will offer full employment! If you are truly interested, you might want to pay closer attention to those TV ads with actor Tom Selleck pitching the virtues of a reverse mortgage.

SpaceX hopes to land the first humans on Mars by 2024. Cargo and crews will travel on their two-stage Big Falcon Rocket. The upper stage is called Starship.
Photo: SpaceX

A relocation to another planet will be no walk in the park. Musk also told Axios, "It's gonna be hard, there's a good chance of death. Going in a little can through deep space, you might land successfully, but once you land you'll be working non-stop to build the base."[8] He cautions that there won't be "much time for leisure, and once you get there there's a very harsh environment, so there's a good chance you'll die there. We think you can come back but we're not sure."[9] Better get a lawyer to read all sections of the contract if you sign up for this trip. I'm certain the words *Caveat Emptor* appear in the fine print.

You may escape the grim reaper with its "good chance for death," but there are significant biomedical issues associated with long duration space flight. Medical research on astronauts who have been on ISS for lengthy stays have identified substantial concerns associated with the immune system and exposure to solar and cosmic radiation. Due to the extended flight in weightlessness, you might grow an inch or two taller, but it will play havoc with your bone density and muscle mass. And since you won't be running laps around a centrifuge core like in the spaceship for *2001: A Space Odyssey*, your ability to perform the most basic physical functions upon arrival will be extremely challenging. But don't worry; I'm sure this is all covered in the FAA-approved Consent Form you'll complete before departure.

Musk is often criticized for promoting unrealistic time schedules for his projects. In hindsight, the predictions by previous space visionaries were also exceedingly ambitious. Remember the prophecies of Venusian spas, $500 rocket flights to the Moon and 60 space shuttle launches per year? Since even Musk admits his time-lines are based on "aspiration goals," it may be unfair to chastise him for exaggerating milestone targets. Many in the space advocacy community are actually inspired by his bold forecasts, even if they are off by months or years.

Other space advocates and stock market analysts aren't as enamored by Musk's chest thumping and feel it harms an industry that already has a credibility issues when forecasting development costs and timetables. Our class motto at Larkin High School was "Aim high and keep your aim," so I get the whole aspiration goal thing. But at some point, I'd like to see space companies hold schedule slips to days and months as opposed to years, and with fewer eye-popping cost overruns.

There is a hint of spiritualism in Musk's obsession with making us a multi-planet species. He believes, "We have a duty to maintain the light of consciousness, to make sure it continues into the future."[10] How's that for a vision?

Mars (No) One

Elon Musk may have the most momentum in the quest to establish a human presence on the Red Planet, but he doesn't have a monopoly on Martian aspirations.

As we've seen, the road to recreational space travel is littered with charlatans and shady entrepreneurs with eyes bigger than their ability to deliver the goods. The proverb "A fool and his money are soon parted" has lingered around the subject of space tourism for years.

For instance, in 2012, a Danish company led by 35-year old wind-energy entrepreneur Bas Lansdorp proposed a venture called Mars One. The goal was to launch eight passengers in 2022 on a one-way trip to establish a Martian colony. However, from the beginning, it seemed more like a scam to separate gullible dreamers and investors from their money.

The organizers had no experience with research, development, manufacturing, or space activities of any kind. But remember, "Mars beckons," so the initial announcement was showered with an unwarranted amount of international media attention. The Mars One concept also received praise from a certain segment of the

space advocate community that prays someone, anyone, will leave NASA in their exhaust and send humans to Mars first.

There was a reality TV component to the scheme, which made it all the more enticing for those with stars in their eyes of another kind. The filming would capture the selection process, follow training activities, and tag along on the mission all the way to landing on the planet. Mars One managers believed advertising and sponsorships for the show could raise the estimated $6 billion required for the first flight, an amount almost no one believed was enough.

I hope you knew better and weren't one of the alleged 200,000 people that sent in a personal video tape and the $35-$75 application fee to be considered for the mission. Chances are you weren't because the company later admitted that while a couple of hundred thousand people expressed interest in leaving the planet for good, fewer than 4,000 actually applied, and that number was later revised to fewer than 2,000.

Two years after the debut, Australian free-lance journalist Elmo Keep wrote a comprehensive exposé on Mars One. Titled "All Dressed up for Mars and Nowhere to Go," the article's conclusions weren't promising for those who were ready to hike out and declare their independence from Earth.

Keep surmised, "From everything I can find, Mars One doesn't appear to be in any way qualified to carry off the biggest, most complex, most audacious, and most dangerous exploration mission in all of human history . . . They don't have the money to do it . . . 200,000 people didn't actually apply. That, with all the good faith one can muster, I wouldn't classify it exactly as a scam—but that it seems to be, at best, an amazingly hubristic fantasy."[11]

This fantasy was based on "absolute faith in the free market, in technology, in the media, in money, to be able to somehow, magically, do what thousands of highly qualified people in government agen-

cies have so far not yet been able to do over decades of diligently trying, making slow headway through individually hard-won breakthroughs, working in relative anonymity pursuing their life's work."[12]

By the end of 2016, things really started to unravel. Lansdrop had to admit that he was having trouble raising the funds to underwrite the mission. In February 2019, Mars One declared bankruptcy; like the idiom reminds us, "Stick a fork in it, it's done."

The fact that something so ill-conceived, so dishonest, and so improbable gained such extensive media and space advocacy attention is hard to fathom. While reporters like Elmo Keep finally started to throw shade on the scheme, the early coverage was quite positive. Not to blame the media for doing their job, but with all the coverage of Mars One and its fanciful promises, it's no wonder dreamers keep thinking a personal space flight is in their future.

Even when it was clear that Mars One was a dead-end initiative, a surprising number of space advocates defended the company's goals as "aspirational" (Where have we heard that word before?) and felt the denunciation was unwarranted. After all, if you were going to condemn Mars One for promoting unrealistic goals, where was the criticism for the many unfulfilled human exploration plans proposed for NASA? The George H. W. Bush administration's Space Exploration Initiative (SEI) to return Americans to the Moon (this time to stay) and then travel to Mars was proposed in 1989. In 2005, his son proposed similar goals with the Vision for Space Exploration. Thirty years later, these goals remain elusive. It's doubtful President Donald J. Trump's directive to return Americans to the Moon by 2024 will be any different.

Galactic Suite and Sour

Speaking of scams, you could have thrown your money away much closer to home had you booked a hotel room with Galactic Suite Ltd. Announced in Barcelona, Spain in 2007, the company claimed

tourists would be ordering room service at their chain of orbiting hotels by 2012. According to reports at the time of the announcement, the startup company received $3 billion from an anonymous billionaire space enthusiast. The interconnected modular resort would be a bio-inspired orbital resort. Guests would arrive on a (unspecified) hybrid rocket-powered spaceship capable of carrying four passengers and two pilots.[13]

The four-day, three-night stay would begin eighteen weeks earlier with an astronaut training course on a tropical island. The experience would set you back three billion Euros ($4.4 to $5 billion, depending on the rate of exchange).

In the company's press release, the unspecified spaceship gets more specific: "For the first time, a revolutionary space launch system is designed to maximize security and minimize the impact on the environment."[14] The team of engineers and architects designed a magnetic levitation infrastructure for a brand-new Maglev launch capability. This infrastructure required a three-mile track to enable the spacecraft to accelerate up to 620 miles per hour (1,000 kilometers per hour) in less than 20 seconds and then launch.

But wait, it gets better; in just four years, they also planned to build a new spaceport: "The new Galactic Spaceport Suite, the first commercial spaceport in the world, will be built on an island in the Caribbean. Galactic Suite does not rule out building new spaceports in the future in other countries around the world, in order to facilitate accessibility to other hotels built in space to as many people as possible."[15] Their claim to be the "first commercial spaceport in the world" would be news to Spaceport America in New Mexico since it broke ground in a ceremony in 2009.

It's difficult to discern just when the thought of room service from the Galactic Resort was no longer viable. Instead of blasting hotel guests off the planet on their magic Maglev, the company switched focus to an attempt to win the $30 million Google Lunar XPRIZE.

This international competition challenged private companies to land a robotic rover on the Moon by the end of 2012.

To pursue the prize, Galactic's CEO Xavier Claramunt kluged together a consortium with Spanish aerospace companies and universities and formed a Barcelona Moon Team. While the team built prototypes and Claramunt managed to secure a launch deal with China's Great Wall Industry Corporation, they ultimately withdrew from the competition.

Galactic Suites of America

If the demise of the Galactic Resort crushed your dream to shuffle off with your intended for a honeymoon at an orbiting hotel, don't despair. You may yet see Kaley Cucco and William Shatner pitching Priceline.com deals so you can consummate your marriage among the stars. This time the neon sign out front of the hotel will flash the name "Bigelow."

Whereas the Barcelona entrepreneurs didn't seem capable of renting you a storage unit, much less a hotel room in space, Robert Bigelow is a different story altogether. He knows a thing or two about hotels because he's built a hotel or two. Founder of the successful Budget Suites of America hotel chain, Bigelow also happens to be a major space advocate and leading champion for space tourism. He dedicated part of the fortune he made from his Earthbound hotels to establish Bigelow Aerospace.

While other space entrepreneurs are working on new modes of transportation and capabilities to provide fleeting hops in weightlessness, Bigelow is concentrating on extended stays in orbit in the not-so-distant future. Like all good space marketers, he believes that the costs will eventually come down enough so those other than the Top One Percent might also bask in star shine.

I had a chance to meet him in 1999 at his Budget Suites headquarters in Las Vegas just before the official announcement of his space

company. He, too, is a visionary who can capture your attention with feasible, yet far-out ideas. Bigelow comes across as a low-key, easy-going guy that doesn't suffer fools. He is laser-focused on developing habitats for a space-bound humanity. The focus for his aerospace company is on places to go and things to do in orbit. He is, wisely, counting on others to show up with space transportation systems at the launch pad.

When Congress directed NASA to abandon its research on Transhab, a spacecraft that featured inflatable technologies, Bigelow saw an opportunity. He negotiated a license for the technology with plans to build large permanent structures for long-duration stays in space. With his new space company, he advanced research on inflatables and by 2006 launched the uninhabited Genesis 1 to test the long-term viability of inflated modules.

A year later, he launched Genesis 2 (both from Russian on Kosmotras Dnepre rockets). Like Genesis 1, the second spacecraft was suited up with instruments and cameras to obtain data and information applicable to future vehicles. The modules are lighter than rigid structures and have the capacity to provide more volume. Both spacecraft operated for two and a half years, much beyond the planned six-month design life. The orbits of the modules will decay over time and will eventually burn up on reentry.

In April 2016, the company followed up the success and lessons learned from the flights of the Genesis spacecraft by docking the Bigelow Expandable Activity Module (BEAM) to the International Space Station. As part of the cargo delivered in a Dragon capsule, a deflated BEAM was attached to the exterior of the station and pressurized to dimensions of 13 feet long and 10.5 feet in diameter. There were hiccups with the inflation process, but it eventually reached its full size. The module remains attached to ISS where it accumulates data on expandable technologies and impacts to the structure from orbital debris and micrometeoroid strikes.

Encouraged by the positive results of the Genesis and BEAM missions, in February 2018, Bigelow announced the formation of a second company, Bigelow Space Operations (BSO). The focus of this company is to launch a series of enormous, inflatable structures that can be used for a wide range of endeavors including hotels, laboratories, and research accommodations for nations with startup space organizations. According to the BSO website, each structure will operate as "one spacecraft serving many missions. An entire space station and human space program in one launch."[16]

With a name more akin to aviation than high-flying spaceships, the module series is called B330. The "B" stands for Bigelow, and the "330" refers to the number of cubic meters (12,000 cubic feet) of volume within the module. The company has plans to launch B330-1 and B330-2 by 2021. Each module can accommodate up to six people with a combined volume equal to approximately two-thirds of the ISS. BSO has a contract with United Space Alliance to launch the B330s on an Atlas V rocket.

However, a decision to launch may depend on a several million-dollar marketing study financed by BSO. Before going off on an altruistic money-losing proposition, BSO wants to verify that a sufficient number of customers exists for the habitats. If the study results don't make sense from a sustainable financial perspective, the would-be labs or hotels would stay in the hangar. In the meantime, in spring 2019, the company reported the two modules were well along in the fabrication process. If the market does prove to exist, they plan to construct four additional B330s. Bigelow is also interested in an expanded version of the modules that could be leased to space agencies as habitats on the Moon.

The price to check-in to one of the orbiting stations has not been decided. If used as a hotel, it will ultimately depend on who comes forward to lease the module(s) and underwrite the costs to outfit the interior for extended stays of visiting guests. Shortly after announc-

ing the formation of BSO, Bigelow told a reporter that he "estimates the cost could be in the low seven-figures, but more likely in the low eight-figures."[17] Depending on what the first digit is in the seven-figure number, you're probably going to have to sell more than your house if you want to read a *Gideon Bible* at one of these hotels. As my home-state senator Everett Dirksen (R. IL) was often credited with saying, "A billion here, a billion there, pretty soon, you're talking real money."[18]

Orion Scan—or Orion Scam?

Competition is a wonderful thing, and thankfully with the arrival of commercial services, national governments no longer have a monopoly on managing your space dreams. It's also reassuring that no single private sector company has a monopoly on providing services related to space tourism, especially since a number of them seem to disappear without a trace.

Just as there is more than one company that wants to offer you a suborbital ride, Robert Bigelow's quest to launch the first space hotel also has competitors. The other entrants have only recently suited up for the game, and bring a scant track record on which to base predictions of success.

In April 2018, Houston-based Orion Scan made its debut and claimed their Aurora Station will be the world's first luxury space hotel. Your stay would be in a module about the size of the interior of a private jet. According to their website, customers "will be equipped for a remarkable astronaut experience that can be had nowhere else in the known universe." Without any specific evidence, they also claim they will cut "the cost of living in space by an order of magnitude over others. We will not rest until our shared destiny in the stars has been realized."[19] They plan to welcome their first guests by 2021.

According to the company, your 12-day, $9.5 million experience will

begin with training that has been streamlined "from the historical 24 months" to just three:

> Early certification units are theory-oriented and completed on your own pace using the Orion Span Astronaut Certification (OSAC) App or your computer. The goal of these units is to gain an understanding of basic spaceflight, orbital mechanics, and of pressurized environments in space. The OSAC App is currently in development and expected to be released in 2019.[20]

You just knew there'd be an app for that. Full certification will be bestowed during your first stay at the Aurora Station.

Orion Scan claims to have proprietary "stack up" architecture that will enable them to add capacity with additional condos for purchase: "Like a city rising from the ground, this unique architecture enables us to build up Aurora Station in orbit dynamically—on the fly—and with no impact to the remainder of Aurora Station."[21]

The Orion Scan website does not list a management team. Frank Bunger, a technology entrepreneur is the CEO and Founder. His bio lists "extensive experience building early stage company teams, product, and go to market, from zero to eight-digit revenue." Although he "has a multi-disciplinary background across several industries, including software, hardware, and manufacturing," there doesn't seem to be much evidence that he has any background in space operations.[22]

You might want to hold off sending in the $80,000 deposit just yet. It turns out the $9.5 million hotel bill *does not* include the cost of the rocket ride to get there, and the company has no agreements with any launch providers. Also, as of February 2019, Orion Scan failed to raise a goal of $2 million from crowdfunding. Crowdfunding? You want to place your dream in the hands of a company with no discernible experience in space activities and is trying to raise capital from small donations through the Internet? And by the by, the website used for the solicitations has gone radio silent.

Axiom—World's First Commercial Outpost?

Since you are unlikely to book a room at the Hotel Aurora, maybe you'll have better luck reserving a few nights with Axiom Space.

The Merriam-Webster Dictionary defines "Axiom" as "an established rule or principle or a self-evident truth." I'm not sure if Axiom Space had this definition in mind when it was created in June 2018, but their website proclaims that they are "The World's first commercial space station."[23] Jeffrey Manber and his MirCorp commercial space station could rightly refute such a proclamation. Perhaps since the MirCorp modules augered into the Pacific Ocean years ago, Axiom assumed their "self-evident truth" would go unchallenged.

Making use of existing infrastructure, Axiom will offer space on a dedicated module attached to the ISS as:

> . . . a home base for professional astronauts and private explorers. It is the microgravity laboratory where educators, scientists and researchers conduct life-improving research. It is the in-space industrial park for manufacturing products to be used on the ground and in orbit. It is the ultimate proving ground to mature critical space systems necessary for the exploration and colonization of space.[24]

Unlike Galactic Suites or Orion Scan, the management team of Axiom has bona fide credentials with space operations. Former ISS program manager Michael Suffredini is the CEO and president, and the head of engineering is Stephen Altemus, a former deputy director of the Johnson Space Center. The team also includes former astronauts Brett Jett and Michael Lopez-Alegria, while the majority of the other 60 employees list positions at NASA on their resumes.

Their first venture will dock a pint-size module to the ISS, but the company plans to build their own spacious orbiting facility at an unspecified date in the future. In the meantime, Axiom plans to have a housewarming for the first eight tourists in the adjoining room to ISS by 2020, two years sooner than the launch of Bigelow's B330s, but maybe at the same time in 2022.

While new space enterprises are often reluctant to state the cost for their inflight experience, on day one, Axiom announced a price tag of $55 million. The ticket price for the eight-day visit includes a 15-week Earth-bound training course and a voucher for a bus ride to ISS on the SpaceX Dragon2.

In an interview with *The New York Times*, Suffredini took a jab at the space merchants peddling the cheap seats on suborbital flights. To highlight the value of Axiom's $55 million sticker price, he remarked:

> The guys who are doing Blue Origin and Virgin Galactic are going to the edge of space—they're not going into orbit. What they're doing is a cool experience. It gives you about 15 minutes of microgravity and you see the curvature of the Earth, but you don't get the same experience that you get from viewing the Earth from above, and spending time reflecting, contemplating.[25]

It remains to be seen if there are enough customers who can afford or think it's worth an extra $45,750,000 million above the cost of a suborbital flight to spend time reflecting and contemplating.

Close, But No Cigar

As the 21st century arrived, many companies were launched in the name of space tourism. Most sported lean staffs of creative thinkers, modest research and development facilities, meager bank accounts, and the fortitude of Roman Gladiators. It's unfair and a bit cynical to disparage or put a damper on their wild-eyed enthusiasm. After all, we've seen that visionaries and entrepreneurs of the past proved they may have known rocket science, but fortunetellers, they weren't. What may have looked promising and inspirational on paper didn't always translate to success in the market place—or reality.

Unfortunately, it was not possible to include a summary of all the companies that have—or are competing—in the race to offer dreamers a ticket to the stars. There are simply too many, and it's

a challenge to keep up with who's down but not out, or who just made a startling breakthrough to save the day. While establishing a sustainable business model proved to be elusive for many companies, they at least deserve an honorable mention in the Space Tourism Hall of Fame.

Join me in a salute to Armadillo Aerospace, Canadian Arrow, Excalibur Almaz, Kelly Space and Technology, Rocketplane Kistler, Interglobal Space Lines, XCOR Aerospace, and Orbital Technologies. A fist bump goes to companies that have not been mentioned. The corporate logos of these companies may never appear on the departure gates of spaceports. However, they valiantly and, in most cases, sincerely toiled to keep the dream alive.

International Affairs

In addition to slighting some of the U.S. companies, I wasn't able to focus on the numerous space tourism initiatives being pursued in other countries—many which have relevance to the spaceflight dream. Thirteen nations have successfully built and launched rockets, and 72 countries have dedicated organizations or agencies to pursue space research, development, and exploration. It takes a lot of bandwidth to track the strategic plans, bold promises, and current status of so many players. Below is a summary of just a few initiatives to watch that are taking place in other countries.

Will the revolutionary British single-stage-to-orbit Skylon space plane really offer a trip at five times the speed of sound and by 2025 deliver passengers to orbit in just 15 minutes? The British company Reaction Engines Limited (REL) hopes to bring this vision to reality. When it comes to sporting a retro-rocket vibe, the sleek, needle-nosed Skylon spaceship gives the SpaceX Starship a run for its money. Remotely controlled by ground pilots, "The technology could be used in vehicles designed to deliver communications satellites or tourists to orbit at rapid speeds before returning to Earth."[26]

The spaceship will be able to transport 30 passengers to orbit in its Skylon Personnel Logistics Module (SPLM). REL has raised less than $200 million toward the $12 billion development costs, so it may be awhile before you see the next stakeholder update.

Will a fleet of 52 Japanese-made Kankoh-maru spacecraft actually conduct 300 flights per year and dispatch 700,000 passengers to orbit for $25,000? Proposed in 1993 by the Japanese Rocket Society, the single-stage-to-orbit launch vehicle employs a vertical takeoff and vertical landing procedure and could carry 50 passengers. With a $28 billion development price tag, it's not all that surprising that no components have been tested.[27]

Speaking of Japan, in 1987, after giving a speech in Tokyo on long-range space planning, I had a chance to visit the Shimizu construction company and was briefed on their Space Resort concept. They proudly showed me plans for a giant space hotel featuring artificial gravity powered entirely by solar energy. Projected to start operations in 2020, the facility features 100 rooms for staff and guests. I was invited to observe a series of stress tests on construction materials to be used for the 460-foot-in-diameter cosmic inn. I haven't heard much about Space Resort lately, but it was presented as a long-range plan, so who knows?

Many space advocates are hoping the escalating pace of space activities in China might ignite a new global Space Race and lead to lots of cash being plowed into American space endeavors. The Chinese began launching taikonauts in 2003, landed robots on both the front and far side of the Moon, plan to launch a space station by 2020, and send taikonauts to the Moon and Mars. There are also longer-range plans for space hotels and asteroid mining.

By 2028, they also intend to make a splash in the suborbital space tourism pool. Led by the China Academy of Launch Vehicle Technology, their reusable rocket will launch vertically and land hori-

zontally like Virgin Galactic's VSS Unity. Don't look for a reduced ticket price with their spaceship; their suborbital outing will also run between $200,000 and $250,000. If you're a senior citizen, don't even bother sending a deposit. Customers over 65 years of age are not welcome. Care to join my class action suit charging age discrimination?

It will also be fun to keep an eye on the four-year old United Arab Emirates Space Agency. In 2018, they selected four UAE astronauts, and the first is scheduled to fly with the Russians to ISS in September 2019. To celebrate the 50th Anniversary of the founding of the UAE, the country plans to launch a robotic mission called Hope in 2020, hoping to orbit Mars by 2021. In the really long-term, the UAE Space Agency has announced its intent to establish a city of 600,000 citizens on the red planet by 2117. Hopefully, UAE's galactic sister city won't trespass on Elon Musk's colony of Martian Sooners.

Reversal of Fortunes

In the previous chapter, we saw where both SpaceX and Boeing were eager to market surplus seats on their ISS-bound spacecraft to civilian passengers. Following the first Dragon2 launch in March 2019, Elon Musk claimed NASA was supportive of such an arrangement. Being *supportive* of private citizens entering the sacred interior of the space station would indeed be a major policy shift for NASA. Recall the major pushback by the agency and its international partners when they objected to the seven private citizens that had paid the Russians for a stay at the ISS.

But low and behold, on June 7, 2019, NASA had a major change of heart and announced ISS was open for expanded commercial endeavors, including opportunities for private astronauts to come on board. The purpose of the new policy is so "U.S. industry innovation and ingenuity can accelerate a thriving commercial economy in low-Earth orbit."[28]

As part of this new opportunity and beginning in 2020, NASA will allow up to two short-duration private astronaut missions (up to 30 days) per year to ISS. The individuals taking part on the missions will be allowed to conduct approved commercial activities, including marketing, testing new products, and filming commercials or movies. The private astronauts will need to meet NASA's medical standards and complete the same training and certification procedures as professional ISS crewmembers.

Beginning in 2020, NASA will allow commercial passengers to work at ISS. SpaceX plans to sell seats on its Dragon2 capsule (left) and Boeing will do the same with its Spaceliner (right)
Photo: SpaceX and Boeing

This is not an inexpensive endeavor. NASA will charge approximately $35,000 per day for incidentals like air and life support, food, medical supplies, use of the toilet, and, of course, access to WiFi. I suppose you could shave off some of those costs if you bring your own oxygen bottle and chow. Instead of using the ISS head, you might bring plastic bags and replicate how early astronauts went to the bathroom—but eww, who wants to do that?

The per diem charge from NASA is just the tip of the financial iceberg for this experience. You'll also need to factor in the transportation cost for a launch with either SpaceX or Boeing. Although neither company has announced a set price, NASA estimates a seat will sell for around $58 million.

Despite the hefty price tag, just a few days after the private astronaut announcement, *GeekWire* reported that Bigelow Space Operations (BSO) "put down substantial deposits and reservation fees for up to four SpaceX launches to the space station." They are targeting a per seat fare of around $52 million. Company CEO Robert Bigelow admitted, "The devil is in the details . . . But we are excited and optimistic that all this will come together successfully and BSO has skin in the game."[29] BSO did not respond to inquiries on what flights to ISS might mean to the schedule for passenger trips to their B330 modules.

While there was a great flurry of reporting over the new NASA policy, less attention was paid earlier in the year to a space tourist-related announcement that Space Adventures made in February 2019. In addition to collaborating with Boeing, the space tourism company revealed it has a new contract with Russia's State Space Corporation, Roscosmos, to carry two space flight participants to ISS. These folks will fly to the station on a Soyuz spacecraft beginning in late 2021.[30] A ticket price for flying with the Russians was not released, but is likely to be similar to a Boeing launch, in the $52 million range.

Did I mention this probably isn't the way the majority of readers will fulfill their dream to fly?

What About Us?

Numerous marketing studies reveal that there should be a sufficient number of wealthy early-adopters to take advantage of the near-term space tourism opportunities. Whether or not there will be enough positive feedback and endorsements from the early birds to enable a sustainable market remains to be seen. Will experiencing less than ten minutes of weightlessness on a suborbital jaunt truly be worth a quarter of a million dollars?

But what about the rest of us? While there have never been so many current, near-term, and one-of-these-days prospects for private citizens to achieve the dream of spaceflight, they all seem to cost a small fortune. Does it matter that 42% of the public would like to fly even if the price of admission remains beyond the maximum limit we can ever hope to charge on our credit cards? Once we get past the first few suborbital flights of celebrities and journeys of the uber rich to space hotels, will ticket prices really fall and become equivalent to transcontinental airline flights?

Many years ago in an interview in *Omni* magazine, Norman Mailer projected how the public really feels about those who earn astronaut wings: "I think there's an unconscious hatred of the people who are going into space. I think a lot of people feel, in effect, that these guys are going to gut everything here and go out and leave us behind, that there may be an embarkation from the dying planet Earth to save a few of the species."[31]

Hopefully, people taking brief suborbital jaunts aren't really planning to leave us behind or gut everything on Earth before their flight. As for those traitors renouncing their Earthly citizenship to emigrate to the Moon or Mars, well . . .?

Might there be some altruistic soul who will take pity on us and pay our way to orbit? Or how about a contest with a trip to space for the lucky winner? If such things were to happen, perhaps our chances of waking up in the dream could still be achieved. Rejoice! It could happen and is happening—kind of.

A trip into space as a contest prize has great potential. Virgin Galactic has already collaborated with two auto manufacturers on promotional campaigns. In 2005, Virgin and Volvo partnered on a marketing promotion with a trip to space offered as the prize. More than 135,000 dreamers registered for the "Go Boldly" campaign. In March of that year, Doug Ramsburg of Northglenn, Colorado was

announced as the big winner. He not only won a ticket to fly on a Virgin Galactic flight, but at the news conference, Volvo surprised Ramsburg with Earth-bound transportation until his spaceship blasts off—a complimentary three-year lease for an SUV! Given the long delays for his flight, Ramsburg is no longer pursuing his suborbital prize.

Virgin's second automobile partnership was revealed in September 2014 at the unveiling of the Land Rover 2015 Discovery Sport SUV. During the event, the two companies announced a "Galactic Discovery Competition." For this opportunity, contestants from 29 countries were invited to team up with three friends and submit a 30-second video or still image to demonstrate their spirit of adventure. Country winners were to be selected in November with a suborbital flight for the winning foursome to be announced in December of that year.

When I asked for a status of the prize for the Galactic Discovery Competition, Land Rover Customer Relationship Representative Danielle Carey explained that due to the 2014 accident with VSS Enterprise, the global prize was revised and replaced with a Land Rover Grand Prize Adventure. Instead of a suborbital ride, the winner from Canada received a trip that started in Port Elizabeth, South Africa and ended in Durban, Ireland. Included in the trip was a visit to the Born Free Foundation at the Shamwari Game Reserve and a shark tagging expedition with scientist Meaghen McCord Grey from the South African Shark Conservatory. South African explorer Kingsley Holgate also joined the excursion.[32]

Other brands have offered space flights as a prize for marketing driven competitions, but unfortunately, the sponsoring companies bet on the wrong spaceship. In 1998, over 700,000 applied to the Pepsi Japan and Pepsi Australia 2001 Space Tours contest. The prize was for one seat on Zegram's Space Voyages spacecraft, a vehicle that never made it beyond the promotional brochures.

To celebrate its 50th Anniversary, the Seattle Space Needle sponsored "Space Race 2012." Kicked off in August 2011, the grand prize was a suborbital ride offered through Space Adventures on an Armadillo Aerospace spaceship. The competition attracted over 50,000 applicants who submitted a video explaining why they wanted to fly in space. For the second phase of the contest, 1,000 names were drawn at random. From this list, five finalists were chosen to compete in physical and mental challenges that took place over three days in May 2012. University of Arizona law graduate Greg Schneider of Tucson emerged as the winner.

Unfortunately, Armadillo's rocket never made it to the launch pad, and in 2013, CEO John Carmack placed the company in "hibernation mode." In the meantime, Schneider became a professional lawyer, has a family, and lives in Phoenix. According to Seattle Space Needle spokesperson Richard Mandapat, although Schneider still dreams of a space flight, he opted to accept the $110,000 value of the grand prize instead of waiting for an alternate launch provider to appear. [33]

The 2013 "Axe Apollo Body Spray" contest is also in limbo. Announced during a Super Bowl XLVII (47) commercial and featuring Apollo Astronaut Buzz Aldrin, the yearlong competition offered winners a free suborbital flight. The competition brought 100 finalists to the Kennedy Space Center for training and tests, and in December 2014, 23 participants were selected to receive the promised complimentary suborbital experiences. Too bad the spaceship provider was XCOR and its Lynx spaceship. Though expected to fly customers in 2014 or 2015, the company went bankrupt in 2017 without ever providing anyone with a suborbital ride.

The marketing department of the Axe fragrance company is undeterred by XCOR's dubious operational status. When asked if they had plans to fly Axe contest winners on an alternate spacecraft, the company told me:

XCOR management has retained critical employees on a contract basis to maintain the company's intellectual property and is actively seeking other options that would allow it to resume full activity. XCOR Space Expeditions is hard at work developing their technology, and they currently anticipate that commercial flights will begin as soon as their rigorous and comprehensive testing program is complete. We are keeping in close contact with the XCOR team as they move forward with exciting new developments, and we will keep our winners updated as we continue to learn more.[34]

I'm guessing Axe hasn't been in touch with XCOR for a while. All of the rocket company's listed phones have been disconnected and social media accounts suspended.

More recently, another company with altruistic fervor plans to fund the flights of 10,000 "normal" people to the stars. With the goal to "democratize space," the nonprofit organization Space For Humanity believes it's important that a more diverse demographic of the global citizenry has the opportunity to travel to space than we've seen thus far.

According to the "The Astronaut Portal" on their website, participants will be selected for Space For Humanity's Citizen Program based on the submission of a three-minute video or written application.[35] All you have to do is make a compelling case for why you want to go to space. Successful applicants will then be invited to a series of interviews to demonstrate how they plan to inspire others through a Citizen Astronaut Program. If selected to fly, you will be given flight training, and in return for performing as a Space for Humanity Impact Ambassador, you'll receive a complimentary suborbital flight.

CEO and Founder Dylan Taylor stated the longer-term vision for the organization "is to send selected groups into Low Earth Orbit by 2022, the Moon by 2027 and deep space by 2030."[36] That's a rather

ambitious agenda and an expensive undertaking. While Taylor raised $10 million in start-up funding, unless Space For Humanity is getting a colossal group rate, flights for the 10,000 planned ambassadors could require a budget on the order of $2 billion. That's a tall order for even an experienced investor like Taylor, who is affiliated with the well-respected Space Angels investment network.

Rachel Lyons, executive director of Space For Humanity, reports that more than 200 people from 41 countries have submitted applications for the first opportunity. If you missed the first chance, an open application period is scheduled every year for the foreseeable future. A launch date for the first Space For Humanity flight has yet to be scheduled.

Historically, space themes have been popular for advertisements and marketing promotions. Despite the uneven track record thus far in delivering the promised prizes of suborbital flights, the concept remains valid. Hopefully, when suborbital flights become operational, advertising agencies will jump on the bandwagon to sponsor new contests, and you might yet have opportunities to apply.

Of course, there's also a snowball's chance in Hell that predictions of radical rate reductions will materialize soon and people of modest means will be able to afford a boarding pass. Not until the ticket price for a suborbital stroll is in the ballpark of the cost to hike up the Himalayas (ranging from $50,000 to $75,000) can we even begin to think about the true democratization of space. Even at that price, many dreamers will still be left behind.

Dearly Beloved

Should you come to the end of the road and still not have achieved your dream of spaceflight, take heart! While you won't consciously make the trip, you can make arrangements to have your cremains or DNA make the journey. With the assistance of the Memorial Spaceflights offered by Houston-based Celestis, your spirit can

meet your maker beyond Earth's boundaries, at least in the form of a few grams of your ashes or hair follicles.

With the $2,500 Earthrise Service, your remains will be placed in a lipstick-sized canister for a journey on a parabolic flight and then be returned. The Earth Orbit option is available for $5,000, and your capsule will launch into space and re-enter the atmosphere like a shooting star. The Luna Service costs $12,500 and lands your canister on the Moon to remain for eternity in a Celestis mausoleum. For the same price, you can go really far out and sail on a permanent celestial journey with the Voyager Service. A unique patch is designed for each mission. Recently Celestis Pets was added to the menu, which certainly brings new meaning to the phrase "go fetch."

Commercial space pioneer Charlie Chafer is the Celestis CEO. He collaborates with multiple rocket companies to acquire piggyback rides for the Celestis container of cremains as a secondary payload on space launches. Clients' remains have been launched from the Kennedy Space Center, Vandenberg Air Force Base, and Spaceport America. Flights have occurred on the Athena; Falcons 1, 9, and the Super Heavy; Pegasus; SpaceLoft XL; and Taurus rockets.

Included in the compact is a solemn, yet celebratory memorial service for the families of the deceased on the day of deployment near the launch site. Guests also receive briefings on current and future space activities. I was invited to speak at one of these services and was overwhelmed by the spiritual and emotional sincerity of the event and the camaraderie that developed among the participants.

Since 1997, Celestis has deployed the remains or DNA of over 1,400 people, and has reservations for 400 more (half still alive). The majority includes people who had a deep passion for the space program and exploration. Among the more well-known clients who have gone where no man has gone before are *Star Trek's* Gene

Roddenberry, space colony champion Gerard K. O'Neill, LSD High Priest Timothy Leary, and astro-engineer Krafft Ehricke. The first attempt to beam up the ashes of *Star Trek's* chief engineer Scotty, AKA James Doohan, and Mercury 7 astronaut Gordon Cooper on a Falcon 1 rocket failed. However, on a subsequent Falcon 9 launch, they successfully met their maker.

Highway to the Danger Zone

After all the accidents and close calls illustrated throughout this book, it's clear that spaceflight is, and always will be, a risky business. Christa McAuliffe was our first space flight participant but lost her life along with the other six valiant crewmembers on Challenger. In 2003, seven additional astronauts perished during the re-entry of STS-107. Commercial companies have also experienced accidents on the ground, on the pad, and in the air during construction of their rocket ships. Two of those incidents led to fatalities.

After the Challenger accident, one of the Teacher in Space Ambassadors implied NASA hadn't done all that much at the national conference to highlight the dangers of space flight. He told a reporter that our emphasis on safety and the hazards involved was "equivalent to reading the warning label on a can of oven cleaner."[37] That's a far cry and totally inaccurate account of what Commander Dick Scobee and other speakers told the teachers during their presentations. So in case you're as clueless as that particular teacher, let me be very clear: Danger! Danger, Will Robinson! Space flight is full of potential perils and is not for the faint-hearted or those with a short attention span. Space veterans may proclaim, "Failure is not an option," but there is no denying it's an inherent possibility.

In an interview with *The Daily Mail*, Richard Branson acknowledged the dangers of spaceflight. In pointing out that NASA had lost three percent of its astronauts, he declared, "With a government-owned company, you can just about get away with losing three percent of your clients. For a private company you can't really lose anybody."[38]

There's a degree of hubris in this statement, as the odds of not losing a passenger are not in his favor. Accidents happen.

What is unknown is how the public and prospective customers will react should a fatal accident occur with space tourists on board. Will it become a national tragedy mourned by millions and covered heavily by the press like the two space shuttle disasters? Or will it be more like the response to the death of Michael Ashbury, the Virgin Galactic pilot who perished during the VSS Enterprise test flight? That tragedy was barely covered beyond a couple of news cycles and very few ticket holders asked for a deposit refund. Would it have been different had there been passengers on board Enterprise? Recovery from an accident will depend on the severity, the cause, and the measures needed to return to flight. We don't yet know how such an episode will affect reservations, future sales, government action, or public sentiment.

Signing all the consent waivers a lawyer sticks under your nose won't make spaceflight any safer. While there have been far more successful human flights than catastrophic accidents, we must always be vigilant. If you do get the chance to strap yourself in for an excursion, please take the training seriously, follow directions, and in case of an emergency, know how to scoot to the nearest exit. Don't say I didn't warn you.

Across the Universe Toward the Evolutionary Spiral

We hold on to the dream of spaceflight because we believe the trip will bestow us with a higher level of consciousness. We want to rise above the daily grind and strive for a more meaningful purpose and higher values for our lives. We covet the "Overview Effect" popularized by Frank White and the "Orbital Perspective" described by Astronaut Ron Garan.[39][40] These phenomena represent life-changing psychological, and, in some cases, physical shifts in how those who have been to space and back now view the world.

White describes the Overview Effect as a "state of mental clarity, that occurs when you are flung so far away from Earth that you become totally overwhelmed and awed by the fragility and unity of life on our blue globe. It's the uncanny sense of understanding the 'big picture,' and of feeling connected, yet bigger than the intricate processes bubbling on Earth."[41] It comes about as a result of being able to observe the impact of natural and man-made activities on the planet.

Even before White and Garan published their books on the subject, the life-altering impact of a trip into space was well known to Apollo-Era astronauts. In a 1972 *Time* magazine article that came out during Apollo 17, the last Moon mission, astronauts Rusty Schweickart and Edgar Mitchell were crystal clear when they admitted that space flight had changed their view of the world.

Schweickart freely acknowledged that he "completely lost his identity as an American. I felt part of everyone and everything sweeping past me below." Schweickart went on to confess, "I am not the same man. None of us are." Ed Mitchell added, "You develop an instant global consciousness, a people orientation, an intense dissatisfaction with the state of the world and a compulsion to do something about it."[42]

Russian space travelers had similar experiences. As cosmonaut Dr. Aleksandr Serebrov relayed at an AIAA space conference in June 1990, "Those who fly in space feel differently and become sick with a global philosophy and a terrible case of cosmic views."[43] I love his use of normally negative-sounding words to describe a great experience.

After spending 12 days on the ISS in 2008, private astronaut Richard Garriott was struck by "The impact of humanity. The footprint of humanity is everywhere across the face of the Earth . . . My sense of the reality of the scale of the Earth collapsed and suddenly I now

understand the Earth in a way that I never could have before. And that has stayed with me and will forever, I am sure."[44]

It made a similar impression on astronaut Ron Garan when he looked down at Earth while being maneuvered outside the space shuttle at the end of the Canadarm:

> As I approached the top of this arc, it was as if time stood still, and I was flooded with both emotion and awareness. But as I looked down at the Earth—this stunning, fragile oasis, this island that has been given to us, and that has protected all life from the harshness of space—a sadness came over me, and I was hit in the gut with an undeniable, sobering contradiction.[45]

University of South Australia Professor in Tourism, Dr. Marianna Sigala, notes, "People will want to go to space for all sorts of reasons—adventure, spiritual wonder, even to gain fame and celebrity—and they will be willing to pay a lot of money for that experience and the services around it."[46]

Dr. Sigala describes the probable impact from space travel in similar terms as the Overview Effect. In the professor's analysis:

> Space tourism falls into the category of what is known as 'transformational services, which are consumed not just to satisfy basic survival needs. Transformational services enable people to rethink and re-set their value system, their priorities and way of thinking, to learn and to self-develop, to change their attitude, mindsets or their behavior or perception about certain things.[47]

For Dr. Sigala, this emphasis on the higher calling of space flight "is what makes space tourism something more than just a trip for the rich—the experience will have deep meaning for many people, so I believe the space tourism industry can expect to see strong growth and demand, even after the novelty of being one of the first to experience it has passed."[48]

In contemplating the changed mindfulness about Earth, ocean explorer Jacques Cousteau once observed, "A new awareness, a space-age consciousness especially among younger people could cause mankind to abandon violence, money, and false material pleasures based on uncontrolled production and consumption, and to start preparing Planet Earth for a cosmic awareness and personal immortality."[49]

It's yet to be proven if the impact of a brief hop, skip, and a jump of suborbital flights will last long enough to instill the Overview Effect, an Orbital Perspective, or transformational services within passengers. For the most part, all dreamers want to do is have some fun and experience moments of joyful weightlessness. Hoping for abandonment of materialistic pleasures and preparation for immortality seems like a heavy responsibility to drop on a bunch of space tourists. However, in between performing somersaults, slurping floating water globules, flying around like Superman, and taking endless selfies, the space flight participants/astronauts/wealthy tourists will hopefully take time to look out the windows and breathe in the awe and wonders of a borderless Earth. With regular launch schedules and when a broader range of people starts to fly, the spread of an enhanced cosmic consciousness may yet arrive.

In the near future, the ability to experience brief periods of weightlessness may be enough for someone to experience their eureka moment or find their muse. Who knows what might result from pinning astronaut wings on a spaced-out artist, entrepreneur, marketing major, entertainer, or village idiot? In any case, national governments are no longer the sole guardians of the galaxy, and a much more diverse crowd will tell us what spaceflight is *really* like. Perhaps after they land, passengers will have an overwhelming incentive to take Jacque Cousteau's advice "to start preparing Planet Earth for a cosmic awareness and personal immortality." How cool would that be?

I Touch the Future—I Teach!

Although the Space Flight Participant Program and the Teacher in Space opportunity no longer exist, promoting STEAM education and careers remains a high priority at NASA. The agency believes it has a core mission to inspire students and teachers through a broad range of educational activities.

As noted in Chapter 11, the first educator-mission specialists, Joseph Acaba, Ricky Arnold, and Dotty Metcalf-Lindenburger, were announced in May 2004. Since joining the astronaut corps, Acaba has flown to ISS three times, Arnold flew to ISS twice and performed a space walk, and Lindenburger conducted research on one ISS mission. She also had a stint as commander on NASA's Extreme Environment Mission Operation (NEEMO) in the Aquarius Reef Habitat off the coast of Florida.

In 2018, two of the three of these astronauts played a key role in helping fulfill Christa McAuliffe's original dream to teach from the "Ultimate Classroom" in space. On their overlapping ISS missions, Joe Acaba and Ricky Arnold performed the experiments and presentations that McAuliffe had planned to deliver during the STS-51-L mission. Since their combined stays on ISS covered the majority of an academic year, NASA designated 2018 as "A Year of Education on Station."

During their respective times in orbit, Acaba and Arnold filmed four of McAuliffe's "Lost Lessons," including Effervescence/Bubbles, Chromatography, Liquids in Microgravity, and Newton's Laws. A curriculum aligned with each lesson is available to educators, and videos of the lessons are available from the Challenger Center's website.[50]

After Ricky Arnold delivered the first lesson during a live broadcast to students and teachers, June Scobee-Rodgers conveyed how grateful she was for his role in the achievement of this education

milestone. Dr. Scobee-Rodgers told Arnold, "Many teachers have worked to make this possible, but you give us the culmination of the dream for Christa's lessons to come to life."[51]

Thirty-two years after the Challenger tragedy, Christa McAuliffe's motto endures: "I touch the future—I teach!" The presentation of the lessons was a most fitting way to honor the legacy of the entire Challenger crew. Perhaps in the future, while fulfilling their dream of spaceflight, another teacher will share similar lessons from a classroom on the Moon or Mars.

Yet He Persisted

Jerry Stoces can teach us something about tenacity in pursuing a journey to space. He's the former high school student mentioned in the Introduction who was resolute in his dream to fly. He flooded NASA, Congress, and the White House with letters begging for a ride on the space shuttle. I had to respond to each of his missives with a big fat *No*, yet he persisted. Well, his determination paid off.

It turns out we've been Facebook friends for years. Because his posts appear under the name of J. R. Stoces, it took a while before I realized he was the same "Jerry" whose orbital aspirations I crushed in 1984. When it finally dawned on me we had previously "met," I followed his stories on Facebook with great interest and was impressed to discover he never gave up.

While still in college, he worked on the Space Shuttle Landing/Recovery team at NASA's Armstrong Flight Research Center (then, Dryden Flight Research Center) and stayed affiliated with the team and other agency programs through 2011. During his professional career, he consulted with NASA, Virgin Galactic, and Blue Origin. After I had already departed from ZERO-G, Stoces experienced parabolic flights on G-Force-1 in 2006 and even ended up flying several times as a flight coach.

Now a father with adult children of his own, Stoces routinely put

money aside to make his dream a reality. I'm thrilled to report that he is planning for a suborbital flight with Blue Origin and has also somehow managed to finagle a ride with Virgin Galactic. In my personal dictionary, the name of Jerry "J.R." Stoces appears as the first definition for the word "tenacious." Way to go, Jerry. So happy to see your dream is alive!

Space Tourism 101

As a former higher education major, I was elated to learn about a course in space tourism being offered at the collegiate level. Dr. Robert A. Goehlich, assistant professor at Embry-Riddle's Worldwide Campus in Berlin, teaches the course as a telelecture with students in America. With doctorates in both economics and aerospace engineering, Goehlich offers a multi-disciplinary look at issues and realities of space tourism. Designed for students pursuing degrees at the master's and PhD levels, the curriculum introduces aerospace and non-aerospace students to the emerging business of space tourism and how it will impact the future of commercial space operations.

In an online description, Dr. Goehlich describes a solid rationale for the course: "At the moment, space tourism is a field where reality, hoaxes, and science fiction are mixed up in such a way that it makes it difficult for the general public to distinguish between reality and wishes. Space tourism is one of the hottest topics in the aerospace business today and assumed to be the future of travel."[52] If there were one thing that would be useful for this emerging commercial sector, it would be to help the general public distinguish between reality and wishes.

The focus of the course is "understanding the developing space tourism business, the market, cost engineering, marketing, delivery vehicles, and safe operations. Specific topics include suborbital and orbital space flight, delivery vehicle capability, market demand, market supply, regulations, and safety."[53] Professor Goehlich also

authored the textbook for the course titled, appropriately enough, *Textbook of Space Tourism*.[54]

Dr. Goehlich invited me to lecture for the course in July 2018 to share the history of the Space Flight Participant Program with his students. The presentation gave me an opportunity to test drive some of the content for this narrative. While there was only a handful of students connected via Skype, their level of enthusiasm was rewarding and uplifting. Most reassuring was the excitement they seemed to display for the subject matter.

The students were especially interested to learn of the many promises that have been made over the years about citizen space travel and the evolution of flight opportunities. Their positive response prompted me to pull the earlier drafts off the back burner to finish the project.

As commercial space tourism continues to grow as a viable endeavor for economic activity, I believe additional academic institutions will offer courses and training in this new discipline. Such courses will help us become educated consumers and mindful, as Professor Goehlich cautions, "where reality, hoaxes, and science fiction are mixed up."

Be Prepared

For those of you who haven't been proactive in saving your loose change and can't afford the super-premium price for the suborbital rides, I have one last trick up my sleeve. For the past six years, I've been collaborating with a small group of commercial space entrepreneurs on a plan to offer an astronaut training experience for the public—and it's not a hoax! While we won't be able to offer you a trip to space, we'll make sure you're prepared when your ship comes in.

When up and running, the Star Harbor Space Training Academy (SHSTA) will be a comprehensive, authentic, and immersive facility

for spaceflight participants, research professionals, and space entrepreneurs. The training is designed for people who plan to take a suborbital hop as well as adventure junkies and dreamers who want to have a genuine astronaut-related experience. As a client, you will experience g-forces while being whipped around in a high gravity centrifuge, see if you can count your toes while experiencing hypoxia at simulated high altitudes in a hypobaric chamber, conduct a "spacewalk" in a 4-million-gallon pool, and capture that Superman shot on a parabolic flight on a Boeing 767.

Maraia Hoffman, whom I met during my ZERO-G days, leads the team. Robert Ward, another ZERO-G veteran, is the chief of Flight Operations. Also onboard are former NASA astronauts Leland Melvin and Ron Garan, and Scott Hartwig, who led United Space Alliance in the final days of space shuttle operations.

Since I've chided the predictive powers and timelines of others and have no desire to be called a hypocrite, let me quickly admit we're about three years behind our original "aspirational" schedule. In seeking a parcel of land for the training campus, we've had our fair share of delays caused by government regulations and bureaucrats who don't have a clue, or could care less, about the financial challenges and need for speed a private company faces. We've also encountered competition to obtain land at several locations. Yeah, yeah, I know—excuses, excuses. Nonetheless, we, too, persist.

If all goes as planned, before the end of 2019, my social media pages will be filled with reports on the groundbreaking ceremony for a 35-acre campus in our yet-to-be-announced location. Pricing details for the experience will be based on the particular training package you select. A one-day parabolic flight experience will start at around $5,000, while the most comprehensive 90-day crew training curriculum will be in the neighborhood of $30,000. I look forward to exchanging high-fives with many dreamers strolling around our campus.

Are We There Yet?

We've seen how the dream to fly in space has spanned decades. Over the years, we've been promised over and over that space tourism is just around the corner. We're told that if enough wealthy people fly, launch costs will eventually come down. Also, since technology advances every day, a new super propulsion system or space age Ruby Red Slippers might emerge to truly and finally make spaceflight affordable.

Given all the hype, are there reasons to remain optimistic that someday you, too, will become a star sailor? In reality, the dream may not be achieved for the majority of us for many fiscal years to come. Things haven't worked out exactly as the visionaries predicted, but then they never seemed to be bothered by limitations or constraints. The saying "Where there is no vision, the people will perish" may be true, but where there is no progress toward a vision, people tend to get a little cynical.

Aim high and keep your aim!
Photo: NASA

Visionaries dream in an ideal world; it's not their fault that we choose not to implement their plans. I once heard Arthur C. Clarke outline a string of predictions about the expansion of civilization into the cosmos. Afterwards, I asked him how we would fund his expansive vision. "I'm not an economist, that's not my problem," he replied.[55]

The early visionaries had an advantage over the planners of today that made them fearless. As Peenemunde prophet Walter Dornberger recalled, "Fortunately we were, for the most part, not even aware of the difficulties which would have to be overcome. We tackled the problems with the courage of inexperience."[56] Despite that inexperience, much was accomplished in their conquest of space. The NewSpace entrepreneurs of today know a good deal more about difficulties to overcome and, thankfully, are still willing to tackle the future of space with the "courage of inexperience."

In the foreseeable future, the majority of economically challenged dreamers will still need to settle for vicarious thrills through the experiences of government astronauts and the more well-to-do private travelers. On a brighter note, at least we will be getting feedback from a wider cross section of citizens who will hopefully bring alternate perspectives from the usual gaggle of scientists and engineers.

We'll see people who want to be in space so badly they are willing to spend oodles of their own money to get there. They won't hesitate to let us know if it is really worth it. Those lucky enough to score a complimentary pass from some corporate promotion are most likely to represent demographics and share insights we've never heard from before.

The NASA archive has a notebook full of "quotes that failed" from experts who made bold predictions regarding things they said could never be done. You don't want to be the editorial board of *The New York Times* that said Goddard's plans to send a rocket to the Moon was a fantasy, or Vannevar Bush, former chairman of NACA, who

proclaimed, "In my opinion, such a thing as a 3,000-mile-high rocket is impossible today and will be impossible for many years."[57][58] You don't want to be quoted in the future claiming our dream to fly will never be achieved. I hear it won't be long until we'll all be flying.

So go ahead, dream to your hearts content. As we know, the impossible is happening every day. Be inspired by all the kids lining up at the simulators at Challenger Centers and Space Camps. These managers of our future are not concerned whether or not they will have the opportunity to fly. They grew up with a space program as a given. *Of course* they will fly in space!

For you who wonder how to improve your chance to fulfill the dream, perhaps you should take Chuck Yeager's advice. The first man to break the sound barrier once admitted, "We didn't know what the word 'macho' meant. We were jes a bunch of hell raisers . . . It wasn't a case of the right stuff. Just dumb luck. When they refer to a pilot having the right stuff, that doesn't mean a rat's ass to me or any other pilot. It's more meaningful to be in the right place at the right time."[59]

If you can't be at the right place, there's always the comfort of following the advice I once heard from either a wise sage or a television commercial—I don't remember which: "It is not the arrival at the destination but the journey that is important." We had better hope so, because some of us have been on the journey towards a destination in orbit for a long, long time.

See Me in Orbit?

In commenting on humanity's evolution into space, author Ray Bradbury once declared, "The Future? Well, Yes! We are going out into the Universe, of course. We are going because we love life. We are going because we are terrified of death. We are going because as Ahab said, 'This was rehearsed by thee and me a billion years before the oceans rolled.'"[60]

Bradbury promises space travel for "we" is inevitable. Well, I love life and I'm terrified of death, but the rest of you may have to roll into space without me. When asked if I have the desire to earn an astronaut badge, I used to feel compelled to respond with the macho-astro huff, "You bech' em." After all, I was originally attracted to the space movement through the Committee for the Future with my own dream for a trip to space. While I still support your dream to whip around the Earth at 17,500 miles per hour, spaceflight has dropped off of my personal Bucket List.

Having experienced about 450 parabolas on ZERO-G's G-Force 1 and NASA's KC-135, I can affirm that the sensation of weightless is mind-boggling fun. The 30-seconds of floating freedom during each parabola is liberating, empowering, and exhilarating, so why not turn it up a notch? The truth be known, the thought of being confined in a small capsule gives me the willies! I've become borderline claustrophobic and would probably beg to be taken back to mother Earth as the first sensation of fright foam formed around the corners of my mouth. Trust me, you wouldn't want me sitting in the middle seat next to you.

No, should I ever end up being at "the right place at the right time" for my turn of an orbital spin, it would have to be in some Death Star-size mammoth. Give me a bridge big enough where the captain can storm about shouting commands and where doors give way with a *whoosh*. And none of this one- or two-hundred-mile-high stuff where social media and my creditors can keep tabs on me. Give me that good old-fashioned warp drive into hyperspace. I'll meet you at that funky bar where the band plays galactic rock 'n roll, and the good-looking people are the ones with two heads.

Until then, aim high and dream big. See you in orbit!

AFTERWORD

This edition of the book includes information collected as of July 1, 2019. Given the tremendous and exciting level of activities within the commercial space sector in general and space tourism specifically, I have no doubt that updates to the last chapters will be required early and often. For the immediate future I will post new information on space tourism-related news and activities on my website, www.ToOrbitProductions.com. New information on space tourism companies and the achievement of significant milestones as well as necessary corrections of text in this edition, will be reflected in future revisions.

There are many other stories of individuals and companies related to our dream to fly in space that I was not able to record. I hope other writers will research these stories and add to the historical narrative of the emerging space tourism industry. In the meantime, and in addition to the websites of companies mentioned in this book, you can learn more about progress in the space tourism sector at the links of the following organizations and news sites:

- www.commercialspaceflight.org - Commercial Spaceflight Federation
- www.ispcs.com/ - International Symposium for Personal and Commercial Spaceflight
- www.nasawatch.com/
- www.space.com/topics/space-tourism
- www.spacedaily.com/
- www.spacefuture.com
- www.spacetoday.net/
- www.spacetourismsociety.org/ - Space Tourism Society
- www.space-travel.com
- www.hobbyspace.com/Tourism/index.html

ACKNOWLEDGEMENTS

A project that took this long to complete created a long list of people to thank and acknowledge.

In the Introduction I already highlighted my wife Debbie's contribution and reinforcement. Her faith in the book never waivered and without her support, there is no book.

I am indebted to the staff of the NASA History Office and NASA Headquarters Library, especially Elizabeth Suckow, Colin Fries, Claudia Jones, Rick Spencer, and Tom Tuszynski. They provided professional and thorough assistance to track down files, books and magazines to document the story. Former NASA chief historian and successful author Dr. Roger Launius also answered questions and provided critical advice on publication procedures. Also, thanks to Christine Peterson of NASA's public engagement staff for tracking down leads.

Speaking of archives, I'm grateful to Dorothy E, Mosakowski, special collection coordinator of the Robert Hutchings Goddard Library at Clark University. Ms. Mosakowski sent me copies of letters that dreamers of the 1920s sent to Dr. Goddard after he first reached for extreme altitudes. The staff at the Hayden Planetarium also uncovered letters from citizens who filled out the Interplanetary Tour Reservation Form in the early 1950s. I visited the Hayden archives over 25 years ago and unfortunately misplaced the names of the staff members who assisted me, but thank you.

I am beholden to former ABC news reporter and author Lynn Sherr. We met early in my NASA career and over the years had occasion to

collaborate on activities with our mutual friend, the late Sally Ride. Lynn helped me refine the initial book proposal and early sample chapters. An accomplished author, Lynn's biography, *Sally Ride: America's First Woman in Space,* is a must read.

While I didn't impose the entire book on my nephew Nathan Ladwig, he did provide comments on many of the initial sample chapters. As a closet writer himself, Nate's comments and insights were helpful in the early stage of the project.

Before I submitted the complete first draft for professional editing, I reached out to old friends, former colleagues, and other family members to serve as Beta Buddies. These were the fabulous folks who downloaded 13 draft chapters and read them on their computers. I asked them to let me know if the story captured their attention and if they could follow the chronology and history of the dream. Did they spot inconsistencies in the timeline, or were they confused about what I was trying to convey? Where was more information needed, and what should end up on the cutting room floor? When was the insertion of humor appropriate, and when was it imprudent? Their collective comments and suggestions led to a much-improved first draft.

One of these reviewers was Dr. Allan Benn, professor of English at East Stroudsburg University (and Debbie's cousin). Although he didn't have to, Allan corrected an embarrassing number of punctuation errors. One of these days I'll figure out proper usage of commas, semicolons, and colons.

The family affair continued when I asked my father-in-law Adrian Morchower to review the first and final draft. He had watched Debbie and me play with this project from the beginning and I'm sure wondered if it would ever come to fruition. His initial comment that he was "pleasantly surprised" by my writing meant a great deal and gave me confidence to move forward.

In between gigs as a standup comedian and aspiring actor, Debbie's nephew Mitchell Lerner added his two cents to the first draft. Maybe he can come up with a joke about the spaceship that was promised to launch at $25 per pound. Mitchell's younger brother Neal came to the review party late, but I value his perspective as a representative of the Millennial demographic. I'll be counting on Neal's digital marketing expertise to increase book sales.

Wanting to make sure my memory of NASA-related events was crystal clear, I reached out to former colleagues and mentors Ann Bradley and Dr. Carolyn Huntoon. Ann was the chair of the Space Flight Participant Evaluation Committee. Her recollections helped validate details of events where my memory faltered. A former director of the Johnson Space Center, Dr. Huntoon was also a member of the Space Flight Participant Evaluation Committee. She helped fill in the blanks related to interactions between NASA Headquarters and JSC.

Two beta readers were laid up with post-surgery recoveries. Terry Kayne (knee) and Terri Niehoff (broken leg) were a captive audience who surely had nothing better to do than read the first draft. Not a space cadet, but an avid reader and educator, Terry's insights were useful to see if the story appealed to a non-space audience. Terri and I collaborated on several writing projects when I was at NASA and when I joined her as a colleague at Science Applications International Corporation (SAIC). An editor by profession, she found it difficult not to devote attention to grammar and punctuation. I'm confident that the pain medication Terry and Terri were on at the time of their review had nothing to do with their positive evaluations.

Facebook is much maligned these days as a sieve of privacy, cesspool of hate, and having an overabundance of cat videos. However, I love how it helps me stay in touch with family and old friends. When it came time to turn the first draft over to a professional editor, I found her through Facebook.

While posting about the book, I heard from Facebook friend Anita Fonte, a fellow graduate of Larkin High School. She alerted me to the fact that Gail Reuben-Kerzner, another Larkin grad, was in the editing and self-publishing business. Owner of The Savvy Red Pen, Gail agreed to become my editor and was my invaluable Sherpa guide to navigate the alternate road from a customary publishing house. Beyond her many contributions to the editing process, I'm especially thankful for her guidance to evolve my early drafts of a traditional historical overview into a more personal narrative. If you've been sitting on a story that needs to be told, give Gail a call. She has a very savvy red pen.

During the editing process, it proved helpful to reach out to subject matter experts to confirm memories and facts of specific episodes. Thanks to Jeffrey Manber, who validated the sequence of events related to MirCorp and the role he played in sending the first "space tourist" to fly to the International Space Station. You would be hard pressed to find someone who has followed space policy more closely for the past 40 years than Jim Muncy. His assistance on the legislative actions related to commercial space and early space tourism was most helpful. Space entrepreneurs Rand Simberg and Dr. John Mankins refreshed my memory of the sequence of events regarding NASA-sponsored studies on space tourism.

Robert Ward and I were colleagues during the startup phase of the Zero Gravity Corporation. He was able to make sure I correctly described and wrote about the early history of the company. Similarly, my former colleague and boss Charlie Chafer updated me on what's up with the memorial flights of Celestes. While up to his ears with all the critical activities to make Virgin Galactic's suborbital flights a reality, CEO George Whiteside always found time to respond to my requests for status reports on their latest plans for test flights and eventual commercial operations.

I can't heap enough praise on Robert K. Weiss for contributing the Foreword. We've had a mutual love of space since we met in college and supported each other's careers when I was at NASA and he joined the XPRIZE Foundation. There is no one who makes me laugh as much or as hard as Bob does. Never have a mouthful of liquid when he gets on a roll.

Once the final version of the story was completed, I turned to yet another family member to make my dream a reality. It just so happens that my sister Linda and brother-in-law Jeffrey Swoger are graphic artists extraordinaire. You never know when it will come in handy to have designers in the family when you need a manuscript formatted for publication.

Finally, I want to give a major shout out to the state finalists of the Teacher in Space Program (TIS), listed in Appendix A. Though we have lost too many of these extraordinary educators over the years, their dedication to the teaching profession and to the goals of the TIS program deserve singular recognition. I'm especially indebted to backup Teacher in Space candidate and eventual astronaut, Barbara Morgan for always encouraging me to complete the book and end the story on a positive note.

Throughout the past 30 years, there were times I wondered if I would ever publish this book. After one too many rejections, I struggled with moments of self-doubt, cynicism, and depression. Would anyone care about the dream of "ordinary people" to fly in space. Had it not been for the reassurance and encouragement of family, friends, colleagues, and countless dreamers, I would not have persevered to achieve this goal. I fear I may have failed to acknowledge all the people who were critical to its publication but you know who you are, and I am forever grateful.

APPENDIX A
Teacher in Space Program

NASA Space Flight Participant Evaluation Committee
Phil Culbertson, chair
Ann Bradley, chair
Neil Hosenball, general counsel
Jack O'Brien, general counsel
Dr. Carolyn Huntoon, associate director, Johnson Space Center
Dr. Harriett Jenkins, assistant administrator for Equal Opportunity Programs
Dr. Frank McDonald, chief scientist
Jesse Moore, associate administrator for Space Flight
C. Robert Nysmith, associate administrator for management
Russell Ritchie, associate administrator for External Affairs

National Selection Panel
Dr. Richard Berendzen, president, American University
Dr. Anne Campbell, vice president, National Parents Teachers Association
Hortense Canady, president Delta Sigma Theta
Dr. Dennis Carey, The Hay Group
Ralph Caulo, executive vice president, Harcourt, Brace, Jovanovich
Gene Cernan, astronaut
Phyllis Curtin, dean Fine Arts and Music, Boston University
Dr. Konrad Dannenberg, former NASA engineer
Pam Dawber, actress, *Mork and Mindy* TV show
Ed Gibson, astronaut
Leroy Hay, 1983 Teacher of the Year
Dr. Robert Jarvik, heart surgeon
Dr. Sidney Marland, former U. S. Commissioner of Education
Harrison Schmitt, astronaut
Deke Slayton, astronaut
Dr. Virginia Smith, president, Vassar College
Estaban Sorian, Lawrence Berkeley Laboratory
Terry Stanford, former senator, president, Duke University
Wes Unseld, former Washington Bullet's basketball player
Dolores Wharton, president, Fund for Corporate Initiatives

State Finalists

(Ten Finalists in Bold)

Alabama
Sophia Ann Clifford, Erwin High School, Birmingham
Pamela Sue Grayson, Minor High School, Birmingham

Alaska
Mildred J. Heinrich, Robert Service High School, Anchorage
Richard C. Houghton, Napaaqtugmiut High School, Noatak

Arizona
Robert Carpenter, Secrist Middle School, Tucson
Robin Kline, Tonalea Elementary School, Scottsdale

Arkansas
William A. Dempsey, Arkansas Senior High School, Texarkana
Mary Beth Greenway, Parkview High School, Little Rock

Bureau of Indian Affairs
Stan Renfro, Wingate High School, Fort Wingate, NM
Sherry Woodside, Wingate Elementary School, Fort Wingate, NM

California
William M. Dillon Jr., Peninsula High School, San Bruno
Gloria M. McMillan, La Jolla High School, La Jolla

Colorado
Kim Natale, Pomona High School, Arvada
Robert Stack, Shawsheen High School, Greeley

Connecticut
Robert Mellette, Conte Arts Magnet School, New Haven
David Warner, Westminster School, Simsbury

Delaware
Henry E. W. Bouchelle, Pilot Elementary School, Wilmington
Stephanie Gerjovich-Wright, Stanton Middle School, Wilmington

Department of Defense
Mary Smothers, Kaiserslautern American High School
Kenneth VanLew, Frankfurt High School

Department of State
Donald Jonasson, Jakarta International School
Bruce Wixted, American of Kuwait

District of Columbia
William A. Barwick Jr., Woodrow Wilson High School
Nancy J. Cooksy, Eastern High School

Florida
Susan W. Forte, Georgestone Vocational School, Pensacola
Michael D. Reynolds, Duncan U. Fletcher Senior High School, Neptune Beach

Georgia
Thomas Phillip Garmon, Benjamin E. Mays High School, Atlanta
Carol G. Hickson, Fernback Science Center, Atlanta

Guam
Dale J. Jenkins, St. John's School, Tumon Bay
M. Bernadette McCorkle, Vocational High School, Barrigada

Hawaii
Joseph Ciotti, St. Louis High School, Honolulu
Arthur Kimura, McKinley high School, Honolulu

Idaho
David M. Marquart, Boise High School, Boise
Barbara R. Morgan, McCall Donnelly Elementary School, McCall

Illinois
John D. Baird, Quincy Senior High School, Quincy
Lynne M. Hoeffel, Bloomington High School, Bloomington

Indiana
Robert S. Foerster, Cumberland Elementary School, West Lafayette
Stephen L. Tucker, West Vigo High School, West Terre Haute

Iowa
A. John Cazanas, Rockford Senior High School, Rockford
Lori M. Goetsch, Mt. Pleasant Junior High School, Mount Pleasant

Kansas
Wendell G. Mohling, Shawnee Mission North West High School, Shawnee Mission Barry L. Schartz, Goddard High School, Goddard

Kentcky
Sue Ellen W. Darnell, North Marshall Junior High School, Calvert City
Judy A. White, L.C. Curry Elementary School, Bowling Green

Louisiana
Debra Harris, Rusheon Junior High School, Bossier City
Denise Van Bibber, Alexandria Country Day School, Alexandria

Maine
Gordon L. Corbett, Yarmouth Intermediate School, Yarmouth
William C. Townsend, Summer Memorial High School, East Sullivan

Maryland
Kathleen Beres, Kenwood High School, Baltimore
David R. Zahren, G. Gardner Shugart Middle School, Hillcrest Heights

Massachusetts
Richard Methia, New Bedford High School, New Bedford
Charles Sposato, Farley Middle School, Framingham

Michigan
Derrick Fries, Seaholm High School, Birmingham
Sharon Newman, West Hills Middle School, West Bloomfield

Minnesota
Steve L Brehmer, Wanamingo Public High School, Wanamingo
Katherine Koch-Laveen, Apple Valley High School, Apple Valley

Mississippi
Connie Moore, Oak Grove High School, Hattiesburg
Joann Reid, Weir Attendance Center, Weir

Missouri
Christopher W. Brown, McCluer North Senior High School, Florissant
Richard K. Kavanaugh, Park Hill R-5 High School, Kansas City

Montana
Paul Dorrance, Helena High School, Helena
Patricia Johnson, Capital High School, Helena

Nebraska
Roger Ray, Northwest High School, Omaha
James R. Schaeffer, Lincoln East High School, Lincoln

Nevada
Ericka J. Turner, Chaparral High School, Las Vegas
Joan C. Turner, Las Vegas High School, Las Vegas

New Hampshire
Christa McAuliffe, Concord High School, Concord
Robert Veilleux, Central High School, Manchester

New Jersey
Jeannine M. Duane, Black River Middle School, Chester
Binnie J. Thom, Walter C. Black Elementary School, Hightstown

New Mexico
Jennifer Dotson, Jones Ranch School, Jones Ranch
Laura Reeves, Rio Grande High School, Albuquerque

New York
Susan A. Agruso, East Islip High School, Islip Terrace
Edward F. Duncanson, Crispell Middle School, Pine Bush

North Carolina
Ernest W. Morgan, Morganton Junior High School, Morganton
Cynthia B. Zeger, Salisbury High School, Salisbury

North Dakota
Sherry L. Hanson, A.L. Hagen Junior High School, Dickinson
Donald L. Hoff, Velva High School, Velva

Ohio
Gail B. Klink, Newark High School, Newark
James B. Rowley, Centerville High School, Centerville

Oklahoma
Freda D. Deskin, Pauls Valley Middle School, Pauls Valley
Frank E. Marcum, Booker T. Washington High School, Tulsa

Oregon
Stephen Boyarsky, Medford High School, Medford
Michael Fitzgibbons Forest Grove High School, Forest Grove

Pennsylvania
Patricia Palazzolo, Clairton High School, Clairton
Charles Tremer, Southern Lehigh High School, Center Valley

Puerto Rico
Nancy M. Lee, Roosevelt Roads Middle School, Ceiba
John G. Wells, Roosevelt Roads Middle School, Ceiba

Rhode Island
Ronald Reynolds, Barrington High School, Barrington
Leisa Sadwin, Halliwell Elementary School, North Smithfield

South Carolina
Michael H. Farmer, Riverside High School, Greer
Myra J. Halpin, Goose Creek High School, Goose Creek

South Dakota
Kevin J. Falon, Lincoln Senior High School, Sioux Falls
Gerald E. Loomer, Rapid City Central High School, Rapid Cit

Tennessee
Carolyn H. Dobbins, McMurray Middle School, Nashville
Bonnie D. Fakes, Lebanon High School, Lebanon

Texas
Peggy Lathlaen, Westwood Elementary School, Friendswood
Stephen A. Warren, Stephen F. Austin High School, Austin

Utah
John W. Barainca, Brighton High School, Salt Lake City
Linda J. Preston, Park City High School, Park City

Vermont
Gail Breslauer, Fayston Elementary School, Waitsfield
Michael Metcalf, Hazen Union Junior High School, Hardwick

Virginia
Ronald C. Fortunato, Norfolk Technical Vocational Center, Norfolk
Judith M. Garcia, Jefferson School For Science and Technology, Alexandria

Virgin Islands
Carol Eby, Peace Corps Elementary School, St. Thomas
Rosa Hampson, Elena Christian Junior High School, Christiansted

Washington
Frances B. Call, Islander Middle School, Mercer Island
Michael R. Jones, Kellogg Middle School, Seattle

West Virginia
Nike M. Wenger, Vandevender Junior High School, Parkersburg
Melanie B. Vickers, St. Albans Junior High School, St. Albans

Wisconsin
Ellen Baerman, Wisconsin Hills Elementary School, Brookfield
Larry Scheckel, Tomah Senior High School, Tomah

Wyoming
Michael G. Pearson, McCormick Junior High School
Julie M. Gess, Evanston High School, Evanston

APPENDIX B
Journalist in Space
Program

Steering Committee

Dr. Robert Hoskins, chair, president, Association of Schools of Journalism and Mass Communications (ASJMC), dean, College of Journalism, Arkansas State University

Dr. Richard Cole, dean, School of Journalism, University of North Carolina

Dr. Richard Johns, instructor of Journalism, University of Iowa

Alan Ladwig, manager, Space Flight Participant Program, NASA Headquarters

Jennifer McGill, executive director, ASJMC

Dr. Billy I. Ross, chairman, Department of Mass Communications, Texas Tech University

Dr. Albert Scroggins, dean emeritus, College of Journalism, University of South Carolina

Dr. Kenneth Starck, director, School of Journalism, University of Iowa

Dr. Dwight Teeter, professor of Communication, University of Texas

National Selection Panel

William Archer, former editor, *Look* magazine

James D. Atwater, dean, School of Journalism, University of Missouri, former senior editor, *Time*

Dr. Lauro F. Cavazos, president, Texas Tech University

Willie D. Davis, president, All-Pro Broadcasting, KACE-FM, Los Angeles, CA

Osborn Elliott, dean, School of Journalism, former editor-in-chief, *Newsweek*

Wilbur Garrett, editor, *National Geographic*

Terry J. Hart, astronaut

Dr. James B. Holderman, president, University of South Carolina

Elmer Lower, former president, ABC News

Kenneth McDonald, former editor and publisher, *Des Moines Register and Tribune*

Dr. Sharon Murphy, dean, School of Journalism, Marquette University

Vermont C, Royster, retired editor, *Wall Street Journal*

William J. Small, former president, NBC News and United Press International

Fay Gillis Wells, former White House correspondent, charter member Ninety-Nines

Marilyn Yarbrough, associate vice chancellor and professor of law, University of Kansas

Regional and National Finalists
(National Finalists in Bold)

Diane Ackerman, *Parade* Magazine, St. Louis, MO
David Arnold, *The Boston Globe*, North Quincy, MA
Theresa M. Anzur, NBC News, Chicago IL
James R. Asker, *The Houston Post*, Houston, TX
A. Blaine Baggett, KCET-TV, Los Angeles, CA
Jay Barbree, NBC News, Cocoa Beach, FL
Marcia F. Bartusiak, freelance writer, Norfolk, VA
Robert Bazell, NBC News, New York, NY
J. Kelly Beatty, *Sky & Telescope*, North Quincy, MA
Burton Bernstein, *The New Yorker*, New York, NY
William B. Blakemore, ABC News, New York, NY
Mark Bowden, *Philadelphia Inquirer*, Philadelphia, PA
Dennis Breo, *American Medical*, Chicago, IL
Mark Chamberlin, KAKE-TV, Wichita, KS
Frederic K. Conover, freelance writer, Denver, CO
Millard (Lew) Cope, *Minneapolis Star-Tribune*, Bloomington, MN
Warren Corbett, BIZNET, Washington, DC
Walter L. Cronkite, CBS News, New York, NY
Morton Dean, INN, New York, NY
Marcida Dodson, *Los Angeles Times*, Los Angeles, CA
Diane L Eicher, *The Denver Post*, Denver, CO
Dinah Y. Eng, *Detroit News*, Detroit, MI
Joan M. Esposito, WLS-TV, Chicago, IL
Susan Farrell, KGTV-TV, San Diego, CA
Timothy T. Ferris, freelance journalist, Hollywood, CA
Thomas Fiedler, *Miami Herald*, Miami, FL
Jerry M. Flint, *Forbes*, New York, NY
Jon Franklin, freelance writer, Glen Burnie, MD
Steven Gauvain, KTRK-TV, Houston, TX
Thomas Garrison, KSTP-TV, Minneapolis, MN
Willard (Gene) Gleeson, KABC-TV, Los Angeles, CA
Michael W. Gold, *Science 86*, San Rafael, CA
Steven Goldsmith, *Seattle-Post Intelligencer*, Seattle, WA
Maximo Gomez, KYW-TV, Philadelphia, PA
Richard Gore, *National Geographic*, Washington, DC
Stanley S. Grossfeld, *The Boston Globe*, Boston, MA

James L. Hartz, WNET-TV, Chevy Chase, MD
Michael Hagedus, KPIX-TV, San Francisco, CA
Richard Hart, KPIX-TV, San Francisco, CA
Larry Hatteburg, KAKE-TV, Wichita, KS
Paul G. Hayes, *The Milwaukee Journal*, Milwaukee, WI
Hal Higdon, freelance writer, Michigan City, IN
John C. Hockenberry, National Public Radio, Washington, DC
Patricia Klein, *Los Angeles Times*, Los Angeles, CA
James J. Klobuchar, *Minneapolis Star Tribune*, Minneapolis, MN
Linda Kohl, *St. Paul Pioneer Press*, St. Paul, MN
Ronald Kotulak, *Chicago Tribune*, Chicago, IL
Martin Kimball Livingston, *San Francisco Chronicle*, San Francisco, CA
Caroline Terry Marotta, freelance columnist, Winchester, MA
Chris Rene Marrou, KENS-TV, Boerne, TX
Michael R. Masterson, WEHCO Media Inc., Little Rock, AR
Jay (Thomas) Mathews, *The Washington Post*, Washington, DC
Malcolm A. McConnell, *Readers Digest*, Queenstown, MD
Lee N. McEachern, Jr., KCO-TV, San Francisco, CA
John Meyer, *Rocky Mountain News*, Lakewood, CO
Thomas Mintier, Jr. CNN, Atlanta, GA
Robert (Chip) Moody II, KHOU-TV, Houston, TX
Mary Murray, *Des Moines Register*, Iowa City, IA
Robert A. Navias, UPI Radio Network, Washington, DC
Alcestis Oberg, freelance writer, Dickerson, TX
Daniel O'Rourke, KPRC-TV, Houston, TX
Michael Parfit, freelance writer, Santa Barbara, CA
Mark Parinkin, *Providence Journal*, Providence, RI
Donn Pearlman, WBBM-TV and Radio, Chicago, IL
Scott Pelley, KFAA-TV, Dallas, TX
Charles Petit, *San Francisco Chronicle*, San Francisco, CA
John Popejoy, KCOP-TV, Los Angeles, CA
Mark Prendergast, *News & Sun Sentinel*, Boca Raton, FL
Paul H. Recer, The Associated Press, Houston, TX
Boyce Rensberger, *The Washington Post*, Washington, DC
James Reston, Jr., *Newsweek*, Bethesda, MD
Peter M. Rinearson, *The Seattle Times*, Seattle, WA
Geraldo Rivera, freelance writer, New York, NY
Michael Rogers, *Newsweek*, Oakland, CA
Roger Rosenblatt, *Time*, New York, NY
Alexander H. Rossiter, Jr., UPI, Washington. DC
Storer H. Rowley, *Chicago Tribune*, Dallas, TX

Peter Salgo, WCBS-TV, New York, NY

Charles Sasser, freelance writer, Gore, OK

Anne Kathy Sawyer, *The Washington Post*, Washington, DC

James Schefter, freelance writer, Playa del Ray, CA

Barry D. Serafin, ABC News, Washington, DC

Robert Shaw, *Des Moines Register*, Des Moines, IA

Lynn B. Sherr, ABC News, New York, NY

Colice Kathryn Sherrod, *Fort Worth Star-Telegram*, Fort Worth, TX

James J. Slade, Mutual Broadcasting System, Arlington, VA

Barbara Stanton, *Detroit Free Press*, Detroit, MI

Dorothy Storck, *Philadelphia Inquirer*, Philadelphia, PA

Douglas Struck, *The Baltimore Sun*, San Francisco, CA

Marty E. Thornton, *The Washington Post*, Washington, DC

Thomas Tuley, *Evansville Press*, Evansville, IN

Frank Tursi, *Winston-Salem Journal*, Clemmons, NC

Lindsey E. Van Gelder, *MS Magazine*, New York, NY

Steve Vogel, WJBC-WBNQ Radio, Bloomington, IL

Robert M. White, *Mexico Ledger*, Mexico City, Mexico

John Noble Wilford, *The New York Times*, New York, NY

Al Wiman, KMOX-TV, St. Louis, MO

James T. Wooten, ABC News, Washington, DC

Gayle Young, UPI, Westport, CT

Linda Yu, WLS-TV, Chicago, IL

NOTES

INTRODUCTION
Epigraphs
 Joseph Campbell, *The Power of Myth With Bill Moyers*, Edited by Betty Sue Flowers, (New York, Doubleday, 1988), 4.
 Howard Rosenberg, "NASA's Travel Agent," *Family Weekly*, Aug. 12, 1984, 7.
1 Krafft Ehricke, "Space Tourism," Proceedings of American Astronautical Society Congress, Dallas, TX, 1967, 286.
2 Earl Hubbard, "The Need for New Worlds: A Declaration of the Right of Mankind to Have a Future," Brochure, 1970, 1.
3 Newhouse News Service, "Dreamers ask to fly in space," *Chicago Sun-Times*, Sep 9 1984, 56.

CHAPTER 1 - THE DREAMS OF YESTERDAY
Epigraphs
 G.A. Koh, Letter to Robert Goddard, Jul 16, 1926.
 Lady Drummond-Hay, "Gossip of the World," *The Mentor World Traveler*, Vol. 22, No. 10, Oct 1930, 25.
 Jean Paul Lorrain, Letter to Hayden Planetarium, Oct 7, 1952.
1 Wolfgang D. Mueller, *Man Among the Stars*, (George G. Harper & Company, London, 1957), 133.
2 Wolfgang Mueller, 134.
3 Konstantin Tsiolkovsky, Quote on the wall of conference room of Space Research Institute, Moscow.
4 *The New York Times*, Editorial, Jan 13, 1920, 12.
5 C. Baucia, Letter to Robert Goddard, Oct 2, 1920.
6 Western Union Telegram to Robert Goddard, Jan 1920.
7 G.E. Maxwell, Letter to Robert Goddard, Mar 1, 1920.
8 Vanora Guth, Letter to Robert Goddard, Apr 1, 1920.
9 Charles Goddard, Letter to Harold Goddard, May 24, 1924.
10 Harold Goddard, Letter to Robert Goddard, May 29, 1924.
11 Unsigned Letter to Robert Goddard, Jan 18, 1924.
12 Francis Hoefft, Letter to Robert Goddard, Apr 21, 1924.
13 Ake Tollet, Letter to Robert Goddard, Mar 31, 1926.
14 "Rub-A-Dub-Dub, Three Men in a Rocket Will Try to Reach the Moon," *The Portsmouth Star*, Feb 3, 1924, 1.
15 C.G. Abbott to Letter to Vanora Guth, Apr 8, 1920.
16 Milton Lehman, *This High Man*, (New York, Pyramid Books, 1963), 102.
17 Lady Drummond-Hay, "Gossip of the World," *The Mentor World-Traveler*, Oct 1920, 25.
18 Lady Drummond-Hay, 26.
19 Lady Drummond-Hay, 26.

20 Lady Drummond-Hay, 26.
21 Lady Drummond-Hay, 26.
22 Helen B. Walter, *Werhner von Braun: Rocket Engineer*, (New York, The Macmillan Co. 1964), 28.
23 "Hitler Targets New York City," www.unmuseum.org/hitlernyc.htm.
24 Obituary of Walter Dornberger, *The Washington Post*, Jul 2, 1980, B-6.
25 Wernher von Braun, "Survey of the Development of Liquid Rockets in Germany and Their Future Prospects," May 1945, contained in von Braun file in NASA Headquarters archives.
26 Douglas Aircraft Company, Inc., Santa Monica Plant, "Preliminary Design of an Experimental World-Circling Spaceship," Report No. SM-11827, vii. This report is also attributed to the RAND Corporation, but the cover of my personal copy attributes the study to Douglas Aircraft Company.
27 Douglas Aircraft Company, vii.
28 Douglas Aircraft Company, viii.
29 James Forrestal, *Report Of The Executive Secretary Of The Research And Development Board, US Department of Defense*, Appendix, (Washington, DC, Department of Defense), Dec 29, 1948. Cited in *Aeronautics And Astronautics: An American Chronology of Science and Technology in the Exploration of Space*, 1915-1960, (Washington, DC, NASA, 1961), 61.
30 Martin Caidin, Rockets *Beyond the Earth*, (New York, The McBride Co., 1952), 144.
31 Martin Caidin, 146.
32 Heinz Haber, "Can We Survive in Space?" *Collier's*, Mar 22, 1952, 66.
33 Heinz Haber, 66.
34 Heinz Haber, 66.
35 "Interplanetary Tour Reservation Form," distributed by Hayden Planetarium at "Conquest of Space" lecture, Mar 9, 1950.
36 A. Hooijmans, Letter to Robert Coles, Dec 30, 1952.
37 Monroe Kaplan, Letter to Hayden Planetarium, Jul 12, 1950.
38 Reservation certificate, "Hayden Planetarium Space Travel Tours, Inter Planetary Route," Hayden Planetarium, New York City, 1950.
39 R.M. Barnes, Letter to Hayden Planetarium, Feb 19, 1952, and Walter Moore, Letter to Hayden Planetarium, May 9, 1953.
40 Elsie Sherwood, Letter to Hayden Planetarium, Aug 1, 1952.
41 Frank Forrester, Letter to Elsie Sherwood, Aug 29, 1952.
42 Breese Industries, Letter to Hayden Planetarium, Mar 19, 1958.
43 List of reservation requests Feb 11, 1952.
44 Ed Meade, Letter to Hayden Planetarium, Jan 5, 1953.
45 Ruby Massengale, Letter to Hayden Planetarium, Jan 2, 1953.
46 Robert Coles in "Foreword" to Frances Frost's *Rocket Away!*, (New York, Whittlesey House, 1953) i.
47 Martin Caidin, 146.
48 Wernher von Braun, "The Mars Project," 2nd Congress of the International Astronautical Federation, Sep 1951.
49 Robert Coles, Letter to Willy Ley, Jun 13, 1951.
50 2nd Space Symposium, Hayden Planetarium, Oct 12, 1952.
51 William Laurence, "Two Rocket Experts Argue Moon Plan," *The New York Times*, Oct 14, 1952.
52 Robert Boardman, "Space Rockets With Floating Base Predicted," *New York Herald Tribune*, Oct 14, 1952.
53 The entire series can be found in the following issues of Collier's: Mar 22, 1952, Oct 18, 1952, Oct 25, 1952, Feb 28, 1953, Mar 7, 1953, Mar 14, 1953, and Apr 30, 1954.

They can be downloaded at: www.rmastri.it/spacestuff/wernher-von-braun/colliers-articles-on-the-conquest-of-space-1952-1954/.

54 Cornelius Ryan, "What Are We Waiting For?" *Collier's*, Mar 22, 1952, 23.

55 Cornelius Ryan, 23.

56 Cornelius Ryan, 23.

57 Heinz Haber, "Can We Survive in Space?," *Collier's*, Mar 22, 1952, 66.

58 Heinz Haber, 66.

59 Heinz Haber, "Man's Survival in Space: Testing the Men," *Collier's*, Mar 7, 1953, 63.

60 Heinz Haber, 63.

61 Heinz Haber, 63.

62 Nancy Carpenter Cavanagh, Interview with Alan Ladwig, Oct 6, 1990.

63 Jimmie Dodd, "Anything Can Happen Day," on "The Mickey Mouse Club LP," Walt Disney Productions, 1962.

64 *Walt Disney's Disneyland* television show, Mar 9, 1955.

65 *Walt Disney's Disneyland*.

66 Scholer Bangs, "Walt Disney Seen As Pulling Trigger on Satellite Program," *Los Angeles Herald And Express*, Aug 1, 1955, A-1.

67 Eugene M. Emme, Editor, *Aeronautics And Astronautics: An American Chronology Of Science And Technology In The Exploration Of Space* 1915-1960, (Washington, DC, NASA, 1961), 78.

68 Loyd Swenson, Jr., James Grimwood, and Charles Alexander, *This New Ocean: A History Of Project Mercury*, (Washington, DC, NASA-SP-4201, 1966), 58.

69 "Musk's big space dream conjures up a decades-old time warp, *The Asahi Shimbun*, Feb 10, 2018, 1.

70 Major General Bernard Schriever, Speech, "ICBM--A Step Toward Space Conquest," Space Flight Symposium, San Diego, Feb 19, 1957.

71 "A Scientific Race Against Time to Launch the First Man-Made Moon," *Life*, Vol. 42, No. 22, Jun 3, 1957, 42.

72 Lt. Gen. James Gavin, Letter to Major General John Medaris, 1956.

73 J. Kelly Beatty, "The Origin of NASA: A 20 Year Perspective," Sky & Telescope, Oct 1978, 276-278.

74 Dwight D. Eisenhower, *Facts on File* 17, Oct 9, 1957, 330.

75 Minutes from Meeting of National Advisory Committee on Aeronautics, Oct 20, 1957.

76 J. Kelly Beatty, 276-278.

77 A. Tarasov, Conversation with V. Mishin-Vasiliy Pavlovich, Sep 1959.

78 "The Seer of Space," *Life*, Vol. 43, No. 21, Nov 18, 1957, 133.

79 Wernher von Braun, Speech, "The Next Hundred Years," Seagram Company Symposium, New York, NY, Nov 22, 1957.

80 "NASA Policy, Plans, and Budgets: Sticking to the Game Plan When Others Wouldn't," *Government Executive*, Vol 15. No. 9, Oct 1983, 3.

81 "United States Civilian Space Programs 1958-1978, Report Prepared for the House of Representatives, Subcommittee on Space Science and Applications," Vol. 1, Jan 1981, 53.

82 "A Statement by the President and Introduction to Outer Space," Prepared by the President's Science Advisory Committee, The White House, Mar 26, 1958.

83 Hanson W. Baldwin, "Conquest of the Moon," *The New York Times*, Apr. 14, 1958, 8.

84 Wolfgang D. Mueller, 134.

CHAPTER 2 - CALLING ALL ASTRONAUTS
Epigraphs

Willy Ley, *Satellites, Rockets, and Outer Space*, (New York, New American Library, 1958), 16.

Scott Carpenter, "This is Something I Would Give My Life For," *Life*, Vol. 47, No. 11, Sep 14, 1959, 41.

"Soviet Traveler Returns From Out of This World," *Life*, Vol. 50, No. 16, Apr 21, 1961, 21.

1 Dick Calkins and Phil Nowlan, "Buck Rogers In the 25th Century," (Club Anni Tenta & Pacific Comics Club), Vol 28, June 14-30, 1936.

2 Wolfgang D. Mueller, *Man Among the Stars*, (London, George C. Harper, 1957), 1.

3 Hal Goodwin, *The Real Book of Space Travel*, (Garden City, NY, Garden City Books, 1952), 108.

4 "Into the Far Frontiers Beyond the Earth," *Life*, Vol 44, No. 1, Jan 6, 1958, 53.

5 Article on astronaut qualifications, *The Washington Post*, Nov 6, 1957, A-3.

6 Ernest Haussman, "Choosing the First," *Space World*, Aug 1961, 18.

7 M. Scott Carpenter, Gordon L. Cooper, John H. Glenn, Virgil I. Grissom, Walter M. Schirra, Alan B. Shepard, Donald K. Slayton, *We Seven: By the Astronauts Themselves*, (New York, Simon and Schuster, 1962), 6.

8 Lloyd Swenson Jr., James Grimwood, and Charles Alexander, *This New Ocean: A History of Project Mercury*, (Washington, DC, NASA SP-4201, 1989), 130.

9 Edgar Cortwright "Men For The Moon: How They Trained," *Apollo Expeditions to the Moon*, (Washington, DC, NASA-SP-350, 1975), 146.

10 Wolfgang Mueller, 19.

11 Charles Mathews, Interview with Alan Ladwig, Washington, DC, Nov. 29, 1990.

12 George Robinson and Harold White Jr., *Envoys of Mankind*, (Washington, DC, Smithsonian Press, 1986), 23.

13 "The Astronauts–Ready to Make History," *Life*, Vol 47, No. 11, Nov 12, 1960, 26.

14 Warren Young, "What it's Like to Fly in Space," *Life*, Vol. 46, No. 15, Apr 13, 1959, 148.

15 Article on NASA press conference for Able and Baker, *The New York Times*, May 30, 1959.

16 Transcript, NASA Press Conference, Washington, DC, May 30, 1959.

17 "Chimps in Space Program," Office of Information Services, Air Research and Development Command, Andrews Air Force Base, Mar 1960.

18 Deke Slayton, Speech, Society of Experimental Test Pilots, Los Angeles, Oct 9, 1959.

19 M. W. Hunter, W.E. Matheson, R. F. Trapp, "Direct Operating Cost Analysis of a Class of Nuclear Spaceships," 11th International Astronautical Congress, Stockholm, Paper 13, 1960, 97-107.

20 Hunter, Matheson, Trapp, 97-107.

21 Hunter, Matheson, Trapp, 97-107.

22 Hunter, Matheson, Trapp, 97-107.

23 "Ticket to the Moon," *Time*, Aug 29, 1960, 41.

24 Wernher von Braun, "What I Believe," *Space World*, Nov 1960, 20.

25 Comments recorded in files in Hayden Planetarium Archives.

26 Hayden Planetarium Archives.

27 James Pickering, Letter to William Miles, 1961.

28 Donald Tepper Letter to Hayden Planetarium, Oct 1, 1964.

29 James Pickering, Letter to Donald Tepper, Oct 1964.

30 Peter Hackes, "First Space Immigrant," Data, Mar 1962, 5.

31 Hackes, Data, 5.

32 *Towards the Endless Frontier: A History of the Committee on Science and Technology, 1959-79*, (Washington, DC, U. S. Government Printing Office, 1980), 80.

33 Loudon Wainwright, "The Chosen Three for the First Space Ride: New Astronaut Team," *Life*, Mar 3, 1961, 26.

34 Y.I. Zaitsey, *From Sputnik to Space Station*, translated by A. York, (Yorks, U. K., British Library, 1971), 46.
35 Zaitsey, *From Sputnik to Space Station*, 46.
36 Sol Levine, *Appointment in the Sky*, (New York, Walker and Company, 1963), 24.
37 Hugh Sidey, "How the News Hit Washington – With Some Reactions Overseas," *Life*, Vol. 50, No 16, Apr 21, 1961, 26-27.
38 Hugh Sidey, 26-27.
39 "Eager Exponent of Zen," *Life*, Vol. 50, No 16, Apr 21, 1961, 88.
40 Hugh Sidey, 26-27.
41 "NASA Policy, Plans, and Budgets: Sticking to the Game Plan When Others Wouldn't," *Government Executive*, Vol. 50, No. 9, Oct 1983, NASA-3.
42 Loudon Wainwright, "Shepard and U. S. A. Feel A-OK," *Life*, Vol. 50, No. 19, May 12, 1961, 19.
43 Louise Shepard, "The Spaceman's Wife: Alan was in His Right Place," *Life*, Vol 50. No 19. May 12, 1961, 28.
44 "Documents on International Aspects of the Exploration and Use of Outer Space, 1954-1962." 88th Congress, 1st sess. Document No. 1. Senate Space Committee, (Washington, DC, U.S. Government Printing Office, 1963), 202-204.
45 "Bob White Takes a New Highway to Space," *Life*, Vol. 53, No. 5, Aug 3, 1962, 54.
46 NASA Authorization Hearing for fiscal year 1963, Senate Committee on Aeronautics and Space Science, June 13, 1962, 34.
47 NASA Authorization Hearing for fiscal year 1963, 34.
48 Gus Grissom, Speech, "Aerospace and It's Impact on Youth," 1963.
49 Gus Grissom.
50 Gus Grissom.
51 Eugene Zuckert, *General Electric Forum*, Aug 6, 1962.

CHAPTER 3 - ASTROCHICKS
Epigraphs

"Qualifications for Astronauts Hearings," Committee on Science and Astronautics, U.S. House of Representatives, 87th Congress, Jul 17-18, 1962, 7.
"Qualifications for Astronauts Hearings," Committee on Science and Astronautics, U.S. House of Representatives, 87th Congress, Jul 17-18, 1962, 67.
Clare Boothe Luce, "But Some People Simply Never Get the Message," *Life*, Vol. 54, No. 26, Jun 28, 1963, 31.
1 Valerie Moolin, *Women Aloft*, (Alexandria, VA, Time Life Books, 1981).
2 Summarized from Jerrie Cobb with Jane Rieker, *Woman Into Space: The Jerrie Cobb Story*, (Englewood Cliffs, NJ, 1963).
3 Lester Del Ray, *Space Flight: The Coming Exploration Of The Universe*, (Minneapolis, MN, General Mills, 1957), 19.
4 Donald Cox, "Women Astronauts," *Space World*, Vol. 1, No. 10, Sep 1961, 59.
5 Jerrie Cobb with Jane Rieker, 131.
6 Jerrie Cobb, 132.
7 Jerrie Cobb, 132.
8 Jerrie Cobb, 148.
9 Jerrie Cobb, 148.
10 Jerrie Cobb, Supplemental Statement for "Qualifications for Astronauts" hearings, 83.
11 Transcript, *Life* Press Conference, Aug 19, 1960.
12 Randolph Lovelace, III, 11th International Astronautical Congress, Stockholm, 1960.
13 "Science: From Aviatrix to Astronautrix," *Time*, Aug 29, 1960, 41.
14 Jerrie Cobb, 163.
15 "Ticket to the Moon," *Time*, Aug 29, 1960, 41.

16 Jerrie Cobb, 174.
17 "Qualifications for Astronauts," 11.
18 W. Randolph Lovelace, III, 11th International Astronautical Congress, Stockholm, 1960.
19 "Qualifications for Astronauts Hearings," 28.
20 W. Randolph Lovelace III, 28.
21 Jerrie Cobb, 174.
22 Donald Cox, 60.
23 Jerrie Cobb, Letter to James Webb, Jun 15, 1961.
24 James Webb, Letter to Jerrie Cobb, Sep 20, 1961.
25 Hiden Cox, Letter to Jerrie Cobb, Mar 1962.
26 Jerrie Cobb, Letter to James Webb, Mar 30, 1962.
27 Jacqueline Cochran, Letter to Jerrie Cobb, Mar 23, 1962.
28 Jacqueline Cochran.
29 Jacqueline Cochran.
30 Jacqueline Cochran.
31 Elvis Stahr, Note to James Webb, May 9, 1962.
32 Jacqueline Cochran, Letter to James Webb, May 15, 1962.
33 James Webb, Letter to Jacqueline Cochran, May 24, 1962.
34 Jacqueline Cochran, Letter to James Webb, Jun 14, 1962.
35 Jerrie Cobb, *Woman Into Space*, 212.
36 All remaining quotes in "Fools on the Hill" from "Qualifications for Astronauts Hearings," Jul 17-18, 1962, 1-22
37 All remaining quotes in "Is That a Rocket in Your Pocket" from "Qualifications for Astronauts Hearings," Jul 17-18, 1962, 22-38.
38 All remaining quotes in "How to Handle a Woman," from "Qualifications for Astronauts Hearings," Jul 17-18, 1962, 39-75.
39 Jerrie Cobb, "Supplemental Statement, Qualifications for Astronauts Hearings," 77-83.
40 Jacqueline Cochran, "Supplemental Statement, Qualification for Astronaut Hearings," 83-84.
41 Jerrie Cobb, Letter to James Webb, Oct 25, 1962.
42 Jerrie Cobb, Letter to James Webb, Oct 30, 1962.
43 Wernher von Braun, Speech at Mississippi State College, Nov 9, 1962.
44 Claire Booth Luce, "She Orbits Over the Sex Barrier," *Life*, Vol. 54, No. 26, Jun 28, 1963, 28.
45 Eugene Konecci, Speech for National Rocket Club, Washington, DC, Jun 18, 1963.
46 Claire Booth Luce, 31.
47 Claire Booth Luce, 32.
48 Claire Booth Luce, 32.
49 Claire Booth Luce, 32.
50 Jim Mahoney, "Jerrie Cobb Thinks Cooper Wrong on Women in Space," *Houston Post*, Jul 1, 1963, 13.
51 Jim Maloney, 13.
52 Jim Maloney, 13.
53 Hugh Dryden, Letter to Clinton Anderson, Mar 2, 1964.
54 John F. Kennedy, Speech, U. N. General Assembly, New York, NY, Sep 20, 1963.
55 *Pravda*, Nov 2, 1963.
56 *Associated Press, Washington Evening Star*, Oct 5, 1963.
57 Stuart Loory, Article on 1st Annual Meeting of American Institute of Aeronautics and Astronautics, *New York Herald Tribune*, Jun 30, 1964.

58 Article on female astronaut qualifications, Dallas Morning News, May 23, 1964.

59 George Mueller, Speech, Dedication of Cedar Crest College Science Center, Allentown, PA, Oct 19, 1966.

CHAPTER 4 - DESTINATION MOON

Epigraphs

Wernher von Braun, "A Look Into the Next 50 Years," *Chicago Tribune Magazine*, Aug 15, 1965.

Dr. Jesse Greenstein, Speech, "Scientific Progress and Human Values, 75th Anniversary Convocation, Cal Tech, Oct 25, 1966.

Pan American Airways advertising campaign, late 1960s.

1 Edward R. Morrow, Letter to James Webb, Sep 21, 1961.

2 James Webb, Letter to Edward R. Murrow, Oct 1961.

3 Kephra Burns and William Miles, *Black Stars in Orbit: NASA's African American Astronauts*, (New York, WNET-TV), Feb 2, 1990.

4 Kephra Burns and William Miles, *Black Stars in Orbit*.

5 "Negro Trainee Elated Over His Space Role," *The Sunday Star*, Washington, DC, Mar 31, 1963, 5.

6 "Negro Trainee Elated Over His Space Role," 5.

7 "Biased in the Astronaut Corps Denied," *The New York Times*, Jun 3, 1965.

8 Dwight Edwards, Letter to President Lyndon B. Johnson, Sep 30, 1965.

9 Dwight Edwards.

10 "Crash of F-104 Jet Kills First Negro Astronaut," *Washington Evening Star*, Dec 9, 1967.

11 Earl Ubell, Los Angeles Times, Jan 29, 1961.

12 *Review of Space Research: Space Science Summer Study*, National Academy of Sciences (NAS), 1963.

13 *Review of Space Research*.

14 W. Randolph Lovelace II, Speech, "Environmental Problems of Man in Space," Paris, France, Oct 29, 1962.

15 Homer Newell, Speech, American Association for the Advancement of Science, "Scientists Should be in the Next Group of Astronauts," Philadelphia, PA, Dec 26, 1962.

16 James Webb, Speech, 3rd National Conference on Peaceful Uses of Space, Chicago, IL, May 6, 1963.

17 NASA News Release, 63-095, "Astronaut Trainees To Be Selected," Jun 5, 1963.

18 *Space Research: Directions for the Future*, National Academy of Sciences, Space Studies Board, 1964.

19 Neal Stanford, "Two U.S. Doors to Space Career," *Christian Science Monitor*, May 8, 1965, 8.

20 Thomas Wolfe, "Post Orbital Remorse, Part 1, The Brotherhood of the Right Stuff," *Rolling Stone*, Jan 4, 1973.

21 Edwin E. "Buzz" Aldrin Jr. With Wayne Warga, *Return to Earth*, (New York, Random House 1973), 180.

22 *Astronautical And Aeronautical Events Of 1962*, Committee on Science and Astronautics, U.S. House of Representatives, (Washington DC, Government Printing Office, 1963), 127.

23 Phil Bono, "ROMBUS Weight Study," (Huntington Beach, CA, Douglas Aircraft Company, 1963), SM 44532.

24 "For Instant Infantry—Ithacus," *Douglas Progress*, Second Quarter 1964, 20-25.

25 "Passenger Rocket, Ultimate Travel for 80s, *Douglas Apogee*, Vol 1, No. 10, Feb 1964, 2.

26 *Space Daily*, Oct 8, 1964, 206.
27 Recoverable Single Stage Spacecraft Booster, Patent No. 3295790, Jan 3, 1967.
28 *Toward The Endless Frontier: History Of The Committee On Science And Technology, 1959-79*, U.S. House of Representatives, (Washington, DC, Government Printing Office, 1980), 270.
29 Unsolicited Proposal from the Martin Company to NASA, May 26, 1965, 68.
30 Martin Company, 70.
31 Martin Company, 71.
32 Martin Company, 71.
33 Martin Company, 71.
34 Anonymous Telephone Interview with NASA engineer.
35 Nick Tatro, "90,000 Names On Waiting List For Commercial Moon Flight," *The Miami Herald*, Nov 30, 1972.
36 Nick Taro.
37 Morris Furgash, Speech, National Defense Transportation Association Conference, Frankfurt, Germany, Oct 30, 1964, re-printed in *Congressional Record*, Jan 7, 1965, 70-74.
38 Wernher von Braun, "Von Braun: A Look into the Next 50 Years," *Chicago Tribune Magazine*, Aug 15, 1965.
39 Wernher von Braun.
40 Wernher Von Braun.
41 Werhner Von Braun.
42 "Space Shuttle for the Future: The Aerospace Plane," *Rendezvous*, Vol 4, No. 1, Oct 1965, 4.
43 "Dr. Walter Dornberger: Father of Dyna-Soar," *Air Force Magazine*, Oct 1965, 80-88.
44 Walter Dornberger, 80-88.
45 Walter Dornberger, 80-88.
46 William Hines, *Washington Evening Star*, Jun 17, 1965.
47 Alan Ladwig, Interview with Tom Stafford, June 7, 1991.
48 Gemini 8 Mission Transcript, NASA, Mar 17, 1966.
49 Howard Simons, Editorial, "Milestones in Manned Flight Hailed," *The Washington Post*, Dec 16, 1965, A-20.
50 *The New York Times*, Aug 22, 1966, 37.
51 Wesley Kuhrt, Speech, 4th Annual Goddard Memorial Symposium, Washington, DC, Mar 15, 1966.
52 Lorne Proctor, Speech, 4th Annual Goddard Memorial Symposium, Washington, DC, Mar 15, 1966.
53 *Way, Way Out*, Movie Advertisement, *The New York Times*, Oct 26, 1966, 23.
54 Jesse L. Greenstein, Speech at "Scientific Progress and Human Values, 75th Anniversary Convocation, Cal Tech, Oct 25, 1966.
55 Solomon W. Golomb, "The space program—A historical perspective," *Astronautics And Aeronautics,* Nov 1967, 14.
56 William Hines, *Washington Evening Star*, Nov 31, 1966, A12.
57 *Washington Evening Star*, Editorial, Jan 28, 1967, A6.
58 UPI, "The Nation Mourns the Deaths of NASA Apollo Astronauts Grissom, White, and Chaffee."
59 Virgil I. "Gus" Grissom, Gemini: *A Personal Account of Man's Venture Into Space*, (New York, Macmillan Company, May 1968), 184.
60 Joseph Kaselow, "Selling Trips to Moon," *World Journal Tribune*, Feb 10, 1967.
61 Krafft Ehricke, "Space Tourism," Proceedings of American Astronautical Society Congress, Dallas, TX, 1967, 286.

62 Barron Hilton, "Hotels in Space," *Proceedings of American Astronautical Society Congress*, Dallas, TX, 1967, 251.

63 Baron Hilton, 251.

64 William Shelton, *Man's Conquest Of Space*, (Washington, DC, National Geographic Society, 1968), 188.

65 George Mueller, Speech, British Interplanetary Society, London, Aug 10, 1968.

66 William Stafford, *Christian Science Monitor*, Aug 15, 1967.

67 Mathew H. Hersch, *Inventing the American Astronauts*, (London, Palgrave Macmillan, 2012).

68 Arthur C. Clarke Remarks, Press Conference for *2001: A Space Odyssey*, Kubrick Productions/MGM, Los Angeles, CA, Mar 31, 1968.

69 Apollo 8 Mission Transcript, NASA, Dec 24, 1968.

70 Samuel Shenton, Speech, International Flat Earth Society, London, England, Dec 12, 1968.

71 President Lyndon B. Johnson, Phone conversation with Apollo 8 crew, Dec 21, 1968.

72 Article on Pan Am and TWA Moon clubs, *This Week*, Mar 16, 1969, 9-10.

73 Sam Phillips, "A Most Fantastic Voyage," National Geographic, Vol 135, No. 5, May 1969, 613.

74 Elizabeth Zarder, Letter to President Ronald Reagan, Sep 14, 1984.

75 *The New York Times*, May 9, 1969, 16.

76 *Washington Evening Star*, Sep 24, 1969, A16.

77 "NASA Aims for 100-Man Station," *Aviation Week & Space Technology*, Feb 24, 1969, 16.

78 *Astronautics And Aeronautics, 1969 A Chronology on Science, Technology, and Policy* (Washington, DC, NASA-SP-4014, 1970), 187.

79 Apollo 11 Mission Transcript, NASA, Jul 20, 1969.

80 Apollo 11 Pre-Launch Press Conference, NASA, Jul 18, 1969.

81 Norman Mailer, *Of A Fire On The Moon*, (New York, New American Library, 1969), 441.

82 Thomas Paine, Speech, National Space Club, Washington, DC, Aug 6, 1969.

83 Arthur C. Clarke, "Apollo & Beyond," *Look*, July 15, 1969, 43.

84 Article on Pan Am First Moon Flights Club, *Washington Evening Star*, Jul 23, 1969, A-7.

85 Article on TWA Moon club, *Astronautics And Aeronautics* 1969, 244.

86 Linda Scarbrough, "Planetarium Loses Moon List," *New York News*, Jul 13, 1969.

87 Article on science astronauts, *The New York Times*, Aug 17, 1969, D2.

88 Victor Cohn, "13 Scientists Cut From Moon Trips, *The Washington Post*, Aug 21, 1969, A1.

89 Victor Cohn, "Cutting Trips to the Moon Opposed," *The Washington Post*, Dec 28, 1969, A27.

90 *Science*, Aug 1969.

91 *The New York Times*, Sep 10, 1970, 54.

92 Editorial, *Washington Star*, Aug 19, 1971.

93 Edwin E. "Buzz" Aldrin, Jr. with Wayne Warga, 247.

94 Earl Hubbard, *The Search Is On*, (Los Angeles, Pace Publications, 1969), 134.

95 Earl Hubbard, 164.

96 Krafft Ehricke, "The Extraterrestrial Imperative," *New Worlds*, Vol. 2, No. 2, Feb 1972, 13-23. Originally published in *Bulletin of the Atomic Scientists*, Vol 27, Sep 1971, 18-26.

CHAPTER 5 - OUR SHIP IS IN
Epigraphs
> The *Post-Apollo Space Program Directions for the Future*, (Washington, DC, NASA Historical Reference Collection, NASA Headquarters, Sep 1969), 15.
>
> Executive Office of the President, Weekly Compilation of Presidential Documents, Space Shuttle Program, Jan 5, 1972, 27.
>
> Tom O'Toole, "New Era Ahead in the Space-Age, *The Washington Post*, Tom O'Toole, Mar 24, 1974, C1.

1 *The Post-Apollo Space Program: Directions for the Future*, NASA Historical Reference Collection, History Office, NASA Headquarters, Washington, D.C., Sep 1969, 15.
2 J.S. Butz, "Space Shuttle," *Air Force And Space Digest*, Dec 1969, 37-44.
3 *Space Daily*, Jan 31, 1969, 86.
4 *Space Daily*, 86.
5 *Space Daily*, 86.
6 *Associated Press*, "First Anniversary of Apollo 11," Jul 19, 1970.
7 *Toward The Endless Frontier: History Of The Committee On Science And Technology: 1959-79*, (Washington, DC, U.S. Government Printing Office, 1980), 272.
8 Howard Cannon, "Liftoff to Economy: The Space Shuttle," Aerospace, Vol. 9, No. 3, Jul 1971, 4.
9 "Space Shuttle: Investment in the Future," *Aerospace*, Vol. 10, No. 2, Apr 1972, 2.
10 Howard Cannon, 2.
11 Transcript, U.S. Congress, Senate Committee on Aeronautics and Space Science, FY 1973 NASA Authorization Hearings, Washington, DC, Apr 12, 1972.
12 Senate Committee on Aeronautics and Space Science, FY 1973 NASA Authorization Hearings.
13 Hugh Downs, Letter to James C. Fletcher, Mar 25, 1971.
14 George Low, Letter to Hugh Downs, Apr 5, 1971.
15 Executive Office of the President, Weekly Compilation of Presidential Documents, Space Shuttle Program, Jan 5, 1972, 27.
16 President Richard M. Nixon's Announcement on the Space Shuttle, Jan 5, 1972, //history.nasa.gov/stsnixon.htm
17 George Low, Memorandum for Record, Jan 12, 1972.
18 "Space shuttle flight becoming routine for average citizens," Editorial, *St. Louis Globe-Democrat*, Jan 12, 1972.
19 "Routine space shuttle flights," Editorial, *Milwaukee Journal*, Jan 7, 1972.
20 James C. Fletcher, Quote on routine space shuttle flights, *U.S. News & World Report*, May 8, 1972.
21 *Washington Daily News*, Mar 28, 1972, 27.
22 Wernher von Braun, Letter to Mahinder Uberoi, Apr 20, 1971.
23 "Space Shuttle Supplement," *Washington Evening Star*, Sep 6, 1971, A3.
24 Wernher von Braun, "The Future of Space Exploration," *The Goddard Library Log*, Nov 11, 1972. 8.
25 *Astronautics And Aeronautics*, 1972, Chronology of Science, Technology and Policy, (Washington, DC 1974, NASA SP-4017), 6.
26 William Hines, *Chicago Sun Times*, Jan 12, 1972, 16.
27 Brian O'Leary, "Pie in the Sky," Op-Ed, *The New York Times*, Jun 5, 1973, 41.
28 Nick Tatro, "90,000 Names on Waiting List for Commercial Moon Flight," *Miami Herald*, Nov 30, 1972.
29 Najeeb Halaby, Speech, "A Commercial Airline Looks at the Space Shuttle," Society of Experimental Test Pilots, Los Angeles, CA, Sep 16, 1971.
30 U.S. House of Representatives, House Resolution 979, May 11, 1972.

31 "Historical Recap of the Committee For The Future, Inc.," (Washington, DC, Committee For the Future, Jan 1975).
32 *Los Angeles Times*, Sep 21, 1972.
33 *The New York Times*, May 13, 1975. See also Space Settlements: A Design Study, Edited by Richard Johnson and Charles Holbrow, (Washington, DC, NASA SP-413, 1977), and John Billingham and Brian O'Leary, Editors, Space Resources And Space Settlements, (Washington, DC, NASA-SP-428, 1979).
34 Thomas Paine, *For All Mankind*, 292-93. I have this quote on a note card, with this reference, but not sure if it was a book or magazine article.
35 Editorial, "Squabbling Congressmen on Shuttle Launch Site," *Wall Street Journal*, Dec 8, 1970, 39.
36 Daily Oklahoman, Jan 6, 1971, 1.
37 *Wall Street Journal*, Dec 8, 1970, 39.
38 NASA News Release, 72-83, "Space Shuttle Operations Site Selected," Apr 14, 1972.
39 Article on available flights for astronauts, *The New York Times*, May 28, 1972, 1.
40 Brad Munson, "Come Down From the Moon," *The New York Times Magazine*, Dec 3, 1972, 37.
41 Brad Munson, 37.
42 Paul Recer, article on astronaut wives, *Washington Evening Star, Women's World*, Apr 18, 1972, C1
43 Howard Munson, 37.
44 Howard Munson, 37.
45 James C. Fletcher Remarks, Advisory Committee on the Future of the U.S. Space Program (The Augustine Committee), Oct 26, 1990.
46 Nancy L. Brun and Eleanor H. Ritchie, Editors, *Astronautics And Aeronautics, 1975, A Chronology*, (Washington, DC, NASA SP-4020, 1979), 42.
47 *UNESCO* magazine article, Quoted in *The New York Times*, Apr 4, 1970, 20.
48 *The New York Times*, 20.
49 Paul W. Valentine, "2 Soviet Cosmonauts Are in City on Goodwill Tour," *The Washington Post*, Oct 20, 1970, A2.
50 Reuters News Service, Article in *The Baltimore Sun*, Jan 12, 1972, A2.
51 "Human Factors in Long Duration Spaceflight," (Washington, DC, National Academy of Sciences, Space Studies Board, 1972), 91.
52 Joan McCullough, "The 13 Who Were Left Behind," *MS*, Sep 1973, 47.
53 Walter Cunningham, The All-American Boys, (New York, Macmillan Publishing, 1977), 261.
54 Walter Cunningham, 261
55 Walter Cunningham, 262.
56 *Washington Star & Evening News*, Jan 29, 1973, A3.
57 Reported in Express Wieczorny (Warsaw, Poland), noted in *Washington Star & Evening News*, Feb 23, 1973. A3.
58 Claire Booth Luce, "She Orbits Over the Sex Barrier," *Life*, Vol. 54, No. 26, Jun 28, 1963, 28.
59 Article on Russian female cosmonauts, *Parade*, Aug 1, 1976.
60 Paul Recer, *Elgin Daily Courier News*, Jun 12, 1983, 6.
61 Paul Recer, 6.
62 Dr. David L. Winter, NASA Director for Life Sciences, NASA Press Briefing, NASA Headquarters, Washington, DC, Feb 21, 1976.
63 Dr. David Winter.
64 NASA News Release, 76-044, "NASA to Recruit Space Shuttle Astronauts," Jul 8, 1976.

CHAPTER 6 - NEW KIDS ON THE BLOCK

Epigraphs

William Bainbridge, *The Space Flight Revolution*, (New York: Wiley, 1976), 14.

William Hines, *Washington Star*, Sep 19, 1976.

James Mitchner, Response to Public Comment opportunity for Citizen in Space Program, Jan 24, 1983.

1 George Low, Memorandum to John Yardley, Nov 5, 1975.

2 George Low.

3 John Yardley, Memorandum to George Low, Dec 1, 1975.

4 Phil Culbertson, Presentation to George Low, Mar 24, 1976.

5 Phil Culbertson.

6 George Low, Memorandum to James C. Fletcher, Mar 24, 1976.

7 George Low.

8 Ann Bradley, Record of Meeting between George Low and Phil Culbertson, Mar 24, 1976.

9 George Low.

10 *KSC Spaceport News*, Kennedy Space Center, Jul 24, 1975, 6.

11 George Low.

12 *Outlook For Space, Report to the Administrator by the Outlook for Space Study Group*, (Washington, DC, NASA-SP-386, 1976), iv.

13 *Outlook for Space*, 180-81.

14 Ken Weaver, Letter to James Fletcher, Mar 24, 1976.

15 James Fletcher, Handwritten Letter to Ken Weaver, Mar 24, 1976.

16 James Fletcher's hand written note on Ken Weaver's incoming letter and retyped on a Buck Slip, Mar 16, 1976.

17 Robert Shafer, Memorandum to Associate Administrator for External Affairs, Apr 13, 1976.

18 David Garrett, Memorandum to Robert Shafer, Apr 2, 1976.

19 David Garrett.

20 David Garrett, Buck Slip to Robert Shafer, Apr 2, 1976.

21 Rusty Schweickart, Memorandum to George Low, Apr 20, 1976.

22 Rusty Schweickart.

23 National Aeronautics and Space Act of 1958, As Amended, and Related Legislation, Sec. 203. (a) (3).

24 John Hammersmith, "Unique Personality for Space Shuttle OFT Flights: Preliminary Report," NASA Headquarters, Jun 8, 1976.

25 John Hammersmith.

26 John Hammersmith.

27 John Hammersmith.

28 John Hammersmith.

29 John Hammersmith, Memorandum to Bill Land, undated.

30 David Garrett, Memorandum to Robert Shafer, Jun 28, 1976.

31 William O'Donnell, Memorandum to Chief of Payload Accommodations, Space Shuttle Program, Jul 12, 1976.

32 Robert Shafer, Memorandum to Herbert Rowe, Jun 6, 1976.

33 Briefing charts, "Non-Astronaut Flight Participation in OFT: Report of Ad Hoc Study Team," July 1976.

34 James Boswell Letter to James Martin, Jul 22, 1976.

35 Stuart Oken and Jason Brett, Letter to Robert Newman, Sep 12, 1976.

36 Robert Newman, Letter to Stuart Oken and Jason Brett, Sep 29, 1976.

37 President Gerald R. Ford, Decision Memo, Sep 8, 1976.

38 Senator Goldwater, Remarks quoted in *Astronautics And Aeronautics*, 1976, A Chronology, Eleanor H. Ritchie, ed, (Washington, DC, NASA, SP-4021, 1984), 222.

39 James C. Fletcher, Speech, Enterprise Rollout Ceremony, Sep 17, 1976.

40 Senator Frank Moss, Letter to James Fletcher, Sep 1976.

41 James C. Fletcher, Letter to Senator Frank Moss, Sep 1976.

42 Tom Rogers, Letter to James C. Fletcher, Sep 24, 1976.

43 Tom Rogers.

44 Tom Rogers.

45 James C. Fletcher, Letter to Tom Rogers, Nov 16, 1976.

46 Howard Benedict, "Spaceplane Era," *Huntsville Times*, Aug 31, 1977.

47 James C. Fletcher, Letter to Ernest Gann, Feb 22, 1977.

48 Louise Lange, "Space Migration: The True High," *Washington Star*, Jan 25, 1977, D-3.

49 Louise Lange.

50 John Noble Wilford, "Shuttling Into Space," *The New York Times Magazine*, Aug 8, 1977, 24.

51 Article on space shuttle cost per pound, *Nature*, April 7, 1977, 489.

52 Article on possible merger of NASA with DOD, *Science*, Jun 17, 1977, 1301.

53 Richard D. Lyons, "US Space Program Lags Because of Interest and Money," *The New York Times*, Apr 13, 1977, D10.

54 Mark Tohey, "Space Shuttle Given A-Ok," *The Clear Lake News Citizen*, Apr 8, 1977.

55 "Shuttle on Track," *Cocoa Today*, Feb 24, 1977.

56 Wernher von Braun Letter to prospective board members for National Space Institute, Jul 15, 1975.

57 Promotional Membership Brochure, National Space Institute, 1977.

58 Transcript, NBC *Tomorrow* television program, Aug 7, 1975.

59 Wernher von Braun Obituary, *The Washington Post*, Jun 18, 1977, A7.

60 NASA News Release, 76-044, "NASA To Recruit Space Shuttle Astronauts," Jul 8, 1976.

61 "At Hand: Revolution in Space Travel," *U.S. News & World Report*, Aug 8, 1977.

62 John Noble Wilford, "Another Small Step for Man," *The New York Times*, Aug 7, 1977, 24.

63 Isaac Asimov, "The Next Frontier?" *National Geographic*, Vol. 150, No. 1, Jul 1976, 76.

64 Michael Gold, "The Second Space Age," The Record, Aug 8, 1977.

65 Walter Barney, "A-Ok: Space Shuttle Sets Down Perfectly," *San Francisco Examiner*, Aug 12, 1977.

66 "Flight of the Enterprise," Editorial, *The Washington Post*, Aug 13, 1977.

67 "Beautiful Drop for a New Bird," *Time*, Aug 22, 1977.

68 Karl Kristofferson, "Come Ride the Shuttle," *Reader's Digest*, Jun 1977, 46.

69 Robert Beason, "We Visit the Space Shuttle," *Mechanix Illiustrated*, Sep 1977.

70 Roone Arledge, Letter to Robert Frosch, Sep 13, 1977.

71 William Brown and Herman Kahn, "Long-Term Prospects For Developments In Space (A Scenario Approach)," prepared for NASA under contract NASW-2924, by Hudson Institute, Croton-On-Hudson, New York, Oct 30, 1977, NASA-CR-156837, 124.

72 Alan Ladwig, "Master Magician Arthur C. Clarke: A Guide to the Future," *FASST Tracks*, Vol. 2, No. 3, Nov 1977, 1.

73 Alan Ladwig, 1.

74 NASA Brochure, "The Role of the Payload Specialist in the Space Transportation System for NASA or NASA-Related Payloads," n.d.

75 NASA Brochure.

76 NASA Brochure.
77 NASA Brochure.
78 *Houston Post*, Mar 13, 1978, 3A
79 *Houston Post*, 3A
80 Alan Brown, "People Came, They Saw, They Enjoyed," *Daily Gazette*, Aug 12, 1977.
81 Draft, "Public Affairs Plan for News Media Participation on Space Shuttle Flights," July 14, 1977.
82 Draft, NASA Management Instruction, "Passenger Flight on Space Shuttle," May 19, 1978.
83 Dick Baumbach, "Shuttle May Take Tourists to Orbit," *Cocoa Today*, Oct 29, 1978, E3.
84 Dick Baumbach, E3.
85 Article on near accident on Russian Salyut 6 spacecraft, *Washington Star*, Jun 28, 1978, A4.

CHAPTER 7 - WE'RE GOING TO THE STARS

Epigraphs

John Young, NASA Press STS-1 Post Landing Press Conference, 1981
NASA Citizen in Space Task Force, 1983
Stewart Brand, Quoted by John Carey, "No Joy Riding Allowed," *Newsweek*, Jun 13, 1983, 40
1 Richard C. Levy, "Everybody is Lining up for Space," *Parade*, Dec 30, 1979, 4.
2 Richard Levy, 4.
3 Richard Levy, 5.
4 NASA News Release 80-2, "NASA Not Taking Passenger Reservations For Shuttle," Jan 8, 1980.
5 *Washington Evening Star*, Jul 8, 1980, A2. Cited in *Astronautics And Astronautics, 1979-1984*, A Chronology, Edited by Bette R. Jansen and Eleanor H. Ritchie, (Washington, DC, 1990, NASA SP-4024, 1990), 180.
6 "China Says It's Training Astronauts for Space Travel," *The Washington Post*, Jan 13, 1980, A16.
7 *Cocoa Today*, Mar 14, 1980, 16A.
8 Tom O'Toole, "NASA Gives Power to Spaceship Captains," *The Washington Post*, Mar 18, 1980, A8.
9 Tom O'Toole, A8.
10 Tom O'Toole, "White House Running Out of Patience with the Space Shuttle," *The Washington Post*, Jun 13, 1980, A2.
11 William Gregory, "Floating in Space," *Aviation Week & Space Technology*, Aug 4, 1980, 11.
12 William Gregory, 11.
13 Jim Schefter, Letter to Robert Newman, Aviation/Space Writers Association, Unsolicited Proposal, Apr 28, 1978.
14 David Garrett, Letter to Jim Schefter, Nov 18, 1980.
15 Roger Rosenblatt, "Aiming High in '81," *Time*, Jan 12, 1981.
16 James Schefter, "The Space Shuttle: High Stakes for the Future," *Washington Star*, Mar 25, 1981, A-6.
17 STS-1 Post-Flight Press Conference, Apr 14, 1981.
18 Andy Lipman, "Shuttle Developers Say I Told You So," *Huntsville Times*, Apr 13, 1981.
19 "Columbia's Perfect Flight," Editorial, *The Washington Post*, Apr 15, 1981. A22
20 Jon Van and Ronald Kotulak, "I Don't Think Any of Us Realize What We've Got in Our Hands," *Chicago Tribune*, Apr 15, 1981.
21 "Touchdown, Columbia," *Time*, Apr 27, 1981, 23.
22 Andrew Pollack, "Benefits Won by Columbia," *The New York Times*, Apr 16, 1981.

23 *Astronautics And Astronautics* 1979-1984, A Chronology, 309.

24 James Beggs, Interview with Alan Ladwig, Oct 17, 1989.

25 James Beggs.

26 Sanford N. McDonnell, Letter to James Beggs, Jul 9, 1985.

27 James Beggs.

28 James Beggs, Letter to Daniel Fink, Feb 25, 1982.

29 "Success of space shuttle's Orbital Flight Tests," Editorial, *San Diego Union*, Jul 7, 1982, B6.

30 *Astronautics And Aeronautics, 1979-1984, A Chronology*, 354.

31 Carl Praktish, Interview with Alan Ladwig, Jan 1991.

32 John Naugle Letter to Opinion Leaders, Dec 9, 1982.

33 T. Keith Glennan, Letter to Carl Praktish, undated.

34 Robert Frosch, Letter to John Naugle, Dec 17, 1982.

35 Robert Frosh.

36 Freeman Dyson, Letter to Carl Praktish, Dec 13, 1982.

37 Thor Heyerdahl, Letter to Carl Praktish, Mar 16, 1983.

38 Norman Mailer, Letter to Carl Praktish, Dec 20, 1982.

39 Norman Mailer, *Of A Fire On The Moon*, (New York, New American Library, 1969), 148.

40 Dennis Flannigan, Letter to Carl Praktish, Dec 22, 1982.

41 William Anders, Letter to Carl Praktish, Dec 27, 1982.

42 Riccardo Giacconi, Letter to Carl Praktish, Jan 18, 1983.

43 Melvin Kranzberg, Letter to Carl Praktish, Jan 6, 1983.

44 Joseph Gavin, Letter to Carl Praktish, Jan 12, 1983.

45 Arthur Kantrowitz, Letter to Carl Praktish, Feb 3, 1983.

46 Freeman Dyson.

47 T. K. Glennan.

48 Richard Lesher, Letter to Carl Praktish, Jan 11, 1983.

49 George Feld Letter, to Carl Praktish, Jan 3, 1983.

50 John Noble Wilford, Letter to Carl Praktish, Jan 14, 1983.

51 Carl Praktish.

52 James Michener, Letter to John Naugle, Jan 24, 1983.

53 Barbara Hubbard, Letter to John Naugle, Mar 11, 1983.

54 Barbara Hubbard.

55 Robert Strauss Letter to Carl Praktish, Jan 7, 1983.

56 Meg Greenfield, Letter to Carl Praktish, Dec 12, 1982.

57 Leonard David, Letter to Daniel J. Fink, Mar 29, 1982

58 Leonard David, "Make Way for Private Citizens in Space," *Space World*, Jan 1983, 4.

59 "Space Shuttle Passenger Project Design Study," Space Age Review Foundation, Apr 1983, 10.

60 Clifford Cunningham, "Civilian space travel is nearing reality," *The Record*, Feb 22, 1983.

61 Clifford Cunningham.

62 "Informal Task Force Report for the Study of Issues in Selecting Private Citizens for Space Shuttle Flight," NASA Advisory Council, Jun 21, 1983.

63 Informal Task Force Report.

64 Informal Task Force Report.

65 Informal Task Force Report.

66 National Aeronautics and Space Act of 1958, As Amended, and Related Legislation, Sec. 203. (a) (3).

67 Bruce Mazlish, "Following the Sun," *The Wilson Quarterly*, Vol 4, No. 4 (Autumn 1980), 91.

68 Robert Sherrod, "The Selling of the Astronauts," *Columbia Journalism Review*, May-June 1973, 17- 25.

69 James Michener.

70 Thomas Tully, *The Evansville Press*, Dec 1983.

71 Allen, Joe and Martin, Russell, *Entering Space: An Astronaut's Journey*, (New York, Stewart, Tabori and Chang, 1985)

72 Noelle Wyckoff, "An English Teacher on the Space Shuttle," 1985.

73 Berkley Breathed, *Bloom County*, June 2, 1983.

74 R. Emmett Tyrell, Jr., "Flinty Americans," *The Washington Post*, Apr 20, 1985, A15.

75 STS-7 Post-Flight Press Conference and *Newsweek*, Apr 24, 1983

76 Anna Fisher, Quote from *Women in Space, Time-Life Video*, ~1978.

77 "Excerpts From News Conference with Crew of Challenger," *The New York Times*, Sep 4, 1983, 36.

78 Dan Brandenstein, Interview with Alan Ladwig, Mar 1990.

79 "The Citizen Astronaut," *The New York Times*, Sep 7, 1983, A22.

80 *Astronautics And Aeronautics, 1979-1984, A Chronology*, Oct 13, 1983, 441.

81 *The Washington Post*, Oct 13, 1983, A15.

82 James Beggs, Letter to Senator Edwin "Jake" Garn, Oct 7, 1982.

83 Chet Lee, Interview with Alan Ladwig, Jan 1991.

84 *Astronautics And Aeronautics, 1979-1984, A Chronology*, Dec 3, 1982, 383. Also in *The Washington Post*, Dec 3, 1982, A1.

85 *Astronautics And Aeronautics, 1979-1984, A Chronology*, 383.

86 Lt. Gen. James A. Abrahamson, Memorandum and Background Paper to James Beggs, Dec 5, 1982.

87 Lt. Gen. James A. Abrahamson.

88 James Beggs, Letter to George Schultz, undated, ~ Dec 6, 1982.

89 Mark Nolan, Memorandum to Lt. Gen. James A. Abrahamson, May 17, 1983.

90 Robert Allnutt, Memorandum for Record, Mar 28, 1983.

91 *Astronautics And Aeronautics, 1979-1984, A Chronology*, Dec 19, 1983, 453. Also in *The Washington Post*, Dec 20, 1983, A4.

92 Henry Clements, Letter to Robert F. Allnutt, Apr 19, 1983.

93 James Beggs, Letter to NASA Employees, Sep 1983.

94 "What Happens Next to the Shuttle?" Government Executive, Oct 1983, 6.

95 "Study of Effective Shuttle Utilization," NASA Advisory Council, Nov 17, 1983.

96 NASA Advisory Council.

97 Dean Jordon Taylor, Letter to James Beggs, Jul 9, 1982.

98 Dean Taylor.

99 James Beggs, Letter to Paul G. Dembling, Aug 22, 1983.

100 James Beggs.

CHAPTER 8 - TEACHERS GO TO THE HEAD OF THE CLASS

Epigraphs

 James Beggs, Remarks, Teacher in Space Press Conference, NASA Headquarters, Aug 27, 1984.

 Ernest Boyer, *Education Daily*, Jul 15, 1985, 3.

 Folencio Ortiz, Letter to James Beggs, Mar 7, 1985.

1 Jay Barbree, Letter to James Beggs, Jan 12, 1984.

2 Michael C. Goodman, Letter to NASA, Code ME, undated.

2 Michael Chabal, Letter to NASA, Code ME, Feb 11, 1984.

4 NASA Working Group on Education, "New Initiatives for 1986 and Beyond," Office of Education, NASA Headquarters, Jan 1984.

5 Steven Giegerich, "You may be the next astronaut," *Ashbury Park Press*, Apr 4,

1984, C1.

6 Phil Culbertson, Memorandum to James Beggs, Apr 4,1984.

7 Howard Rosenberg, "NASA's Travel Agent: Want to Fly With Him?" *Family Weekly*, Aug 12, 1984, 7.

8 Phil Culbertson Memorandum to James Beggs, Jun 11, 1984.

9 James Beggs, Interview with Alan Ladwig, Oct 17, 1989.

10 Ronald Reagan Speech, Ceremony for Excellence in Education 1982-83, Washington, DC, Aug 27, 1984.

11 Ronald Reagan.

12 James Beggs, Remarks, Teacher in Space Press Conference, NASA Headquarters, Aug 27, 1984.

13 Alan Ladwig, Remarks, Teacher in Space Press Conference, NASA Kennedy Space Center, Aug 28. 1984.

14 Charlie Walker, Letter to CO-Evolutionary Quarterly, "Space Colonies," *Special Edition*, Edited by Stewart Brand, Sep 1977, 43.

15 J. R. Sirkin, "Teacher in Space: A Strategy to Widen NASA's Civilian Support," *Education Week*, Feb 5, 1986, 9-10.

16 J.R. Sirkin, 9-10.

17 "Reagan rediscovers classrooms," Editorial, *The Boston Globe*, Sep 4, 1984.

18 Terry Hashu, Letter to NASA, Aug 28, 1984.

19 Peter Sudimack, Letter to NASA, Aug 28, 1984.

20 Robert Stephens, Letter to President Reagan, Nov 26, 1984.

21 "Teacher Aloft," Editorial, *Elkhart Truth*, Aug 28, 1984.

22 *Elkhart Truth*.

23 Russell Baker, "Heaven's Not for Teachers," *The New York Times*, Sep 2, 1984.

24 Joseph Kraft, "A Teacher in Space," *The Washington Post*, Aug 30, 1984.

25 James Beggs, Interview with Alan Ladwig, Oct 17, 1989.

26 Barbara Zigli and Peter Johnson, "Space riders add diversity, eloquence," *USA Today*, Nov 13, 1984, A1.

27 Toni Harrell, Letter to NASA, Aug 28, 1984.

28 Tony Tsao, Letter to NASA, Aug 28, 1984.

29 Heather Hardin, Letter to NASA, Aug 28, 1984.

30 Tiffany Campbell, Letter to NASA, Oct 1, 1984.

31 Jay Carlson, Letter to NASA, Oct 1, 1984.

32 "Teachers Aim High at Space Camp," *The New York Times*, Oct 29, 1984, A10.

33 Richard C. Levy, "Everybody is Lining up for Space," *Parade*, Dec 30, 1979.

34 Robby Benson, Letter to James Beggs, Nov 14, 1985.

35 Jim Davis, Call to Alan Ladwig, Oct 25, 1984.

36 Jann S. Wenner, Letter to Russell Ritchie, Jan 23 1985.

37 Barbara Rowes, "Flight of the Stars," *Omni*, Aug 1982, 62.

38 George Lucas, Letter to William O'Donnell, Jun 28, 1984.

39 Alan Ladwig, Letter to George Lucas, Mar 13, 1985.

40 John Denver, Letter to James Beggs, Sep 1, 1982.

41 James Beggs, Letter to John Denver, Sep 30, 1982.

42 John Denver, Letter to James Beggs, May 10, 1984.

43 James Beggs, Letter to John Denver, Jun 8, 1984.

44 James Beggs, Interview.

45 Entry in Alan Ladwig's personal office notebook, Apr 26, 1984.

46 "Nurses are eager to spend time in space," *RN Magazine*, Nov 1985.

47 *RN Magazine*, January 1985, 6.

48 Alan Ladwig, Letter to *RN Magazine*, Feb 28, 1986.

49 Hearings, Senate Subcommittee on Appropriations for Department of Housing and Urban Development-Independent Agencies, Appropriation for Fiscal Year 1981, May 12, 1982, 1204.

50 Philip M. Boffey, "A Space Inspection," *The New York Times*, Nov 9, 1984.

51 Hearings, Senate Subcommittee on Appropriations for Department of Housing and Urban Development-Independent Agencies, Appropriation for Fiscal Year 1985, Mar 29, 1984, 1088.

52 Gordon White, Letter to NASA, Sep 13, 1984.

53 James Beggs, Letter to Senator Edwin Garn, Nov 7, 1984.

54 Senator Edwin Garn, Letter to James Beggs, Nov 7, 1984.

55 "The Ultimate Junket," Editorial, *The New York Times*, Nov 9, 1984.

56 "Shabby Shakedown," Editorial, *The Baltimore Sun*, Nov 11, 1984.

57 Don Fuqua, Letter to James Beggs, Nov 21, 1984.

58 Don Fuqua.

59 Maudella Peterson, Letter to Senator Orin Hatch, Nov 11, 1984.

60 Congressman Larry Hopkins, Letter to James Beggs, Nov 14, 1984.

61 Senator Barry Goldwater, Letter to *Washington Times*, Mar 20, 1985, 7A.

62 Article about Senator Garn's "management" responsibilities, *Associated Press*, Nov 9, 1984.

63 David Kelly, Letter to NASA, Sep 6, 1984.

64 Dr. William Pierce, Speech, Teacher in Space National Awards Conference, Jun 22, 1985.

65 James Beggs, Speech, Teacher in Space National Awards Conference, Jun 22, 1985.

66 President Ronald Reagan's, Speech, White House Teacher in Space Reception, Jun 23, 1985.

67 Ann Bradley, Speech, Teacher in Space National Awards Conference, Jun 26, 1985.

68 Lyle Hamilton, Letter to Alan Ladwig, Sep 3, 1985.

69 James Beggs, Speech, White House Teacher in Space Ceremony, Jul 19, 1985.

70 Ann Bradley, Interview with M. H., NASA Oral History Program. May 25, 1988.

71 Ann Bradley.

72 James Beggs.

73 Vice President George Bush, Speech, White House Teacher in Space Ceremony, Jul 19, 1985.

74 The White House ceremony: www.youtube.com/watch?v=04V8FNCJX0g&t=16s.

75 Christa McAuliffe, Letter to Alan Ladwig, Dec 5, 1985.

CHAPTER 9 - JUNKETS, BYLINES, AND ARTISTS IN SPACE
Epigraphs

Alcestis R. Oberg, "NASA bumps Hughes engineer so Nelson can 'play astronaut,'" *Florida Today*, Oct 24, 1985.

Oriana Fallaci quoted by Michael Olesker, "Journalist Too Wimpy for Space Travel," *RTNDA Communicator*, Dec 1985.

"Sky and Space Arts Manifesto," The Sky Art Conference, MIT, Sep 29 to Oct 3, 1986.

1 Steve Gerstel, "Garn's journey into space," *The Washington Times*, Feb 27, 1985, 2C.

2 *The New York Times*, Editorial, Apr 20, 1985.

3 Representative Bill Nelson, Letter to James Beggs, Jul 11, 1983.

4 James Beggs, Letter to Representative Bill Nelson, Aug 5, 1983.

5 Response to Query, NASA Office of Public Affairs, Nov 1985.

6 Alcestis R. Oberg, "NASA bumps Hughes engineer so Nelson can 'play astronaut,'" *Florida Today*, Oct 24, 1985.

7 E.C. Aldridge Jr., Memorandum to Verne Orr, Sep 20, 1984.

8 E.C. Aldridge Jr.

9 General Lawrence A. Skantze, Letter to James Beggs, Apr 3, 1985.

10 E. C. Aldridge Jr. , Letter to James Beggs, May 2, 1985.

11 James Beggs, Letter to General Lawrence A. Skantze, May 29, 1985.

12 "Is Nancy next?" Editorial, *Houston Post*, Sep 13, 1985.

13 Jim Schefter, Letter to Frank Johnson, Jan 31, 1985.

14 Frank Johnson, Memorandum to Ann Bradley, Jul 2, 1985.

15 Mark Brender, Letter to Frank Johnson, Jul 24, 1985.

16 Alan Ladwig, Memorandum to Space Flight Participant Evaluation Committee, Oct 18, 1985.

17 Alan Ladwig, Memorandum through Ann Bradley to James Beggs, Oct 17, 1985.

18 James Beggs, Remarks, Journalist in Space Press Conference, NASA Headquarters, Washington, DC, Oct 24, 1985.

19 James Beggs.

20 Harrison Schmitt, Letter to James Beggs, Nov 1, 1985.

21 Eugene Cernan, Letter to James Beggs, Nov 8, 1985.

22 Ann Bradley, Letter to Eugene Cernan, Dec 20, 1985.

23 "Picking a Reporter for the Space Beat," *Time*, Jan 27, 1986.

24 Dave "Bucko" Barry, Letter to Association of Schools of Journalism and Mass Communications, Nov 7, 1985.

25 "Call for space flight," *Editor & Publisher*, Dec 21,1985.

26 *Editor & Publisher*.

27 James Reston Jr., Letter to Nathaniel Cohen, Feb 3. 1984.

28 Timothy R. Gaffney, Letter to Eric Johnson, Jan 10, 1986.

29 Mark Brender, Memorandum For Record, Jul 24, 1985.

30 Jamie Murphy, "Dateline: Aboard the Shuttle," *Time*, Jan 27, 1986, 58.

31 Kalen Henderson, Letter to Association of Schools of Journalism and Mass Communication, Jan 17, 1986.

32 Dave Bussen, Letter to James Beggs, Nov 27, 1985.

33 Richard K. Culbertson, Letter to Senator John Warner, Jan 15, 1986.

34 Dr. Philip Morrison remarks, "1-D, 2-D, 3-D, 4-D," Sky Art Conference 1983, MIT, Center for Advanced Visual Studies, Sep 24-27, 1983.

35 Robert Jarvik, Letter to Ronald Reagan, Apr 16, 1986.

36 James Fox, "William Burroughs: Return of the Invisible Man," *Rolling Stone*, Oct 23, 1986.

37 James Fox.

38 James Fox

39 Hannah Hotovy, "NASA and Art: A Collaboration Colored with History," Apr 18, 2017, www.universal-sci.com/headlines/2017/4/18/nasa-and-art-a-collaboration-colored-with-history.

40 For the definitive history of the NASA Art Program and examples of the works in the NASA collection, see James Dean and Bertrum Ulrich, *NASA/Art: 50 Years of Exploration*, (New York, Abrams, 2008).

41 Ann Marie Martin, "Space Age artistry: NASA's art program head sees limitless possibilities," *Huntsville Times*, Feb 2, 1989.

42 Mort Kunstler, Letter to Dr. Robert Frosh, Mar 24, 1980.

43 Gene Marianetti, Letter to Mort Kunstler, n.d

44 Mort Kunstler, Letter to James Beggs, 1983.

45 Chris Robinson, Letter to George Abbey, Jan 18, 1984.

46 Roger Ressmeyer, Letter to James Beggs, Jun 6, 1984.

47 Dianne Feinstein, Letter to Frank Johnson, May 23, 1984.

48 Robert Van Kay, Letter to President Ronald Reagan, Jun 13, 1984.

49 Robert A. M. Stephens, Letter to President Ronald Reagan, Nov 26, 1984.
50 Robert McCall, Call to Alan Ladwig, May 5, 1985.
51 Chet Jezierski, "The Artist As Mission Specialist, A Proposal to the National Aeronautics and Space Administration," 1984.
52 Jesse Moore, Letter to Chet Jezierski, Aug 14, 1985
53 Chet Jezierski, Letter to Jesse Moore, Sep 4, 1985.
54 Chet Jezierski, Letter to Alan Ladwig, Sep 20, 1985.
55 Chet Jezierski.
56 Chet Jezeirski, Letter to Alan Ladwig, Oct 22, 1985.
57 Chet Jezierski.
58 Alan Ladwig, Call to Murray Welsh, Jun 18, 1985.

CHAPTER 10 – CHALLENGER AND ITS TESTAMENT
Epigraphs
> Christa McAuliffe, Teacher in Space Application, Jan 1985.
> Jack Presbury, "Icarus," sent to Alan Ladwig, Feb 1986.
> Dave Alonso, personal conversation, 1986. Dave admits he may have heard this somewhere, but he's the one that implanted it in my mind.

1 Christa McAuliffe's Teacher in Space Application, Jan 1985.
2 "Christa's Challenge: A Student's Guide to the Space Shuttle," *Concord Monitor Special Supplement*, Jan 1986.
3 John Noble Wilford, "A Teacher Trains For Outer Space," *The New York Times Magazine*, Jan 5, 1986, 16-22.
4 Maria Goodvage, "Welcome Aboard the Starship Private Enterprise," *News/Sun-Sentinel* Sunday Supplement, Ft. Lauderdale, FL, Jun 18, 1986, 16.
5 Maria Goodvage, 18.
6 Maria Goodvage, 18.
7 Anita Baker, "The Sky is not the limit on space-oriented travel plans," *Chicago Tribune*, Jan 11, 1986.
8 Ronald Reagan, Proposed comments for State of Union, Jan 28, 1986.
9 STS 51-L Mission Transcript, Jan 28, 1986.
10 *Report of the Presidential Commission on the Space Shuttle Challenger Accident,* (Washington, DC, 1986), 21.
11 *Report of the Presidential Commission on the Space Shuttle Challenger Accident,*.
12 Peggy Noonan, *What I saw at the Reagan Revolution*, (New York, Random House, 1990), 256.
13 National Academy of Sciences, Space Studies Board, Apr 20, 1961.
14 Art Buchwald, "Teachers in Space: A Class Act," *The Washington Post*, Feb 6, 1986, C1.
15 President Ronald Reagan, Eulogy, Challenger Memorial Service, Houston, TX, Jan 31, 1986.
16 *Report of the Presidential Commission on the Space Shuttle Challenger Accident.*
17 Dr. William Graham, Remarks, NASA Press Conference, Feb 12, 1986.
18 Mary McGrory, *The Washington Post*, Feb 3, 1986.
19 Dave Brody, Letter to Editor, *The Washington Post*, copy to Alan Ladwig, Feb 10, 1986.
20 Walter Pincus, "NASA's Push to Put Citizens in Space Overtook Fully Operational Shuttle," *The Washington Post*, Mar 3, 1986.
21 Wally Shirra, "How to Get American Back Into Space," *Popular Mechanics*, Mar 1987.
22 Ed Magnuson, "Fixing NASA," *Time*, Jun 9, 1986.
23 Various national polls conducted in February and March 1986. Polls conducted by *ABC/Washington Post, CBS/New York Times*, Gallup, Harris, *NBC/Wall Street*

Journal, and *Los Angeles Times*.

24 Chuck Yeager, Comments to *UPI* reporter, New Orleans, Mar 23, 1986.

25 Robert Jastrow, Quoted in interview for *USA Today*, Mar 12, 1986.

26 Jan Talcott, Letter to Office of Administrator, NASA, Jan 29, 1986.

27 Bob Caltrider, Letter to Alan Ladwig, Jan 30, 1986.

28 Megan Cortazzo, Letter to NASA, Feb 27, 1986.

29 Mary Hartwell Futrell, Statement, Feb 13, 1986.

30 Mary Hartwell Futrell.

31 Mary Hartwell Futrell, Letter to Dr. James C. Fletcher, Jul 22, 1986.

32 Teacher in Space National Finalists', Letter To the NASA Family, Feb 1, 1986.

33 Timothy P. King, Letter to Association of Schools of Journalism and Mass Communication, Jan 31, 1986.

34 Richard M. Stanley, Letter to Association of Schools of Journalism and Mass Communication, Feb 8, 1986.

35 William Renfro, "A Futurist Looks at Space," *Washington Times*, Mar 24, 1986.

36 *Newsweek*, Feb 10, 1986.

37 "The Death of a School Teacher," Editorial, *The New York Times*, Jan 29, 1986.

38 John Noble Wilford, "Risks Were Spelled Out, Shuttle 'Survivor' Says," *The New York Times*, Apr 21, 1986. A15.

39 Commander Richard Scobee, Speech, Teacher in Space National Awards Conference, Jun 24, 1985.

40 Dan Brandenstein, Interview with Alan Ladwig, March 1990.

41 Sally Ride, Interview with Alan Ladwig, March 1990.

42 Sally Ride.

43 Lowell Wood, Quoted in *San Jose Mercury News*, Nov 11, 1989.

44 Press Release, Teacher is Space Foundation, Mar 18, 1986.

45 Challenger Center for Space Science Education website, www.challenger.org.

46 Challenger Center.

47 William R. Graham, Memorandum to Associate Administrator for External Affairs, Apr 14, 1986.

48 Ann Bradley, Memorandum to James C. Fletcher, Jun 27, 1986.

49 Press Release, Association of Schools of Journalism and Mass Communication, Jul 14, 1986.

50 *Pioneering the Space Frontier: The Report of the National Commission on Space*, (New York, Bantam Books, 1986), iv.

51 *Pioneering the Space Frontier*.

52 Morrie Gelman, "All This And The Moon, Too: Space-Based Reports by 2006 Predicted at RTNDA Session," *Variety*, Sep 3, 1986.

53 Public Law 99-170, "National Aeronautics and Space Administration Authorization Act of 1986," Approved. Section 111, Codified at 42 USC 2451, Dec 5, 1985.

54 James Fletcher, Letter to Don Fuqua, Sep 26, 1986.

55 Rich Corrigan, "NASA's Fletcher: We Let Things Slide," *National Journal*, Jan 24, 1987.

56 *Leadership and America's Future in Space* (The Ride Report), (Washington, DC, NASA Headquarters, Aug 1987), 57.

57 P. Q. Collins and D. M. Ashford, "Potential Economic Implications of the Development of Space Tourism," 37th IAF Congress, Innsbruck, Austria, Oct 4-11, 1986.

58 Companies that developed designs for passenger modules for the cargo bay of the space shuttle or submitted proposals to lease modules included Rockwell International, The Space Trust Corporation, Orbital Adventures, and Society Expeditions.

59 "Throttle Up!" Editorial, *Times-News*, Hendersonville, NC, Sep 30, 1988.

60 "Nation's Hope Rides on Shuttle," Editorial, *Gazette-Telegraph*, Colorado Springs, CO, Sep 29, 1988.

61 Jerome Richards, "In Search of The Ultimate Vacation," *Final Frontier*, Jun 1989, 22.

62 Executive Summary, *Report of the Advisory Committee on the Future of the U.S. Space Program* (Augustine Report), Washington, DC, Dec 1990.

63 William Broad, "The Shuttle Saga May Be Heading Toward a Close," *The New York Times*, Dec 16, 1990.

64 Buddy Nelson, Interview with Alan Ladwig, Jun 3, 1986, 16-17.

CHAPTER 11 – KEEP YOUR EYE ON THE PRIZE
Epigraphs
Miracle on 34th Street, 20th Century Fox, 1947.
Tom De Vries, "A lottery for free ride on space shuttle could beef up NASA budget," *Los Angeles Times*, Apr 1981.
Maryland Lottery advertisement, n.d.

1 James C. Fletcher, Memorandum to Officials in Charge, NASA Policy for Payload Specialists and Space Flight Participants, Jan 11, 1989.

2 Margaret "Peggy" Finarelli, Memorandum to Richard Truly, Jan 17, 1991.

3 NASA News Release 92-40, "NASA Administrator Supports Teaching From Space," Mar 26, 1992.

4 Larry LaRocco, Letter to George H. W. Bush, Feb 2, 1994.

5 Peter West, "In Shift, NASA Head Says 'Teacher in Space' Program a Low Priority," *Education Week*, Apr 13, 1994.

6 Daniel S. Goldin, Memorandum to Distribution, Jun 6, 1994.

7 "Teachers in Space," *The Christian Science Monitor*, Aug 30, 1984, 18.

8 *The Christian Science Monitor*.

9 XPRIZE web site, www.xprize.org/prizes.ansari.

10 Daniel S. Goldin talking points for press conference to announce the XPrize, St. Louis, May 18, 1996.

11 Daniel S. Goldin.

12 Connie Farrow, "The Real Prize of this $10 Million Contest: A Weekend Getaway in Space," *Associated Press*, May 4, 1997.

13 Press Release, Space Transportation Association, Arlington, VA, Sep 12, 1995.

14 Executive Summary, "General Public Space Travel and Tourism, Volume 1," Feb 19-21, 1997, Washington, DC, 6.

15 Executive Summary.

16 Executive Summary.

17 Executive Summary.

18 Alan Boyle, "NASA boards bandwagon for space tourism," *MSNBC*, Mar 25, 1998.

19 Rand Simberg, Interglobal Space Lines, Inc., Space Tourism Report, Jun 8, 2000, www.interglobal.org/sophron/table.html.

20 James Irwin, Letter to James Beggs, Mar 8, 1985.

21 Chuck McCutcheon, "Critics: Glenn Flight a Boost for NASA, Not Science," *Congressional Quarterly*, posted on *CNN* All Politics website, Apr 25, 1988.

22 Jim Banke, "Space tourism among the possible uses for X-34," *Florida Today*, Sep 22, 1995.

23 Jim Banke.

24 Jim Banke.

25 Robert Zimmerman, "How NASA's X-34 ended up rotting in someone's backyard," *Behind the Black* blog post, Feb 20, 2019. www.behindtheblack.com/behind-theblack/points-of-information/now nasas-x34-ended-up-rotting-in-someones-backyard/.

26 en.wikipedia.org/wiki/MirCorp.

27 Robert W. Poole Jr., "The Final Frontier of Tourism," *Wall Street Journal*, May 4, 2001.

28 Jeffrey Manber, Email to Alan Ladwig, Mar 16, 2019.

29 Peter B. de Selding and Brian Berger, "Europe's Space Station Chief Blasts Tourist Trips," *Space News*, Feb 5, 2001.

30 Peter B. de Selding and Brian Berger.

31 Jeffrey Manber.

32 Richard Garriott, Interview, "What's it like to travel in space from a tourist who spent $30 million to live there for 12 days," *CNBC*, Oct 19, 2018.

33 Melissa Harris, "Suddenly, Tourism isn't a Crazy Idea," *Orlando Sentinel*, Jun 27, 2001.

34 House Resolution 2443, the Space Tourism Promotion Act of 2001.

35 Patrick Collins, "The Next Century of Flight," *Aviation Week And Space Technology*, Dec 10, 2001, 98.

36 Patrick Collins.

37 Patrick Collins.

38 NASA News Release, 02-250, "NASA's Educator Astronaut Assigned First Flight," Dec 12, 2002.

39 NASA News Release.

CHAPTER 12 – WAGONS HO!
Epigraphs

Chris Ferguson, Commander STS-135, Post-flight comments, Jul 21. 2001.

Michael Kelly, CEO Kelly Aerospace, quoted by Stan Crock, "Space Travel is Still a Dream," *Business Week*, Jul 10, 2000, 96.

Daimler-Benz Advertisement, ~2005

1 Rob Navius, STS-135 Mission Transcript, Jul 21, 2001.

2 Christian Davenport, *The Space Barons*, (New York City, PublicAffairs, 2018).

3 Tim Fernholz, *Rocket Billionaires*, (Boston, Houghton, Mifflin, Harcourt, 2018).

4 Burt Rutan Biography, www.burtrutan.com.

5 Brian Berger, "Billionaire Shops for Space Tourism Vehicle," *Space News*, May 10, 1999, 10.

6 Chris Leadbeater, "Infinity and beyond: Will Virgin Galactic ever make it into space?" *The Telegraph*, Jan 18, 2018.

7 Jim Parker, "Commercial space travel expected next year, Virgin Galactic announces Spaceport Cup event," *KVIA-TV*, El Paso, TX, Jun 19, 2019.

8 Jim Parker.

9 https://www.virgin.com/news/virgin-galactic-unveils-under-armour-spacewear-and-astronaut-performance-programme-partner.

10 Staff reporter, "When Virgin Galactic's SpaceShipTwo potentially starts operating from the UAE, it will be paired with a carrier aircraft vehicle," *Khaleej Times*, Mar 26, 2019.

11 www.blueorigin.com/our-mission.

12 www.blueorigin.com/new-shepard/become-an-astronaut/.

13 Jack Crosbie, "Bezos: Space Tourism is Going to Be Great Practice for Space Colonies," *Inverse*, Mar 7, 2017. www.inverse.com/article/28717-blue-origin-jeff-bezos-space-tourism

14 www.worldview.space/voyage/#overview.

15 Jeff Faust, "Bezos emphasizes altitude advantage of New Shepard over Space ShipTwo," *Space News*, Feb 20, 2019.

16 Leonard David, "Beyond Tito: Space Travelers Wanted," *Space.com*, May 1, 2001.

17 Code of Federal Regulations, Title 14, Chapter 3, Subchapter C, Part 460–Human

Space Flight Requirements.

18 Eric Berger, "Soon, hundreds of tourists will go in to space. What should we call them? Astronaut or astro-nots?" *Ars Technica*, Mar 4, 2019. www.artechnica.com/science/2019/03/soon-hundreds-of-tourists-will-go-to-space-what-should-we-call-them/.

19 Eric Berger.

20 Eric Berger.

21 Eric Berger.

22 Eric Berger.

23 Eric Burger.

24 Elon Musk, "Prepared Statement, Hearing on Space Shuttle and the Future of Space Launch Vehicles," Senate Committee on Commerce, Science and Transportation, May 5, 2004.

25 Post-launch Press Conference of Dragon2 Mission, Mar 2, 2019.

26 Eric Berger, "Boeing suffers a setback with Starliner's pad abort test," *Ars Technica*, Jul 21, 2018. https://www.arstechnica.com/science/2018/07/boeing-may-have-suffered-a-setback-with-starliners-pad-abort-test/

27 Press Release, "Boeing and Space Adventures to Offer Commercial Spaceflight Opportunities," Sep 15, 2010.

28 Christina Chapman, Email to Alan Ladwig, Jun 24, 2019.

29 www.unoosa.org/oosa/en/ourwork/psa/hsti/FreeFlyer_Orbital_Mission.html

30 Kimberly Schwandt, Email to Alan Ladwig, Apr 30, 2019.

CHAPTER 13 – BEYOND EARTH'S BOUNDARIES—WAY BEYOND

Epigraphs
Tom Rogers, Letter to Daniel S. Goldin, Dec 18, 1995.
Daniel S. Goldin Speech, "Building Your Wings on the Way Down," International Automotive Roundtable, J.D. Powers & Associates, Jan 21, 2000.
Elon Musk, Keynote Address, SXSW, Austin, TX, Mar 9, 2013.

1 Angela Chen and Loren Gush, "SpaceX plans to send two people around the Moon," *The Verge*, Feb 27, 2017.

2 https://www.forbes,com/profile/yusaku-maezawa/#1e9e44466d0e.

3 Yusaku Maezawa, "I choose to go to the Moon with artists," https://dearmoon.earth.

4 Yusaku Maezawa (MZ) Twitter site, @yousuck2020, May 5, 2019.

5 Yuji Nakamura, "Billionaire Jokes 'I have No Money' as He Sells Art, Lends Stock," *Bloomberg* via *Yahoo Finance*, May 7, 2019.

6 Elon Musk, Twitter Post, @elonmusk, Feb 10, 2019.

7 Axios interview, www.youtube.com/watch?v=Wgo4-SsDP1k, Dec 2, 2018.

8 Axios.

9 Axios.

10 Dante Orazio, "Elon Musk believes colonizing Mars will save humanity," *The Verge*, Oct 4, 2014.

11 Elmo Keep, www.medium.com/matter/all-dressed-up-for-mars-and-nowhere-to-go-7e76df527ca0.

12 Elmo Keep.

13 Press Release, "Thirty-eight people have already made a reservation in the space hotel Galactic Suite," Galactic Suite Ltd., Sep 1, 2008.

14 Galactic Suite Ltd.

15 Galactic Suite Ltd.

16 Bigelow Space Operations website, https://www.bigelowspaceops.com.

17 Duncan Madden, "Mankind's First Space Hotel is Coming in 2021–Probably,"

Forbes, Mar 9, 2018.

18 Although this quote is frequently credited to Senator Everett Dirksen, he once told a reporter that he never said it.

19 Orion Space website, www.orionspan.com/about.

20 Orion Span.

21 Orion Span.

22 Orion Span.

23 Axiom Space website, www.axiomspace.com.

24 Axiom Space.

25 Sheila Marikar, "Here comes private space travel – with cocktails, retro-futuristic Philippe Starck designs and Wi-Fi. Just $55 million a trip!" *The New York Times*, Jun 9, 2018.

26 Harry Pettit, "Skylon spaceplane that will take tourists into orbit at five times the speed of sound could be a reality by 2025 after getting £26 million in funding." *Daily Mail*.com, Apr 12, 2018.

27 www.revolvy.com/page/Kanhoh%252Dmaru.

28 NASA News Release 19-044, "Commercial Activities Aboard the Space Station," Jun 7, 2019.

29 Alan Boyle, "Bigelow aims to see rides to space station on SpaceX Dragon ships for $52M a seat," *GeekWire*, Jun 11, 2019.

30 Press Release, "Roscosmos and Space Adventures Sign Contract for Orbital Space Tourist Flight," Space Adventures, Feb 19, 2019.

31 Tom Piazza, "Close Encounter: Norman Mailer," *OMNI*, Jul 1989, 18.

32 Danielle Carey, Email to Alan Ladwig, Jul 11, 2019.

33 Richard Mandapat Call with Alan Ladwig, Jun 21, 2019.

34 Shannah C. Email to Alan Ladwig, Jun 25, 2019.

35 www.spaceforhumanity.org/application-hub.

36 Kerry Hebden, "Space for Humanity wants to send you to space," *The Space Journal*, Jul 3, 2017.

37 Have quote on notecard, but do not have the appropriate reference. It was from a book about Challenger accident.

38 Lizzie Edmonds, "We really can't lose anyone: Sir Richard Branson says Virgin Galactic space flights can't risk NASA's 3% death rate," *Daily Mail.com*, Feb 22, 2014.

39 Frank White, *The Overview Effect: Space Exploration and Human Evolution*, (Boston, MA, Houghton Mifflin Company), 1987.

40 Ron Garan, *The Orbital Perspective: An Astronaut's View*, (Chelsea, England, John Blake Publishing, Limited), 2015.

41 Julia Calderone, "Something profound astronauts see from space for the first time," *Business Insider*, Aug 31, 2015.

42 "Space: The greening of the astronauts," *Time*, Dec 11, 1972, 43.

43 Dr. Aleksandr Serebrov, Speech, American Institute of Aeronautics and Astronautics Conference, Jun 1990.

44 Catherine Clifford, "What's it like to travel to space, from a tourist who spent $30 million to live there for 12 days," *CNBC*, Oct 19, 2018.

45 Julia Calderon.

46 "Space tourism–a launch Australia can't afford to miss," *Camden-Narellan Advertiser*, Apr 2019.

47 *Camden-Narellan Advertiser*.

48 *Camden-Narellan Advertiser*.

49 *San Francisco Examiner*, Aug 8, 1972.

50 www.challenger.org/challenger_lessons/christas-lost-lessons/.

51 Marcia Dunn, "Christa McAuliffe's lost lessons," *Orlando Sentinel*, Aug 7, 2018.

52 Lacey McLaughlin, "Worldwide Course Prepares Students for Space Tourism Business," The Embry-Riddle Newsroom, Jul 24, 2017.

53 Lacey McLaughlin.

54 Robert A. Goehlich, *Textbook of Space Tourism*, Second Edition, (Berlin, Germany, Epubli, 2015).

55 Alan Ladwig, "Master Magician Arthur C. Clarke: A Guide to the Future," *FASST Tracks*, Vol. 2, No.3, Nov 1977, 1.

56 Wolfgang D. Mueller, *Man Among the Stars*, (New York, Criterion Books, 1957), 38.

57 "Topics of the Times: A Severe Strain on Credulity," *The New York Times*, Jan 13, 1920. The paper retracted their statement in Jul 17, 1969.

58 Vannevar Bush, "Inquiry into Satellite and Missile Program, Part 1, ~late 1940s, 83. Also found at www.azquotes.com/author/2255-Vannevar_Bush.

59 Chuck Yeager, *The Washington Post*, April 23, 1985, D1.

60 Ray Bradbury, Quoted in *Why Man Explores*, (Washington, DC, Government Printing Office, NASA-EP-123, 1997), 87.

INDEX

Page numbers in *italics* refer to photos

ABOUT THE AUTHOR
Alan Ladwig

In semi-retirement, Ladwig is the chief of To Orbit Productions, an independent company that provides consulting services and lectures on space issues, as well as the creation of folk art based on space themes. He also serves on the board of directors and is chief of communications of the Star Harbor Space Training Academy, a startup company with plans to offer astronaut training to the public.

He served three terms at NASA Headquarters. As a political appointee of the Obama Administration, he was the head of Public Outreach. During the Clinton Administration, Ladwig was associate administrator of the Office of Policy and Plans. From 1981 to 1989, he held positions in the Office of Education, the Office of Space Flight, and the Office of Exploration. He managed the Shuttle Student Involvement Program and the Spaceflight Participant Program, which included the Teacher in Space and Journalist in Space competitions.

He was chief operating officer during the startup phase of the Zero Gravity Corp. As vice president of Washington Operations, he established and managed Space.com's Washington Bureau, where he authored stories for the web and an opinion column, "Are We There Yet?" for *Space Illustrated* magazine.

Ladwig is the recipient of NASA's Distinguished Service Medal, the Exceptional Achievement Medal, two Exceptional Service Medals, and the Outstanding Leadership Medal. He is a Fellow of the American Astronautical Society. In 2014, Ladwig received the Distinguished Alumni Award from both Elgin Community College and the Illinois Community College Trustees Association.

He earned both a master's degree in higher education and a bachelor's degree in speech from Southern Illinois University; he also received an associate degree in business from Elgin Community College. He served in the U.S. Army from 1972-1974.

Email address: ToOrbitProductions@gmail.com
Website: www.ToOrbitProductions.com
Twitter: @SpaceArtAl

Made in the
USA
Middletown, DE